PENGUIN CLASSICS

LIVES OF THE ARTISTS

VOLUME I

GIORGIO VASARI was born in 1511 at Arezzo in Tuscany. While still a boy he was introduced to Cardinal Silvio Passerini who put him to study in Florence with Michelangelo – who later became a close friend – then with Andrea del Sarto. He left Florence when his patron, Duke Alessandro, was assassinated, and wandered round Italy filling his notebooks with sketches; it was during this period that he conceived the idea of the *Lives*. By now, in his thirties, Vasari was a highly successful painter and when his *Lives* were published they were received enthusiastically. He returned to Florence in 1555 to serve Duke Cosimo who appointed him architect of the Palazzo Vecchio. After a grand tour of Italian towns he published the revised and enlarged edition of his *Lives* in 1568. Vasari spent the rest of his life in a glow of self-satisfaction and public recognition, and in 1971 he was knighted by Pope Pius V. He died in 1574.

•

GEORGE BULL is an author and journalist who has translated six volumes for the Penguin Classics: Benvenuto Cellini's *Autobiography*, *The Book of the Courtier* by Castiglione, Vasari's *Lives of the Artists* (two volumes), *The Prince* by Machiavelli and Pietro Aretino's *Selected Letters*. He is also Consultant Editor to the Penguin Business Series. After reading history at Brasenose College, Oxford, George Bull worked for the *Financial Times*, McGraw-Hill *World News*, and for the *Director* magazine, of which he was Editor-in-Chief until 1984. His other books include *Vatican Politics; Bid for Power* (with Anthony Vice), a history of take-over bids; *Renaissance Italy*, a book for children; *Venice: The Most Triumphant City*; and *Inside the Vatican*.

GIORGIO VASARI

LIVES OF THE ARTISTS

VOLUME I

A SELECTION TRANSLATED BY
GEORGE BULL

PENGUIN BOOKS

PENGUIN BOOKS

Published by the Penguin Group
27 Wrights Lane, London W8 5TZ, England
Viking Penguin Inc., 40 West 23rd Street, New York, New York 10010, USA
Penguin Books Australia Ltd, Ringwood, Victoria, Australia
Penguin Books Canada Ltd, 2801 John Street, Markham, Ontario, Canada L3R 1B4
Penguin Books (NZ) Ltd, 182–190 Wairau Road, Auckland 10, New Zealand

Penguin Books Ltd, Registered Offices: Harmondsworth, Middlesex, England

This tranlation published as *Lives of the Artists* 1965
Reprinted with minor revisions 1971
Reprinted as *Lives of the Artists: Volume 1* 1987
3 5 7 9 10 8 6 4

Made and printed in Great Britain by
Richard Clay Ltd, Bungay, Suffolk
Set in Monotype Bembo

CONTENTS

For Catherine and Jennifer

INTRODUCTION

VASARI'S LIVES

In the second edition of the *Lives*, which was seen through the press in Florence in 1568, Giorgio Vasari informed his fellow artists that of the large number of volumes printed of the first edition, eighteen years before, not one had been left on the booksellers' hands. A best seller when they were first published four hundred years ago, his biographies of the artists of the Renaissance have over the centuries maintained both their wide popular appeal and their immense historical value.

Vasari was born in 1511 (about the time Henry VIII came to the throne of England) in Arezzo, a Tuscan town which was subject to the Republic of Florence. He was a year old when by force of Spanish arms the Medici family were restored to power in Florence (to rule there almost without interruption for over two hundred years). As he grew up the dynastic conflict between France and Spain, in which Florence became a pawn in the Spanish camp, was caught up in the shattering turmoil of the Reformation. When he died in his early sixties the Catholic world was busy on harsh internal reform and offensive military action against Protestant states and rulers. The city state of Florence had long since settled down to the paternal rule of a Medici duke. Still developing vigorously in the north of Europe, in Italy the ideas and attitudes of the Renaissance were being modified or reversed by an alien spirit in art and life.

Though a fairly pious Catholic and a fierce patriot, Vasari was not the slightest bit interested in the religious and political issues of his time: the faintest whiff of gunpowder or heresy was enough to send him running for cover. Like Uccello, murmuring about the beauties of perspective as his wife nagged him to come to bed, like his contemporary Benvenuto Cellini, a braver but not a better man, Vasari was obsessed by art: the pictures and plans he was pouring out himself, the products and performance of his fellow artists. Nevertheless, the *Lives* were shaped by the historical circumstances of sixteenth-century Italy: autocratic governments in Rome and Florence, a balance between freedom of movement and incipient censorship of thought, and a newly established role for the artist in society, partly servant to the court and the people and partly a professional answerable to himself and God alone.

At the end of the *Lives* Vasari included a 'Description' of his own works. From this and from what he tells us elsewhere emerges an autobiography which is generally unexciting in itself but valuable for the light it throws on the genesis of the *Lives*.

He came of a family of tradesmen (the name Vasari derives from *vasaro* or *vasaio*, a potter) which had already given one famous name to art, that of Luca Signorelli, the cousin of Giorgio's grandfather, who gave Giorgio some of his first lessons in drawing. His father, Antonio Vasari, was none too well off (Giorgio was the eldest son of a very big family) but tolerably well connected. He encouraged Giorgio's talent for drawing (as a child, Giorgio copied 'all the good pictures to be found in the churches of Arezzo'); then in 1524 he used a family connexion to give the boy his big chance, taking him along to pay his respects to Cardinal Silvio Passerini, who was passing through Arezzo on his way, as representative of the newly elected Medici Pope, Clement VII, to take over the government of Florence during the minority of Alessandro and Ippolito de' Medici.

When he saw that the boy, who was no more than nine [sic] years old . . . had been so well taught that he knew by heart a great part of Virgil's Aeneid, which he had him recite, and heard that he had been taught how to draw by the French painter Guglielmo da Marsiglia, he told Antonio to bring him to Florence.

Vasari recounts that the cardinal put him to study with Michelangelo in Florence, but almost immediately Michelangelo was called to Rome and he was placed with Andrea del Sarto instead. One would like to know more about the first, providential encounter between the middle-aged Michelangelo and the young Vasari. For over the years Michelangelo came increasingly to value and encourage Giorgio's enthusiastic friendship and Vasari came to idolize Michelangelo as an artist and to revere him as a man; the scheme and structure of the *Lives*, published a quarter of a century after they first met, depend completely on the climax provided by the Life of Michelangelo.

After a good start, with Andrea del Sarto and Baccio Bandinelli as his teachers, Vasari's first few years as a practising artist were fairly harassed and precarious. His father died of the plague, leaving him a family to support; Florence – in revolt against the Medici in 1527 and besieged in 1529 – was for some years a centre of unrest and war. A busy and fruitful interlude was cut short in 1537, when his patron, Duke Alessandro, was assassinated. This was a crushing blow to Vasari's hopes and self-esteem.

I found myself [he wrote later] robbed of all the expectations held out by his favour ... and I determined no longer to seek my fortune at court but to follow art alone, though I could easily have had a position with the new duke, Cosimo de' Medici.

Vasari's immediate reaction to the death of Alessandro was to become ill: he had a nervous breakdown. After he recovered, for four years he refused to return to Florence. During this period, however, and after he again set up house in Florence in 1540, he worked busily, wandering from town to town as far south as Naples, covering canvases and walls with pictures for a variety of patrons and, more fortunately for posterity, filling his notebooks with sketches of the works he saw on his travels. The idea of writing the *Lives* took shape.

By now, in his thirties, Vasari was a highly successful painter, his services constantly in demand and well paid for, the employer of a band of assistants and a propertied man with influential friends, of considerable standing among his fellow artists. He was argued into marriage by one of his friends and patrons, Cardinal del Monte (the future Julius III). The *Lives* were published and acclaimed.

At length, in 1555, he returned to serve the Medici rulers of Florence, appointed by Duke Cosimo as architect for the Palazzo Vecchio and sacrificing his freedom for erratic but powerful patronage and the status of official artist and impresario. He corresponded on terms of growing familiarity with Michelangelo, founded in Florence in 1563 the first of the new academies of art – the *Accademia del Disegno*–which exactly institutionalized the professional and academic purposes of the artists of the time, and arranged elaborate ceremonies and decorative schemes for the ruling family. In preparation for the second edition of the *Lives* he went on a grand tour of Italian towns, checking his facts, gathering new material and consulting with friends. When the revised and far bulkier edition was published, at fifty-seven, he was the respected doyen of the art world of Rome and Tuscany.

The remaining six years of his life were spent in a glow of self-satisfaction and public recognition (his work for Pope Pius V won him a knighthood in 1571), punctuated by worries about his health and his salary and by tiffs with other artists, but otherwise happily devoted to vast and uninspired decorative projects in Rome and Florence, including notably the decoration of the dome of Santa Maria del Fiore. He and Grand Duke Cosimo – grown very fond of each other – died in the same year, 1574.

Vasari's artistic labours were dwarfed by the stature and success of the *Lives*. His work as an architect can be judged from the Uffizi Palace, the Palazzo dei Cavalieri at Pisa, the tomb of Michelangelo in

Santa Croce, in Florence, and the Loggie in Arezzo. His principal paintings are the large frescoes representing the history of Florence and the Medici in the Palazzo Vecchio, the '100 days' fresco'[1] in the Sala della Cancelleria, in the Palazzo San Giorgio at Rome, and the frescoes painted in the Sala Regia, at the Vatican, for Pius V. In addition, he left for posterity a host of crowded canvases, displaying his erudition and his virtuosity.

Until fairly recently Italian art of the years 1520–1600, loosely labelled Mannerist, was regarded as essentially decadent. The name has now fallen into some disfavour, as failing to define the complex and in some cases strongly opposed trends in the art of this period. None the less, Vasari's own highly competent productions still find no admirers. With their rhetoric and fussiness and emphasis on the human figure, they typified the 'court art' practised at Florence under the autocracy of Cosimo, lacking the clarity and boldness of earlier Florentine painting, and untouched by spiritual grandeur. When Robert Carden wrote Vasari's biography early this century he commented:

It may be urged by those who are acquainted with the works executed by Giorgio Vasari, both in architecture and painting, that they are not such as to merit the serious labour involved by an extended biography: and with this view I am in entire agreement.

The sarcasm is a little harsh.

So, too, have been the judgements passed on Vasari himself over the years. His first influential denigrator was Benvenuto Cellini in the pages of whose outrageous *Autobiography* Vasari is shamelessly abused. Cellini describes, for example, how once he gave 'little Giorgio' hospitality in Rome only to have him turn his house upside down and, sharing a bed with an apprentice, tear the skin off the young man's legs when scratching with 'those filthy little claws whose nails he never cut'. Vasari, through Cellini's eyes, appears as a time-server, a liar, and a coward. Cellini, of course, was a monster of prejudice. Vasari quite clearly had a gift for friendship, winning and holding the affection of Michelangelo himself in a way not to be explained simply by Michelangelo's appreciation of the useful publicity which his compatriot could provide. As it is, what Vasari was like emerges clearly and fully from the *Lives* themselves; the

1. So called because of the speed with which they were painted. Vasari was a great believer in the virtues of productivity. But when Michelangelo was told that the frescoes were the work of a young painter he remarked: 'That's obvious . . .' – a story told (without naming the culprit) by Vasari himself.

writing conveys the man, with his conventional wisdom, his respect for the authorities, his lack of guile, but his eye for the main chance, his unsophisticated humour, his delight (so long as they were not *too* outlandish) in the quirks of the artistic temperament, his fondness for money, and his unflagging enthusiasm and frequent perspicacity. A translator gets to know his subject too well not to end by liking him immensely, for his human failings as much as anything else. The reader can judge Vasari for himself.

But it is time to come to the book. From his earliest years Vasari was a keen collector of the drawings of the great masters and of stories about them. Of the drawings, Vasari made his *Libro di disegni*, to which he refers very often in the *Lives*. The fabulous collection no longer exists, though many of the items are extant. He tells in his own biography how the idea of a great history of the artists was finally formed.

When in 1546 he was decorating the Cancelleria in Rome for Cardinal Farnese he used to go along in the evenings and join the cardinal while he was having supper and enjoying the conversation of various artists and writers such as the poet Francesco Maria Molza, Annibale Caro, translator and *littérateur*, and Paolo Giovio, the biographer and art collector. On one of those evenings

the conversation turned to Giovio's museum and the portraits of famous men that he has collected. . . . Giovio said that he had always wanted and would still like to have as well as his museum and his book of eulogies a treatise discussing all illustrious artists from the time of Cimabue up to the present. Enlarging on this, he showed that he enjoyed considerable judgement and understanding in regard to the arts. But it must be said that, talking in general terms, he was careless about details and often made up stories about the artists. . . . When Giovio had finished this discourse the cardinal turned to me and said:

'*What do you say, Giorgio? Would this not be a fine work?*'

'*Splendid,*' *I answered,* '*if Giovio were to be helped by someone of the profession to put things in the right places and to describe matters as they really were. I'm saying this because although what he told us was admirable he had changed and confused many things.*'

Then, urged on by Giovio, Caro, Tolomei, and the others, the cardinal added: '*Then you could give him a catalogue of all these artists and their works, listed in chronological order. . . .*'

This I readily promised to do, as best I could, though I knew it was really beyond my powers. And so I started to look through my memoranda and notes, which I had been gathering on this subject since my childhood as a pastime and because of the affection I bore towards the memory of our artists, every scrap of information about whom was precious to me. Then I put together everything that seemed relevant and took the material along to Giovio. . . .

Giovio, adds Vasari, persuaded him to undertake the complete work himself. And he agreed to this, intending, however, to publish it under a name other than his own.

Some doubts have been cast on the reliability of Vasari's account of the famous dinner-party at Cardinal Farnese's when the subject of the *Lives* was broached. By then, he was already collecting his material. The substantial accuracy of his account, however, is accepted. In gathering his material, checking his facts, writing and revising the *Lives*, Vasari was heavily dependent on the help and ideas of others. He leaned, above all, for literary advice on his friend ('they're really one, though they seem two', said Cellini) the Florentine prior, Vincenzo Borghini. He pressed into his service all kinds of sources, occasionally to the point of plagiarism: traditions handed down by word of mouth, the recollection of his own friends and correspondents, and the considerable body of written material already in existence (the *Commentaries* of Ghiberti, for example, the anonymous Life of Brunelleschi, Boccaccio's *Decameron* and many other biographies, chronicles, commentaries, and records).

The theories of the nature and history of art which are expressed in and through the *Lives* were similarly derivative. Vasari's achievement was to fuse in a work of great literary merit all the knowledge possessed by Florentine artists about their incomparable artistic heritage and the art theories current in intellectual circles in Florence and Rome. In doing this, he also achieved an impressive success as a critic.

He wrote, above all, for his fellow artists, and his purpose was essentially to establish and maintain artistic standards. The complete text of the *Lives*, indeed, includes Vasari's '*parte teorica*' or three-part Introduction, dealing in a highly technical and practical fashion with the methods and materials of architecture, sculpture, and painting.

I have endeavoured [he claimed in his preface to the second part of the Lives] *to distinguish between the good, the better, and the best . . . I have tried as well as I know how to help people who cannot find out for themselves how to understand the sources and origins of various styles. . . .*

In his dedication of the 1550 edition of the *Lives* to Cosimo de' Medici, Vasari again stressed his didactic purpose. His intention, he said, had been not to win praise for his writing but as a craftsman to praise the skill and keep alive the memory of the great artists, hoping also that

the example of so many able men and all the various details of all kinds collected by my labours in this book will be no little help to practising artists as well as pleasing all those who follow and delight in the arts. . . .

The letters of dedication to Cosimo for the 1550 and 1568 editions of the *Lives* echo in their obsequiousness other letters addressed by artists and writers to the Medici – notably Machiavelli's letter to Cosimo's father, Lorenzo, at the head of *The Prince*: the humble posture adopted in these dedications reflected, perhaps, standard modes of address as much as genuine servility. More interesting is the manner in which both Machiavelli and Vasari interpreted political and art history, respectively, in terms of inevitable progression and decline and yet, paradoxically, suggested that the decline could be arrested by genius, by the *virtù* of a political leader or artist, endowed by nature with great ability and taught to emulate the perfection reached in the past. This affirmation of *virtù* has been called the 'fundamental theme of the *Lives*'.

The acceptance of rise and decline in the affairs of men and the idea that a rebirth or renaissance of the fine arts had taken place in Tuscany were both common currency in the intellectual world of Vasari's time. For the idea of a rebirth of the arts, however, Vasari gave compelling chapter and verse: the signs were first seen in such and such buildings, such and such works of sculpture; the men who some two hundred years before had first turned away from the degenerate art of the post-classical world were Cimabue and Giotto, legendary figures to some extent but artists many of whose works could still be seen and whose influence could be traced on succeeding generations. In the second period flourished the flesh-and-blood figures of Ghiberti, Brunelleschi, and Donatello; in the third, when the arts reached the 'summit of perfection', men who worked within living memory or were still alive, Leonardo and Raphael and Michelangelo.

Allowing for various paradoxes or contradictions (such as the belief that the inevitable decline of the arts could be arrested by human effort), Vasari's historical theory is reasonably coherent. But he was no philosopher. His theory of art, confused in any case, was largely expressed in the alarmingly imprecise language of neo-platonism. The best approach to it may be through a brief discussion of some of the key-words used by Vasari (and his fellow artists) in a fairly technical sense, bearing in mind that the influence of neoplatonist thought had, by the middle of the sixteenth century, imbued art jargon with a lofty and even mystical significance.[1]

The reader anxious to judge for himself the content and coherence of Vasari's theories could do worse than read the three prefaces of the *Lives* before embarking on the biographies. On the other hand

1 . See under: Vasari and the Renaissance Artist.

anyone who finds the discussion tedious can go straight to the biographies whose enduring appeal, after all, lies in the colourful manner in which they portray to the life so many of the greatest artists the world has ever known.

There are boring stretches in the *Lives*. When he is moralizing or philosophizing Vasari's writing grows stilted and tortuous. He is at his best when describing a work that has fired his enthusiasm, telling a story, giving a rapid character-sketch, or recalling some significant gesture or encounter. Then his language becomes euphonious, lively and direct, conveying with graceful familiarity his mood of tenderness or humour, wonder or admiration. In such passages Vasari achieves the lucidity and grace of the finest Tuscan writers.

As part of our heritage (like King Alfred's cakes and Newton's apple) the picturesque and often significant details of the *Lives* are familiar enough: Cimabue watching the young Giotto scratching his first drawings on a stone, Giotto drawing his O, Brunelleschi showing the Florentines how to make an egg stand on end, Donatello gaping at Brunelleschi's Crucifix and letting the eggs drop from his apron, Leonardo freeing the birds from their cages or staring for hours on end at the *Last Supper*, the Jews of Rome 'flocking like starlings' to see the great statue of Moses, Michelangelo 'altering' the nose of the *David* to fool Soderini, in his youth storming angrily out of Rome, and in his old age, sick at heart and near to God, refusing ever to leave. In their entirety, the *Lives* may fairly be called a work of art. On one great canvas Vasari painted a harmonious and glowing composition which sustains with ease the task of conveying the revolutionary nature of what happened in Italian art between the fourteenth and sixteenth centuries. He lifted the story of Tuscan art – a series of explosive discoveries by men chosen by God – to the plane of the heroic, stretching back to the quasi-legendary figures of Cimabue and Giotto, and forward to the inspired Michelangelo Buonarroti, genius and saint.

Vasari's accuracy on this, that, or the other point is often impugned by one scholar only to be vindicated by another (as, for example, in the dispute over whether Lorenzo de' Medici did in fact establish an Academy for young artists); but he was certainly careless (even scornful) of dates, many of his attributions are faulty, and his descriptions of particular works are often muddled and wrong in detail. None the less, for the art historian the *Lives* remain today a source of the highest importance, transcending all others for many subjects which may be as broad as the development of Italian sculpture in the sixteenth century or as contained as Michelangelo's plan for the dome of St Peter's. The *Lives* are important, furthermore, not only as

literature and source material. Vasari was, to be sure, starkly out of sympathy with Gothic and Byzantine art. His total lack of interest in the relationship between art and political and social development now appears as a grave omission. However, his critical approach still contains much that is intellectually valid and instructive. He perceived, for example, that a major task of the art historian is to distinguish good work from bad; to relate a work of art both to the artist's intentions and to the central artistic tradition of the age; to judge a work of art by the standards and knowledge available at the time of its creation as well as by the highest standards set by contemporary criticism. These precepts he applied with a large measure of success when making his own judgements. Moreover, he rightly saw (as an artist himself) that the first job of a critic is to look long and carefully at the work being criticized: an obvious duty, perhaps, but not one that art historians have consistently observed.

By using his eyes he often succeeded in rising above his academic prejudices; not enough to see the rich influence of the Byzantine or Gothic on the art he admired, but enough, for example, to appreciate contemporary Venetian art despite its violation of the rules as he knew them. (When he looked at a picture he was prone, however, not only to describe what he saw but to use the scene as starting-point for a *Novella* or story in words of his own, reversing the process by which painters of the early Renaissance had turned literary fantasies into pictures. The story-teller in Vasari wins at the expense of the critic but to the reader's benefit, if he reads for pleasure.) Some artists he underrated (by our present-day standards) and to others (including himself) he did much more than justice. None the less his verdicts on the best, the good, and the not so good have in general stood the test of time.

VASARI AND THE
RENAISSANCE ARTIST

WHEN William Aglionby rendered some of the *Lives* into English in the seventeenth century he wrote:

> That of all the Civilized Nations in Europe, we are the only that want Curiosity for Artists; the Dutch in the midst of their Boggs and ill Airs, have their Houses full of Pictures, from the Highest to the Lowest; the Germans are also Curious in their Collections; the French have as good as can be had for Money. . . .

Reading the *Lives* one is constantly struck not so much by the influence of rich or religious patrons as by the part played by pictures, statues, and beautiful buildings in the everyday life of ordinary people. It is arguable whether this was characteristic of the Renaissance, or of Italy, or is simply (as Aglionby suggested) uncharacteristic of England. Michelangelo said of a statue that it was by the light of the public square that it would be judged. Vasari's description of Michelangelo's funeral includes an extraordinary account of popular fervour. At the time of Giotto, art was essentially popular and religious. By Vasari's time, despite the importance of autocratic patronage, the opinion of the crowd still mattered and by then its hunger for art was also being fed by reproductions.

Religion still provided the main theme and inspiration, but by the middle of the sixteenth century the artist had been largely freed from the restrictions of the guilds and the narrow requirements of ecclesiastical patronage. His prestige was immeasurably greater: Cellini boasted that artists were above the laws; the Pope invited Michelangelo to sit down when he came into his presence in case he did so without being asked; Raphael, who went to work attended by a proud escort of painters, was, in Vasari's words, a 'mortal God'. In more practical terms, the artist had become a professional man, dependent on the whims of his patron – who was now usually at or near the Court – but conscious and jealous of his transformed status. He was bourgeois rather than Bohemian. The development can be traced in the *Lives* themselves, throughout which Vasari was anxious to demonstrate the important part played by the artist in society, on the one hand showing an awareness that the artist's status had in fact improved, on the other anxious to elevate even the early craftsmen to

a higher rank than that of simple decorators or builders. In Vasari the ideas of genius and of the fine arts – the arts of design – assume something like their modern form. So does the idea of the *cognoscenti*, the discriminating, knowledgeable critics, either artists or connoisseurs.

As they became professional, so artists acquired a more esoteric jargon, heavily influenced by fashionable philosophical theories. Art theory and practice were interpreted by new rules meant to refine but often serving to deaden creative work. The following comments on some of the key-words used by Vasari indicate the broad content of his approach to the actual process of artistic creation and the qualities looked for in a perfect work of art.

Disegno. This can mean *design, draughtsmanship*, or simply *drawing* according to the context. Drawing, for the Florentine, was the foundation of sound art: the painter achieved perfection in his finished work by careful practice with preparatory sketches; when he applied his paint to the wall or panel he worked by filling up his outlines with tints arranged in graduation. (In the *Lives*, Michelangelo and Vasari are found regretting that Titian for all his ability had never learned to draw properly!) At the same time, for Vasari and his contemporaries design was the foundation of the fine arts in the philosophical sense that in the creative act the artist has (implanted in his mind by God) an Idea of the object he is reproducing. The figure he draws or carves must reflect both what he sees and the perfect form or design existing in his mind.

Natura. It follows that although Vasari insists that true art consists in the imitation of *nature* – and this was itself a revolutionary discovery or rediscovery of the early fifteenth century – mere reproduction falls short of perfection. An artist may be praised for painting a figure so that it seems to breathe; figures are commended if they seem not painted but three-dimensional – in relief. But the artist must bring to his copying of natural forms a knowledge of the great works of the past as well as the Platonic Idea in his mind. Art, in fact, can and must improve on nature, although nature remains both a starting-point and a constant reference.

Just as in the work of art, nature is enhanced by imitation and judgement, so in the life of the artist, natural or inborn talent is enhanced by constant practice and study.

Grazia. *Grace* is one of the essential qualities of a perfect work of art. In Vasari's art theory its appearance is a 'crucial feature' and it 'takes on a quite new function . . .' as 'an undefinable quality dependent on judgement and therefore on the eye'.[1] By contrast with the

1. Cf. *Artistic Theory in Italy*, by Anthony Blunt (Oxford, 1940).

dryness of the early Renaissance painters and with the severity and sublimity of Michelangelo's style, grace is a quality suggesting softness, facility, and appropriateness.

Decoro. The sense of *decorum* is basically and simply that of appropriateness: thus, if the painter depicts a saint, his gestures, expression, and clothes should reflect the character of a holy man. Later, the meaning was extended to cover the suitability of a work of art to its surroundings and the idea of decorum was used, for example, to attack the over-exposure of Michelangelo's nudes. Vasari was uncomfortably aware of the sterner attitude towards art prevailing in Rome in the 1560s (the Index was first published in 1559); generally, however, he uses the word decorum in its earlier sense.

Iudizio. Decorum, like grace, depends on the painter's *judgement* which is a faculty not so much of the reason as of the eye. It comes into operation *after* an artist has observed all the rules (of imitation, measurement, proportion) and when he is executing the final work swiftly and surely.

Maniera may be translated as *style* or *manner*, referring either to an artist's personal style or to the style of a school. Vasari talks of a 'new style' discovered by Giotto and his pupils and of a 'renewal of style' during the second phase of the rebirth of the arts. He also, however, referred to a 'true' or 'fine' style, namely the *maniera* of the 'modern age' which originated with Leonardo da Vinci and reached perfection with Michelangelo. (Vasari gives his own definitions of 'rule, order, proportion, design, and style' in his preface to the third part of the *Lives*.)

TRANSLATOR'S NOTE

My selections are taken from the second edition of the *Lives*, published in 1568. The full title was: *The Lives of the Most Excellent Painters, Sculptors, and Architects, written by Giorgio Vasari, Painter and Architect of Arezzo, revised and extended by the same, with their portraits, and with the addition of the Lives of living artists and those who died between the years 1550 up to 1567*. When he wrote the first edition Vasari already had the intention of adding further lives of living artists at a later period, but to a great extent the first edition reflected more accurately his brilliant historical design, ending as it did with the climax of the Life of Michelangelo, to whom everything that had gone before was leading. In the second edition there are about a hundred and sixty Lives (including several groups of artists, brief references to various Flemish artists and Vasari's autobiography) as well as the long Introduction, three Prefaces, the dedications to Cosimo de' Medici, and an address to fellow artists. I have translated the three Prefaces and twenty of the Lives, aiming at giving a balanced view of Vasari's attitude towards the development of the arts, but including only those artists still regarded as great masters. As this is itself a mutilation of the *Lives* I have not abridged any of those translated, save the Life of Michelangelo, which is by far the longest. The edition I have mostly used is that of Carlo Ragghianti (*I Classici Rizzoli*) published in 1945 at Milan. Generally, I have not corrected Vasari's inaccuracies in the text. The correct dates at the head of each *Life* may, therefore, be contradicted by what Vasari says himself. Notes have been kept to a minimum: single phrases in Vasari have prompted libraries of comment, but my translation is meant for easy reading. I have given place names and proper names in the form current in English today. The lists at the end of the translation were supplied by Professor Peter Murray.

A selection from the *Lives* was first translated into English by William Aglionby in 1685. The first almost complete translation came in 1850 from Mrs Jonathan Foster, who was followed by A. B. Hinds, in 1900, and Gaston du C. de Vere, in 1912. Various selections have also been published, all or most of them based on one or other of these translations. My own version is fairly close to the Italian text, though for the sake of clarity I have paraphrased here and there, especially when translating Vasari's philosophical reflections and his involved

technical descriptions. Vasari's grammar and punctuation were both erratic and his stock of adjectives limited; in these matters I have, of course, tried to improve in departing from the original. But Vasari, like most writers of the Italian Renaissance in my experience, goes smoothly into modern English; my version of some of the most important of the *Lives* may perhaps restore for a new generation of readers some of the highlights of the original picture.

Sadly lacking in English is a complete, critical edition of the *Lives*. This may one day be supplied by Peter and Linda Murray, to whom I am deeply indebted for unfailing encouragement and expert assistance. I must also acknowledge my debt of gratitude to Dr E. V. Rieu for advice and guidance, to Michael Quinlan (who helped me with the *Lives* where they strayed into Latin), and to my wife, for her patience.

Sutton, Surrey G. B.

THE LIVES OF THE
MOST EMINENT PAINTERS'
SCULPTORS' AND ARCHITECTS'
WRITTEN BY
GIORGIO VASARI'
PAINTER AND ARCHITECT
OF AREZZO

PREFACE TO THE LIVES

I AM fully aware that all who have written on the subject firmly and unanimously assert that the arts of sculpture and painting were first derived from nature by the people of Egypt. I also realize that there are some who attribute the first rough pieces in marble and the first reliefs to the Chaldeans, just as they give the Greeks credit for discovering the brush and the use of colours. Design, however, is the foundation of both these arts, or rather the animating principle of all creative processes: and surely design existed in absolute perfection before the Creation when Almighty God, having made the vast expanse of the universe and adorned the heavens with His shining lights, directed His creative intellect further, to the clear air and the solid earth. And then, in the act of creating man, He fashioned the first forms of painting and sculpture in the sublime grace of created things. It is undeniable that from man, as from a perfect model, statues and pieces of sculpture and the challenges of pose and contour were first derived; and for the first paintings, whatever they may have been, the ideas of softness and of unity and the clashing harmony made by light and shadow were derived from the same source.

Now the material in which God worked to fashion the first man was a lump of clay. And this was not without reason; for the Divine Architect of time and of nature, being wholly perfect, wanted to show how to create by a process of removing from and adding to material that was imperfect in the same way that good sculptors and painters do when, by adding and taking away, they bring their rough models and sketches to the final perfection for which they are striving. He gave His model vivid colouring; and later on the same colours, derived from quarries in the earth, were to be used to create all the things that are depicted in paintings.

It is true that we do not know for certain what men did

before the Flood to emulate this beautiful model in painting
and sculpture. However, it is more than probable that they
too executed paintings and sculptures in every kind of style.
For later, about two hundred years after the Flood, Belos,
son of the proud Nimrod, was responsible for the statue that
was subsequently used for idolatry; and again, his famous
daughter-in-law, Semiramis, queen of Babylon, when that
city was built included in its adornments not only various
kinds of animals, drawn and coloured from life, but also
effigies of herself and her husband, Ninus, besides bronze
statues of her father- and mother-in-law and the latter's
mother. We are told this by Diodorus, who anachronistically
calls them Jove, Juno, and Ops.[1] It may have been from these
statues that the Chaldeans learned how to fashion the images
of their own gods; because we are clearly told in Genesis how
a hundred and fifty years later Rachel stole the idols of her
father Laban, when she fled from Mesopotamia with Jacob
her husband.

It was not only the Chaldeans who produced sculptures and
paintings. The Egyptians were also very proficient in those
arts, as was proved by the marvellous sepulchre of their
ancient king, Ozimandias, which is fully described by Dio-
dorus. And there is another proof in the stern commandment
which Moses issued during the flight from Egypt, which
forbade the Jews under pain of death to make any images
whatsoever of God. When he came down from the moun-
tain, Moses found that his people had made the Golden Calf
and were solemnly adoring it; incensed at seeing divine wor-
ship offered to the image of a beast, he not only smashed it
and crushed it to powder but also, to punish that sin, he
ordered the Levites to kill many thousands of the wicked sons
of Israel for taking part in the idolatry. But it was the worship
given to statues, not the making of them, which was wickedly
sinful; and we read in Exodus that the art of design and of
sculpture, in all kinds of metal as well as marble, was taught
by God to Besaleel, of the tribe of Judah, and to Ooliab, of
the tribe of Dan. They made the two golden cherubim, the

1. Diodorus was Diodorus Siculus, a contemporary of Julius Caesar, who
wrote a universal history in forty books, fifteen of which have survived intact.

candlesticks, and the veil, and the hems of the sacerdotal vestments, and all the beautiful casts for the Tabernacle. Their only motive was to persuade the people to contemplate and adore them.

It was from the works seen before the Flood that men, in their pride, discovered the way to make statues of those whose fame they wanted to perpetuate. The Greeks assigned a different origin to sculpture, arguing, as Diodorus says, that the first statues were made by the Ethiopians, and that the Egyptians learned from the Ethiopians and the Greeks from the Egyptians. Sculpture and painting were perfected by Homer's time, as is proved by the inspired poet himself, who presents the shield of Achilles with such art that we seem to see it carved and painted before our eyes rather than merely described.[1] Lactantius Firmianus, in a fable, attributes their discovery to Prometheus, who like God formed the human image from clay; and he affirms that the art of sculpture can be traced back to him.[2] According to Pliny, painting was brought to Egypt by Gyges of Lydia; for he says that Gyges once saw his own shadow cast by the light of a fire and instantly drew his own outline on the wall with a piece of charcoal. (Pliny adds that for some time afterwards men used to compose their works using only lines and without colour.) This method was later rediscovered, though more laboriously, by Philocles the Egyptian, and also by Cleanthes and Aridices of Corinth, and by Telephanes of Sicyon.

Cleophantes of Corinth was the first of the Greeks to introduce colours and Apollodorus was the first to make use of the brush. They were followed by Polygnotus of Thasos, Zeuxis, and Timagoras of Chalcis, with Pythias and Aglaophon, all of whom were famous artists. And after them came the celebrated Apelles, who was greatly honoured and cherished for his genius by Alexander the Great and who, as we see in Lucian, brilliantly investigated the nature of slander and false

1. *The Iliad*, Book XVIII, where Homer describes in great detail Achilles' 'large and powerful shield, adorned all over, finished with a bright triple rim of gleaming metal . . .', translation by E. V. Rieu (Penguin Books, 1950).

2. Lactantius was a fourth-century Christian writer, author of *Divinae Institutiones* from which Vasari is quoting.

favour.[1] With hardly an exception the painters and architects of that time were capable of faultless work, possessing not only a talent for poetry, like Pacuvius, but also knowledge of philosophy. Metrodorus, for example, was as accomplished a philosopher as he was a painter; he was sent by the Athenians to Paulus Aemilius to arrange the adornments for his Triumph, and he stayed on to teach his sons philosophy.

So the art of sculpture flourished in Greece and was practised by many splendid artists, notably Phidias of Athens, with Praxiteles and Polycletus, as well as Lysippus and Pyrgoteles, who did excellent work in intaglio, and Pygmalion, who produced relief sculpture in ivory.[2] It was Pygmalion of whom the story goes that, in answer to his prayers, the girl he had carved in stone was brought to life.

The ancient Greeks and Romans also honoured and rewarded painters: those who created great works were given the freedom of cities and other impressive dignities. The art of painting so flourished in Rome that Fabius, by signing the delightful pictures he did in the temple of Salus as Fabius Pictor, acquired this as his family name.[3]

In Roman cities slaves were officially debarred from working as painters; and as the people never failed to pay the highest honour to painting and to painters, notable works of art were sent as magnificent trophies to be exhibited among the other spoils in the Triumphs held in Rome. Freedmen became famous artists and received honourable rewards from the republic. The Romans so revered the arts that when Marcellus was despoiling the city of Syracuse he ordered that an illustrious artist who lived there should be treated with the greatest respect. And when he determined to lay waste the city he was careful not to set fire to the quarter where there was a very beautiful painting. This picture was subsequently brought very ceremoniously to Rome, for the Triumph.

1. The essay on Slander by Lucian (Greek satirist of the second century A.D.) mentions a painting by Apelles of Slander (or Calumny) preceded by Envy, Intrigue, and Deception.

2. Intaglio consists in cutting forms in a surface to produce a kind of relief in reverse.

3. i.e. Fabius the Painter.

And in the course of time, after Rome had despoiled almost the whole world, along with their marvellous works the artists themselves came to the city. In this way it became a place of remarkable beauty, for it was lavishly adorned with statues brought from abroad, where there were far more works of art than in Rome itself. For example, in Rhodes, an island city of no great size, there were more than thirty thousand statues, in bronze and marble. The Athenians possessed just as many; there were still more in Olympus and Delphi; and in Corinth the statues were without number, and all extremely beautiful and valuable. Is there not the story of how Nicomedes, king of Lycia, yearned for a statue by Praxiteles, and exhausted almost all the resources of his people in acquiring it? And did not Attalus behave in the same way, being prepared to spend over six thousand sesterces for a painting of Bacchus by Aristides? (It was this painting which Lucius Mummius ceremoniously placed in the temple of Ceres for the embellishment of Rome.)

Although this proves the high value that was placed on the arts of painting and sculpture, it still throws no clear light on their origins. As we have already discussed, they were practised in very ancient times by the Chaldeans; some attribute their discovery to the Egyptians; and the Greeks claim it for themselves. And, according to the testimony of our own Leon Battista Alberti, there are reasons for thinking that the arts flourished at even remoter periods among the Etruscans. Solid evidence for this is provided by the marvellous tomb of Porsena at Chiusi, where not so long ago, buried between the walls of the Labyrinth, were discovered some terracotta tiles in half-relief of such fine workmanship and style that it can easily be seen that they are not the products of an immature art. On the contrary, they are so perfect that they prove the existence of an art that was approaching its zenith. The same conclusion can be reached from evidence found every day in the shape of numerous pieces of those red-and-black Aretine vases which, judging from their style, were made about the same time; they are decorated with very delicate carvings and little figures and histories, in low relief, and with many small round masks, cleverly made by

the artists of that time who must have had considerable skill and ability.

From the statues found at Viterbo at the beginning of the pontificate of Alexander VI it is also clear that sculpture was valued and brought to a high degree of perfection in Tuscany. It is impossible to be precise about dates, but from the style of the figures and from the way the tombs and buildings are constructed, as well as from inscriptions in those Tuscan letters, it may be conjectured that they are very old and that they were made at a time of greatness and prosperity. But what more convincing evidence of this can there be than the bronze figure representing Bellerophon's Chimaera which was discovered in our own times, in 1554, when ditches and walls were being built for the fortification of Arezzo? This figure proves that the art of sculpture had reached perfection among the Tuscans in very early times. It is Etruscan in style, and, moreover, there are some letters cut in one of the paws which, it is conjectured (since today no one can understand the Etruscan language), give the name of the artist and possibly the date according to the usage of those times. Because of its beauty and antiquity, this work has today been placed by the Lord Duke Cosimo in the hall of the new rooms at his palace, where I recently painted scenes from the life of Pope Leo X.[1] As well as this, in the very same place and the very same style were discovered a number of little bronze figures. These, too, are now in the possession of the duke.

The works made by the Greeks, the Ethiopians, and the Chaldeans are all of equally uncertain antiquity, just as much as, or more than, ours are, and so all our judgements contain a large element of uncertainty. However, our conjectures are not so fanciful as to be completely wide of the mark, and I do not think that I myself have strayed from the truth. I am sure that anyone who considers the question carefully will come to the same conclusions as I have reached above: namely, that the origin of the arts we are discussing was nature itself, and that the first image or model was the beautiful fabric of the world, and that the master who taught

1. The discovery of the figure of the Chimaera (a fire-breathing monster slain by Bellerophon) is also mentioned by Cellini in his *Autobiography*.

us was that divine light infused in us by special grace, which has made us not only superior to the animal creation but even, if one may say so, like God Himself. Now, in our own time (as I hope to show a little farther on by a number of examples) simple children, brought up roughly in primitive surroundings, have started to draw instinctively, using as their only models the trees around them, the lovely paintings and sculptures of nature, and guided only by their own lively intelligence. But the first men were more perfect and endowed with more intelligence, seeing that they lived nearer the time of the Creation; and they had nature for their guide, the purest intellects for their teachers, and the world as their beautiful model. So is there not every reason for believing that they originated these noble arts and that from modest beginnings, improving them little by little, they finally perfected them?

It goes without saying that the arts must have been discovered by some one person; and I realize that someone made a beginning at some time. And of course it is possible for one man to have helped another, and to have taught and opened the way to design, colour, and relief; for I know that our art consists first and foremost in the imitation of nature but then, since it cannot reach such heights unaided, in the imitation of the most accomplished artists. Still, I think it is very dangerous to insist that the origin of the arts can be traced to this or that person, and in any case this is hardly something we need to worry about. We have, after all, already seen what is the true origin and basis of art. An artist lives and acquires fame through his works; but with the passing of time, which consumes everything, these works – the first, then the second, then the third – fade away. When there were no writers there was no way of leaving for posterity any record of works of art, and so the artists themselves also sank into obscurity. Then, when writers started to commemorate what had been done before their time, they could only take note of artists of whom some knowledge had come down to them; and so the first artists of whom any record was made are those whose memory was the most recent. For example, by general agreement the first of the poets was said to have been Homer. This

is not because there were no poets before his time. There were none as excellent as Homer, but there were certainly some, as we can see from Homer's own writings. It was because all knowledge of these forerunners, whoever they were, had been lost some two thousand years before. However, this matter takes us too far back into antiquity to be discussed with certainty. Let us come to matters which are less obscure: to the attainment of perfection in the arts, their ruin, their restoration or, to put it better still, their rebirth. Here we can put things on a far more solid basis.

Let us accept that the arts started to be practised at a late period in Roman history, if, as is reported, the first figures were the images of Ceres made of metal taken from the belongings of Spurius Cassius who, because he plotted to make himself king, was killed without any compunction by his own father. I am sure that although the arts of sculpture and painting continued to be practised until the death of the last of the twelve Caesars, their earlier perfection and excellence were not sustained. We can see from the buildings constructed by the Romans that, as emperor succeeded emperor, the arts continually declined until gradually they lost all perfection of design.

There is clear evidence for this in the works of sculpture and architecture produced in Rome at the time of Constantine, and notably in the triumphal arch which the Roman people built for him at the Colosseum. This shows how, for lack of good instructors, they made use not only of marble histories made at the time of Trajan but also of spoils which had been brought from various parts of the world. One can see that the *ex voto* in the medallions, namely, the sculptures in half-relief, and likewise the captives and the great histories and the columns and cornices and other ornaments (which were all either earlier works or else spoils) are beautifully fashioned. On the other hand, one can see that the works made to fill in the gaps, for which contemporary sculptors were solely responsible, are a complete botch, as also are some little histories under the medallions composed of small marble figures, and the pediment, where there are one or two victories. Between the side arches there are some river-gods

which are also very crude; indeed, they are so badly made that it is obvious that the art of sculpture had started to decline before that time. Nevertheless, this was before the coming of the Goths and the other barbarian invaders who destroyed the fine arts of Italy, along with Italy itself. In fact, architecture was not in such a sorry state as the other arts of design. For example, the Baptistry built by Constantine at the entrance to the principal portico of the Lateran (even disregarding the porphyry and marble columns, and double bases, which are beautifully executed and were brought from elsewhere) is as a whole an excellently thought out composition. On the other hand, there is no comparison between the stucco, the mosaic, and some incrustations on the walls, which were all the work of contemporary artists, and the ornaments, which were mostly taken from heathen temples and used by Constantine for the Baptistry. It is said that Constantine proceeded in the same way when he built the temple in the garden of Aequitius, which he later endowed and handed over to the Christian priests. There is further evidence for what I am saying in the magnificent church of San Giovanni in Laterano, which was also built by Constantine. For the sculptures in this church are clearly decadent: the silver statues of the Saviour and the Twelve Apostles, which were made for Constantine, were very inferior works, crudely executed and poorly designed. As well as this, anyone who studies with care the medals and effigies of Constantine and other statues made by sculptors of that period, which are now in the Capitol, can see clearly that they are a long way from the perfection of the medals and statues of the other emperors. All this demonstrates that, a long time before the invasion of Italy by the Goths, the decline of sculpture was well under way.

Architecture, as we said, even if not as perfect as it had been, at least maintained higher standards than sculpture. Not that this is anything to wonder at, because the architects constructed their big buildings almost entirely from spoils and it was a simple matter for them to imitate old edifices which were still standing, when they were building afresh. It was far easier for them to do this than for sculptors who were unskilled to imitate the good statues of the ancient world. The

truth of this is demonstrated by the church of the Prince of the Apostles on the Vatican hill, which owed its beauty to columns, bases, capitals, architraves, cornices, doors, and other adornments and incrustations all brought from various parts and taken from magnificent buildings which had been constructed in former times. The same can be said of the church of Santa Croce in Gerusalemme, which Constantine built at the entreaty of his mother, Helen; of San Lorenzo Fuori Le Mura; and of Sant'Agnese, also built by Constantine, at the request of his daughter, Constance. And it is well known that the font at which Constance and one of her sisters were baptized was ornamented with sculptures made a long time before, notably the porphyry pillar carved with beautiful figures, some marble candelabra exquisitely carved with foliage, and some *putti* in low relief, which are wonderfully beautiful.

To sum up, it is clear that for these and various other reasons by the time of Constantine sculpture had already fallen into decline, together with the other fine arts. And if anything were needed to complete their ruin it was provided decisively when Constantine left Rome to establish the capital of the Empire at Byzantium. For he took with him to Greece not only all the finest sculptors and other artists, such as they were at that time, but also countless statues and other extremely beautiful works of sculpture.

After Constantine had departed, the Caesars whom he left in Italy continually commissioned new buildings, both in Rome and elsewhere. They endeavoured to have the work done as well as possible; but we can see that sculpture and painting and architecture went inexorably from bad to worse. And the most convincing explanation for this is that once human affairs start to deteriorate improvement is impossible until the nadir has been reached. Under Pope Liberius the architects evidently tried to achieve great things when they built the church of Santa Maria Maggiore. But they were not altogether successful. Admittedly, the building (which was also constructed from spoils) has the right proportions. Nevertheless, other faults apart, it is undeniable that the space above the columns going right round the church, which is

decorated with stuccoes and paintings, is of very poor design; and there are many other features of that great church which bear witness to the imperfect condition of the arts at that time.

Many years later, when the Christians were being persecuted under Julian the Apostate, a church was built on the Coelian Hill and dedicated to the martyrs SS. John and Paul; and this was so inferior in style to the churches mentioned above that it proves conclusively that by then art had almost completely died out.

The buildings put up in Tuscany during that period also give eloquent testimony of this. I shall pass many others over in silence, and cite only the church which was built outside the walls of Arezzo and dedicated to St Donatus, the bishop of Arezzo who was martyred with the monk Hilarion under Julian the Apostate. It was architecturally no improvement at all on the church mentioned above; and this was simply because of the lack of good architects, for it was built at great cost, with no expense spared. As we have been able to see in our own lifetime, the church was constructed with eight sides from the remains of the theatre, the colosseum, and other buildings which had stood in Arezzo before the city was converted to the Christian faith; it was adorned with columns of granite, porphyry, and variegated marble, taken from those buildings. For myself, I am convinced, considering what was lavished on the church, that if the Aretines had had better architects they would have produced something marvellous. We can see from what they did achieve that they spared nothing to make the building as rich and well proportioned as possible. And since, as we have said several times already, architecture was in better shape than the other arts, their church did have some good aspects. The church of Santa Maria in Grado was also built at that time and dedicated to Hilarion, who had lived in Arezzo for a long time before he received the palm of martyrdom with Donatus.

However, after fortune has carried men to the top of her wheel, she usually, for sport or from regret for what she has done, spins the wheel right round again. Just so, after the events we have described almost all the barbarian nations rose up against the Romans in various parts of the world, and this

within a short time led not only to the humbling of their
great empire but also to worldwide destruction, notably at
Rome itself. This destruction struck equally and decisively at
the greatest artists, sculptors, painters, and architects: they
and their work were left buried and submerged among the
sorry ruins and debris of that renowned city. Painting and
sculpture were the first of the arts to fall on evil days, since
they existed chiefly to give pleasure. Architecture, being
necessary for sheer physical existence, lingered on, but with-
out its former qualities or perfection. Statues and pictures
intended to immortalize those in whose honour they had been
done could still be seen by succeeding generations; had it
not been so, the memory of both sculpture and painting would
soon have been destroyed. Some men were commemorated
by effigies and inscriptions placed not only on tombs but also
on private and public buildings such as amphitheatres and
theatres, baths, aqueducts, temples, obelisks and colossi,
pyramids, arches, and treasuries. But a great many of these
were destroyed by savage and barbarian invaders, who
indeed were human only in name and appearance.

Among them were the Visigoths who, under Alaric,
assailed Italy and Rome and twice sacked the city mercilessly.
The Vandals, coming from Africa under King Genseric,[1]
followed their example; and then, content neither with the
cruelties he inflicted nor with the booty and plunder he
seized, Genseric made slaves of the people of Rome, plunging
them into terrible misery. He also enslaved Eudoxia, wife of
the Emperor Valentinian who had been murdered a little
while previously by his own soldiers. These men had mostly
forgotten the ancient valour of the Romans; a long time
before, all the best troops had left with Constantine for
Byzantium and those who remained were dissolute and cor-
rupt. At one and the same time every true soldier and every
kind of military virtue were lost. Laws, customs, names, and
language were all changed. All these events brutalized and
debased men of fine character and high intelligence.

But what inflicted incomparably greater damage and loss
on the arts than the things we have mentioned was the fervent

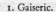

1. Gaiseric.

enthusiasm of the new Christian religion. After long and bloody combat, Christianity, aided by a host of miracles and the burning sincerity of its adherents, defeated and wiped out the old faith of the pagans. Then with great fervour and diligence it strove to cast out and utterly destroy every least possible occasion of sin; and in doing so it ruined or demolished all the marvellous statues, besides the other sculptures, the pictures, mosaics and ornaments representing the false pagan gods; and as well as this it destroyed countless memorials and inscriptions left in honour of illustrious persons who had been commemorated by the genius of the ancient world in statues and other public adornments. Moreover, in order to construct churches for their own services the Christians destroyed the sacred temples of the pagan idols. To embellish and heighten the original magnificence of St Peter's they despoiled of its stone columns the mausoleum of Hadrian (today called Castel Sant'Angelo) and they treated in the same way many buildings whose ruins still exist. These things were done by the Christians not out of hatred for the arts but in order to humiliate and overthrow the pagan gods. Nevertheless, their tremendous zeal was responsible for inflicting severe damage on the practice of the arts, which then fell into total confusion.

As if these disasters were not enough, Rome then suffered the anger of Totila:[1] the walls of the city were destroyed, its finest and most noble buildings were razed to the ground with fire and sword, and then it was burned from one end to the other, left bereft of every living creature and abandoned to the ravages of the conflagration. For the space of eighteen days not a living thing moved; Totila tore down and destroyed the city's marvellous statues, its pictures, mosaics, and stuccoes. As a result, Rome lost, I will not say its majesty but rather, its identity and its very life. Now the ground floors of the palaces and other buildings in Rome had been decorated with stuccoes, paintings, and statues; these were buried under the ruins, and only in our own day have many of these rare works been rediscovered. Those who lived after the disasters,

1. Last king of the Ostrogoths, eventually defeated by the Byzantine general, Narses.

believing that everything was lost, planted vines on the rubble; and so the ground floors of the buildings which had been destroyed stayed for centuries under the earth. For that reason in modern times they have been called grottoes, and the paintings that can now be seen in them have been called grotesques.

After the Ostrogoths had been exterminated by Narses, the ruins of Rome were inhabited in miserable fashion until, a hundred years later, the arrival of Constantine II, the emperor of Constantinople; he was affectionately welcomed by the Romans, yet he dissipated, despoiled, or carried away everything of value which had been left (more by chance than by the deliberate choice of the plunderers) in their unhappy city. True enough he was unable to enjoy his booty, because while at sea he was swept by a tempest to Sicily, where he was justly killed by his own men, losing to fortune his spoils, his kingdom, and his life. However, fortune, not content with the losses Rome had already suffered, in order to prevent what had been stolen ever being brought back led a band of Saracens to the island, who carried off to Alexandria the wealth of the Sicilians and the spoils taken from Rome, to the great shame and loss of Italy and the Christian faith. So what had not been destroyed by the pontiffs (notably St Gregory, who is said to have issued an edict against all the remaining statues and works of art, which were taken from the buildings) was finally lost because of that wicked Greek. In the end there was left not the slightest trace of good art. The next generation of artists were awkward and crude, especially when it came to painting and sculpture. However, prompted by nature and civilized by the very atmosphere in which they lived, they did start to create works of art, not according to the rules of good art, of which they were ignorant, but with each one following his own ideas.

Such was the condition of the arts of design before, during, and after the period when the Lombards ruled Italy as despots. Precious little was done, but the practice of the arts did at least continue, and so did their decline. The work produced could not have been more awkward or more lacking in the qualities of design. Of this, one proof among many is

provided by some figures above the doors in the portico of St Peter's at Rome, which were made in the Byzantine style and which commemorate some Fathers of the Church who had defended Holy Church before some of the Councils. Other examples can be found in the city and throughout the Exarchate of Ravenna, notably some figures just outside the city in Santa Maria Rotonda, made soon after the Lombards were chased out of Italy. I cannot deny that this church contains one impressive and very noteworthy feature, namely, the vaulting or rather cupola which covers it. This is nearly twenty feet in diameter and serves as a roof covering the whole building, and yet it is all in one piece. It seems impossible that such a large, unwieldy slab of stone, weighing over two hundred thousand pounds, could have been raised so high.[1] But to go back to what I was saying: what came from the hands of the artists of those times were only fantastic abortions of the kind we can still see in many old works.

Architecture met the same fate as sculpture. Men still had to build, but all sense of form and good style had been lost by the death of good artists and the destruction and decay of their work. Consequently those who practised architecture produced buildings which were totally lacking in grace, design, and judgement as far as style and proportion were concerned. And then new architects came along who built for the barbarians of that time in the kind of style which we nowadays know as German; they put up various buildings which amuse us moderns far more than they could have pleased the people of those days. Then some idea of form and some approximation to the good ancient rules were rediscovered by better architects, who have left examples of their style throughout Italy in the oldest as distinct from the antique churches. For instance, they built a palace for Theodoric, king of Italy, at Ravenna, another at Pavia and another at Modena, all of which, however, were in that barbarous style, vast and ornate but showing little grasp of sound architectural principles. The same criticism can be levelled against San Stefano in Rimini, San Martino in Ravenna, and the

1. The *libra* (pound) is equivalent to about twelve ounces of the lb. avoirdupois.

church of San Giovanni Evangelista built in the same city by
Galla Placidia, around the year 438 A.D., as well as San Vitale
which was built in 547, the Abbey of Classe di Fuori, and in
short against many other monasteries and churches built
after the time of the Lombards. All these buildings, as I have
said, are vast and magnificent, but extremely clumsy in their
architecture; they include many monasteries in France, dedi-
cated to St Benedict, the church and monastery of Monte
Cassino, and the church of San Giovanni Battista at Monza,
built by that Theodolinda, queen of the Goths, to whom
Pope St Gregory addressed his *Dialogues*. It was there that the
history of the Lombards was painted for the queen. The
scenes show that the Lombards shaved the back of their heads,
wore their hair long in front, and dyed their bodies up to
their chin. Like the Angles and Saxons, they wore broadcloth,
multicoloured cloaks, and sandals open along the foot and
bound at the ankle with leather straps.

The church of San Giovanni at Pavia, built by Theo-
dolinda's daughter, Gondiberta, was similar to the churches
mentioned above, as also was the church of San Salvatore
(built in the same city by Aribert, Gondiberta's brother, who
succeeded Rodoald, the queen's husband) and the church of
Sant'Ambrogio of Pavia, built by Grimoald, the Lombard
king who drove out Bertrid, the son of Aribert. After the
death of Grimoald when Bertrid was restored to the throne
he built in Pavia a convent, in honour of Our Lady and St
Agatha, called the New Convent, and his queen built a con-
vent outside the walls, dedicated to Our Lady in Pertica.
Bertrid's son, Cunibert, erected, in the same style as the
above, a monastery and church in honour of St George,
called San Giorgio di Coronate, at the spot where he had won
a major victory over Alahi. And similar to these was the
church which the Lombard king Luitprand, who was a
contemporary of Charlemagne's father, King Pepin, built at
Pavia, which is called San Pietro in Ciel d'Oro. Also in the
same style was the church of San Pietro Clivate, in the
diocese of Milan (which was built by Desiderius who reigned
after Astolphus), the monastery of San Vincenzo in Milan,
and the monastery of Santa Giulia in Brescia: they were all

very costly works, but in the ugliest, most impure styles. Later on, architecture showed some improvement, and in Florence the church of SS. Apostoli, which was built by Charlemagne, was extremely beautiful even though it was small. The shafts of the columns are formed of separate pieces, but they are very graceful and finely proportioned; and, moreover, the capitals and the arches which form the vaulting for the two side aisles show that one good artist remained, or rather arose, in Tuscany at that time. In fact, the architecture of the church is such that Filippo Brunelleschi was not ashamed to use it as a model when he built the churches of Santo Spirito and San Lorenzo in Florence.

The same progress can be seen in the church of St Mark at Venice (not to mention the church of San Giorgio Maggiore, built by Giovanni Morosini in 978). St Mark's was started near San Teodosio under the Doges Justiniano and Giovanni Particiaco, when the body of the Evangelist was brought to Venice from Alexandria; after the Doge's palace and the church itself had been damaged several times by fire, it was eventually rebuilt on the same foundations in the Byzantine style, as it appears today, at tremendous expense and under the direction of several architects. This was in A.D. 973, when the doge was Domenico Selvo. It was he who had the columns brought from various parts of the world. Work on the church continued, with as I said several architects, all Greeks, supervising the design, until 1140, when the doge was Piero Polani.

The seven abbeys which Count Ugo, marquis of Brandenburg, built in Tuscany at that time were also Byzantine, as we can see from the Abbey of Florence, the one at Settimo, and from the others. All these buildings and the ruins of others show us that architecture was still alive, although very bastardized and very remote from the sound antique style. The same is shown by many old palaces which were built in Florence after Fiesole was destroyed. These are the work of Tuscans, but they are barbarously impure in style, as we can see from the proportions of their ridiculously long windows and doors, and from the zigzags in the vaulting of their arches after the practice of foreign architects of that time.

Then in 1013 the reconstruction of the beautiful church of San Miniato sul Monte showed that architecture had regained some of its earlier vigour. This was when the Florentine Alibrando was bishop of Florence. The interior and the exterior of the church are richly ornamented with marble, and its façade shows how the Tuscan architects were striving to reproduce in the doors, the windows, columns, arches, and cornices as much as they could of the pure antique style, which to some extent they recognized in the very ancient church of San Giovanni in their own city.[1] At the same period the art of painting, after having almost completely disappeared, started to revive a little, as we can see from the mosaic executed in the principal chapel of San Miniato.

From these beginnings the arts of design slowly started to revive and flourish in Tuscany. In the year 1016, for example, the Pisans began to construct their cathedral; and at that time it was a major step forward to set to work on a church which had five naves and was almost entirely faced with marble, both inside and out. This church was built from the designs and ideas of a Greek from Dulichium by the name of Buschetto, a notable architect of that time. It was constructed and decorated by the Pisans from innumerable spoils shipped from all parts of the world, they being then at the height of their power. We can see this clearly from the cathedral's columns, bases, capitals, and cornices, and from the other stones of every kind which it contains. These materials were of various sizes, small, large, and medium; so in fitting them together and arranging them to build the church Buschetto showed no little skill. The exterior and interior of the cathedral are both beautifully constructed. Not to mention other things, for the principal façade of the church Buschetto used a great number of columns, achieving a very ingenious diminution towards the gable, which he adorned with various kinds of sculptured columns and antique statues. Similarly he made the principal doors of the façade; and it was between these (near the door of the *Carroccio*)[2] that Buschetto was subsequently

1. The Baptistry of San Giovanni, built in the eleventh century or earlier.
2. The *Carroccio* was the sacred car or chariot, bearing the altar and banner of the Commune.

given an honourable burial-place, with three epitaphs, one of which, in Latin verse, is typical of the style of the period. It reads as follows:

> *Quod vix mille boum possent iuga iuncta movere,*
> *Et quod vix potuit per mare ferre ratis,*
> *Buschetti nisu, quod erat mirabile visu,*
> *Dena puellarum turba levavit onus.*[1]

As I referred above to the church of SS. Apostoli at Florence, I should add that on a marble slab on one of the sides of its high altar there is an inscription which runs:

viii. v. die vi APRILIS *in resurrectione* DOMINI KAROLUS *Francorum Rex a Roma revertens, ingressus Florentiam cum magno gaudio et tripudio susceptus civium, copiam torqueis aureis decoravit....* ECCLESIA *Sanctorum Apostolorum. In altari inclusa est lamina plumbea, in qua descripta apparet praefata fundatio et consecratio, facta per* ARCHIEPISCOPUM TURPINUM *testibus* ROLANDO *et* ULIVERIO.[2]

The construction of the cathedral at Pisa revived in many craftsmen throughout all Italy, but especially in Tuscany, the ambition to create beautiful works of art. It encouraged the building of the church of San Paolo in the city of Pistoia; this was started in 1032 in the presence of Blessed Atto, bishop of Pistoia, as we can read in a contract, too long to quote here, which was drawn up at that time.

I must also add that some time later in the year 1060 the circular church of San Giovanni was built on the very same square, opposite the cathedral. It is an amazing thing, and almost unbelievable, that it took two weeks and no more to

1.　　　A load was here that scarce a thousand yoke
　　　　Of oxen link'd might budge, scarce any ship
　　　　Bear o'er the sea; yet, wondrous sight to see
　　　　Buschetto's toil a band of maidens ten
　　　　Hath given power to lift it up on high.

2. . . . on the sixth of April, the day of the Lord's Resurrection, Charles the king of the Franks, coming back from Rome and having entered Florence amid great rejoicing and been welcomed by the citizens with ceremonial dancing, bestowed necklaces of gold upon a large number of them . . . the Church of the Holy Apostles. There is inlaid in the altar a leaden plate, on which there is written a record of its foundation and consecration as aforesaid by Archbishop Turpin in the presence of Roland and Oliver.

erect and complete the columns, pilasters, and vaulting of this church, as is recorded in an ancient document in the cathedral's office of works. In the same record, which anyone may consult, it is written that a tax of a penny on every hearth was imposed to raise funds for building the church, although it does not say whether this means a gold or copper coin. And at that time, the record also tells us, there were thirty-four thousand hearths in Pisa. The building certainly took a great deal of money and proved very difficult to bring to completion, especially the vaulting of the tribune which is pear-shaped and covered on the outside with lead. The exterior is rich in columns, carvings, and histories, and the frieze of the centre door has a figure of Jesus Christ with the Twelve Apostles carved in bas-relief in the Byzantine style.

At the same time, namely 1061, the Lucchese, in rivalry with the Pisans, started building the church of San Martino at Lucca, using the designs of certain pupils of Buschetto as there were then no other architects of Tuscany. Attached to the main façade of the church is a marble portico with many ornaments and carvings done in memory of Pope Alexander II, who was bishop of Lucca just before he was raised to the pontificate. And there are nine lines of Latin verse telling the full story of the building of the church and of Alexander himself; these are cut in marble, in antique lettering, between the doors under the portico. The façade has several figures, and under the portico there are many bas-relief carvings in marble, in the Byzantine style, depicting scenes from the life of St Martin. The best carvings, however, which are over one of the doors, were done a hundred and seventy years later by Nicolò Pisano, and finished, as I shall recount later on, in 1233, the original wardens being Abellenato and Aliprando, as is plainly described by some words cut in marble on the same site. These figures from the hand of Nicolò Pisano show how greatly he advanced the art of sculpture.[1] Most if not all of the buildings erected in Italy from that time up to 1250 were similar to the above, because over all those years there was little or no progress or improvement in

1. Nicolò Pisano, who lived in the middle of the thirteenth century, along with his son Giovanni is considered to be the founder of 'modern' sculpture.

architecture, which remained confined within the same limits, continuously illustrating the same crude style; many examples still survive, but I shall not draw attention to them now as there will be opportunities later on.

During the period we are discussing good paintings and sculptures remained buried under the ruins in Italy, unknown to the men of that time who were engrossed in contemporary rubbish. For their works they used only the sculptures or paintings produced by a few remaining Byzantine craftsmen, either clay or stone figures or pictures of grotesque figures with only the rough outlines drawn in colour. These Byzantine artists, being the best there were and in fact the only surviving representatives of their profession, were brought to Italy where they introduced their manner of sculpture and painting along with mosaic. Thus, the Italians learned how to copy their clumsy, awkward style and for a certain time continued to employ it, as I shall describe later.

The men of that time had no experience of anything better than those imperfect productions, which were regarded as great works of art, villainous though they were. And yet, helped by some subtle influence in the very air of Italy, the new generations started to purge their minds of the grossness of the past so successfully that in 1250 heaven took pity on the talented men who were being born in Tuscany and led them back to the pristine forms. Before then, during the years after Rome was sacked and devastated and swept by fire, men had been able to see the remains of arches and colossi, statues, pillars, and carved columns; but until the period we are discussing they had no idea how to use or profit from this fine work. However, the artists who came later, being perfectly able to distinguish between what was good and what was bad, abandoned the old way of doing things and started once again to imitate the works of antiquity as skilfully and carefully as they could.

I want to give a simple definition of what I call old and what I call ancient. Ancient works of art or antiques are those which were produced in Corinth, Athens, Rome, and other famous cities, before the time of Constantine up to the time of Nero, Vespasian, Trajan, Hadrian, and Antoninus. Old

works of art are those which were produced from the time of St Silvester by a few surviving Greek artists, who were dyers rather than painters. As we described earlier, the great artists of earlier times died out during the years of war, and the few Greeks who survived, belonging to the old not the ancient world, could only trace outlines on a ground of colour. We have daily evidence in the countless mosaics done by the Greeks which can be seen in every old church in all and every city in Italy, notably in the cathedral of Pisa and St Mark's at Venice. Over and over again they produced figures in the same style, staring as if possessed, with outstretched hands, on the tips of their toes, as can still be seen in San Miniato outside Florence, between the doors of the sacristy and the convent, and in Santo Spirito in the same city, all along the cloister leading to the church, and similarly in Arezzo, in San Giuliano and San Bartolommeo and in other churches, and in old St Peter's at Rome, in the scenes all round the windows; the way they are drawn, they all resemble grotesques rather than what they are meant to represent.

The Greeks also produced countless pieces of sculpture, examples of which we can still see in low relief above the door of San Michele, in the Piazza Padella at Florence, and in Ognissanti, and in many other places. Among examples to be seen on tombs and on the doors of churches are figures, acting as corbels to support the roof, which are so clumsy and ugly and made in so gross a style that it is impossible to imagine anything worse.

So far I have been talking about the origins of sculpture and painting, perhaps at greater length than was called for at this stage. However, the reason for my doing so has been not so much my great love of the arts as the hope that I would say something useful and helpful to our own artists. For from the smallest beginnings art attained the greatest heights, only to decline from its noble position to the most degraded status. Seeing this, artists can also realize the nature of the arts we have been discussing: these, like the other arts and like human beings themselves, are born, grow up, become old, and die. And they will be able to understand more readily the process by which art has been reborn and reached perfection

in our own times. And if, which God forbid, because of indifference or evil circumstances or the ruling of Providence (which always seems to dislike the things of this world proceeding undisturbed) it ever happens at any time that the arts once again fall into the same disastrous decline, then I hope that this work of mine, such as it is, if it proves worthy of a happier fate may, because of what I have already said and what I am going to write, keep the arts alive, or at least may inspire some of the more able among us to give them every possible encouragement. In this way, my good intentions and the work of outstanding men will, I hope, provide the arts with support and adornment of a kind which, if I may be allowed to say this outright, they have been lacking hitherto.

But now it is time to come to the life of Cimabue who, since he originated the new way of drawing and painting, should rightly and properly be the first to be described in my *Lives*, in which I shall endeavour as far as possible to deal with artists according to schools and styles rather than chronologically. I shall not spend much time in describing what artists looked like because their portraits, which I have myself collected diligently with no little expenditure of time and money, are far more revealing as to their appearance than any written description could ever be. If any portrait is missing, this is not my fault but simply because it was impossible to find it anywhere. And if any of the portraits happens to appear dissimilar to others that may have been found, I should remind the reader that a portrait made of someone when he was, say, eighteen or twenty, would never resemble one made fifteen or twenty years later. As well as this, remember that you never get as good a likeness with a black-and-white reproduction as with a painting; and apart from that, engravers, who have little sense of design, always rob the image of something, because of their lack of knowledge and ability regarding those small details which make a good portrait, and their failure to capture the perfection which woodcuts rarely if ever achieve. The reader will appreciate the exertions, the expense, and the care that have gone into this work when he sees that I have as far as possible used only the best originals.

LIFE OF

CIMABUE

Florentine painter, c. 1240–1302?

THE flood of misfortunes which continuously swept over and submerged the unhappy country of Italy not only destroyed everything worthy to be called a building but also, and this was of far greater consequence, completely wiped out the artists who lived there. Eventually, however, by God's providence, Giovanni Cimabue, who was destined to take the first steps in restoring the art of painting to its earlier stature, was born in the city of Florence, in the year 1240. As he grew up he was seen by his father and by others to be of excellent character and intelligence, and he was sent for schooling to a family relation who was then teaching grammar to the novices at Santa Maria Novella. But instead of studying his letters Cimabue spent all his time, as if inspired, covering his paper and books with pictures showing people, horses, houses, and the various other things he dreamt up. And fortune certainly looked kindly on this instinctive talent, for it happened that the rulers of Florence decided to send for some Greek painters, solely in the hope of restoring the art of painting which at that period was not so much in decline as altogether lost. Among other projects, these craftsmen started to decorate the Gondi Chapel, situated next to the principal chapel of Santa Maria Novella, which is still there though its roof and walls have been almost wholly destroyed by time. Now Cimabue, taking his first steps in the art which attracted him, was always playing truant to spend the whole day watching those artists as they worked. As a result his father and the Byzantine painters decided that he had an aptitude for painting and that if he gave his time to it he could be expected to do extremely well. So, to Cimabue's delight, his father made an agreement for him to work under those artists; and subsequently, helped by his natural talents, he applied himself so well that he easily

surpassed those who taught him, both in drawing and colouring. As for them, they were unambitious men and the work they executed in Florence was, as we can see today, carried out in the stiff contemporary style of that period, not in the fine antique style of Greece. So although Cimabue imitated those Greeks he vastly improved the art of painting and raised it far above their level; and he won honour for his native place by the work he did and the fame he acquired. In Florence we have evidence of this in the paintings he has left, such as the altar dossal at St Cecilia, and a panel of the Madonna in Santa Croce, which is still hanging where it was placed on a pillar at the right-hand side of the choir. After this he did a small panel picture of St Francis, on a gold ground, drawing the saint to the best of his powers from nature; and this was a new departure for that time. He added scenes telling all the story of the life of St Francis, using twenty small pictures crowded with little figures on a gold ground. Then he undertook a large panel for the Vallombrosan monks in their abbey at Santa Trinità at Florence; and in this painting Cimabue took great pains to justify the reputation he had already secured, showing original powers of invention and depicting the Madonna, beautifully posed, carrying her son in her arms and surrounded by adoring angels, on a gold ground. When the panel was finished the monks put it over the high altar of their church; subsequently, to make room for the painting by Alesso Baldovinetti which is there today, it was removed to the side chapel of the south aisle. Then Cimabue worked in fresco in the hospital of the Porcellana, at the corner of the Via Nuova leading to Borgo Ognissanti. On one side of the façade, with the main door in the middle, he painted the Annunciation, and on the other Jesus Christ with Cleophas and Luke, all the figures being life-size. And in this work Cimabue broke decisively with the dead tradition of the Greeks, for whereas their paintings and mosaics were covered with heavy lines and contours, his draperies, vestments, and other accessories were somewhat softer and more realistic and flowing. (To be sure, their crude, stiff, and mediocre style owed nothing to study, but came from blindly following what had been handed on year

after year by painters who never thought of trying to improve their drawing and never sought after lovely colours or any creditable inventions.) After this, Cimabue was approached again by the same Father Superior who had commissioned the work for Santa Croce, and he painted a large Crucifixion on wood which can still be seen in the church today. The Father Superior was so well satisfied that he took Cimabue to the convent of San Francesco in Pisa, where he painted a panel picture of St Francis. The people there considered this work of rare quality, for they perceived an indefinable excellence, both in the attitude of the head of St Francis and in the fall of the drapery, which had not previously been attempted by anyone working in the Byzantine style, either in Pisa or indeed in all Italy. For the same church Cimabue then painted a large panel picture of Our Lady holding her son in her arms and surrounded by angels on a gold ground. After a short while this painting was removed to make room for the marble altar which is there now and put inside the church on the left by the door. For this work the Pisans praised and rewarded him generously. It was in Pisa, too, that at the request of the abbot of San Paulo in Ripa d'Arno, he did a small panel picture of St Agnes, surrounded by various small figures representing scenes from her life; today, this little painting is above the altar of the Holy Virgins in the same church.

These works made Cimabue famous. He was asked to the city of Assisi, in Umbria, where in collaboration with some Byzantine artists he decorated some of the vaults in the Lower Church of San Francesco, adding on the walls scenes from the lives of Our Lord and of St Francis. In these works he easily surpassed the Byzantine painters, and growing more ambitious he started painting some frescoes in the Upper Church without any assistance. In the apse over the choir he painted in four sections various scenes from the life of Our Lady: her death, her soul being carried up by Christ on a throne of clouds to heaven, and her coronation by Christ in the midst of a choir of angels, with a throng of male and female saints standing below. These have now been worn away by time and dust. He also painted a large number of

scenes in the intersections of the five vaults of the church.
In the first, above the choir, he showed the four evangelists,
larger than life-size and so well done that even today one can
see how good they are; and from the freshness of the colours
used for their flesh one can see what great strides were made
through Cimabue's exertions in the art of fresco. He painted
the second intersection with gold stars on a ground of ultra-
marine. In the third he painted several medallions showing
Jesus Christ, his mother the Virgin Mary, St John the Baptist,
and St Francis; there was one of these figures in each medal-
lion and one medallion in each of the vault's four sections.
Between this and the fifth he painted the fourth vault, like
the second, with a host of gold stars on a ground of ultra-
marine. In the fifth he depicted the four Doctors of the
Church, each accompanied by a member of one of the four
great religious orders. This was an exhausting work executed
with tremendous diligence.

When he had finished the vaulting Cimabue worked in
fresco on all the upper part of the wall of the north side of
the church, painting eight scenes from the Old Testament
between the windows up to the vault, near the high altar. He
started with the beginning of Genesis and continued in order
with the most famous subsequent events. And around the
windows, to where they terminate at the triforium, he
depicted events from the other books of the Old Testament in
another eight scenes. Opposite these frescoes, in a further
sixteen scenes, he painted incidents from the lives of Our
Lady and Jesus Christ. On the wall below, over the main
doorway of the church and around the rose window, he
depicted Our Lady's Assumption into Heaven, and the
Descent of the Holy Ghost upon the Apostles. This truly great
work by Cimabue, so richly and skilfully executed, must in
my opinion have astounded everyone at that time, especially
as the art of painting had been completely unenlightened for
so long. As for me, when I set eyes on it again in 1563 I
thought it wonderfully beautiful and I was astonished at the
vision Cimabue had shown, although he was surrounded by
so many shadows. But it is worth remarking that of all the
paintings those which he did on the vaults, being less damaged

by dust and other accidents, are by far the best preserved. When he had finished these works, Giovanni made a start on decorating the lower parts of the wall, stretching down from underneath the windows. He completed one or two things; but then his affairs made it necessary for him to go back to Florence and he left the work uncompleted for Giotto to finish many years later, as I shall describe when the time comes.

When Cimabue returned to Florence he worked in the cloister of Santo Spirito, the whole side of which opposite the church is covered with paintings in the Byzantine style by other artists. He depicted on three small arches scenes from the life of Christ, which were drawn very competently. At this time as well he sent some of the work he did in Florence to Empoli; and these paintings are still there in the parish church, where they are held in great reverence. Then he did a panel picture of Our Lady for the church of Santa Maria Novella, where it hangs up high between the Rucellai Chapel and the chapel of the Bardi of Vernio; the figure was larger than any that had been painted up to that time, and some of the angels show that although he worked in the Byzantine style he was gradually adopting something of the draughtsmanship and method of modern times. As a result this painting so astonished his contemporaries, who had never seen anything better, that it was carried to the sound of trumpets and amid scenes of great rejoicing in solemn procession from Cimabue's house; and Cimabue was generously praised and rewarded for it. It is said, and we can read it in some records left by the old painters, that while Cimabue was at work on this painting in some gardens near St Peter's Gate, the old King Charles of Anjou passed through Florence, and that among the many courtesies that the Florentines extended to him they took him to see Cimabue's painting. As this had not yet been seen by anyone, when it was shown to the king all the men and women of Florence flocked there as well, jostling each other and rejoicing. The people who lived in the neighbourhood were so delighted that they called the place Borgo Allegri, the Joyful District, and when over the years it came to be included within the walls of the city, it still kept the same name, and still does.

In San Francesco at Pisa, where as I said above Cimabue did several other paintings, there is a small panel by his hand, in tempera, in the cloister at a corner near the church door. It shows Christ hanging on the cross, with several angels who are weeping and holding in their hands a few words written above His head; they are directing these words towards the ears of Our Lady, who stands in tears on the right, and of St John, who is there grief-stricken on the left. The words meant for the Virgin are: *Mulier, ecce filius tuus*, and those for St John read: *Ecce mater tua*. And to one side there is another angel holding the message: *Ex illa hora accepit eam discipulus in suam*. From this we can see that Cimabue was starting to shed new light and to open the way to invention by expressing the meaning of his painting with the help of words; this was certainly a very novel and fanciful departure.

After Cimabue had won a considerable reputation and no small profit from these works he was taken into partnership by Arnolfo Lapi, a highly skilled architect of that time, in the construction of Santa Maria del Fiore at Florence. But at length in the year 1300, at the age of sixty, Cimabue departed from this life, having all but succeeded in bringing the art of painting back to life. He left many disciples, including the great painter, Giotto; and Giotto lived after Cimabue in his master's house in the Via del Cocomero. Cimabue was buried in Santa Maria del Fiore, and his epitaph, by one of the Nini family, was as follows:

Credidit ut Cimabos picturae castra tenere,
Sic tenuit vivens; nunc tenet astra poli.[1]

I must also add that if his disciple Giotto had not diminished his glory, Cimabue's fame would have been even greater, as was indicated by Dante in his *Divine Comedy*, where in the eleventh Canto of the *Purgatorio* in an allusion to Cimabue's epitaph he says:

Credette Cimabue nella pintura
Tener lo campo, ed ora ha Giotto il grido;
Sí che la fama di colui oscura.[2]

1. 'Twas Cimabue's belief that he did hold the field in painting. So in life he did; but now the stars of heaven are his.

A commentator on Dante wrote an interpretation of these lines during the lifetime of Giotto, some ten or twelve years after the death of Dante himself, about the year of Our Lord 1334. Talking about Cimabue he used these exact words:

Cimabue was a Florentine painter who lived at the time of the poet; he had outstanding ability, but he was so arrogant and disdainful that if anyone remarked any fault or defect in his work or if he had noticed any himself (for, as often happens, an artist can make a mistake because of some defect in his materials or some inadequacy in the instruments he is using) he immediately rejected it, no matter how precious it might be. Giotto was and is the greatest of painters and also comes from the city of Florence; and his work at Rome, Naples, Avignon, Florence, and Padua bears this out. . . .

This commentary is now in the possession of the Very Reverend Vincenzo Borghini, prior of the Innocenti, a man renowned for his nobility, goodness, and learning, who is also a lover and connoisseur of all the fine arts and who well deserved the post of official representative at our Academy of Design, for which he was wisely chosen by the Lord Duke Cosimo.

But to return to Cimabue: although Giotto's fame obscured his, this was only in fact in the way that a great light dims the splendour of a lesser. Cimabue was, as it were, the first cause of the renewal of the art of painting. Giotto, although he was his pupil, inspired by a worthy ambition and helped by providence and his natural gifts, aspired even higher. And it was Giotto who opened the door of truth to those who have subsequently brought the art of painting to the greatness and perfection it can claim in our own century. In our time there have been so many marvels and so many miraculous, indeed, well-nigh impossible artistic triumphs to see every day that we have come to the point where no matter what is done, even if it seems superhuman, no one is astonished. And those artists who exert themselves in a

2. Once, Cimabue thought to hold the field
In painting; Giotto's all the rage today;
The other's fame lies in the dust concealed.
 From Dorothy Sayers's translation (Penguin Books, 1955).

praiseworthy way are lucky if they avoid being blamed and even very often brought to shame instead of earning praise and admiration. The portrait of Cimabue by Simone Martini can be seen in the chapter-house of Santa Maria Novella. It is done in profile, in Simone's painting of the Faith; the figure shows a thin face, with a small, pointed beard, reddish in colour, and wearing a hood after the fashion of those days wound very gracefully round the head and throat. The figure beside him is Simone himself, the artist, who drew himself with the help of two mirrors facing each other, so that he could show his own head in profile. And the heavily armed soldier standing between them is, it is said, Count Guido Novello, who was then ruler of Poppi. In conclusion, I must record that I have some little works from the hand of Cimabue, resembling miniatures, at the beginning of a book in which I have collected drawings by artists from his time to our own; although today these may seem rather crude, all the same they show how much the art of design profited from his labours.[1]

1. Vasari's collection of drawings - the *Libro di Disegni* - to which he often refers in the *Lives*. The book no longer exists; many of the drawings are now in the Uffizi Gallery at Florence.

LIFE OF

GIOTTO

Florentine painter, sculptor, and architect, 1266/7–1337

In my opinion painters owe to Giotto, the Florentine painter, exactly the same debt they owe to nature, which constantly serves them as a model and whose finest and most beautiful aspects they are always striving to imitate and reproduce. For after the many years during which the methods and outlines of good painting had been buried under the ruins caused by war it was Giotto alone who, by God's favour, rescued and restored the art, even though he was born among incompetent artists. It was, indeed, a great miracle that in so gross and incompetent an age Giotto could be inspired to such good purpose that by his work he completely restored the art of design, of which his contemporaries knew little or nothing. And yet this great man, who started life in the year 1276 in the village of Vespignano, fourteen miles out in the country from the city of Florence, was the son of a poor peasant farmer called Bondone, who gave him the name Giotto and then brought him up just like any other boy of his class.

By the time he reached the age of ten Giotto showed in all his boyish ways such unusually quick intelligence and liveliness that he delighted not only his father but all who knew him, whether they lived in the village or beyond. Bondone used to let him look after some sheep; and while the animals grazed here and there about the farm, the boy, drawn instinctively to the art of design, was always sketching what he saw in nature, or imagined in his own mind, on stones or on the ground or the sand. One day Cimabue was on his way from Florence to Vespignano, where he had some business to attend to, when he came across Giotto who, while the sheep were grazing near by, was drawing one of them by scratching with a slightly pointed stone on a smooth clean piece of rock. And this was before he had received any instruction

except for what he saw in nature itself. Cimabue stopped in astonishment to watch him, and then he asked the boy whether he would like to come and live with him. Giotto answered that if his father agreed he would love to do so. So Cimabue approached Bondone, who was delighted to grant his request and allowed him to take the boy to Florence. After he had gone to live there, helped by his natural talent and instructed by Cimabue, in a very short space of time Giotto not only captured his master's own style but also began to draw so ably from life that he made a decisive break with the crude traditional Byzantine style and brought to life the great art of painting as we know it today, introducing the technique of drawing accurately from life, which had been neglected for more than two hundred years. Although, as I said before, one or two people had tried to do this, no one succeeded as completely and as immediately as Giotto. Among the things that he did at this time was, as we can see today, a painting in the chapel of the palace of the Podestà at Florence, showing his dear friend Dante Alighieri, who was no less famous as a poet than he was as a painter. (We find Giotto being highly praised by Giovanni Boccaccio in the introduction to his story about Forese da Rabatta and Giotto himself.[1]) In the same chapel are portraits by Giotto of Dante's master, Brunetto Latini, and of Corso Donati, an eminent Florentine citizen of those days.

Giotto's first paintings were done for the chapel of the high altar of the abbey of Florence where he executed many works which were highly praised. Among them, especially admired was a picture of the Annunciation in which he convincingly depicted the fear and trembling of the Virgin Mary before the Archangel Gabriel; Our Lady is so fearful that it appears as if she is longing to run away.

The panel painting over the high altar of the same chapel is also by Giotto, but this work has been kept there more from respect for anything by so great an artist than for any other reason. Four of the chapels in Santa Croce were also painted by Giotto, three of them between the sacristy and the main chapel and one on the opposite side of the church. In the first

1. *Decameron*, 6th day, *novella* 5.

of the three, that of Ridolfo di Bardi where the bell-ropes are, is the life of St Francis. In this painting Giotto painted with great effect the tears of a number of friars lamenting the death of the saint. In the second, the Peruzzi Chapel, are two scenes from the life of St John the Baptist, to whom the chapel is dedicated: in these, Giotto has depicted in very lively fashion the dancing and leaping of Herodias and the prompt service given by some servants at table. In the same place are two marvellous scenes from the life of St John the Evangelist, showing him restoring Drusiana to life and then being carried up into heaven. In the third chapel, belonging to the Giugni family, and dedicated to the Apostles, Giotto has painted scenes showing the martyrdom of many of those holy men. In the fourth chapel on the other side of the church towards the north, belonging to the Tosinghi and the Spinelli families and dedicated to the Assumption of Our Lady, Giotto painted the Birth of Our Lady, her Betrothal, the Annunciation, the Adoration of the Magi, and the Presentation of the Christ-child to Simeon in the Temple. This is a beautiful work, for apart from the skill with which he has depicted the emotions of the old man as he takes Christ from His mother, the attitude of the child Himself, who is frightened of Simeon and all timidly stretches out his arms and turns towards his mother, could not be more moving or beautiful. Then in the painting showing Our Lady's death Giotto depicted the Apostles and a number of angels with torches in their hands, very beautifully executed.

In the Baroncelli Chapel of the same church there is a painting in tempera by Giotto, in which he has very carefully depicted the Coronation of Our Lady with a great number of small figures and a choir of angels and saints, finished with great care. On this work are Giotto's name and the date, in gold letters; and any artist who considers when it was that Giotto, without any enlightenment from the good style of our own time, gave the first impulse to the correct way of drawing and colouring, is bound to hold him in the greatest respect.

In the same church of Santa Croce there is also, above the marble tomb of Carlo Marsuppini of Arezzo, a Crucifixion,

with the Virgin, St John, and the Magdalen at the foot of the cross. On the other side of the church, directly opposite this, above the tomb of Leonardo of Arezzo near the high altar, is an Annunciation; and this has been retouched by later painters, with results that show little judgement on the part of whoever was responsible. In the refectory there is a Tree of the Cross, with scenes from the life of St Louis and a Last Supper, all by the hand of Giotto; and on the presses of the sacristy there are a number of scenes, with small figures, from the lives of Christ and of St Francis.[1]

The chapel of St John the Baptist in the Carmelite Church was also decorated by Giotto with four paintings tracing the life history of St Francis: and in the Guelph Palace at Florence there is by his hand a history of the Christian Faith, perfectly executed in fresco, containing the portrait of Pope Clement IV who established the Guelph magistracy and conferred on it his own coat-of-arms which it has held uninterruptedly ever since.[2] When all this work was finished, Giotto left Florence for Assisi in order to finish the works which had been started there by Cimabue. On his way he decorated the chapel of St Francis, which is above the baptistry in the parish church of Arezzo, as well as painting from life portraits of St Francis and St Dominic, on a round column which is near a very fine, antique Corinthian capital, and also, in a little chapel of the Duomo outside Arezzo, executing the beautifully composed picture of the Stoning of St Stephen.

After this Giotto went on to Assisi in Umbria, having been summoned there by Fra Giovanni di Murro della Marca, who at that time was minister general of the Franciscans; and at Assisi in the Upper Church of San Francesco, on the two sides of the church under the gallery that crosses the windows, he painted thirty-two histories from the life and works of St Francis. There are sixteen frescoes on each wall, and they were so perfect that they brought Giotto tremendous fame. There

1. A Tree of the Cross is a picture of the cross with the genealogical tree of Christ composed of medallions of the patriarchs and prophets.
2. Vasari himself did some work for the (still standing) Palazzo di Parte Guelfa built in the fourteenth century for the Captains of the Guelph (or papal) party.

is, indeed, wonderful variety not only in the gestures and attitudes of all the figures shown in the cycle but also in the composition of every single scene; moreover, it is marvellous to see the way Giotto painted the various costumes worn at that time and his observation and imitation of nature. One of the most beautiful scenes is of a man showing signs of great thirst kneeling down to drink eagerly at a fountain; the incident is conveyed so exactly and movingly that one might be looking at a real person. There are many other things in the cycle which demand our attention. For the sake of brevity I shall not dwell on them; it is enough to record that this work won tremendous fame for its author because of the excellence of the figures, and because of the liveliness, the ease, order, and proportion of Giotto's painting, qualities which were given him by nature but which he greatly improved by study and expressed clearly in all he did. As well as being naturally talented, Giotto was extremely studious; he was always going for new ideas to nature itself, and so he could rightly claim to have had nature, rather than any human master, as his teacher.

After the fresco cycle was finished, Giotto did some more work in the same place, but in the Lower Church, painting the upper part of the walls beside the high altar and all four angles of the vault, above where St Francis is buried, with scenes of great beauty, imagination, and inventiveness. In the first he depicted St Francis glorified in heaven, surrounded by the virtues necessary if one wants to be in a state of perfect grace before God. On one side there is Obedience, putting a yoke on the neck of a friar who kneels in front of her; the reins of the yoke are being drawn up towards heaven, and Obedience, a finger at her lips, is cautioning silence and turns her eyes towards the figure of Jesus Christ, whose side is flowing with blood. Standing among the various virtues are the figures of Prudence and Humility, intended to show that where there is true obedience there is always humility and always the prudence to make every action wise. Chastity is depicted on the second angle of the vault, standing secure in a strong castle and unmoved by the offers being made to her of kingdoms and crowns and palms of glory. At

her feet is the figure of Purity, washing the naked and attended by Fortitude who is bringing people to be washed and purified. To the side of Chastity is the figure of Penitence, chasing away Cupid with the cord of discipline and putting Impurity to flight. On the third angle is Poverty, who goes in her bare feet trampling on thorns; there is a dog behind her, barking, and near at hand one naked boy throwing stones and another pressing thorns into her legs with a stick. We see this same figure of Poverty being wed by St Francis, with her hand held by Jesus Christ, in the mystical presence of Hope and Charity. In the fourth and last of the angles of the vault is St Francis, again in glory, clothed in the white tunic of a deacon; he stands triumphant in heaven in the middle of a great choir of angels, who bear a standard showing a cross and seven stars, and over above is the Holy Ghost. On each of these paintings are written some words in Latin, which explain their significance.

As well as the paintings on the vault, there are on the walls of the transepts some beautiful pictures which truly deserve to be held in great esteem, not only because they are perfect works of art but also because they were executed with such tremendous care that they are still as fresh today as when they were done. Among them is an excellent portrait of Giotto himself. And above the door of the sacristy there is another painting by Giotto, again in fresco, showing St Francis receiving the stigmata and displaying such devout emotion that it seems to me the finest Giotto did in that group, although all the paintings are really beautiful and praiseworthy.

When he had finally finished his work with the painting of St Francis, Giotto returned to Florence where, after his arrival, he did a panel picture to be sent to Pisa, showing St Francis standing on the fearful rock of La Vernia. He took extraordinary pains over this work, for as well as depicting a landscape full of trees and rocks, which was an innovation for that time, he showed in the attitude of St Francis, who is eagerly kneeling down to receive the stigmata, a burning desire to be granted it and a tremendous love for Jesus Christ, who is seen above surrounded by seraphim and who concedes it to him, showing such expressive tenderness that

it is impossible to imagine anything better. On the predella of the same painting are three other scenes from the life of St Francis, all beautifully executed.

This painting, which can be seen today on a pillar at the side of the high altar in San Francesco at Pisa, where it is kept as a memorial of so great a man, was the reason why the Pisans, who had just finished the fabric of the Campo Santo according to the designs of Giovanni, the son of Nicolò Pisano (as I have described already) commissioned Giotto to paint some of the interior. They wanted the inside walls to be decorated with the most noble paintings, since the outside had been encrusted at very great expense with marbles and intaglios, the roof covered with lead, and the interior contained very many antique monuments and tombs from the times of the pagans which had been brought to Pisa from all parts of the world. So having gone to Pisa for this purpose, Giotto made a start on one of the walls of the Campo Santo with six great frescoes showing scenes from the life of the patient prophet Job. Now, very judiciously, Giotto took note of the fact that the marble in the part of the building where he had to work was turned towards the sea and therefore, being exposed to the sirocco, was always damp and tended to exude salt, just as do nearly all the walls in Pisa, with the result that colours and paintings are eaten into and fade away. So to preserve his work as long as possible, wherever he intended to paint in fresco he first laid on an undercoat, or what we would call an intonaco or plaster, made of chalk, gypsum, and powdered brick. This technique was so successful that the paintings he did have survived to the present day. They would be in even better condition, as a matter of fact, if they had not been considerably damaged by damp because of the neglect of those who were in charge of them. No precautions were taken (although it would have been a simple matter to have done so) and as a result the paintings which survived the damp were ruined in several places, the flesh tints having darkened and the plaster flaked off. In any case when gypsum is mixed with chalk it always deteriorates and decays, so although when it is used it appears to make an excellent and secure binding, the colours are invariably spoilt.

In these histories as well as the portrait of Farinata degli Uberti there are many beautifully executed figures, notably those of a group of villagers bringing Job the sad news of his losses; their emotion and grief at the loss of Job's cattle and his other misfortunes could not have been better portrayed. There is also tremendous grace in the figure of a servant with a fan of branches in his hand standing by the side of Job, who is weeping and abandoned by everyone else; the figure of the servant is beautiful no matter how it is considered, but his attitude is especially striking as with one hand he brushes away the flies from his leprous, stinking master, and with the other holds his nose in disgust, to avoid the stench.

The comparable beauty of the other figures in these histories and of the heads of the men and the women, along with the delicate treatment of the draperies, make it no wonder that because of this work Giotto won such a reputation in Pisa and beyond that Pope Benedict IX, who was intending to have some paintings commissioned for St Peter's, sent one of his courtiers from Trevisi to Tuscany to find out what sort of man Giotto was and what his work was like. On his way to see Giotto and to find out whether there were other masters in Florence who could do skilful work in painting and mosaic, this courtier spoke to many artists in Siena. He took some of their drawings and then went on to Florence itself, where one day he arrived at Giotto's workshop to find the artist at work. The courtier told Giotto what the Pope had in mind and the way in which he wanted to make use of his services, and, finally, he asked Giotto for a drawing which he could send to his holiness. At this Giotto, who was a very courteous man, took a sheet of paper and a brush dipped in red, closed his arm to his side, so as to make a sort of compass of it, and then with a twist of his hand drew such a perfect circle that it was a marvel to see. Then, with a smile, he said to the courtier: 'There's your drawing.'

As if he were being ridiculed, the courtier replied:

'Is this the only drawing I'm to have?'

'It's more than enough,' answered Giotto. 'Send it along with the others and you'll see whether it's understood or not.'

The Pope's messenger, seeing that that was all he was going to get, went away very dissatisfied, convinced he had been made a fool of. All the same when he sent the Pope the other drawings and the names of those who had done them, he also sent the one by Giotto, explaining the way Giotto had drawn the circle without moving his arm and without the help of a compass. This showed the Pope and a number of knowledgeable courtiers how much Giotto surpassed all the other painters of that time. And when the story became generally known, it gave rise to the saying which is still used to describe stupid people: 'You are more simple than Giotto's O.' This is a splendid witticism, not only because of the circumstances which gave rise to it but also because of the pun it contains, the Tuscan word *tondo* meaning both a perfect circle and also a slow-witted simpleton.

So the Pope sent for Giotto to come to Rome, where he recognized and honoured his genius, and commissioned from him five scenes from the life of Christ for the apse of St Peter's, as well as the principal work for the sacristy. Giotto executed these so painstakingly that they were the most finished work in tempera ever to have left his hands. The Pope, realizing how well he had been served, had Giotto given as a reward six hundred gold ducats, and did him so many other favours besides that it was talked about through all Italy.

In Rome at that time (to mention something that deserves to be recorded) there was a great friend of Giotto's called Oderisi of Agobbio. As he was a first-class illuminator he had been brought to Rome by the Pope, and he illuminated many books for the Vatican library, most of which have not survived the passage of time. However, in my book of old drawings there are one or two things of his. He was indeed a very competent artist, although Franco of Bologna was a far better craftsman. Franco did a great deal of excellent work for the same Pope, and for the same library, in exactly the same style as Oderisi, as can be seen in my book where I have designs done by him for paintings and illuminations, among them a beautifully drawn eagle and a very fine lion which is tearing a tree. Dante mentions these two superb illuminators in the eleventh canto

of the *Purgatorio*, where he describes the vainglorious, in these lines:

> O, dissi lui, non se' tu Oderisi,
> L'onor d'Agobbio e l'onor di quell'arte,
> Ch'alluminare è chiamata in Parisi?
> Frate, diss' egli, più ridon le carte
> Che pennelleggia Franco Bolognese:
> L'onor è tutto or suo, e mio in parte.[1]

When the Pope had seen what Giotto could do, he was so pleased with his style that he ordered him to decorate the interior of St Peter's with scenes from the Old and New Testaments. First, Giotto painted in fresco the angel, fourteen feet high, which is now over the organ; he did many other paintings, some of which have been restored in our own time and some of which, when work was started on the new walls, were either destroyed or else moved from old St Peter's to under the organ. This was the case with a wall painting of Our Lady. To save the picture from destruction, it was cut out of the wall, supported with beams and bars of iron, and in this way carried away and for the sake of its beauty built into a place chosen by the piety and devotion of the Florentine doctor Niccolò Acciaiuoli, an admirer of great works of art, who lavishly adorned the work with a framework of modern paintings and stuccoes. The Navicella mosaic above the three doors of the portico in the courtyard of St Peter's is also by Giotto; this is really a miraculous work, rightly praised by all discerning minds because of the excellence of the drawing and the grouping of the apostles who in various attitudes strain to guide their boat through the raging sea while the wind fills a sail which seems to be in such high relief that it looks real. It must have been extremely difficult to achieve with pieces of glass the harmonious composition shown in the

1.
> 'Why, sure,' I cried, 'that's Oderisi's face,
> Honour of Gubbio and the art they call
> *Illuminating*, in the Paris phrase!'
> 'Brother,' said he, 'a touch more magical
> Smiles now from Franco of Bologna's page;
> Some honour's mine, but his is all in all.'
> (Sayers's translation.)

lights and shadows of that great sail; even a painter working
deftly with the brush would have found the task challenging.
And Giotto also succeeded in conveying by the attitude of a
fisherman who is throwing his line from a rock and on whose
face is a look of eager anticipation the extraordinary patience
one associates with that occupation. Under the mosaic there
are three little arches painted in fresco, but I shall say no more
about them since they are all nearly ruined. This work
thoroughly deserves the praise it has won from all other
artists.

For the Dominican church of Santa Maria sopra Minerva
Giotto painted a large Crucifixion, coloured in tempera,
which was very enthusiastically praised; and then, after an
absence of six years, he went back to his own country. How-
ever, shortly afterwards Benedict IX died, Clement V was
declared Pope in Perugia and Giotto was forced to go and
work for him in Avignon where he established his court.
He executed a large number of very fine panel pictures and
frescoes in Avignon and elsewhere in France, giving great
satisfaction to the Pope and all his court. When the time came
for him to leave, therefore, he was dismissed very affection-
ately and loaded with gifts; and so he returned home having
acquired as much wealth as he had honour and fame, and
bringing with him, among other things, a portrait of the Pope
which he later gave to his pupil, Taddeo Gaddi. It was the
year 1316 when Giotto returned to Florence; but he was not
allowed to stay there long before being called to Padua to
work for the Signori della Scala, for whom he decorated a
very fine chapel in the Santo, a church which had just been
built. From Padua he went to Verona, where he painted
several pictures for the palace of messer Cane, notably a
portrait of the ruler himself as well as a panel picture for the
friars of San Francesco. When these works were finished, on
his way back to Tuscany Giotto had to stop at Ferrara to do
some paintings for the palace of the Este family, and some
work in Sant'Agostino which can still be seen there today.

In the meantime, the poet Dante got to hear that Giotto
was in Ferrara and so arranged matters that he went to
Ravenna where Dante himself was in exile. When Giotto

arrived Dante persuaded him to paint some histories in fresco around the interior of the church of San Francesco, for the lords of Polenta; and these are moderately good. From Ravenna Giotto went on to Urbino where he also did some paintings. Then, having decided to go through Arezzo, he could not refuse to do something for Piero Saccone, who had been very good to him, and so he painted on a pillar in the principal chapel of the bishop's palace a fresco showing St Martin cutting his cloak in two and giving half to a beggar who is standing before him almost completely naked. After this, for the abbey of Santa Fiore, he did a large panel painting of the Crucifixion, in tempera, which is now in the middle of the church; and then he at length returned to Florence where, among many other things, he did some paintings both in fresco and tempera for the convent of the nuns of Faenza. These no longer survive as the convent has been destroyed.

Giotto also worked in Lucca, where he went in 1322 (his very dear friend Dante having, to his great sorrow, died the year before), and at the request of Castruccio, who was then ruler of his native city, he painted a panel picture for San Martino; this showed Christ above and the four patron saints of the city, namely, St Peter, St Regulus, St Martin, and St Paulinus, recommending a Pope and an Emperor, these, it is commonly believed, being Frederick of Bavaria and the anti-Pope Nicholas V. It is also believed by some that Giotto designed the impregnable castle and fortress of Giusta at San Frediano in the same city.

Subsequently, after Giotto had returned to Florence, Robert, king of Naples, wrote to his eldest son, Charles, king of Calabria, who was then in Florence, telling him at all costs to send Giotto to Naples, because the building of the convent and royal church of Santa Chiara had been completed and he wanted Giotto to decorate it with some truly noble paintings. At the request of so famous and renowned a king Giotto was more than willing to go to Naples, where on his arrival he painted many scenes from the Old and the New Testaments in several of the convent chapels. It is said that Dante provided suggestions for the scenes from the Apoca-

lypse which Giotto did in one of the chapels, just as he may well have provided ideas for the famous paintings at Assisi, which I talked about in detail earlier on. To be sure, Dante was no longer living, but Giotto and he could have talked together about these subjects in the way that friends often do. But to return to Naples: Giotto did a great deal of work in the Castel Nuovo, especially for the chapel, and the results greatly pleased the king who became so fond of him that very often he would come and talk with him when he was working. The king enjoyed watching Giotto at work and hearing what he had to say; and Giotto, who was always ready with a joke or a witty response, would hold the king's interest with his painting on the one hand and a stream of amusing conversation on the other. Once, for example, the king told Giotto that he wanted to make him the first man in Naples, and Giotto retorted that he was already the first man in Naples, since he was living at the very gates of the city by the Porta Reale. Another time, the king said to him:

'Giotto, if I were you I would leave off painting for a while, now it's so hot.'

And Giotto answered: 'And so would I, if I were you.'

So Giotto delighted the king and painted for him a large number of pictures, both in the hall which King Alfonso I later destroyed to build the castle and in the church of the Incoronata; and among those in the hall were portraits of many famous men, including Giotto himself. One day the king asked him, for a joke, to paint his kingdom; and Giotto, so the story goes, painted an ass with a saddle on its back and another at its feet, eagerly sniffing the one on the ground. Both saddles, the one on the animal's back and the new one at its feet, carried the royal crown and sceptre. When the king asked Giotto to explain what this meant, he said that it represented his kingdom, and his subjects, who wanted to have a new ruler every day.

Having left Naples for Rome, Giotto then stopped at Gaeta, where he had to paint some scenes from the New Testament for the church of the Annunziata. These have been spoilt by the passage of time, though not to the extent that one cannot see clearly a portrait of Giotto himself next to a

large and very beautiful Crucifixion. When this work was finished, Giotto was persuaded to spend some days in Rome in the service of Signor Malatesta, and from there he went to Rimini, which was ruled by Malatesta. There he painted very many pictures in San Francesco, which were later torn down and destroyed by Gismondo, the son of Pandolfo Malatesta, when he completely rebuilt the church.

Giotto also painted a fresco for the cloisters opposite the façade of San Francesco, depicting the life of the Blessed Michelina; and because of the many beautiful ideas it expressed this was one of the finest and most wonderful paintings he ever did. The beautiful draperies and the graceful and lively heads are both marvellous; but the outstanding feature is the remarkably lovely young woman who is swearing on a book to refute an accusation of adultery. Her attitudes and gestures are stupendous: she stands there, staring straight into the eyes of her husband, who is compelling her to declare her innocence on oath because of the distrust aroused in him by the dark-skinned boy to whom she has given birth, and whom he just cannot accept as his own. While her husband shows suspicion and contempt in his expression, the purity of her face and her eyes proclaim to those who are watching her so intently her innocence and her simplicity and the wickedness of the wrong that is being done in having her make her protestation and be falsely accused as a whore. Giotto also showed great powers of expression in the figure of a sick man covered in sores; the women standing near him are all wriggling in disgust, but in the most graceful fashion imaginable. Then again Giotto's use of foreshortening in another picture showing a group of deformed beggars is very creditable and should be valued very highly by all artists since it marked a new departure, apart from the fact that for the first attempt at that kind of effect it was reasonably successful. The most marvellous feature of the fresco, however, is the attitude of the Blessed Michelina as she stands before a group of usurers who are paying her for the possessions she has sold them in order to help the poor. One can see how she despises and loathes the money and all other worldly things; and on their part the usurers are the personification of

human greed and avarice. Again, the face of the man who is counting the money and at the same time making signs to the notary, who is writing, is very fine indeed; the way his eyes are fixed on the notary, although he keeps his hands over the money, betrays his lust for gain, his avarice, and his suspicion. And one cannot praise too highly the three figures representing Obedience, Patience, and Poverty who are holding up the habit of St Francis; for the style in which Giotto has painted their garments, with the folds falling so convincingly, demonstrates clearly that he was born to shed new light on the art of painting. As well as this, he did a very realistic portrait of Signor Malatesta, on board a ship, looking so lifelike that he seems to be breathing; there are also some sailors and other people whose lively movements, dispositions, and attitudes (and notably those of the man who as he talks with the others is putting a hand to his mouth and spitting into the sea) all proclaim Giotto's great skill. Certainly of all Giotto's pictures this is the best, seeing that among the many he depicted there no two figures are alike and each one reflects his creative genius. It is no wonder, therefore, that he was magnificently rewarded and praised by Signor Malatesta.

After his work for Malatesta was finished, at the request of the Florentine prior of San Cataldo of Rimini Giotto executed for the exterior of the church door a portrait of St Thomas Aquinas reading to his brethren. Then he left for Ravenna where he decorated a chapel in San Giovanni Evangelista with frescoes which were very highly praised. And then he returned to Florence, renowned and prosperous, where he painted for San Marco a larger than life-size Crucifixion, in tempera on a gold background. He did a similar Crucifixion for Santa Maria Novella, working with the help of his assistant Puccio Capanna. This work is still there today, above the principal door on the right over the tomb of the Gaddi family by the entrance. In the same church for Paolo di Lotto Ardinghelli he executed over the screen a portrait of St Louis, at the foot of which he painted life-portraits of Paolo and his wife.

In 1327 Guido Tarlati da Pietramala, bishop and ruler of

Arezzo, died at Massa di Maremma when he was returning from Lucca where he had gone to visit the emperor, and his body was brought to Arezzo to receive the honour of a magnificent funeral; and then Piero Saccone and Dolfo da Pietramala, the bishop's brother, decided that this great man, who had been both a spiritual and a temporal lord and head of the Ghibellines of Tuscany, should be properly commemorated with a marble tomb. So they wrote to Giotto, instructing him to design a very rich tomb, as noble as possible; they sent him the measurements and they asked if he would put them in touch with the best sculptor he knew in Italy, since they were ready to place themselves completely in his hands. Giotto, who was always very courteous, sent them the finished design, and the tomb was executed in accordance with it, as I shall describe. Shortly after he received the design, Piero Saccone, who had boundless admiration for Giotto's abilities, captured the Borgo di San Sepolcro and brought back to Arezzo a panel by Giotto showing various small figures, which later on fell to pieces. However, a Florentine gentleman, Baccio Gondi, a great lover of talent and the fine arts, who was then commissary at Arezzo, searched very diligently for the pieces, found some of them, and brought them to Florence where he has since treasured them along with various other works from the hand of Giotto, who indeed executed so many that it would scarcely be believed if I described them all.

Not many years ago, when I happened to be visiting the hermitage of Camaldoli where I have done a good deal of work for the reverend fathers, I saw an autograph painting by Giotto in one of the cells, where I was taken by the Very Reverend Don Antonio of Pisa.[1] It was a small Crucifix on a field of gold, a very beautiful work; and today, according to what I was told by the Reverend Don Silvano Razzi, a monk of the Camaldoli, this work is in the Degli Angeli monastery at Florence, in the prior's cell, where it is guarded as a precious work from the hand of Giotto, along with a very beautiful little painting by Raphael of Urbino.

For the Umiliati friars of Ognissanti at Florence Giotto

1. The order of Camaldoli was a monastic order of hermits founded in 982.

painted a chapel and four panel pictures, including a Madonna
and Child with a choir of angels, and a large Crucifix on
wood, whose design was used by Puccio Capanna who was
expert in Giotto's own style and who subsequently repro-
duced many copies of it in various parts of Italy. When my
Lives of the Painters, Sculptors, and Architects was first printed,
there was also in the transept of Ognissanti a small panel
picture in tempera which had been painted by Giotto with
great care and which showed the death of Our Lady, with a
group of apostles and with the figure of Christ receiving her
soul into his arms. This work has been highly praised by
painters, especially by Michelangelo Buonarroti, who, as I
record elsewhere, affirmed it was a painting of great quality
and truth. Well, as I say, this little picture attracted con-
siderable attention after my book was first published and was
then removed by someone or other who perhaps, as our poet
says, acted ruthlessly out of piety and love of the arts, because
he thought that the painting was not held in respect. And it
was indeed miraculous that in those days Giotto could paint
with such sublime grace, especially when we consider that he
learned his art, so as to speak, without any instructor.

After this, on 9 July 1334, Giotto set his hand to the
campanile of Santa Maria del Fiore; a foundation of solid
stone was laid at a depth of about forty feet, after the water
and gravel had been excavated, and on this base he laid about
twenty-four feet of good ballast and then had the remaining
sixteen feet filled with masonry. The bishop of the city
attended the ceremony, solemnly laying the first stone in the
presence of all the clergy and magistrates. The work was
carried forward according to the original plan, which was in
the contemporary German style, and Giotto designed all the
subjects for the ornamentation, very carefully marking the
model with white, black, and red colours where the marbles
and the friezes were to go. The base measured some 200 feet,
namely, fifty feet for each side, and the height was about
288 feet. And if what Lorenzo di Cione Ghiberti left in
writing is true, and I certainly think it is, Giotto was respon-
sible not only for the model for the campanile but also for
some of the scenes in marble in which are the beginnings of

all the arts of sculpture and relief. Lorenzo also claims to have
seen models in relief from the hand of Giotto and in par-
ticular models for the works mentioned above; and this we
can readily believe, because design and invention are the
father and mother of all, and not merely one, of the arts.

According to Giotto's model, the campanile was in fact
meant to have a spire, or rather a four-sided pyramid, about
100 feet high; but because of its old-fashioned, German style,
modern architects have never thought this worth doing,
believing it better to leave the campanile as it is. For all these
works, Giotto was not only given Florentine citizenship but
also granted by the Commune a hundred gold florins a year,
which was a lot of money in those days. He was also made
overseer of the work on the campanile, which was later on
brought to a conclusion by Taddeo Gaddi, after Giotto's
death.

While work was progressing on the campanile, Giotto
painted a panel picture for the nuns of San Giorgio, and on an
arch inside the doorway of the abbey of Florence he painted
three half-length figures, since covered in whitewash to
lighten the church. And in the great hall of the Podestà at
Florence he painted a representation of the Commune,
plundered by many. The figure is represented as a judge
seated with a sceptre in his hand, the balanced scales of justice
over his head, and attended by four virtues, namely, Strength
with generosity, Prudence with the laws, Justice with arms,
and Temperance with the word.

Then he returned to Padua where as well as decorating
several chapels and executing many other works he painted
a Worldly Glory for the church of the Arena, which won him
considerable honour and profit. He also executed some works
in Milan, which are dispersed in various parts of the city and
which are still regarded as extremely good.

Eventually, in the year 1336, fairly soon after his return
from Milan, Giotto (who had made so many beautiful works
of art and whose devout life as a Christian matched his
achievements as a painter) gave up his soul to God, to the
great sorrow of all his fellow citizens and all those who had
known him or merely heard his name. And he was buried,

as his accomplishments deserved, with great honour. During his life he was loved by everyone, especially by those who were eminent in the professions; for apart from Dante, whom we mentioned above, Giotto and his works were greatly esteemed by Petrarch, and so much so that we read in the latter's will that he left to Signor Francesco da Carrara, ruler of Padua, among the other possessions he treasured, a painting from the hand of Giotto, depicting the Madonna, as a rare and pleasing gift. The relevant clause of the will reads as follows:

Transeo ad dispositionem aliarum rerum; et praedicto igitur domino meo Paduano, quia et ipse per Dei gratiam non eget, et ego nihil aliud habeo dignum se, mitto tabulam meam sive historiam Beatae Virginis Mariae, opus Jocti pictoris egregii, quae mihi ab amico meo Michaele Vannis de Florentia missa est, in cujus pulchritudinem ignorantes non intelligunt, magistri autem artis stupent: hanc inconem ipsi domino lego, ut ipsa Virgo benedicta sibi sit propitia apud filium suum Jesus Christum etc.[1]

This same Petrarch, in a letter in Latin in the fifth book of his Intimate Letters, writes as follows:

Atque (ut a veteribus ad nova, ab externis ad nostra transgrediar), duos ego novi pictores egregios, nec formosos, Joctum Florentinum civem, cujus inter modernos fama ingens est, et Simonem Senensem. Novi scultores aliquot etc.[2]

Giotto was buried in Santa Maria del Fiore, on the left of the entrance to the church where there is a slab of white marble as his memorial. And, as I mentioned in the *Life* of

1. I turn now to the disposal of my other possessions. To my lord of Padua aforementioned, both since he by God's grace is not in want, and since I have nothing else worthy of him, I leave my portrait or rather representation of the Blessed Virgin Mary by the great painter Giotto, which was left to me by my friend Michele Vannis of Florence; the ignorant do not comprehend its beauty, but the masters of the art wonder at it; to my lord then I bequeath this painting, in hope that the Blessed Virgin herself may intercede for him with her Son Jesus Christ . . .

2. Moreover (to turn from ancient to modern, from abroad to home) I have known two painters of greatness, not of mere prettiness, Giotto of Florence, whose reputation is immense among contemporary artists, and Simone of Siena. I have also known a number of sculptors . . .

Cimabue, a commentator on Dante, who was contemporary with the great Giotto, said:

> Giotto was and is the greatest of painters and comes from the same city of Florence; and his work at Rome, Naples, Avignon, Florence, and Padua, and in many other parts of the world bears this out.

His pupils included Taddeo Gaddi, who as I have said was his godson, and the Florentine, Puccio Capanna. At Rimini, in the church of San Cataldo belonging to the Friars Preachers, Capanna executed a superb fresco showing the abandonment of a ship which is sinking under the waves while the men are throwing their belongings into the water, among the sailors being a self-portrait of Puccio himself. After Giotto's death, the same artist completed many works in the church of San Francesco at Assisi. And in the church of Santa Trinità at Florence he decorated the Strozzi Chapel, beside the door on the river-front, painting in fresco the Coronation of the Virgin, with a choir of angels, which owes a great deal to Giotto's own style; on the walls he painted some very finely executed scenes from the life of St Lucy. In the abbey of Florence he painted the Covoni Chapel, dedicated to St John the Evangelist, which is near the sacristy. And at Pistoia he painted in fresco the principal chapel of the church of San Francesco and the chapel of San Lodovico with scenes from the lives of the two saints, which are reasonably good. In the same city, in the middle of the church of San Domenico, there is a Crucifixion by Puccio with a Madonna and St John, painted with great tenderness; at the feet of these figures there is an entire skeleton, which demonstrates how at a time when this was unheard of Puccio endeavoured to discover the basic principles of art. This work is signed by the author as follows: PUCCIO DI FIORENZA ME FECE. Also in the same church, in the tympanum above the door of Santa Maria Novella, are three half-length figures, namely, Our Lady holding her son in her arms, with St Peter on one side and St Francis on the other.

As I mentioned before, Puccio also worked in Assisi, where in the Lower Church of San Francesco he executed some frescoes, showing scenes from the Passion of Jesus Christ,

which were skilfully and vigorously done, and he painted a fresco for the chapel of the church of Santa Maria degli Angeli depicting Christ in glory with the Virgin interceding with him on behalf of all Christians; this work is very fine, but it has been all blackened by smoke from the lamps and candles which are always burning there in great numbers. As far as can be judged, in fact, Puccio had captured the personal style and approach of his master Giotto and knew how to express them very competently in the works that he did (although it has been asserted that his life was cut short because working too much in fresco undermined his health and then killed him). He is also credited with the frescoes depicting scenes from the life of St Martin, executed for Cardinal Gentile in the chapel dedicated to that saint in the same church. And in the middle of the street called Portica there is a Christ at the Column and a picture of Our Lady between St Catherine and St Clare.

Paintings by Puccio Capanna are found in various other parts of Italy, as in Bologna, for example, where in the nave of the church there is a panel picture of the Passion of Christ with scenes from the life of St Francis; in short, Puccio left many other works which it would take too long to discuss. It is worth mentioning, however, that in Assisi, where most of his works are and where, I believe, he assisted Giotto, I have discovered that they regard him as their fellow citizen and that there are some members of the family of Capanni still living; from this we may readily conclude that he was born in Florence (since he wrote this himself), and that he was a disciple of Giotto, but that he then took a wife in Assisi by whom he had children whose descendants still live there. But there is little point in worrying about the exact truth of this; it is enough that he was a good artist.

Another of Giotto's pupils, and a very expert painter, was Ottaviano da Faenza: he painted a number of pictures at Ferrara in San Giorgio, the church belonging to the monks of Monte Oliveto. At Faenza, where he lived and died, he painted in the tympanum above the door of San Francesco a figure of Our Lady with St Peter and St Paul; and he completed many other works in his own native city and in Bologna.

Yet another of Giotto's pupils was Pace da Faenza, who stayed with him for a long time and helped him very often. There are some frescoes by his hand at Bologna, on the façade of San Giovanni Decollato. Pace was a very skilful painter, especially of small figures, as one can see today in the church of San Francesco at Forlì where there are two very successful paintings of his: a Tree of the Cross and a little panel picture in tempera depicting the life of Christ and four small subjects from the life of Our Lady. It is also reported that in the chapel of Sant'Antonio at Assisi he executed some frescoes depicting scenes from the life of St Anthony for a duke of Spoleto, who is buried there with one of his sons. (These two were killed when fighting on the outskirts of Assisi, as may be seen from a lengthy inscription on their tomb.) In the old book of the Guild of Painters it is recorded that he had a certain Francesco, said to be 'of Master Giotto', as his pupil; but I know nothing more about this.

Guglielmo da Forlì was also one of Giotto's pupils, and his many commissions included the painting of the chapel of the high altar for the church of San Domenico at Forlì, his native town. Still other pupils of Giotto were Pietro Laureati, Simon Memmi of Siena, Stefano of Florence, and the Roman, Pietro Cavallini. But I shall discuss these when I come to write their lives, merely recording here the fact that they were taught by Giotto. And how well Giotto drew for his time, and what his personal style was like, can be seen from a number of parchments in my book of drawings; these contain water-colours, pen-and-ink drawings, and chiaroscuros with the lights in white, all from his hand. In comparison with the work of artists who lived before Giotto, these are truly marvellous.

As I have already said, Giotto was a very sharp-witted, light-hearted man, always ready with a witty remark, as is well remembered in Florence; apart from what Giovanni Boccaccio wrote, Franco Sacchetti in his Three Hundred Novelle records many of Giotto's best sayings. I think it is worth while recording some of these, using Franco's own words, so that in reading one of his stories we can be reminded of some of the phrases and modes of speech used

in those days. So here is one of his stories, under its proper title:

A man of no importance asked the great painter Giotto to paint a buckler for him. In mockery, Giotto paints it in such a way that he is covered in confusion.

NOVELLA LXII

Everyone must have heard of Giotto, and how he surpassed every other painter. His fame came to the ears of a common workman who for some reason, perhaps to do feudal service, decided to have his buckler painted. So straightaway he went along to Giotto's workshop, followed by someone carrying the buckler. When he arrived and found Giotto, he said:

'Good day, sir. Be good enough to paint my coat-of-arms on this buckler.'

Giotto considered both the man and his manners, and then said merely:

'When d'you want it done?'

When he was told this, he added:

'Leave it to me.'

The man went his way and Giotto was left behind, thinking to himself:

'What is all this about? Could the fellow have been sent for a joke? Well, no matter what it is, I've never before been asked to paint a buckler. The man who brought it is a miserable little fool, asking me to paint his coat-of-arms just as if he were a member of the royal house of France. Well, I will certainly make him an original coat-of-arms.'

Musing in this fashion, Giotto took the buckler, improvised a design, and then told one of his pupils to finish the painting. When this was done, it showed a head-piece, a gorget, a pair of armlets, a pair of iron gauntlets, a pair of cuirasses, a pair of cuisses and gambadoes, a sword, a dagger, and a lance.

The worthy owner, whom nobody knew anything about, came back and said:

'Well sir, is that buckler ready?'

Said Giotto: 'Certainly it is. Bring it down here.'

The buckler arrived, the proxy gentleman stared at it, then he turned to Giotto and said:

'What's this rubbish you've daubed on?'

'You'd better have the rubbish to pay for it,' said Giotto.

'I won't pay you a penny.'

'Well, what did you ask me to paint?' said Giotto.

'My coat-of-arms.'

'Isn't that what I've done?' retorted Giotto. 'Is there something missing?'

'There certainly is.'

'God damn you,' said Giotto, 'you must be a great fool. If someone asked who you were you'd scarcely know what to say; yet you come here and demand "paint my coat-of-arms". That would be fine – if you belonged to the house of Bardi. What are your arms? Where do you come from? Who are your ancestors? Aren't you ashamed of yourself? You'll have to make people aware you exist before you start talking about your coat-of-arms, as if you were the duke of Bavaria himself. I've painted all your arms for you on your buckler. If there's anything more, tell me and I'll put it in.'

'You're insulting me, and you've spoilt my buckler.'

He left, went to the justice, and had Giotto summoned.

Giotto appeared, had him summoned in return, sued him for the payment of two florins for the painting, and was sued for the same amount. When the officials had heard their pleas, Giotto putting his case far better than the other, they decided that the workman should take his painted buckler and pay Giotto six lire, as the latter was in the right. So the fellow took the buckler, paid what was due, and was dismissed.

In this way, someone who didn't know his place had it shown to him; and this should happen to all such wanting to have coats-of-arms and found noble houses, and whose fathers have often as not come from the foundling hospital.

There is a story that when Giotto was still a young man in Cimabue's workshop, he once painted on the nose of one of the figures Cimabue had executed a fly that was so lifelike that when Cimabue returned to carry on with his work he tried several times to brush it off with his hand, under the impression that it was real, before he realized his mistake. I could recall many other of Giotto's tricks and witticisms, but I shall be content with what I have said above about things that are important to art, referring to Franco and other writers for the rest.

Let me say finally that it was thought that Giotto's memory should be preserved not only in the works he painted but also in the work left by the writers of those times; for it was

Giotto who set painting once more on the right path, from which it had strayed many years before. And so by public decree, through the personal devotion and command of the elder Lorenzo de' Medici, in admiration of Giotto's artistic abilities his bust, sculptured in marble by that excellent artist Benedetto da Maiano, was placed in Santa Maria del Fiore, along with the following verses by the inspired Angelo Politian.[1] This was done so that others coming after Giotto, who excelled in their various professions, might hope for similar memorials to the one which Giotto's abilities so fully earned and deserved:

> Ille ego sum, per quem pictura extincta revixit,
> Cui quam recta manus, tam fuit et facilis.
> Naturae deerat nostrae quod defuit arti:
> Plus licuit nulli pingere, nec melius.
> Miraris turrim egregiam sacro aere sonantem?
> Haec quoque de modulo crevit ad astra meo.
> Denique sum Jottus, quid opus fuit illa referre?
> Hoc nomen longi carminis instarerit.[2]

In future, artists will be able to see drawings from Giotto's own hand and so recognize fully his excellence as an artist, because in my book, which I mentioned before, there are some splendid examples; I went to a lot of time and trouble to collect these, and a great deal of expense.

1. Poliziano – Angelo Ambrogini – one of the most brilliant of the Italian humanists.
2. That man am I, by whose accomplishment
 The painter's art was raised from the dead.
 My hand as ready was as it was sure;
 What my skill lack'd, Nature lack'd too; no one
 Was privileg'd more fully life to paint
 Or better paint. Dost thou admire a tower
 In beauty echoing with sacred chime?
 By my design this too reach'd for the stars.
 But I am Giotto; why recite these deeds?
 My name alone is worth a long-drawn ode.

PREFACE TO PART TWO

WHEN I first undertook these *Lives* I did not intend to compile a list of artists with, say, an inventory of their works; and I was far from thinking it a worthwhile objective for my work (which, if not distinguished, has certainly proved long and exhausting) to give details of their numbers and names and places of birth and describe in what city or exact spot their pictures or sculptures or buildings might be found. I could have done this simply by providing a straight-forward list, without offering any opinions of my own. But I have remarked that those historians who are generally agreed to have produced the soundest work have not been satisfied just to give a bald narration of the facts but have also, with great diligence and the utmost curiosity, investigated the ways and means and methods used by successful men in forwarding their enterprises; they have tried to point out their mistakes, as well as the fine strokes, the expedients, and the prudent courses of action they sometimes followed in the management of their affairs. In short, the best historians have tried to show how men have acted wisely or foolishly, with prudence or with compassion and magnanimity; recognizing that history is the true mirror of life, they have not simply given a dry, factual account of what happened to this prince or that republic but have explained the opinions, counsels, decisions, and plans that lead men to successful or unsuccessful action. This is the true spirit of history, which fulfils its real purpose in making men prudent and showing them how to live, apart from the pleasure it brings in presenting past events as if they were in the present. For this reason, having set out to write the history of distinguished artists in order to honour them and to benefit the arts to the best of my ability, I have tried as far as I could to imitate the methods of the great historians. I have endeavoured not only to record what the artists have done but also to distinguish between the good,

the better, and the best, and to note with some care the methods, manners, styles, behaviour, and ideas of the painters and sculptors; I have tried as well as I know how to help people who cannot find out for themselves to understand the sources and origins of various styles, and the reasons for the improvement or decline of the arts at various times and among different people.

At the beginning of the *Lives* I said as much as was necessary about the noble origins and antiquity of the arts; I left out many things from Pliny and other authors which I could have used had I not wanted, perhaps in a controversial way, to leave everyone free to discover other people's ideas for himself in the original sources. It now seems the right place for me to do what I could not do before (if I wanted to avoid writing tediously and at a length fatal to attention) and give a clearer idea of my purpose and intention, explaining my reasons for dividing the contents of these *Lives* into three parts.[1]

It is certainly true that some men become great artists by diligent application and others by study; some by imitation, some by knowledge of the sciences (which are all useful aids to art), and some by combining all or most of these things. However, in my biographies I have spent enough time discussing methods, skills, particular styles, and the reasons for good, superior, or pre-eminent workmanship; so here I shall discuss the matter in general terms, paying more attention to the nature of the times than to the individual artists. In order not to go into too much detail, I have divided the artists into three sections or, shall we say, periods, each with its own recognizably distinct character, running from the time of the rebirth of the arts up to our own times.

In the first and oldest period the three arts evidently fell a long way short of perfection and, although they may have shown some good qualities, were accompanied by so much that was imperfect that they certainly do not deserve a great deal of praise. All the same, they did mark a new beginning, opening the way for the better work which followed; and if only for this reason I have to speak in their favour and to

1. Vasari's earlier and subsequent borrowings from Pliny (A.D. 23–79) are from the *Natural History*, Books VII, XXXIV–XXXVII.

allow them rather more distinction than the work of that time would deserve if judged by the strict rules of art.

Then in the second period there was clearly a considerable improvement in invention and execution, with more design, better style, and a more careful finish; and as a result artists cleaned away the rust of the old style, along with the stiffness and disproportion characteristic of the ineptitude of the first period. Even so, how can one claim that in the second period there was one artist perfect in everything, producing works comparable in invention, design, and colouring to those of today? Who at that time rendered his figures with the shadows softly darkened in, so that the lights remain only on the parts in relief, and who achieved the perforations and various superb finishings seen in the marble statues executed today?

These achievements certainly belong to the third period, when I can say confidently that art has achieved everything possible in the imitation of nature and has progressed so far that it has more reason to fear slipping back than to expect ever to make further advances.

Having very carefully turned all this over in my mind, I have come to the conclusion that it is inherent in the very nature of these arts to progress step by step from modest beginnings, and finally to reach the summit of perfection. And I believe this is so from having seen almost the same progression in other branches of learning; the fact that the liberal arts are all related to each other in some way is a persuasive argument for what I am saying. As for painting and sculpture in former times, they must have developed on such similar lines that the history of one could stand for the history of the other with only a change in their names. We have to trust the word of those who lived soon afterwards and could see and judge the work of the ancient world; and from these we learn that the statues of Canacus were very hard and lifeless, with absolutely no sense of movement, and therefore far from giving a true representation; and the same is said of the statues made by Calamides, though these did possess rather more charm. Then there came Myron who, even if he did not altogether reproduce the truth that we find

in nature, nevertheless gave to his works such grace and proportion that they could justifiably be called very beautiful. In the third stage flourished Polycletus as well as other famous sculptors who, it is credibly reported, produced works that were absolutely perfect. The same progression must have occurred in the art of painting, for it has been said (and surely correctly) that the work of those who used only one colour, the monochromatists, fell a long way short of perfection. Then the works of Zeuxis, Polygnotus, Timanthes, and others, who used only four colours, were enthusiastically praised as linear compositions, though of course still leaving something to be desired. And then we come to Erione, Nicomachus, Protogenes, and Apelles, who produced beautiful work which was perfect in every detail and could not possibly have been improved on; for these artists not only painted superb forms and gestures but also depicted the emotions and passions of the spirit.

However, I shall say no more about them since (though I have gone to the best authors for my remarks) we do have to rely on the opinions of others, whose evaluations and, still more, whose dates sometimes conflict. Let us look at our own times, where we can rely on the guidance and verdict of our own eyes, which is far better than going by hearsay.

Is it not clear, to take one of the arts, that architecture advanced and improved considerably during the period from Buschetto the Greek to the German Arnolfo and Giotto? The buildings of that time show this in their pilasters, columns, bases, capitals, and all the cornices with their deformed members. Examples are provided by Santa Maria del Fiore in Florence, the incrustation of the exterior of San Giovanni, San Miniato sul Monte, in the bishop's palace at Fiesole, the cathedral at Milan, San Vitale in Ravenna, Santa Maria Maggiore in Rome, and the old Duomo outside Arezzo. Except for the fine workmanship of some antique fragments, there are no signs of good style or execution. Arnolfo and Giotto, all the same, certainly improved matters, and under them the art of architecture made reasonable progress. They improved the proportions of their buildings, making them not only stable and strong but also in some measure ornate.

To be sure, their ornamentation was muddled and imperfect and, if I may say so, far from ornamental. This was because in their columns they failed to observe the correct measurements and proportions, nor did they distinguish the orders: instead of being distinctively Doric, Corinthian, Ionic, or Tuscan they were all confused and based on some anarchic and improvised rule. They made them extremely thick or extremely slender, just as they thought best. All the designs they invented were copied from antique remains or sprang from their own imaginations. Thus the building plans of that time showed the influence of sound architecture as well as contemporary improvisation, with the result that when the walls were raised the results were very different from the models. Nevertheless, whoever compares the work of that time with what was done previously will see that it was better in every way, even though there were some things that we find displeasing nowadays, such as the little brick churches, covered with stucco, at St John Lateran in Rome.

The same holds true for sculpture. In the first period of its rebirth some very good work was done, for the sculptors had abandoned the stiff Byzantine style which was so crude that it suggested more the quarry than the skill of the artist, and which produced statues, if they can be called that, completely devoid of folds, movement, or pose. After Giotto had improved the quality of design several artists did good work in marble and stone; among them were Andrea Pisano, his son Nino, and other pupils of his, all of whom were far more skilful than their predecessors. Their statues were more plastic and better posed; as we see, for example, in the work of the two Sienese, Agostino and Agnolo, who as I said made the tomb for Guido, bishop of Arezzo, and the Germans who made the façade of Orvieto.

So at that time sculpture made definite progress: the figures were better formed, their folds and draperies flowed more beautifully, their heads were sometimes better posed, and their attitudes less rigid; in short, the sculptors were on the right path. But just as clearly there were innumerable defects, because at that time design still fell a long way short of perfection and there were only too few good works to imitate.

Consequently, the artists whom I have placed in the first period deserve to be praised and valued for what they did, if one considers that, like the architects and painters of the day, they had no help from their predecessors and had to find the way forward by themselves; and any beginning, however modest, always deserves more than a little praise.

Painting enjoyed no better fortune in those days, except in so far as popular enthusiasm meant that it was more in demand and there were more painters than architects and sculptors, and therefore it made more definite progress. Thus the old Byzantine style was completely abandoned – the first steps being taken by Cimabue and followed by Giotto – and a new style took its place: I like to call this Giotto's own style, since it was discovered by him and his pupils and was then generally admired and imitated by everybody. In this style of painting the unbroken outline was rejected, as well as staring eyes, feet on tiptoe, sharp hands, absence of shadow, and other Byzantine absurdities; these gave way to graceful heads and delicate colouring. Giotto, especially, posed his figures more attractively, started to show some animation in his heads, and by depicting his draperies in folds made them more realistic; his innovations to some extent included the art of foreshortening. As well as this, he was the first to express the emotions, so that in his pictures one can discern expressions of fear, hate, anger, or love. He evolved a delicate style from one which had been rough and harsh. It is true that he painted the eyes without their natural vivacity, that his weeping figures were expressionless, that his hair and beards lacked their true downiness and softness, his hands did not show their natural muscles and articulations, and his nudes were not realistic; but he must be excused by the difficulties of the art and because he had not seen any painters better than himself. And we must concede that Giotto showed sound judgement in his paintings at a time of general and artistic decay. Look at the way he observed human expressions, and the ease with which he could translate his ideas into pictures. One can see how his figures correspond with his intentions, showing that his judgement was extremely sound even if imperfect.

We can see the same with the painters who followed him,

in the works of Taddeo Gaddi, for example, whose colouring is more forceful and charming, especially in the flesh-tints and draperies, and whose figures move more dramatically; and then in the paintings of Simone Martini, who composed his scenes with such decorum, and Stefano Scimmia and his son Tommaso, whose draughtsmanship showed considerable gains and who gave new dimensions to perspective and improved the shading and blending of colours, though still following Giotto's style. Similar skill and dexterity were shown by Spinello of Arezzo, his son Parri, Jacopo of Casentino, Antonio of Venice, Lippi, Gherardo Starnini, and other painters who worked after Giotto, following his manner, outlines, colour, and style, sometimes even making improvements though never decisively breaking away.

Now if the reader reflects on what I have been saying he will realize that up to this point the three arts remained, as it were, very rough and ready and still fell short of the perfection they deserved; indeed, if the story ended here the progress so far recorded would not amount to much and would have been of no great value. I do not want anyone to think me so stupid and lacking in judgement as to ignore the fact that if we compare the work of Giotto, Andrea Pisano, Nino, and all the others whom I have grouped in the first period (because of their similarities in style) with what was done later, the former do not deserve even modest, let alone unqualified, praise. And of course I was well aware of this when I praised them. All the same, if one considers when it was that they lived, the few of them that there were, and the difficulty of obtaining good assistance, one is forced to conclude not that their work was, as I said, excellent but rather that it was downright miraculous. It is surely gratifying in the extreme to discern the first beginnings, the first glimmerings of excellence, as they appeared in painting and sculpture. The victory which Lucius Marcius won in Spain was not so great that the Romans could boast of none greater! But in view of the timing, the place, and the circumstances, and the nature and numbers of those involved, it was considered a stupendous achievement, and even today it is still held to deserve all the praises the historians have lavished on it.

So considering all these things I have decided that the artists in the first period deserve not only a careful record of what they did but also all the warm and enthusiastic praise I have bestowed on them. I do not think that my fellow artists will have found it boring to hear the story of their lives and study their styles and methods, and perhaps they will derive no little benefit from this. This would certainly bring me great pleasure, and I would consider it a wonderful reward for my work, in which my only aim has been to serve and entertain them to the best of my ability.

Now that we have, as it were, taken the three arts away from the arms of their nurse and seen them through their childhood we come to the second period, in the course of which there is a tremendous, overall advance. We shall see compositions being designed with a greater number of figures and richer ornamentation, and design becoming more firmly grounded and more realistic and lifelike. Above all we shall see that even in works of no great quality there is careful organization and purpose: the style is lighter, colours are more charming, and the arts are approaching the state of complete perfection in which they exactly reproduce the truth of nature. For first of all, through the studies and diligence of Filippo Brunelleschi, architecture rediscovered the proportions and measurements of the antique, applying them in round columns, flat pilasters, and plain or rusticated projections. Then it carefully distinguished the various orders, leaving no doubt about the difference between them; care was taken to follow the classical rules and orders and the correct architectural proportions; design became more forceful and methodical. Architecture revealed its excellence in the graceful work which was produced; it rediscovered how to make cornices and capitals of great beauty and variety. The plans for churches and other edifices were well conceived, and the buildings themselves were beautifully proportioned, ornate, and magnificent. Examples are provided by the stupendous structure of the cupola of Santa Maria del Fiore at Florence, by the beauty and grace of its lantern, by the varied, beautifully decorated and graceful church of Santo Spirito, and by the no less lovely San Lorenzo, by the

fanciful invention shown in the octagonal church of the
Angioli, by the wonderfully airy church and convent of the
Badia at Fiesole, and by the ambitious and magnificent com-
mencement of the Pitti Palace. There are other examples to
be seen in the great and commodious building for which
Francesco di Giorgio was responsible, namely, the palace and
church of the Duomo at Urbino, the strong and sumptuous
castle at Naples, and the impregnable castle of Milan, not to
mention the many other notable buildings of that time. Later
on, architects made their cornices with a certain delicacy and
exquisite grace, carved their leaves lightly and smoothly, and
perfected the detail of their foliage; these were accompanied
by other refinements, as we shall see in the third section
where we shall study those who, unlike the old architects,
executed everything I mentioned above perfectly, effortlessly
creating a wealth of graceful and beautifully finished work.
Although the architecture we are discussing here fell short in
these respects, none the less it was certainly beautiful and
good. I cannot say that the buildings of that time were per-
fect, since as the art of architecture was to prove itself capable
of greater achievements they can reasonably be said to have
been lacking something. All the same there was some mar-
vellous work which has not been surpassed even in our own
times, nor perhaps ever will be: as, for example, the lantern
of the cupola of Santa Maria del Fiore, and, for size, the cupola
itself, where Filippo determined not only to rival the ancients
in the body of the building but also to surpass them in the
height of the walls. However, we are talking of the period as
a whole, and one should not use the fineness and excellence of
a single work to prove that everything was perfect.

The same remarks hold good for painting and sculpture,
of which we still have today some exceptionally fine examples
left by the artists of the second period; such are the works
executed in the Carmine by Masaccio, including the figure of
a naked man shivering with cold, as well as other lifelike and
vigorous pictures. But as a whole they did not achieve the
perfection of the third period, about which I shall write later
on, for the moment concentrating on the second. Now the
sculptors, first of all, departed a long way from the style of the

first artists, making so many great improvements that little was left for the third generation to accomplish. Their style was more graceful, more lifelike, more pure; and they possessed a better sense of design and proportion. As a result the statues they made began to seem almost alive, unlike the figures of the artists of the first period whose statues were plainly just statues and nothing more. We shall see the difference when discussing the works produced during this period of stylistic renewal in the second part of the *Lives*. The figures of Jacopo of Siena, for example, show more movement, grace, design, and careful workmanship; Filippo's show a more exact investigation of anatomy, better proportions, and fine judgement; and their pupils' work exhibits the same qualities. The greatest progress, however, was made by Lorenzo Ghiberti when he worked on the doors of San Giovanni; for the invention, the stylistic purity and design that he displayed made his figures seem to move and breathe. Although Donatello was a contemporary of these artists, I was uncertain whether I should not place him among the artists of the third period, seeing that his works are the equal of those of the fine artists of the ancient world. Anyhow, in this context he may be said to have set the standard for the rest, since in himself he possessed all the qualities shared among the others. He imparted movement to his figures, giving them such vivacity and animation that they are worthy to rank both, as I said, with the work of the ancient world and also with that of the modern.

During this period painting progressed in the same way as sculpture. The superb Masaccio completely freed himself of Giotto's style and adopted a new manner for his heads, his draperies, buildings, and nudes, his colours and foreshortenings. He thus brought into existence the modern style which, beginning during his period, has been employed by all our artists until the present day, enriched and embellished from time to time by new inventions, adornments, and grace. Examples of this will be given in the individual biographies which will reveal the appearance of a new style of colouring and foreshortening, of attitudes that are true to life, a far more accurate interpretation of emotions and physical gestures, and

the constant endeavour to reproduce nature more realistically, with facial expressions so beautifully true to life that the men portrayed appear before us just as they were seen by the painter himself.

In this way the artists tried to reproduce neither more nor less than what they saw in nature, and as a result their work began to show more careful observation and understanding. This encouraged them to lay down definite rules for perspective and to make their foreshortenings in the exact form of natural relief, proceeding to the observation of light and shade, shadows, and other problems. They endeavoured to compose their pictures with greater regard for real appearances, attempting to make their landscapes more realistic, along with the trees, the grass, the flowers, the air, the clouds, and the other phenomena of nature. They did this so successfully that the arts were brought to the flower of their youth, holding out the promise that in the near future they would enter the golden age.

And now with God's help I shall start writing the life of Jacopo della Quercia of Siena, and then the lives of the other architects and sculptors until we come to Masaccio, the first of the painters to improve design, when we shall see how greatly he was responsible for the rebirth of painting. I have chosen Jacopo as a worthy beginning for the second part of the *Lives* and I shall group the artists who follow by style, showing in each life-story the problems presented by the beautiful, challenging, and noble arts of design.

LIFE OF
PAOLO UCCELLO
Florentine painter, 1396/7–1475

THE most captivating and imaginative painter to have lived since Giotto would certainly have been Paolo Uccello, if only he had spent as much time on human figures and animals as he spent, and wasted, on the finer points of perspective. Such details may be attractive and ingenious, but anyone who studies them excessively is squandering time and energy, choking his mind with difficult problems, and, often enough, turning a fertile and spontaneous talent into something sterile and laboured. Artists who devote more attention to perspective than to figures develop a dry and angular style because of their anxiety to examine things too minutely; and, moreover, they usually end up solitary, eccentric, melancholy, and poor, as indeed did Paolo Uccello himself. He was endowed by nature with a discriminating and subtle mind, but he found pleasure only in exploring certain difficult, or rather impossible, problems of perspective, which, although fanciful and attractive, hindered him so much when he came to paint figures that the older he grew the worse he did them.

It is undeniable that anyone who does violence to his nature by fanatical studies may polish one facet of his genius but cannot produce work with the facility and grace associated with artists who can put each stroke in its place temperately and with a calm and judicious intelligence. The latter shun the subtleties that tend to burden an artist's work with a kind of hesitant, dry, laboured, and bad personal style, attracting pity more than admiration. For an artist's creative intelligence can truly express itself only when prompted by his intellect and when he is in a state of inspired rapture; it is then that he abundantly demonstrates his God-given powers and sublime ideas.

Now Paolo was always tackling the most difficult artistic problems and never allowing himself a moment's respite; eventually he perfected a method for drawing perspectives from the ground-plans of houses and the profiles of buildings, carrying them right up to the summits of the cornices and roofs, by means of intersecting lines which he converged towards a centre point, having first determined the eye-level, either high or low just as he wanted. He was so painstaking that he discovered a method and rule for standing his figures firmly on the plane of the floor while foreshortening them bit by bit, and making them recede and diminish in proportion; formerly this had been done without any set method. He also discovered the way to turn the intersections and arches of vaulted roofs, to foreshorten floors by converging the beams, and to design columns in perspective in such a way that even if there were an acute angle in the wall on which they were painted they seemed to be in a straight line. Because of all these researches he came to live a hermit's life, hardly knowing anyone and shut away out of sight in his house for weeks and months at a time.

The work he did was challenging and attractive, but if he had spent the same amount of time on the study of figures (which he could in fact draw well enough) he would eventually have come to do them perfectly. However, all his time was given over to these puzzles, and so throughout his life he was more poor than famous. He used to show Donatello, the sculptor, who was a close friend of his, the *mazzocchi*[1] that he had drawn with their points and surfaces shown from various angles in perspective, and spheres showing seventy-two facets like diamonds, with shavings twisted round sticks on every facet and other oddities, on which he wasted all his time. And Donatello would often say:

Ah Paolo, this perspective of yours makes you neglect what we know for what we don't know. These things are no use except for marquetry – that's the kind of work where you need shavings with spirals and circles and squares and things like that.

1. These were wooden circles or hoops which, covered with cloth, formed part of a man's headgear in fifteenth-century Florence.

Paolo's first pictures were in fresco in an oblong niche painted in perspective at the hospital of Lelmo, and they showed St Anthony the Abbot, standing between SS. Cosmas and Damian. In the Annalena Convent he did two figures; and in Santa Trinità, over the left door inside the church, he painted in fresco scenes from the life of St Francis, showing the saint receiving the stigmata, supporting the Church on his shoulders, and embracing St Dominic. He also did some paintings in Santa Maria Maggiore, for a chapel next to the side door leading to San Giovanni which contains the panel painting and predella by Masaccio. There Uccello painted a fresco of the Annunciation in which he showed a building which deserves our attention; this work was an original achievement, for it was the first in a good style showing artists how, with grace and proportion, lines can be made to recede to a vanishing point, and how a small and restricted space on a flat surface may be extended so that it appears distant and large. When artists achieve this effect and then with judgement and grace use colouring to add shadows and lights in the right place they deceive the eye so surely that the painting seems to be in actual relief. But this did not satisfy Uccello, who wanted to show how to solve even greater problems; and this he did in some columns foreshortened in perspective which curve round and break the salient angle of the vaulting where the four evangelists are. This was held to be a fine and difficult achievement, and indeed Paolo displayed great ability and ingenuity in this part of his work.

Uccello also did some work in *terra verde* and colour in the cloister of San Miniato outside Florence.[1] He painted scenes from the lives of the Fathers of the Church, in which he ignored the rule of consistency in colouring, for he made the fields blue, the cities red, and the buildings in various colours as he felt inclined. He was wrong to do so, because something which is meant to represent stone cannot and should not be coloured with another tint. It is said that while Paolo was at work on this painting the abbot gave him for his meals hardly anything but cheese. Paolo grew sick of this, but being a

1. *Terra verde* is a natural green earth used for monochrome painting.

mild-mannered man he merely decided not to go there any more. The abbot sent to look for him, but whenever Paolo heard the friars asking for him he arranged not to be at home. And if he happened to meet a pair of them in Florence he took to his heels as fast as he could in the opposite direction. Seeing this, two of them who were more curious than the rest (and could run faster) caught him up one day and demanded why he never returned to finish the work he had started and why he always ran away when he caught sight of a friar. Paolo said:

You've brought me to such a sorry state that I not only run away from the sight of you, I can't even go where there are carpenters working. This is all the fault of your dim-witted abbot. What with his cheese pies and his cheese soups, he's stuffed me so full of cheese that I'm frightened they'll use me to make glue. If he went on any more I wouldn't be Paolo Uccello, I'd be pure cheese.

The friars roared with laughter and went and told the abbot what Uccello said; and then the abbot persuaded him to come back and gave him something else for his meals.

Subsequently, Paolo painted for the Pugliesi Chapel of San Girolamo in the church of the Carmine the altarpiece of SS. Cosmas and Damian. In the house of the Medici he painted in tempera on canvas several scenes of animals. He always loved painting animals, and in order to do them well he studied them very carefully, even keeping his house full of pictures of birds, cats, dogs, and every kind of strange beast whose likeness he could obtain, since he was too poor to keep the animals themselves. Because he loved birds most of all he was called Paolo Uccello, Paolo of the Birds. Included among the animal paintings that he kept in his house was one showing lions fighting among themselves with such terrible vigour and fury that they seemed alive. There was a re-markable picture of a serpent fighting a lion, showing the serpent's fury as it threshed about and spat poison from its mouth and eyes and a peasant girl near by looking after an ox which is drawn in marvellous foreshortening. The sketch for this, by Paolo himself, is in our book of drawings, as is another showing the peasant girl just about to flee panic-stricken from

the lion and the serpent. The same scene shows some very life-like shepherds and a landscape that was considered very beautiful when it was done. On other canvases Uccello depicted some contemporary men-at-arms on horseback, several of them drawn from life.

Several scenes were then commissioned from Paolo for the cloister of Santa Maria Novella. The first of these, at the entrance from the church into the cloister, represent the creation of the animal kingdom, and contain an endless variety of creatures found on land, in the sea, or in the air. In these Uccello showed how delightfully imaginative he was and how, as I mentioned, he loved painting animals to perfection; for example, one can see the tremendous nobility of his lions as they endeavour to rend each other and the swiftness and timidity of his stags and bucks. He also painted the birds and fishes with very realistic feathers and scales. And he showed the creation of the first man and woman, and their fall, painting this subject with great care, and in a beautiful and accomplished style. He took great pleasure in this work in colouring the trees, something which was not often done well at that time; and he was the first of the old painters to be acclaimed for his landscapes, which he executed far more skilfully than previous artists had done, although he was surpassed by those who came later. And this was because, despite all his efforts, Paolo could never impart the softness and harmony that we find in the oil paintings of our own time. He was content to go on following the rules of perspective and drawing and foreshortening his subjects exactly as he saw them, painting everything in view, the meadows, the ploughed fields, the furrows, and the other details of country life, in that dry and hard style of his. If he had been selective and included in his work only the subjects lending themselves to painting, they would have been absolutely perfect. When he had finished all this, he did some more painting below two scenes by other artists in the same cloister. Lower down, he painted the Flood and Noah's Ark; and here, taking great pains and with great care and skill, he reproduced the dead bodies, the tempest, the fury of the wind, the flashes of lightning, the rooting up of trees, and the terror of

men, in a manner that defies description. He portrayed a dead body, foreshortened, with a crow pecking out its eyes, and a drowned child, whose body, sodden with water, is arched up grotesquely. He also conveyed in his painting many kinds of human emotion. In two men fighting each other on horseback one can see, for example, utter disregard of the deluge; and the utmost fear of death is seen in the expressions of a man and a woman who have given up hope of saving themselves because the buffalo, which they are astride, is sinking under the water. This painting was so excellent in every way that it won Uccello very considerable fame. His figures were foreshortened according to the lines of perspective, and there are various things which he depicted, such as the *mazzocchi* worn by some of the men, that were most beautifully done. Under this scene Uccello depicted the drunkenness of Noah and the irreverence of Ham his son (introducing the portrait of his friend Dello, a Florentine painter and sculptor); and he showed Noah's other sons, Shem and Japhet, covering up their father's shame. He also painted in this scene a foreshortened cask, curving on every side, which was greatly admired, and a pergola covered with vines whose trellis-work recedes towards the vanishing point. But here Uccello made a mistake, because the lines of the plane on which the figures are standing recede parallel to those of the pergola, whereas the cask does not follow the same lines. I have often wondered how such an accurate and careful painter could have made such a remarkable error. Uccello also painted in Santa Maria Novella the sacrifice of Noah, showing the open ark drawn in perspective with the ranges of perches in the upper part for the birds, which are depicted, in perspective, as they fly away in their various families. In the air above the sacrifice which Noah and his sons are offering appears the figure of God the Father; and of all the figures painted by Uccello in that work this was the most difficult, for it is flying towards the wall with the head foreshortened, and it is so forceful that it seems to be in relief, and to be bursting through it. As well as this, Noah has around him innumerable beautifully painted animals. Altogether, in short, Uccello imbued the entire work with such

softness and grace that it is overwhelmingly superior to everything else that he did, and has therefore won great praise ever since.

In Santa Maria del Fiore Uccello painted a horse in *terra verde* to commemorate Giovanni Acuto,[1] the English captain of the Florentines who died in 1393; this was a beautiful work of extraordinary grandeur, with the figure of the captain above, done in chiaroscuro and coloured with *terra verde*, in a fresco twenty feet high on the middle of one wall of the church. Paolo drew there in perspective a large sarcophagus supposed to contain the corpse, and over this he painted the image of the captain on horseback and wearing his armour. This fresco has always been regarded as a very fine example of that kind of work. Unfortunately, Paolo's horse has been painted moving its legs on one side only, and this is something which horses cannot do without falling. Perhaps he made the mistake because he was not in the habit of riding and not as familiar with horses as with other animals. Anyhow, but for that the painting would be absolutely perfect: the horse, which is very large, is done in beautiful perspective, and on the pedestal is the inscription: PAULI UCCELLI OPUS.

At that time Uccello painted in colour the clock-face over the principal doorway of the same church, with four heads at the corners coloured in fresco. He also worked in *terra verde* in the loggia which overlooks the garden of the Angeli, facing west, painting under each arch a scene from the life of St Benedict the abbot and including the most notable events of his life. Among the finest of these scenes is one showing the destruction of a monastery through the agency of the devil, with the body of a dead friar pinned under the stones and timbers; no less remarkable is the fear expressed in the figure of another monk, whose clothes are swirling gracefully round his naked body as he runs away. This provided an inspiration for other artists, who have subsequently always imitated the same stylistic device. Very beautiful also is the devout and grave figure of St Benedict himself, shown in the presence

1. Sir John Hawkwood, an Englishman who soldiered as a *condottiere* in fourteenth-century Italy.

of all his monks restoring the dead friar to life. All these scenes, indeed, contain details worthy of careful study, especially in some instances where the perspective has been carried to the slates and tiles of the roof. In the death scene of St Benedict there are some remarkably fine representations of infirm and senile people, who have come to see him only to find his monks making his obsequies and grieving over his death. And among the many devout and loving followers of the saint is an old monk hobbling on two crutches, whose emotions are marvellously expressed and who, perhaps, is hoping to recover his health. Although this work contains no coloured landscapes nor many buildings or difficult perspectives, it is boldly designed and well executed.

In many Florentine houses can be found a number of pictures by Uccello, all of them small, painted in perspective to decorate the sides of couches, beds, and so forth; in particular, at Valfonda, on a terrace in a garden once belonging to the Bartolini, there are four battle scenes painted by Uccello on wood and showing horses and armed men wearing the beautiful costumes of those days. Among the men are portraits of Paolo Orsini, Ottobuono da Parma, Luca da Canale, and Carlo Malatesta, ruler of Rimini, all commanders of that time. In our own day, since they have been damaged and spoilt, those pictures were restored by Giuliano Bugiardini, who did them more harm than good.

When Donatello went to work in Padua, he sent for Uccello, and at the entrance of the Vitaliani Palace he painted in *terra verde* some giants which, as I discovered in a letter in Latin which Girolamo Campagnola wrote to Leonico Tomeo, the philosopher, were greatly admired for their beauty by Andrea Mantegna. Paolo decorated the vaulting of the Peruzzi in fresco with triangular sections in perspective, and in the angles of the corner he painted the four elements, representing each by an appropriate animal: a mole for earth, a fish for water, a salamander for fire, and for air the chameleon, which lives on air and assumes any colour. Since he had never seen a chameleon, Uccello painted instead a camel which is opening its mouth and filling its belly by swallowing air: and in this he certainly showed his great simplicity in alluding

by the name of the camel to an animal which is like a small, shrivelled lizard, and depicting it by a lumbering great beast.

Paolo undoubtedly worked hard at his profession; he drew so much that he left his relations, as they have told me themselves, whole chests full of drawings. But although designs are good in themselves it is better to translate them into works which have a longer life. In our book there are many drawings by Uccello of figures, perspectives, birds, and wonderfully fine animals, but best of all is a study for a *mazzocchio* drawn in outline only, yet so beautifully intricate that only Paolo could have had the patience to do it. Although he was eccentric, Paolo loved the talent he saw in his fellow-craftsmen; and to preserve their memory for posterity he painted the portraits of five distinguished men with his own hand on a long panel which he kept in his house in memory of them. One was the painter Giotto, standing for the light and origin of painting; the second was Filippo Brunelleschi, for architecture; then Donatello, for sculpture; Uccello himself, for perspective and animal painting; and for mathematics his friend Giovanni Manetti, with whom he often conferred and discoursed on the problems of Euclid.

The story goes that Uccello was once commissioned to paint over the door of the church of San Tommaso in the Old Market a fresco showing St Thomas feeling for the wound in Christ's side, and that he put all he could into the work, saying that he wanted it to display all his ability and knowledge. So he had a screen of planks put up round the painting to keep it hidden until it was ready. One day Donatello met him on his own and said:

'And what kind of work is this that you've hidden behind a screen?'

Paolo answered: 'You'll just have to wait and see.'

Donatello would not press him any further, expecting that he would see some miracle, as usual, when the time came. Then one morning Donatello happened to be buying some fruit in the Old Market when he saw that Paolo was uncovering his work. He greeted Paolo courteously, and Paolo, who was anxious to have his opinion, asked him what he thought

of the painting. After he had closely scrutinized it, Donatello commented:

 'Well now. Paolo, now that it ought to be covered up, you're showing it to the whole world.'

Paolo was deeply offended by this, and finding that instead of all the praise he had anticipated he was being censured for this, his last work, he felt so humiliated that he no longer had the heart to go out of doors, and he shut himself up in his house and devoted all his time to perspective, which kept him poor and secluded till the day he died. He lived to a ripe but disgruntled old age, dying in 1432 in his eighty-third year. He was buried in Santa Maria Novella.[1]

He left a daughter, who had some knowledge of drawing, and a wife who told people that Paolo used to stay up all night in his study, trying to work out the vanishing points of his perspective, and that when she called him to come to bed he would say: 'Oh, what a lovely thing this perspective is!'

And indeed, if perspective was dear to Uccello it also proved, thanks to his works, attractive and rewarding to those who have used it since.

1. Uccello died in 1475, and was buried in the church of Santo Spirito.

LIFE OF

LORENZO GHIBERTI

Florentine sculptor, 1378–1455

ALL over the world men of acknowledged genius can expect to be revered and emulated both by posterity and by their contemporaries; and certainly during their own lifetime they are generously praised and rewarded. In fact, there is nothing which so inspires men or makes the burden of their studies seem lighter, than the prospect that their work will eventually bring them respect and riches. These rewards make difficult undertakings seem easy; men cultivate their talents with re-doubled ambition when they are spurred on by applause. When they see and hear others being praised, there is no end to the number of people who will exert themselves to earn what some of their fellow citizens have already won. This was why in ancient times men who distinguished themselves were rewarded with riches or honoured with triumphs and statues. Talent, all the same, only too often provokes envy; and to make sure of success or even survival in the face of envious onslaughts men who have talent must either prove their complete superiority or, at least, demonstrate that their achievements are soundly based and will stand up to criticism. How to do this well was shown perfectly, thanks to his own merit as well as his good fortune, by Lorenzo di Cione Ghiberti (also known as Lorenzo di Bartoluccio) an artist to whom those two distinguished craftsmen, the sculptor Donatello and the sculptor and architect Filippo Brunelleschi, readily took second place, despite their natural inclination to do otherwise, since they clearly recognized that he was far more expert in casting bronzes than they were. This action brought them great credit, but it threw into confusion those arrogant enough to push in front of better artists, take an eternity to produce something worthless, and upset and frustrate the skill of others by their envy and ill-will.

Lorenzo was the son of Bartoluccio Ghiberti. From his earliest years he studied the goldsmith's art with his father, whom he soon outpaced although Bartoluccio was an accomplished craftsman. Lorenzo, however, was more interested in sculpture and drawing, and he used sometimes to use colours or cast little figures in bronze, finishing them very gracefully. He also loved to counterfeit the dies of antique medals, and he made portraits of many of his friends. In 1400 when he was still working with Bartoluccio and striving to make progress in his profession, the plague broke out in Florence (as Ghiberti himself described in his own book on art, which is in the possession of Cosimo Bartoli, a gentleman of Florence).[1] As well as the plague, Florence was troubled by civil discord and other disturbances, and so, along with another painter, Ghiberti was forced to leave for the Romagna. In Rimini they decorated a room for Signor Pandolfo Malatesta and executed many other works which were finished very diligently and gave much satisfaction to the prince, who while still a young man took great pleasure in the art of design.

Lorenzo himself kept up his studies and practised working in relief with wax, stucco, and similar materials, knowing that small works of that kind constitute the preparatory sketches which a sculptor must make to achieve perfection in his finished work.

Now not long after Lorenzo had left the plague died out in Florence, and the Signoria and the Cloth-merchants Guild determined (seeing that there were many first-rate sculptors available at that time, both native and foreign) that as had so often been discussed a start should be made on the other two doors for San Giovanni, the very ancient and principal church of the city. They resolved to invite to Florence the best craftsmen in Italy to make in competition, as a trial specimen of their work, a scene in bronze similar to one of those that

1. The book is Ghiberti's *Commentarii*, a work sketching the development of art, with a notable autobiographical section on which Vasari drew heavily, and of which an English translation is included in Ludwig Goldscheider's *Ghiberti* (Phaidon, 1949). Ghiberti was the son of Cione di Ser Bonaccorso and Monna Fiore, who later married Bartolo (Bartoluccio), Lorenzo's step-father. However, at one time Ghiberti was alleged to be the illegitimate child of Bartoluccio and Monna Fiore, born before Cione's death.

Andrea Pisano had made earlier for the first door. Bartoluccio wrote sending the news of this decision to Lorenzo, who was then working in Pesaro, and urging him to come back to Florence and show what he could do. Lorenzo, he argued, would be given the chance to make his name known and to prove his skill and ability; and, moreover, the work could bring him so big a reward that neither of them would ever again need to rely for a living on making trinkets.[1]

Lorenzo was so stirred by what Bartoluccio said that he insisted on taking his leave despite the favours and affection shown him by Signor Pandolfo and all his court and by the other painter who was with him. Indeed, every hour's delay seemed to Lorenzo like an eternity. And so with great reluctance and displeasure they let him go, having failed to win him over either by their promises or their offers of more money; and Lorenzo set off joyfully for home.

Already many strangers had arrived and presented themselves to the consuls of the Guild, who chose seven artists in all, three Florentines and the rest Tuscans, voted them a salary, and stipulated that by the end of a year each one should complete as an example of his work a bronze scene of the same size as those in the first door. For the subject, they choose Abraham sacrificing his son Isaac, considering that this would test the competitors in all the problems of their craft since it demanded the ability to render landscapes, both nude and draped figures, and animals, and because the foremost figures were to be shown in full relief, the second in half relief and the third in low relief. The competitors were Filippo Brunelleschi, Donatello, and Lorenzo di Bartoluccio (all Florentines), Jacopo della Quercia of Siena, Niccolò Aretino his pupil, Francesco di Valdambrino, and Simone dal Colle, called Simone de' Bronzi. These artists promised to deliver their finished scenes by the stipulated time, and they set to work with great diligence and enthusiasm, exerting

1. Vasari wrote 'ear-rings'. In his *Ghiberti* Ludwig Goldscheider reminds us that: 'In the early days of the Renaissance a Florentine would walk into an artist's workshop ... and would there give his orders – for anything from a decorated button to a painted altarpiece or a marble tomb could be ordered in the same workshop.'

all their energies and knowledge to surpass one another and jealously hiding what they were doing lest they should copy one another's ideas. Lorenzo alone (advised by Bartoluccio who told him to do several models before selecting one from which to work) continually brought along citizens, and even passing strangers if they knew about the art, to give their opinion of his work; and helped by their advice he produced a faultless model. When he had made the moulds and cast the work in bronze it came out very well, and then with the help of his father, Bartoluccio, he polished it with such patience and love that nothing could have been better executed or finished.

The time had now arrived for the scenes to be judged, and Lorenzo's and those of the other artists were completely finished and given to the Merchants Guild for their decision. After they had all been inspected by the consuls and a number of other citizens, a great many different opinions were expressed. There were many strangers in Florence, painters, sculptors, and goldsmiths, who had been summoned by the consuls to take part in the judging along with other craftsmen from Florence itself.

Altogether there were thirty-four judges, each one an expert in his particular art, and although opinions varied considerably, some of them liking the style of one man and some that of another, they all agreed none the less that Filippo Brunelleschi and Lorenzo di Bartoluccio had composed and finished their scenes better, and with a richer variety of figures, than had Donatello, even though his also showed great qualities of design. The figures in Jacopo della Quercia's scene were good, but they lacked delicacy despite all the care and design that had gone into them. Francesco di Valdambrino had made some good heads and his scene was well finished, but the composition was confused. Simone dal Colle had done a beautiful casting, since he specialized in that craft, but his scene was poorly designed. Niccolò Aretino's showed good workmanship, but his figures were stunted and the work was badly finished. Only the scene which Lorenzo offered as a specimen, which can still be seen in the audience chamber of the Merchants Guild, was absolutely perfect in every detail:

the whole work had design, and was very well composed; the finely posed figures showed the individuality of his style and were made with elegance and grace; and the scene was finished so carefully that it seemed to have been breathed into shape rather than cast and then polished with iron tools. When Donatello and Filippo saw the diligence with which he had worked they drew aside and determined between themselves that the commission should go to Lorenzo. In that way, they considered, both the public and the private interest would be best served and given the opportunity Lorenzo, who was still a young man of under twenty, would be enabled to produce the even greater results that were promised by his beautiful scene which, in their judgement, was far better than the others. They remarked that it was only fair to let him have the commission and that the shame of denying him it would be too great.

So Lorenzo started work on the doors for the entrance opposite the Office of Works of San Giovanni, making for one section a framework of the exact size that the bronze was to be, with frames and with the ornaments of the heads at the corners of the spaces for the scenes, and with the friezes surrounding them. Then very carefully he made and dried the mould and, in a room that he had hired opposite Santa Maria Novella, where the hospital of the Weavers stands today on the spot called the Threshing-floor, he built a huge furnace (which I remember seeing myself) and cast the framework in bronze. As luck would have it, it came out badly, but without panicking or losing heart Lorenzo found out what had gone wrong and promptly made a fresh mould and cast it again in secret; and it came out splendidly. He continued working in this way, casting each scene separately and putting it in place when it was ready. The arrangement of the scenes followed that which Andrea Pisano had adopted earlier for the first door, designed for him by Giotto. Lorenzo did twenty scenes from the New Testament, leaving underneath eight corresponding spaces. For these he made the four evangelists, two for each leaf of the door, and likewise the four Doctors of the Church. All these figures were given distinctive poses and draperies: one is writing, another reading, others are

meditating; they are all lifelike and varied, and beautifully exe-
cuted. As well as this, in the frames round each scene Lorenzo
made a border of ivy leaves and other kinds of foliage and
moulding, with a male or female head in full relief at every
corner, representing prophets and sibyls. These again are
extremely attractive and varied and give ample testimony of
Lorenzo's genius. Above the panels showing the Doctors of
the Church and the evangelists, starting from below on the
side nearer Santa Maria del Fiore, the first of the four pictures
shows the Annunciation of Our Lady. Lorenzo conveys in
the pose of the Virgin her sudden fear and alarm as she turns,
with exquisite grace, when the angel appears. Beside this
scene he represented the Nativity of Christ, showing Our
Lady resting after she has given birth, with St Joseph medi-
tating and the shepherds and the angels singing. On the
other side of the door, on the same line, follows the scene
showing the coming of the Magi who are adoring Christ
and offering him their tribute; their servants and horses and
the rest of their retinue follow them and are very skilfully
portrayed. Next is the scene of Christ disputing among the
doctors in the Temple, in which Lorenzo expressed the
wonder and attention with which the doctors are listening to
Christ and the joy of Mary and Joseph at finding him again.
Over these four scenes, starting with the panel above the
Annunciation is, first, the Baptism of Christ by John in the
Jordan, in which the attitudes of the two figures convey
perfectly the reverence of the one and the faith of the other.
Then comes the Temptation of Christ by the devil, who is
shrinking in terror at the words of Jesus in an attitude that
shows he recognizes that he is the son of God. Corresponding
to these on the other side Lorenzo has shown Christ driving
the traders out of the Temple, overturning the money, the
sacrificial victims, the doves, and the rest of their merchandise;
and with wonderful skill and invention he has depicted some
of the traders falling over each other and sprawling headlong.
Then comes the shipwreck of the Apostles, where St Peter
leaves the boat and starts to sink but is held up by Christ.
The attitudes of the Apostles who are labouring in the
boat are beautifully portrayed, and the faith of St Peter is

demonstrated by his walking towards Christ. Going back to the other side, over the Baptism we see the Transfiguration on Mount Tabor, where Lorenzo expressed in the poses of the three Apostles the way in which mortal men are dazzled by the supernatural; and here Christ is displayed on high in his divinity, standing between Elias and Moses with his arms outspread. Beside this scene is the Raising of Lazarus, who has come out of the tomb bound hand and foot and who stands upright to the wonder of the onlookers. We see Martha and Mary Magdalen, who is kissing the feet of the Lord with great reverence and humility. On the other side of the door there follows the scene showing Christ riding into Jerusalem on a donkey, the Jewish children spreading their clothes and olive branches and palms on the ground before him, and the Apostles following the Saviour. Next comes the Last Supper, where the Apostles, in a beautifully composed scene, are shown seated at a long table, half of them on one side and half on the other. Over the scene of the Transfiguration is, first, the Agony in the Garden, with the three Apostles asleep in various attitudes. Beside this Lorenzo showed Christ being seized and receiving the kiss of Judas, in a scene with many remarkable details such as the fleeing Apostles and the Jews who are laying hands on him with violent brutality.

On the other side, on the same line, Lorenzo showed Jesus Christ bound to the column, his face somewhat contorted from the pain of the scourging, in an attitude of compassion and contrasted with the Jews who are beating him with terrible expressions of rage and hatred. Next we see Christ being led before Pilate, who washes his hands and condemns him to the Cross. Over the Agony in the Garden, on the other side, in the last line of scenes, Christ is shown carrying the cross and going to his death, led by a band of soldiers who are forcibly dragging him along with rough gestures; and we see the tears and the lamentations of the two Marys, just as if we were eye-witnesses. Beside this scene he did the Crucifixion of Christ, showing Our Lady and St John the Evangelist sitting on the ground, desolate and outraged. On the other side of the door there follows the Resurrection: the guards have been stunned by the thunder and look as if they are dead

and Christ ascends into heaven in a state of glory that Lorenzo's skill has perfectly expressed in the beauty of his body. In the last space we see the descent of the Holy Ghost upon the Apostles, whose expectant attitudes are marvellously portrayed.

So Lorenzo brought this work to its finished perfection; and no bronze could ever have had more labour or time expended on it. The limbs of the nude figures are extremely beautiful in every detail, and the draperies (although they still have something of the old-fashioned manner of Giotto's time) have a general air suggesting the style of the moderns and producing in figures of that size an impression of exquisite grace. The composition of each scene is so well ordered and arranged that Lorenzo more than justified the praise which Filippo had given him before he started. He won full recognition from his fellow citizens and was enthusiastically praised by them and by all other artists, both native and foreign. With the surrounding ornamentation of festoons of fruits and animals (also in bronze) the work cost twenty-two thousand florins; and the bronze doors themselves weighed thirty-four thousand pounds.

After the doors had been finished and Lorenzo acclaimed for what he had achieved, the consuls of the Merchants Guild considered that they had been very well served, and they decided to commission from him a bronze statue, nine feet high, to commemorate St John the Baptist, for one of the niches in the pilasters outside Orsanmichele belonging to the cloth-dressers. Lorenzo worked on this continuously until it was finished. It has always been very highly regarded, and Lorenzo put his own name on the hem of the robe. The statue, which was put in position in 1414, shows the beginning of the good modern style, in the head, in one of the arms which looks like living flesh, in the hands, and in the whole pose of the figure. Lorenzo was, indeed, the first to imitate the works of the ancient Romans, which he studied very carefully (as must everyone who wants to do good work). On the frontal of the shrine he tried his hand at a mosaic, completing a half-length figure of one of the prophets.

By now Lorenzo's reputation as the most resourceful artist

in bronze casts had spread through all Italy and beyond. As a result, after Jacopo della Fonte, Vecchietto of Siena, and Donatello had made some bronze scenes and figures to adorn the baptismal font of the church of San Giovanni, for the Signoria of Siena, the people of Siena, who had seen Lorenzo's work in Florence, reached an agreement with him that he should make for them two additional scenes from the life of St John the Baptist. One of these scenes, containing a large number of figures, both nude and richly draped, showed John baptizing Christ; the other, the time when John was seized and taken before Herod. In this work Lorenzo surpassed the others, winning unstinted praise from the Sienese themselves and from all who have seen it.

In Florence, the directors of the Mint had to put up a statue in one of the niches around Orsanmichele, facing the Wool Guild. It was to be a St Matthew, the same height as the St John mentioned earlier. So they allocated the work to Lorenzo, who did it perfectly and, since it was more modern in style, received for it far more praise than he had for the St John. This statue prompted the consuls of the Wool Guild to commission from him a bronze figure for the niche next to the one with the St John, of the same size as the other two. It was to be of their patron, St Stephen. Lorenzo finished this work, imparting a very fine polish to the bronze, and it gave no less satisfaction than his previous works.

At that time Leonardo Dati, the general of the Friars Preachers, wanted to have his own public memorial put up in Santa Maria Novella, where he had taken his vows. So he commissioned from Lorenzo a bronze tomb, with an effigy of himself lying on top; this was so much admired that Lorenzo was then asked to make a memorial in Santa Croce for Lodovico degli Albizzi and another for Niccolò Valori.[1] Subsequently, Cosimo and Lorenzo de' Medici, wanting to honour the bodies and relics of the three martyrs, Protus, Hyacinthus, and Nemesius, had them brought from the Casentino, where for many years they had been held in scant respect, and had a bronze reliquary made by Lorenzo, in the middle of which are two angels in low relief, holding an

1. In fact, Lodovico degli Obizzi and Bartolommeo Valori.

olive wreath encircling the names of the martyrs. They had the relics deposited in the urn, which was then placed in the church of the monastery of the Angeli at Florence, with the following words carved below in marble, on the side facing the monks' church:

Clarissimi viri Cosmas et Laurentius fratres, neglectas studio ac fidelissima pietate, suis sumptibus aereis loculis condendas colendasque curarunt.[1]

And on the outside, where the little church faces the street, are these words, cut in the marble under a coat-of-arms with the balls:

Hic condita sunt corpora sanctorum Christi martyrum Prothi et Hyacinthi, et Nemesii. Ann. Dom. MCCCCXXVIII.[2]

This work was very successful and it persuaded the wardens of Santa Maria del Fiore to commission a bronze reliquary and memorial for St Zenobius, bishop of Florence.

Lorenzo decorated the front of this tomb (which was seven feet in length and two feet high) with a scene showing St Zenobius restoring to life a child left in his care which had died while its mother was on pilgrimage. In a second scene another child, killed by a wagon, is brought back to life by St Zenobius, as well as one of the servants sent by St Ambrose who had been left for dead on the Alps: the second servant is shown stricken with grief in the presence of the saint who is filled with pity and saying: 'He is only sleeping, go and you will find him alive.'

In the background are six little angels holding a garland of elm leaves within which there is an inscription in memory and praise of the saint. Lorenzo executed this work with great skill and craftsmanship, and it was deeply admired for its beauty.

Lorenzo was continuing to add to his reputation and carrying out innumerable commissions in bronze, silver, and gold, when there fell into the hands of Giovanni de' Medici a large

1. The most noble brothers Cosimo and Lorenzo, in their zeal and faithful love and at their own expense, have had these neglected remains enshrined for veneration in this coffer of bronze.

2. Here are bestowed the bodies of Christ's holy martyrs Protus, Hyacinthus, and Nemesius. A.D. 1428.

cornelian engraved in intaglio with a scene showing the flaying of Marsyas at Apollo's command. It was said that it had once served as the Emperor Nero's seal. Because of the stone's weight and size, and the marvellous engraving, it was a very rare thing and Giovanni gave it to Lorenzo with instructions to mount it in gold. After many months' work Lorenzo finally completed the setting, producing a carving that was no less perfect than the beautiful intaglio of the stone itself. This led to his being commissioned many similar works in gold and silver, which have been lost to us. He also made a splendid gold clasp, with figures in full relief and precious jewels, for the cope of Pope Martin, for whom, as well, he made a marvellous mitre chased with gold leaves and with many small figures in full relief which were thought very beautiful. This work, besides enhancing Lorenzo's reputation, proved very profitable for him because of the Pope's generosity. Then in 1439 Pope Eugene came to Florence, where he held a Council in the hope of uniting the Greek and Latin Churches. He saw and liked Lorenzo's work, and he was no less pleased by Lorenzo himself, and he ordered from him a gold mitre weighing fifteen pounds and containing pearls weighing five and a half pounds, which including the jewels were valued at thirty thousand gold ducats. They say that this mitre contained six pearls as big as hazel-nuts, and if we go by a later drawing it is impossible to imagine anything more beautiful and curious than the settings of the jewels and the great variety of *putti* and other figures which served as so many varied and graceful adornments. For making the mitre, apart from the first payment, Lorenzo received countless favours from the Pope both for himself and his friends.

The quality and excellence of Lorenzo's work had brought so much credit to the city of Florence that the consuls of the Merchants Guild decided to commission from him the third door for San Giovanni, which was also to be of bronze. On their instructions, in style and execution Lorenzo had matched his first door, including the ornamentation that surrounds the figures and covers the framework on both sides, with Andrea Pisano's. But having seen how far Lorenzo had surpassed him, the consuls determined to remove Andrea's door, which was

in the centre, and put it opposite the Misericordia. Lorenzo, they decided, should make his new door for the middle; and confident that he would put into it all his energy and talent they left themselves in his hands, saying that he should do just what he wanted and make the door as rich, ornate, perfect, and beautiful as he possibly could. Nor was he to worry about time or money in making sure that, just as he had surpassed all other sculptors so far, now he should surpass himself.

So bringing to the task all his skill and knowledge Lorenzo started to make the door. He divided it into ten panels, five on each side, with the spaces enclosing the scenes measuring about two and a half feet. All the way round in the ornamentation of the framework surrounding the scenes there are niches with figures in almost full relief; there are twenty upright figures, all extremely beautiful, such as the nude Samson with his arm round a column and holding a jaw-bone which is as perfect as any bronze or marble Hercules made by the ancients. Equally fine is a figure of Joshua who is in the act of speaking to his army. And there are several prophets and sibyls dressed in different kinds of draperies and with varied arrangements of their heads, hair, and other adornments. In addition, there are four figures reclining in the niches in the transverse borders, and at the corners of the scenes there are circles containing the heads of women, youths, and old men, to the number of twenty-four.[1] Among these, in the middle of the door near where he inscribed his name, Lorenzo portrayed his father, Bartoluccio; and the younger man's head is that of Lorenzo himself. Besides the heads, he adorned the borders with a wonderful variety of foliage, mouldings, and other ornamentation.

The scenes are taken from the Old Testament. The first shows the creation of Adam and of Eve his wife, and we can see from the perfect form and execution of these figures how, very felicitously, Lorenzo intended them to be the finest he had ever done, since Adam and Eve had been the most beautiful creatures made by God. In the same scene they eat

1. Vasari (or his printer) made the number of reclining figures twelve and the number of circles thirty-four.

the apple and are driven out of Paradise: as they feel the first effects of sin they are conscious of their shame and cover themselves with their hands, and we see their remorse as they are expelled from Paradise by the angel. In the second space are Adam and Eve with their young children, Cain and Abel. We see Abel's sacrifice of the first fruits and Cain's inferior offering; and Cain's gestures express the envy he feels towards his brother, whose own attitude conveys his love of God. An extraordinarily beautiful detail of this scene shows Cain ploughing the earth with a pair of oxen, realistically dragging the plough with the yoke; and just as impressive is the detail showing Cain murdering Abel as he watches his flock. Cain appears pitiless and cruel as he clubs his brother to death, and the very bronze used for the dead limbs of Abel's beautiful body itself falls limp. The figure of God is shown in the distance, in low relief, asking Cain what he has done with Abel: four incidents being combined to form one picture.

In the third picture Lorenzo represented Noah leaving the ark with his wife, his sons and daughters, and his daughters-in-law. He showed all the animals, both the birds and beasts, each one after its kind in as perfect an imitation of nature as art can achieve: the ark is open and the desolation is expressed in low relief casting done in perspective so gracefully that it defies description. As well as this the figures of Noah and his sons are expressed with wonderful realism and vivacity in the incident where he is offering sacrifice, and the rainbow appears as a token of peace between God and him. But superior to all the rest is the scene where Noah is planting the vine and then exposes himself in his drunkenness while his son Ham mocks him. It would be impossible to improve on the representation of the sleeping Noah as he sprawls in drunken abandon, or of the respect and affection shown by the beautiful gestures of his other two sons as they cover him up. In addition, Lorenzo showed the casks and the vines and the implements for wine making, introduced so skilfully and appropriately that they embellish rather than impede the narrative.

For the fourth scene Lorenzo chose the appearance of the three angels in the vale of Mambre, making them alike and

showing the holy old man adoring them with the most appropriate and lifelike expression in his hands and face. Also very effective are the figures of the servants waiting with an ass at the foot of the mountain for Abraham, who has gone to sacrifice his son. The boy kneels naked on an altar and Abraham, with his arm raised, is about to prove his obedience to God when he is prevented by the angel who saves Isaac from death, restraining Abraham with one hand while with the other he points to the ram that is to be sacrificed instead. This is a really beautiful scene, showing, for example, so striking a contrast between Isaac's slender limbs and the thicker limbs of the servants that every single stroke must have been applied with consummate skill. Lorenzo also surpassed himself in this scene in the way he tackled the buildings, in the incident showing the birth of Isaac, and of Jacob and Esau, and when he showed Esau hunting in obedience to his father and Jacob, on Rebecca's instructions, offering the roast kid to his father, Isaac, who feels the skin which he is wearing round his neck and gives him his blessing. In this scene there are some beautifully realistic dogs as well as the figures of Jacob, Isaac, and Rebecca, who in Lorenzo's sculpture evoke the same responses that their actions must have done when they were living.

With practical experience Lorenzo gained more and more facility and was encouraged to try his hand at more ambitious and difficult subjects. So in the sixth scene he portrayed Joseph being thrown by his brothers into the pit, being sold by them to the merchants, who hand him over to Pharaoh, interpreting the dream of the famine, for which provision is made, and being honoured and rewarded by Pharaoh. Also shown is the time when Jacob sends his sons to buy corn in Egypt and when, recognizing them, Joseph makes them return for his father. For this detail Lorenzo, solving very considerable problems, made a round temple in perspective containing various figures carrying corn and flour as well as an incredibly large number of asses. We are also shown the feast prepared for Joseph's brothers, and the hiding of the gold cup in Benjamin's sack, and finding of the cup, and Joseph acknowledging and embracing his brothers.

The quality of Lorenzo's discerning mind and the distinction and grace of his work in this branch of sculpture were such that he unfailingly produced figures of outstanding beauty, as in the seventh scene where he featured Mount Sinai with Moses on the summit kneeling in reverence as he receives the commandments from God. Half-way up the mountain Joshua stands waiting, and at the foot the people are shown very realistically, in various poses but all terrified by the thunder, lightning, and earthquakes. Next, Lorenzo applied himself with loving diligence to the eighth scene, representing with very lively figures Joshua going to Jericho, crossing the Jordan, and pitching the twelve tents for the twelve tribes. Most remarkable is the incident, shown in low relief, when the ark is carried in procession round the walls of Jericho which crash down to the sound of the trumpets, allowing the Jews to capture the city; here the casting, perfectly executed, recedes accurately in perspective from the figures in the foreground to the mountains, from the mountains to the city, and from the city to the very low relief of the distant landscape. His skill in casting becoming more perfect every day, Lorenzo then executed the ninth panel which shows the slaying of the giant Goliath and David cutting off his head in a proud, boyish attitude, and the rout of the Philistines by the army of God, and which contains horses and chariots and the other accessories of war. Then in a lively and well considered detail he showed David returning with the head of Goliath in his hand and being met by the people, who are making music and singing. There remained for Lorenzo's greatest efforts the tenth scene, showing the queen of Sheba visiting Solomon with all her great court, where, with fine effect, he introduced a building shown in perspective, with figures similar to those in the other scenes. Finally, with the tenth scene, he did the ornamentation of the architraves which surround the door, composed of fruits and festoons of the same excellence as all his work.

Every single detail of Lorenzo's doors demonstrates what the skill and genius of an accomplished sculptor can effect when he is casting figures in the round, in half relief, in low relief or very low relief. In the imaginative composition, the

striking poses of his male and female figures, the perspectives, and the consistently graceful bearing of both sexes, Lorenzo demonstrated his perfect grasp of decorum, expressing gravity in the old and lightness and grace in the young.[1] The doors are undeniably perfect in every way and must rank as the finest masterpiece ever created, either in ancient or modern times. It would be difficult to praise Lorenzo too much, seeing that one day Michelangelo Buonarroti himself, standing to look at the doors and being asked what he thought of them and whether they were not beautiful, remarked: 'They are so beautiful that they would grace the entrance to Paradise.'

This tribute was indeed fitting, and it was offered by a man in a position to judge. And Lorenzo well deserved to bring the doors to completion, having started them when he was twenty and slaved on them for over forty years.

Lorenzo was assisted in finishing and polishing the work after it had been cast by many young men who afterwards became accomplished artists in their own right: namely, by Filippo Brunelleschi, Masolino da Panicale, and Niccolò Lamberti, goldsmiths, and by Parri Spinelli, Antonio Filarete, Paolo Uccello, Antonio Pollaiuolo, who was then quite young, and many others. By working in close collaboration on the doors and conferring with each other as a team they benefited themselves as much as Lorenzo. As well as being paid by the consuls, Lorenzo himself was given by the Signoria a good farm near the abbey of Settimo. Not long afterwards, he was made a member of the Signoria and so given the honour of serving on the chief magistracy of the city. For their treatment of Lorenzo the Florentines, therefore, are to be commended, just as they are to be censured for the ingratitude they have shown to other accomplished citizens. After he had completed the stupendous work of the doors, Lorenzo made the bronze ornamentation for the door of the same church which is opposite the Misericordia, introducing his marvellous foliage; but he died suddenly before he could finish it, after he had arranged everything and almost completed the model for the reconstruction of the door that

1. For the sense and implications of *decorum* in this context see the note on Vasari and the Renaissance Artist.

Andrea Pisano had made. This model has fared badly in recent times, but when I was a young man I once saw it in the Borgo Allegri, before Lorenzo's descendants had let it go to ruin.

Lorenzo had a son called Bonaccorso who himself very diligently completed the frieze and ornamentation, which, I maintain, constitute the rarest, most marvellous work in bronze anywhere to be seen.[1] If he had not died while he was still young, Bonaccorso would have executed a great many works, since he was left the secret of casting bronzes so that they come out very delicately and he had the experience and knowledge needed for perforating the metal in the manner we can see in Lorenzo's works. Lorenzo left his heirs not only work he had done himself but also many marble and bronze antiques such as the bed of Polycletus, a very remarkable work, the lifesize model of a leg in bronze, several male and female heads, and some vases that he had procured from Greece at no small expense. He also left some torsos and many other things which were all dissipated with his property, some of them being sold to Giovanni Gaddi, who was then clerk to the Camera Apostolica; among these were the bed of Polycletus and the best of the other things. Bonaccorso left a son called Vittorio who devoted himself to sculpture, but not very profitably as we can see from the heads that he made in the palace of the duke of Gravina at Naples which are poor specimens, for he never practised the art with affection or diligence but allowed the property and the other things left by his father and grandfather to go to rack and ruin. In the end when he was going to Ascoli as architect for Pope Paul III he had his throat cut by a servant who wanted to rob him. So the family died out, but not the fame of Lorenzo, which will endure for ever.

To return to Lorenzo himself: during his life he took an interest in many different things and he loved painting and working on glass. For Santa Maria del Fiore he made the circular windows around the cupola, except for the one showing the Coronation of Our Lady by Christ, which is by Donatello. Lorenzo also made the three windows over the

1. Bonaccorso was Ghiberti's grandson.

principal doorway of Santa Maria del Fiore and all those in
the chapels and the tribunes, as well as the rose window in the
façade of Santa Croce. At Arezzo he made a window for the
principal chapel of the parish church, containing the Corona-
tion of Our Lady, and he did two other figures for a very rich
merchant called Lazzaro di Feo di Baccio. But since they
were all made of very highly coloured Venetian glass they
tend to darken the places where they were put. Brunelleschi
was given Lorenzo as his collaborator when he was com-
missioned to raise the cupola of Santa Maria del Fiore but
(as I shall describe in my *Life* of Filippo) Lorenzo was sub-
sequently removed.

Lorenzo Ghiberti wrote a book in Italian in which he dealt
with many different subjects but in a most unhelpful way. In
my opinion all that can be said for the book is that after
Lorenzo has discussed several ancient painters (especially
those cited by Pliny) he gives a brief mention to Cimabue,
Giotto, and various others of that time; but discussion of
these is cut too short, and only to lead to a fine discourse
about himself and to leave room for a catalogue, which he
duly supplied, of all his own works. I shall not hide the fact
that Lorenzo intended the book to read as if it were by some-
one else; but then as the narrative proceeds, being better at
drawing and using the chisel or casting a bronze than he was at
spinning stories, Lorenzo starts slipping into the first person
when referring to himself, writing 'I said this' or 'I did
that . . .'.

At length Lorenzo was attacked by a severe and persistent
fever, and he died at the age of sixty-four, leaving behind him
the undying fame brought him by his works and by what was
written of him.[1] He was honourably buried in Santa Croce.
His portrait in bronze is on the principal door of San Giovanni,
in the middle border when the door is closed, showing him as
a bald man, and with the likeness of his father, Bartoluccio,
next to it. Near by can be read the inscription: LAURENTII
CIONIS DE GHIBERTIS MIRA ARTE FABRICATUM.[2] The
designs that he did were superb and made with great relief,

1. He died aged seventy-seven.
2. Made by the wondrous skill of Lorenzo Cio, of the Ghiberti.

as can be seen in our book of drawings where there is his drawing of one of the evangelists as well as several others beautifully done in chiaroscuro. His father, Bartoluccio, was also a fairly good draughtsman as is shown by another evangelist in my book, although this is clearly inferior to Lorenzo's. I had these designs, along with some by Giotto and others, from Vittorio Ghiberti in 1528, when I was still a young man, and I have treasured them ever since because of their beauty and also in memory of such great men. Among the many verses both in Latin and Italian which have been written at various times to commemorate Lorenzo I shall, to avoid troubling the reader further, content myself with quoting this:

> *Dum cernit valvas aurato ex aere nitentes*
> *In templo, Michael Angelus obstupuit:*
> *Attonitusque diu, sic alta silentia rupit:*
> *O divinum opus: O janua digna polo!*[1]

1. When Michelangelo the panels saw
 Gleaming upon the church in gilded bronze
 Amaz'd he stood; after long wonder thus
 The solemn silence broke: 'O work divine!
 O door worthy of heaven!'

LIFE OF

MASACCIO

Painter of San Giovanni di Valdarno, 1401–28?

THE appearance of a man of outstanding creative talent is very often accompanied by that of another great artist at the same time and in the same part of the world so that the two can inspire and emulate each other. Besides bringing considerable advantages to the two rivals themselves, this phenomenon of nature provides tremendous inspiration for later artists who strive as hard as they can to win the fine reputation and renown which they hear every day attributed to their predecessors. How true this is we can see from the fact that in the same period Florence produced Filippo Brunelleschi, Donatello, Lorenzo Ghiberti, Paolo Uccello, and Masaccio, each of whom was an outstanding artist and through whose efforts the crude and clumsy style which had persevered up to that time was finally discarded. Moreover, their beautiful work so forcefully stimulated and inspired their successors that the techniques of art were brought to the greatness and perfection that we know today. So we are certainly deeply indebted to those innovators whose work showed us how to bring art to the summit of perfection. To Masaccio especially we are indebted for the good style of modern painting; for it was Masaccio who perceived that the best painters follow nature as closely as possible (since painting is simply the imitation of all the living things of nature, with their colours and design just as they are in life). Knowing this, and hungry for fame, Masaccio learnt so much from his endless studies that he can be numbered among the pioneers who almost entirely rid painting of its hardness, difficulties, and imperfections. He gave a beginning to beautiful attitudes, movements, liveliness, and vivacity, rendering relief in a way that was characteristic and natural and that no painter had ever before attempted.

Masaccio possessed extremely sound judgement, and so he realized that figures which were made to seem on tiptoe instead of being posed firmly with their feet in foreshortening on the level lacked all the basic elements of good style, and that those who painted like that had no understanding of foreshortening. Although Paolo Uccello had tackled this problem with a fair measure of success, Masaccio introduced many new techniques and made his foreshortenings, which he painted from every angle, far better than any done before. His paintings were remarkably soft and harmonious, and he matched the flesh-tints of his heads and nudes with the colours of his draperies, which he loved to depict with a few simple folds just as they appear in life. All this has been of great benefit to later artists, and indeed Masaccio can be given the credit for originating a new style of painting; certainly everything done before him can be described as artificial, whereas he produced work that is living, realistic, and natural.

Masaccio was born in the village of San Giovanni in the Valdarno, where, it is said, one can still see some figures that he made in early childhood. He was very absent-minded and erratic, and he devoted all his mind and thoughts to art and paid little attention to himself and still less to others. He refused to give any time to worldly cares and possessions, even to the way he dressed, let alone anything else; and he never bothered to recover anything owing to him unless his need was desperate. So instead of calling him by his proper name, which was Tommaso, everyone called him Masaccio.[1] Not that he was in any way vicious. On the contrary, he was goodness itself; and although he was extraordinarily neglectful, he was as kind as could be when it came to giving help or pleasure to others.

Masaccio began painting at the time when Masolino da Panicale was working in the Brancacci Chapel in the Carmelite Church at Florence. Although he was a painter, as far as possible he followed in the steps of Filippo and Donatello; and he always tried to express in his figures the liveliness and beautiful animation of nature itself. His outlines and his painting were so modern and original that his works can be

1. Silly Billy, or sloppy Tom.

favourably compared with modern work for their design and colouring. He was extremely painstaking in his paintings and in the studies he made of the problems of perspective, in which he achieved very competent and impressive results, as can be seen in one of the histories he did, which is today in the house of Ridolfo del Ghirlandaio. In this picture, as well as a representation of Christ liberating a man possessed by demons, there are some very fine buildings drawn in perspective; and one can see simultaneously both the interior and the outside, because he chose the point of view not of the front but over the angles, as being the more difficult. Masaccio also made more use than other artists of nude and foreshortened figures, which indeed had rarely been seen before. He worked with great facility and, as I said, his draperies were very simple.

There is a panel picture in tempera by Masaccio showing Our Lady on the lap of St Anne with her son in her arms; this picture is today in Sant'Ambrogio at Florence, in the chapel by the door leading to the nuns' parlour. And on the screen of the church of San Niccolò sopr' Arno there is another of his panel pictures, in which as well as showing the Annunciation, with the angel and Our Lady, he painted a building with many columns very finely depicted in perspective. Apart from his perfect rendering of the lines, he demonstrated his understanding of perspective by shading his colours in such a way that the building seems gradually to disappear from view. In the abbey at Florence, in the niche of a pillar opposite those supporting the arch of the high altar, he did a fresco painting of St Ives of Brittany, who is seen from below with his feet foreshortened. This had never been done so well before and it won him no little praise. Underneath St Ives, above another cornice, he painted the widows, orphans, and beggars being helped by the saint in their need.

Below the choir in Santa Maria Novella he painted a fresco showing the Trinity, which is over the altar of St Ignatius and which has Our Lady on one side and St John the Evangelist on the other, contemplating the crucified Christ. At the sides are two kneeling figures, which as far as

one can tell are portraits of those who commissioned the work, although they can scarcely be made out as they have been covered over with gold ornamentation. But the most beautiful thing, apart from the figures, is the barrel-vaulted ceiling drawn in perspective and divided into square compartments containing rosettes foreshortened and made to recede so skilfully that the surface looks as if it is indented. In Santa Maria Maggiore, in a chapel near the side door which leads towards San Giovanni, Masaccio also painted a panel picture showing Our Lady, St Catherine, and St Julian, and on the predella he painted several little figures illustrating scenes from the life of St Catherine, and St Julian killing his father and mother; in the middle he depicted the Nativity of Jesus Christ with characteristic simplicity and liveliness.

In the Carmelite Church at Pisa, inside a chapel in the transept, there is a panel painting by Masaccio showing the Virgin and Child, with some little angels at her feet who are playing instruments and one of whom is sounding a lute and inclining his ear very attentively to listen to the music he is making. Surrounding Our Lady are St Peter, St John the Baptist, St Julian, and St Nicholas, all very vivacious and animated. On the predella below are some small figures illustrating scenes from the lives of those saints, with the three Magi in the centre offering their gifts to Christ. In this section there are some horses so beautifully portrayed from life that nothing finer could be wished for; and the three kings' court attendants are dressed in various clothes of the kind worn in those days. Above this panel picture is some ornamentation divided into several squares showing a crowd of saints gathered around a crucifix. It is believed that one of the figures, a saint in the robes of a bishop, which is painted in fresco by the side of the door leading to the convent, is also by Masaccio; but I am certain that it is by his pupil, Fra Filippo.[1] After Masaccio had returned from Pisa to Florence he executed a panel picture showing two life-size nudes, a man and a woman, which is now in the Palla Rucellai Palace.

1. Fra Filippo Lippi.

Later on, feeling rather discontented at Florence and prompted by his love and enthusiasm for painting, he determined to go to Rome in order to perfect his work and – as he succeeded in doing – make himself superior to all other painters. In Rome he became very famous, and he decorated a chapel for Cardinal San Clemente, in the church of San Clemente, painting in fresco the Passion of Our Lord, showing the crucified thieves and scenes of the martyrdom of St Catherine. He also painted a number of panel pictures in tempera, which were all either lost or destroyed during the troubles at Rome. He did another painting in the church of Santa Maria Maggiore, in a little chapel near the sacristy: it shows four saints, so skilfully painted that they look as though they are in relief, with Our Lady of the Snow[1] in the middle, and a portrait from life of Pope Martin, who is marking the foundations of the church with a hoe and near to whom stands the Emperor Sigismund II. One day after Michelangelo and I had been studying this work he praised it very highly and remarked that those men had been contemporaries of Masaccio.

Pisanello and Gentile da Fabriano shared with Masaccio some of the work they were doing on the walls of the church of San Giovanni for Pope Martin; but then he heard that Cosimo de' Medici (whose support and favour he enjoyed) had been recalled from exile, and so he returned to Florence where he was commissioned to decorate the Brancacci Chapel of the Carmine, because of the death of Masolino da Panicale. Before he began this work, to show the progress he had made as a painter Masaccio painted the St Paul which is near the bell-ropes. And he certainly excelled himself in this picture, where one can see in the head of the saint (which is a portrait from life of Bartolo di Angiolino Angiolini) so awe-inspiring an expression that the figure needs only speech to be alive. Anyone knowing nothing of St Paul has only to look at this painting to understand his greatness as a citizen of Rome and his saintly force of will, utterly dedicated to the propagation

1. Our Lady of the Snow – Santa Maria della Neve – a title for the Virgin which sprang from the legend that Santa Maria Maggiore was built following a miraculous fall of snow during the month of August.

of the faith. In the same painting Masaccio showed his
knowledge of the technique of foreshortening figures from
below in a way that was truly marvellous, as may be seen
today from his successful rendering of the feet of the Apostle,
in contrast to the crude style of earlier times which, as I said
a little while earlier, depicted every figure as if it were stand-
ing on tiptoe. This style persisted uncorrected until Masaccio's
time, and before anyone else he alone brought painting to the
excellence we know today.

While he was engaged on this work it happened that the
church of the Carmine was consecrated, and to commemorate
this event Masaccio painted a picture of the entire ceremony
as it had taken place, in chiaroscuro and *terra verde*, inside the
cloister over the door which leads to the convent. He showed
countless citizens following the procession and in their cloaks
and hoods, among them being Filippo Brunelleschi, wearing
wooden shoes, Donatello, Masolino da Panicale, who had
been his own master, Antonio Brancacci, who commissioned
Masaccio's work for the chapel, Niccolò da Uzzano, Giovanni
di Bicci de' Medici, and Bartolommeo Valori, all of whom
are also portrayed by the same hand in a painting in the
house of a Florentine gentleman, Simon Corsi. Masaccio also
painted there a portrait of Lorenzo Ridolfi, who at that time
was ambassador of the Florentine Republic in Venice. And
he not only portrayed these noblemen from life but also
painted the door of the convent just as it was, with the porter
holding the keys in his hand.

There are many excellent qualities in this work, for
Masaccio succeeded in showing these people, five or six in
line together on the level of the piazza, receding from view
with such proportion and judgement that his skill is indeed
astonishing. Even more remarkable, one can see his per-
spicacity in painting these men as they really were, not as
being all the same size but with a certain subtlety which dis-
tinguishes the short and fat from the tall and thin; and they
are also posed with their feet firmly on one level, and so well
foreshortened in line that they look the same as they would in
real life.

After this, Masaccio started work again on the Brancacci

Chapel, continuing the scenes from the life of St Peter which Masolino had begun and finishing some of them, namely, St Peter enthroned, the healing of the sick, the raising of the dead, and the restoring of the cripples as St Peter's shadow falls on them while he walks to the Temple with St John. The most notable among them, however, is the painting in which St Peter, in order to pay the tribute, at Christ's command is taking the money from the belly of the fish; for as well as being able to see in one of the Apostles, the last in the group, a self-portrait which Masaccio executed so skilfully with the help of a mirror that it seems to breathe, we are shown the bold way in which St Peter is questioning Our Lord and the attentiveness of the Apostles as they stand in various attitudes around Christ, waiting for his decision with such animated gestures that they look truly alive. St Peter is especially remarkable, as he flushes with the effort he is making in bending to take the money out from the belly of the fish; and even more when he pays the tribute, where we can see his emotion as he counts the money and the greed of the man who is receiving it and is looking at it in his hand with great satisfaction.

He also painted there the raising of the praetor's son by St Peter and St Paul; but he died before this work was finished, and it was subsequently completed by Filippino.[1] In the scene showing St Peter baptizing there is a figure of a naked man, who is trembling and shivering with cold as he stands with the others who are being baptized. This is very highly regarded, being executed in very fine relief and in a very charming style; it has always been praised and admired by artists.

Because of Masaccio's work, the Brancacci Chapel has been visited from that time to this by an endless stream of students and masters. There are still some heads to be seen there which are so beautiful and lifelike that one can say outright that no other painter of that time approached the modern style of painting as closely as did Masaccio. His work deserves unstinted praise, especially because of the way he formed in his painting the beautiful style of our own day.

1. Filippino Lippi, the son of Fra Filippo.

How true this is is shown by the fact that all the most renowned sculptors and painters who have lived from that time to this have become wonderfully proficient and famous by studying and working in that chapel: namely, Fra Giovanni da Fiesole, Fra Filippo, Filippino (who finished the chapel), Alesso Baldovinetti, Andrea del Castagno, Andrea del Verrocchio, Domenico Ghirlandaio, Sandro Botticelli, Leonardo da Vinci, Pietro Perugino, Fra Bartolommeo di San Marco, Mariotto Albertinelli, and the inspired Michelangelo Buonarroti. In addition, Raphael of Urbino found in the chapel the first inspiration for his lovely style. Masaccio has also influenced Granaccio, Lorenzo di Credi, Ridolfo Ghirlandaio, Andrea del Sarto, Rosso, Franciabigio, Baccio Bandinelli, Alonso the Spaniard, Jacopo Pontormo, Pierino del Vaga, and Toto del Nunziata. In short, all those who have endeavoured to learn the art of painting have always gone for that purpose to the Brancacci Chapel to grasp the precepts and rules demonstrated by Masaccio for the correct representation of figures. And if I have failed to mention many other foreigners and Florentines who have gone there to study, let me just say that where great artists flock so do the lesser.

Although Masaccio's works have always had a high reputation, there are those who believe, or rather there are many who insist, that he would have produced even more impressive results if his life had not ended prematurely when he was twenty-six. However, because of the envy of fortune, or because good things rarely last for long, he was cut off in the flower of his youth, his death being so sudden that there were some who even suspected that he had been poisoned.

It is said that when he heard the news Filippo Brunelleschi, who had been at great pains to teach Masaccio many of the finer points of perspective and architecture, was plunged into grief and cried: 'We have suffered a terrible loss in the death of Masaccio.'

Masaccio was buried in the Carmelite Church itself, in the year 1443. During his lifetime he had made only a modest name for himself, and so no memorial was raised. But there

were some to honour him when he died with the following epitaphs:

by ANNIBAL CARO

I painted, and my picture was like life;
　I gave my figures movement, passion, soul:
They breathed. Thus, all others
　Buonarroti taught; he learnt from me.

by FABIO SEGNI

Invida cur, Lachesis, primo sub flore juventae
　Pollice discindis stamina funereo?
Hoc uno occiso, innumeros occidis Apelles:
　Picturae omnis obit, hoc obeunte, lepos.
Hoc Sole extincto, extinguuntur sydera cuncta.
　Heu! decus omne perit, hoc pereunte, simul.[1]

1.　O jealous Fate, why doth thy finger fell
　　Asunder pluck the threads of youth's first bloom?
　　Countless Apelles this one slaying slays;
　　In this one death there dies all painting's charm.
　　With this sun's quenching, all the stars are quench'd;
　　Beside this fall, alas! all beauty falls.

LIFE OF
FILIPPO BRUNELLESCHI
Florentine sculptor and architect, 1377–1446

THERE are many men whom nature has made small and insignificant, but who are so fiercely consumed by emotion and ambition that they know no peace unless they are grappling with difficult or indeed almost impossible tasks and achieving astonishing results. These men enhance and distinguish whatever they happen to take up, no matter how commonplace or worthless it may seem. So one must never look down one's nose at those who lack the fine grace and bearing with which nature should endow all artists when they come into the world; lumps of earth often conceal veins of gold. Men of unprepossessing appearance are very often magnanimous and pure in heart, and when nobility is added to their other qualities they may confidently be expected to work miracles. This can clearly be seen in the case of Filippo Brunelleschi; just like Forese da Rabatta and Giotto he was insignificant to look at, but his genius was so commanding that we can surely say he was sent by heaven to renew the art of architecture. For hundreds of years men had neglected this art and had squandered their wealth on buildings without order, badly executed and poorly designed, which were full of strange inventions, shamefully devoid of grace and execrably ornamented. The world having for so long been without artists of lofty soul or inspired talent, heaven ordained that it should receive from the hand of Filippo the greatest, the tallest, and the finest edifice of ancient and modern times, demonstrating that Tuscan genius, although moribund, was not yet dead.

Moreover, Filippo was endowed with outstanding personal qualities, including such a kind nature that there was never anyone more gentle or lovable. He was dispassionate in judgement, and he never allowed his own advantage or the

interest of his friends to blind him to merit and worth in others.
He knew himself, he let others benefit from his success, and
he was always ready to help someone in need. He was a forth-
right enemy of all vice and a friend of the virtuous. He never
wasted his time, but was always working to help others,
either directly or indirectly; and he would go round on foot
visiting his friends and was always ready to serve them.

It is said that there lived in Florence a man of excellent
reputation, industriously following a good way of life, whose
name was Brunellesco di Lippo Lapi. His grandfather Cambio
had been a highly educated man and was himself the son of a
physician, Ventura Bacherini, who was very famous in those
days. Brunellesco married a very well-bred young woman
from the noble family of Spini, and as part of her dowry she
brought him a house where he and his sons lived all their
lives. And this house stands in a corner opposite San Michele
Berteldi, past the Piazza degli Agli. Brunellesco was leading a
busy and contented life when, in 1398, to his great joy his
wife bore him a son to whom he gave the name of Filippo,
after his own dead father. When Filippo was still a child his
father anxiously tried to teach him the rudiments of letters,
but the boy showed such intelligence and detachment that it
seemed as if he were deliberately giving his mind to things of
greater importance, turning away from what he was being
taught as if it lacked interest for him. Brunellesco, who
wanted him either to become a notary like himself or to
follow the profession of his great-great-grandfather, was
deeply upset. All the same, seeing that the boy was always
investigating ingenious problems of art and mechanics, he
made him learn arithmetic and writing, and then apprenticed
him to the goldsmith's art with a friend of his so that he might
study design. Filippo was overjoyed by this, and after he had
started to learn the art not many years passed before he was
setting the precious stones better than experienced craftsmen.
He occupied himself with niello[1] and with bigger pieces of
work such as the silver figures, including two half-length
prophets, which are at the head of the altar of San Jacopo
in Pistoia. (These figures, made by Filippo for the city

1. Niello is the art of engraving on silver.

commissioners, are considered extremely beautiful.) He also made some figures in bas-relief, showing that he understood the craft so well that his mind would inevitably be led on to greater things. He became well acquainted with some highly educated people and started to speculate about problems of motion and time, and of weights and wheels, and how the latter can be made to revolve and by what means they are kept in motion; and he made with his own hands some very splendid and very beautiful clocks.

Not content with this, he grew extremely ambitious to do some sculpture. And this ambition was satisfied, because he became a constant companion of Donatello, who was also a young man at that time and was regarded as very able and as showing considerable promise. Such great affection sprang up between them, because of the wonderful qualities they saw in each other, that it seemed as if the one could not possibly live without the other. Then Filippo, who was very versatile, tried his hand at several crafts, and he had not been working at them long before he was held by those who were know-ledgeable to be a very sound architect. This is clear from all the work he did on the construction of various houses: for example, the house of his relation Apollonio Lapi, at the corner of the Ciai, towards the Old Market, on which he worked very assiduously while it was being erected, and also the tower and house of Petraia, at Castello outside Florence. In the Palazzo della Signoria he arranged all those rooms where the officials of the Monte used to transact their busi-ness, constructing doors and windows in a style which had been employed in the ancient world but was then out of fashion because of the crudeness of contemporary architecture. Meanwhile, the friars of Santo Spirito in Florence wanted to commission for one of their chapels a statue in lime showing the penitent St Mary Magdalen, and Filippo, having executed a good many small works and wanting to prove that he could succeed on a larger scale, accepted the commission. When the statue was finished and put in its place it was regarded as a very fine piece of sculpture; but it was destroyed in a fire which broke out about then, in 1471, along with many other valuable works.

Filippo made a careful study of perspective, which because of all the errors of practice was in a deplorable state at that time, and he worked for a long while until he discovered for himself a technique by which to render it truthfully and accurately, namely, by tracing it with the ground-plan and profile and by using intersecting lines. This ingenious discovery made a great contribution to the art of design. It gave him so much satisfaction that he went to the trouble of drawing the Piazza San Giovanni and showing all the squares in black-and-white marble receding beautifully, and he also drew in the same way the house of the Misericordia, with the shops of the wafer-makers and the arch of the Pecori, and the pillar of St Zenobius on the other side. What he did was so highly praised by the experts that he grew still more ambitious and before long he started another work; this showed the palace, the piazza, and the loggia of the Signori, as well as the roof of the Pisani and all the surrounding buildings. These works encouraged his contemporaries to continue enthusiastically on the same lines.

Filippo took special pains to teach the young painter Masaccio, who was a close friend of his and who did his teacher credit, as we can see from the buildings depicted in his work. And he also taught his method to those who worked in tarsia, which is the art of inlaying coloured woods. His influence on these craftsmen was so fruitful that he can be given credit for the excellent results which were achieved then and later, and for the many fine works which over the years have brought renown and profit to Florence.

Now one evening Paolo dal Pozzo Toscanelli invited Filippo when his work was over to join him in his garden, where he had been entertaining some friends at supper. Filippo went along and heard Paolo talking about the art of mathematics. He soon struck up a close friendship with him and started to take lessons from him in geometry; and although Filippo had had no theoretical training he was able to discourse so skilfully from practical experience that very often he bested Paolo in argument. Then Filippo went on to study the Christian scriptures, and whenever he could he went to hear learned disputations and sermons. His wonderful

memory enabled him to profit tremendously from what he heard, and Paolo used to say in his praise that when he listened to Filippo it was as if he were hearing a new St Paul. At that time Filippo also made a careful study of the writings of Dante, which he fully understood with regard to the places described and their proportions, and he would often cite Dante in his conversations and use his work to make comparisons. He was constantly thinking how to devise and solve ingenious and difficult problems, and he never found anyone whose discernment responded better to his own than Donatello's; they delighted in each other's company and conversation, and used to discuss the problems of their art together.

At that time Donatello made a wooden crucifix which was placed in Santa Croce in Florence, below Taddeo Gaddi's picture of the child being restored to life by St Francis. He was anxious to hear Filippo's opinion of it, but he soon regretted this because Filippo told him that he had shown a peasant hanging on the cross. This provoked Donatello to retort with the words that have now become proverbial: 'Get some wood and do it yourself.' (I explain the story more fully in the *Life* of Donatello.) Now Filippo never lost his temper whatever the provocation, and on this occasion he merely kept quiet for a few months while he worked on a wooden crucifix of the same size. He executed it with great care and skill, producing a work so well designed and so beautiful that when for a joke he sent his unsuspecting friend home before him Donatello stopped short in astonishment, let fall the apron in which he was carrying all the eggs and other things for their meal, and stood there gaping, carried away by the marvellous skill and artistry Filippo had shown in his figure's legs, torso, and arms, which were so harmoniously combined that Donatello admitted he was beaten and said it was a miracle. Today this work is in Santa Maria Novella, between the chapels of the Strozzi and of the Bardi da Vernia, and it is still enthusiastically praised by modern artists. Following this, after their qualities had been recognized, the Butchers and Drapers Guilds commissioned from these excellent artists two marble statues wanted for their niches

outside the church. However, since Filippo had undertaken some other work he left the statues for Donatello, who executed them perfectly.

After this, in 1401, seeing that the art of sculpture had reached a new level of perfection, the decision was taken to reconstruct the two bronze doors of the church and Baptistry of San Giovanni; from the time of Andrea Pisano until then there had been no artists competent to do this work. What was wanted was made known to all the sculptors who were then in Tuscany and they were called to Florence where each was given an adequate allowance and allowed a year to produce one scene for the doors. Both Filippo and Donatello were asked to compose scenes, in competition with Lorenzo Ghiberti, Jacopo della Quercia, Simone da Colle, Francesco di Valdambrino, and Niccolò Aretino. The artists completed their work that same year and the scenes were exhibited together. One, namely Donatello's, was well designed but badly executed; another, Jacopo della Quercia's, was well designed and skilfully executed, but the figures did not diminish to give a good composition; another showed feeble invention and contained tiny figures, and that was how Francesco di Valdambrina had executed his scene; however, the poorest were by Niccolò d'Arezzo and Simone da Colle and the best was by Lorenzo di Cione Ghiberti; Lorenzo's work was well designed, skilfully and diligently executed, and inventive; and his figures were robustly presented. All the same, the panel by Filippo was almost as good: his scene of Abraham sacrificing Isaac showed a servant who, as he waits for Abraham and while the ass is grazing, is drawing a thorn from his foot. And this work deserves the highest praise. When all the scenes were exhibited, Filippo and Donatello decided that only Lorenzo's was satisfactory, and they agreed that he was better qualified for the work than they or the others were. So they approached the consuls and argued very persuasively that the commission should be given to Lorenzo, making it clear that both the public and the private interest would be best served if this were done. They thereby showed true qualities of friendship, talent untouched by envy, and sound judgement of their own abilities, and for

this they deserved more praise than if they had done the work perfectly themselves. What happy men they were! They helped each other and they found pleasure in praising the work of others. What a deplorable contrast is presented by our modern artists who are not content with injuring one another, but who viciously and enviously rend others as well!

The consuls asked Filippo if he would cooperate with Lorenzo, but he refused to do so as he was determined to be supreme in some other art rather than merely be a partner or take second place in that particular project. So he gave the bronze he had done to Cosimo de' Medici, who subsequently had it placed in the old sacristy of San Lorenzo, at the back of the altar, where it is today. Donatello's work was given to the Bankers Guild.

Filippo and Donatello were left to themselves after the work had been commissioned from Lorenzo Ghiberti, and they resolved to leave Florence and to spend several years at Rome, where they would study, the one architecture, and the other sculpture. Filippo chose architecture as being more useful to mankind than either sculpture or painting, and he hoped that what he did as an architect would enable him to surpass both Lorenzo and Donatello. He sold a small farm that he owned at Settignano, and then in company with Donatello he left Florence for Rome. And when he walked through Rome seeing for the first time the grandeur of the buildings and the perfect construction of the churches he kept stopping short in amazement, as if thunder-struck. He and Donatello made arrangements for taking the ground-plans of the buildings and measuring the cornices, and they set to work regardless of time or expense. They saw everything there was to see, both in Rome and in the countryside around, and they recorded the measurements of every good piece of work they came across. As Filippo had no domestic ties he was able to give himself completely to his studies, not caring whether he went without food and sleep and concentrating utterly on the architecture of the past, by which I mean the good ancient orders and not the barbarous German style which was then fashionable. Filippo conceived two tremendous ambitions: first, to restore the practice of good

architecture, in the belief that if he did so his name would be regarded by posterity as highly as Cimabue's and Giotto's; and secondly, if he could, to discover a way to raise the cupola of Santa Maria del Fiore at Florence, which was so difficult an undertaking that after the death of Arnolfo Lapi no one had ever had the courage to contemplate attempting it without allowing for vast expenditure on a wooden framework. He confided his ambition neither to Donatello nor to any other living soul, although while he was in Rome he continually investigated all the problems that had been involved in vaulting the Pantheon. He noted and made drawings of all the ancient vaults and was always studying their construction. And if he and Donatello unearthed any remains, such as pieces of capitals, columns, cornices, or the bases of buildings, they would start excavating and have them completely dug out in order to make a detailed examination. This led to their becoming known throughout Rome as 'treasure-hunters', which was what they were called by the people when they passed carelessly dressed through the streets on their expeditions. It was thought that they studied geomancy in order to discover buried treasure, the reason for this being that they had once unearthed an old earthenware pot stuffed with medals.

Filippo ran short of money and had to meet his wants by setting jewels for some friends of his who were goldsmiths. He was now alone in Rome, as Donatello had gone back to Florence, and even more intently and energetically than before he carried on studying the old ruins. There was no kind of building of which he did not make drawings: round, square, and octagonal temples, basilicas, aqueducts, baths, arches, colosseums, amphitheatres, and all the brick temples, from which he noted the methods used in binding and clamping with ties and encircling the vaults. He recorded all the methods used for binding stones together and for balancing and dovetailing them; and he investigated the reason for there being a hole hollowed out in the centre and underside of all the large stones, discovering that it was for the iron used to haul them up, which we call the *ulivella*. He subsequently brought this into use again and employed it

himself. Then he distinguished the several orders, namely, Doric, Ionic, and Corinthian; and his studies were so thorough and intelligent that in his mind's eye he could see Rome as it had stood before it fell into ruins.

However, in 1407 the climate in Rome caused him some upset and he was advised by his friends to seek a change of air. So he went back to Florence. Many building projects had suffered because of his absence, and on his return he provided various plans and suggestions.

The same year[1] the wardens of works of Santa Maria del Fiore in company with the consuls of the Wool Guild called a congress of local architects and engineers to discuss how to raise the cupola. Filippo was among those who took part, and his advice was that Arnolfo's plans should be disregarded and that instead of raising the fabric directly from the roof they should construct a frieze thirty feet high, with a large round window in each of its sides, since this would take the weight off the supports of the tribunes and also make it easier to raise the cupola. Following this, models were designed and executed.

Now one morning, a few months after he had recovered from his indisposition, Filippo was on the piazza of Santa Maria del Fiore discussing antiquities and sculpture with Donatello and several other artists. Donatello was saying that when he came back from Rome he passed through Orvieto in order to see the famous marble façade of the Duomo, on which a number of artists had worked, and which in those days was considered very remarkable; and when he was travelling through Cortona, he added, he went into the parish church, where he saw a very beautiful antique sarcophagus on which there was a scene carved in marble. At that time, before the wealth of antiquities that we enjoy today had been brought to light, this was a very remarkable discovery. Donatello went on to describe the way in which the artists had executed this marble, and he praised its finish and the perfection and excellence of the workmanship. While Donatello was talking, Filippo conceived a tremendous desire to set eyes on the work, and so, just as he was in his

1. In fact, in 1417.

cloak and hood and wooden shoes, without saying where he was going he trudged off to Cortona, drawn there by his love and enthusiasm for the art of sculpture. He saw and admired the sarcophagus, made a sketch of it, and with that went back to Florence before Donatello or anyone else realized that he had been away. On his return he showed Donatello the drawing he had executed so painstakingly, filling him with amazement at his dedicated enthusiasm.

Filippo stayed in Florence for many months, quietly making models and machines for the cupola, talking and joking every day with the other craftsmen. (This was the time when he made the joke about the Fat Man and Matteo.) And very often he would amuse himself by going along to help Lorenzo Ghiberti polish some part of his doors. However, after a time he took it into his head to return to Rome; for there was talk of arranging for some engineers to vault the cupola, and Filippo thought that he would be valued more highly if he had to be sought after than if he stayed in Florence. While Filippo was in Rome the project was discussed, and at the same time men recalled how shrewd he was, since he had shown in his suggestions a confidence and courage lacking in the other artists who were now standing along with the masons inactive and frustrated, convinced that they would never find a way to vault the cupola or beams to make a bridge strong enough to support the framework and mass of so tremendous an edifice. Determined to see the enterprise through they wrote to Filippo in Rome, begging him to return to Florence; and this being just what Filippo wanted, he very politely did what they asked.

After Filippo had arrived, the wardens of Santa Maria del Fiore and the consuls of the Wool Guild assembled together and explained all the difficulties, great and small, that had been raised by all the other artists, who were also present at this meeting. Filippo listened to all this and then he said:

Sirs, naturally great projects always present great problems, and especially this enterprise which raises even more difficulties than you may be aware of, because I wonder if even the ancients ever raised a vault as daunting as this will be. I have often thought about the framework that is needed both on the outside and within, so that the

work can be done safely, and I have never been able to make up my mind, being appalled by the breadth no less than by the height of the construction, since if the cupola could be round it would be possible to follow the method the Romans used when they vaulted the Pantheon, that's to say the Rotunda, whereas in this case we have to follow the eight sides, using ties and dovetailing the stones. And that will be a far more formidable undertaking. But when I remember that this is a church dedicated to God and to the Virgin I am confident that since it is being built in her honour she will not fail to give us the knowledge which is lacking and to grant strength, wisdom, and understanding to whoever is responsible for the work. But how can I help, since the project has not been entrusted to me? All I can say definitely is that, if it were, I would be bold and resolute in finding a way round the difficulties in order to vault the cupola. I have not yet given this much thought; and yet you want me to explain what method to use! All the same, if you, sirs, were to make up your minds to go ahead you would have to make a trial of more people than just me, since I don't think I could advise on such a great undertaking by myself. You would also have to go to the expense of arranging for many architects, from Florence and Tuscany but also from Germany, France, and other countries, to come together in Florence during the coming year; then you would have to explain the enterprise to them, so that after it had been discussed and settled among so many artists a start might be made and the commission given to the one showing concrete proof of his ability or demonstrating the best working method and judgement. And I know no better plan or advice you could follow than this.

The consuls and wardens were delighted with Filippo's scheme and suggestions, but for the time being they urged him to make them a model which they could study. However, he showed no inclination to provide one; and instead he took his leave of them, saying that he had been approached by letter to go back to Rome. When the consuls saw that neither their pleas nor those of the wardens had any effect on Filippo they got many of his friends as well to beg him to stay. But he still refused. And so one morning, 26 May 1417, the wardens decided to grant him an allowance (which can be seen credited to Filippo in the accounts of the Office of Works) in order to win him over. However, Filippo still refused to change his mind; and he left Florence for Rome where he spent all his time studying how to vault the cupola,

rightly believing that he was the only one who could do it. As for his advice that other architects should be consulted, this was given by him more because he wanted to prove his superior intelligence than because he thought they would be able to vault the tribune or even undertake the task, which was much too difficult for them.

After a considerable time the architects arrived from their various parts of the world, summoned long distances by orders given to Florentine merchants, living in France, Germany, England, and Spain, who were told to spare no expense in securing from the rulers of those countries the services of the most skilled and intelligent artists and sending them to Florence. When the year 1420 arrived there were at last assembled in Florence all those experts from north of the Alps and from Tuscany, along with all the most able Florentine designers; and Filippo himself returned from Rome. They assembled in the Office of Works of Santa Maria del Fiore, in the presence of the wardens and consuls and a number of the most able citizens, all of whom were to listen to each artist's suggestions and then reach a decision on how to vault the cupola. So they were all called into the audience and everyone spoke his mind in turn, each architect explaining his own plan. It was wonderful to hear their strange and diverse opinions on the subject: some said that piers should be constructed from ground-level and that the arches should turn on these and support the wooden bridges for sustaining the weight; others said it would be as well to make the cupola out of pumicestone so that it would be less heavy; many others agreed that there should be a central pier and that the cupola should be raised in the form of a groined vault, like that of San Giovanni at Florence. And there were even some who suggested that the best method would be to fill it with a mixture of earth and coins so that when it was raised those who wanted to could be given permission to help themselves to the earth, and in that way they would quickly remove it all without expense. Filippo alone said that it could be raised without a great deal of woodwork, without piers or earth, at far less expense than arches would entail, and very easily without any framework.

To the consuls, who had been expecting to hear him expound some beautiful scheme, and to the wardens and all the citizens present, it seemed that Filippo was talking nonsense. They mocked and laughed at him and turned away saying that he should talk about something else, and that his ideas were as mad as he was. Filippo took offence at this and said:

Sirs, I assure you that it is impossible to raise it in any other way. You may well laugh at me, but you must understand, unless you are obstinate, that it neither should nor could be done otherwise. What is necessary, if the method I have devised is to be used, is that the cupola should be turned with the curve of a pointed arch and made double, with one vault inside and the other outside so that a man can walk upright between them. And over the corners of the angles of the eight sides the fabric must be bound together through its thickness by dovetailing the stones, and likewise the sides must be bound with oaken ties. Attention must be paid to the lights, the stairways, and the conduits to draw off the rain-water. And none of you has remembered that it will be necessary to provide for internal scaffolding for the mosaics, and for countless other difficult things. But I can already envisage the completed vaulting and I know there is no method or way of doing it other than as I'm explaining.

Filippo grew more and more heated as he was talking, and the more he tried to explain his concept so that they might understand and accept it the more sceptical their doubts about his proposal made them, until they dismissed him as an ass and a babbler. Several times he was told to leave, but he absolutely refused to go, and then he was carried out bodily by the ushers, leaving all the people at the audience convinced that he was deranged. This ignominious affair was the reason why Filippo had later to admit that he dared not walk anywhere in the city for fear of hearing people call out: 'There goes the madman.'

The consuls remained in the audience chamber, thoroughly confused both by the difficult solutions proposed by the other artists and by Filippo's own scheme. They thought his ideas absurd, and it seemed to them there were two reasons why he must fail: first, by making the vaulting double (which certainly meant a tremendous and unwieldy mass); and secondly, by raising the cupola without a framework. As for

Filippo, who had spent so many years studying in order to win the commission, he did not know what to do with himself and he was more than once tempted to quit Florence. However, in order to triumph in the end he had now to arm himself with patience, and he was shrewd enough to know that in the city of Florence no one's mind stays unchanged for very long. In fact, he could have shown them a small model he had made for the project, but he was reluctant to do so because he realized the lack of understanding among the consuls, the jealousy of the other artists, and the fickleness of the citizens, each of whom favoured now one and now another as it took his fancy. And this comes as no surprise to me, since everyone in Florence has pretensions to understanding art as much as the experienced masters, although there are very few who do in fact understand; and I say this without offence to those who are knowledgeable.

What he had failed to prove in front of the tribunal Filippo then tried to do elsewhere, talking now to this consul, now to that warden, and also to various other citizens. After he had shown them part of his design he led them to decide to commission the work either from him or from one of the foreigners. As a result, the consuls, the wardens, and the citizens who had been involved in the earlier discussions were encouraged to call another meeting and the architects once again disputed the matter. But with various arguments Filippo crushed and defeated them all. It was on this occasion, it is said, that there arose the dispute about the egg. It happened in this way. They wanted Filippo to explain his mind in detail and show his model as they had shown theirs. He was unwilling to do this, but he suggested to the other masters, both the foreigners and the Florentines, that whoever could make an egg stand on end on a flat piece of marble should build the cupola, since this would show how intelligent each man was. So an egg was procured and the artists in turn tried to make it stand on end; but they were all unsuccessful. Then Filippo was asked to do so, and taking the egg graciously he cracked its bottom on the marble and made it stay upright. The others complained that they could have done as much, and laughing at them Filippo retorted that they would also

have known how to vault the cupola if they had seen his model or plans. And so they resolved that Filippo should be given the task of carrying out the work, and he was told to give more details to the consuls and the wardens.

Then he went home and wrote what he had in mind as clearly as he could on a sheet of paper, to be given to the tribunal, as follows:

My lords, I have considered the difficulties involved in this structure and I find that there is no possible way in which it can be made perfectly round, seeing that the surface bearing the lantern would be so great that if any weight were put on it it would immediately collapse. Now it seems to me that architects who do not try to ensure that what they build will last for ever have no love for lasting memorials and do not understand what they are doing. For my part, I have decided to turn the inner part and also the exterior faces of this vault in gores, using the proportions and curves of the pointed arch; this is because the curve of this kind of arch always thrusts upwards, and so when the lantern is loaded both will unite to make the fabric durable. At the base the vaulting must be seven and a half feet thick and it must rise like a pyramid narrowing towards where it closes at the juncture to support the lantern. At this point it must be two and a half feet thick. And then over this vaulting there must be another vault, five feet thick at the base, to protect the inner one from the weather. This must also diminish proportionately like a pyramid, so that it meets the lantern like the other; and at this point it should be one and a half feet thick. There must be a rib at each of the angles, making eight in all; there must be two ribs for the middle of each face, giving sixteen; two ribs must be built between the angles, for the inside and the outside, each one being eight feet thick at the base. The two vaults, built pyramidically, must rise together in proportion up to the eye at the top closed by the lantern. As well as the twenty-four ribs with the vaults built round them there must be six cross-arches of grey-stone blocks, stout and long and well braced with irons; the irons must be covered with tin, and over the blocks there must be an iron chain to bind the vaulting to the ribs.[1] The construction must be solid, leaving no space between the vaults, up to a height of ten and a half feet; from there the ribs must be continued and the two vaults separated. The first and second courses at the base must be reinforced throughout with long blocks of grey-stone laid horizontally so that both the vaults of the cupola may rest on them. At the

1. Here, and elsewhere, *macigno* is usually translated as 'grey-stone'.

height of every eighteen feet the vaults should have little cross-arches stretching from one rib to another, with thick ties of oak, to bind together the ribs supporting the inner vault; and then the oak ties must be covered with iron plates for the sake of the stairways. All the ribs must be made of grey-stone and hard-stone, and the sides of the cupola must also all be of hard-stone and coursed into the ribs up to a height of forty-eight feet. From there to the summit use should be made of brick or pumice, as the builder may decide in making the fabric as light as possible. A passage must be built on the outside above the windows, forming a gallery below, with pierced parapets four feet high, corresponding with those of the little tribunes below; or rather there should be two passages, one above the other, resting on a richly ornamented cornice, with the one above left uncovered. The rain-water must run from the cupola to a marble gutter, eight inches across, and must run off below the gutter through outlets made of hard-stone. On the outside faces of the cupola there should be eight marble ribs for the angles, as thick as may be thought necessary, rising two feet above the cupola with a four-foot-wide cornice to act as a roof and serve as gable and eaves for the whole structure. The ribs should rise like a pyramid from their base up to the summit. The two vaults of the cupola must be built as I described, without framework, up to a height of sixty feet, and from there on in whatever way the builders decide, since experience shows what has to be done.

When he had finished writing this Filippo went along in the morning to the tribunal and gave them the sheet of paper, which they then carefully studied. They were incapable of grasping what he had written, yet considering how ready and willing Filippo seemed and that none of the other architects stood on better ground (for Filippo appeared absolutely confident, repeating the same words all the time so that it appeared certain that he had raised ten cupolas already), after they had gone into a huddle they showed themselves inclined to give him the work. They did, however, want to see how the cupola could in practice be raised without any centering, being ready to approve all the rest. As it happens they were fortunate in their wishes, because Bartolommeo Barbadori had spoken to Filippo about a chapel he wanted to have built in Santa Felicita, and Filippo had set to work and had this chapel, which is at the entrance of the church on the

right by the holy-water stoup, vaulted without using framework. He was also responsible at that time for another vault in San Jacopo sopr' Arno, beside the chapel of the high altar, which was done for Stiatta Ridolfi. These inspired more confidence than his words did.

So, being reassured by what Filippo had written and by the work they had seen, the consuls and the wardens gave him the commission for the cupola, voting with the beans to make him the chief superintendent. But they contracted for him to go ahead only up to a height of twenty-four feet, saying that they wanted to see how the work succeeded and that, if it did turn out as he had forecast, then they would certainly allocate the rest to him. Filippo was puzzled to see such obstinacy and mistrust, and if he had not known that he was the only one capable of executing the work he would have had nothing to do with it. But he was anxious for the fame it would bring and so he took it on, giving a pledge that he would finish it perfectly. His written statement, as well as this pledge, was copied into the book used by the steward for keeping the accounts for wood and marble; and Filippo was granted the same allowance as had formerly been given to the other superintendents.

When it became known to the craftsmen and citizens that Filippo had been given the commission, some of them approved but others resented it, in a way that is typical when it comes to the opinions of the populace, of the thoughtless, and the envious. And while the preparations for building were being made a faction was formed among the workmen and citizens, and representations were made to the consuls and wardens that the decision had been too precipitate. A project of this kind, they argued, should not be undertaken on the advice of one individual and they could be excused for doing so only if they were short of first-class artists, whereas there was in fact an abundance of them. The decision brought no credit to the city, it was said, because if there were some accident, as sometimes happened when a building was being put up, they would rightly be blamed for having given too much responsibility to a single man without considering the loss and disgrace that might result for the people. And so to

restrain Filippo's impetuosity, it was argued, he should be given a partner.

Lorenzo Ghiberti, as it happened, had earned high praise for the great skill he displayed when he made the doors of San Giovanni, and now in addition it was clearly shown how affectionately he was regarded by certain men who were very influential in the government of Florence; for when they saw how Filippo was carrying all before him, under the cloak of love and devotion for the building they so successfully influenced the consuls and wardens that Ghiberti was commissioned to share the work. The extent of Filippo's despair and bitterness when he heard what the wardens had done may be gauged from the fact that he was on the point of running away from Florence; and if it had not been for the way Donatello and Luca della Robbia comforted him he might even have gone out of his mind. The impious spite of those who are so blinded by envy that they let their jealousy and ambition threaten the honour and fine works of others is truly incredible! It was no fault of theirs that Filippo did not smash his models, burn his drawings, and in a matter of minutes wreck what it had taken him many years to complete. At first the wardens made excuses for themselves and encouraged Filippo to continue, saying that he and no one else was the inventor and creator of that fabric; all the same they gave Lorenzo the same salary. Filippo carried on without enthusiasm, knowing that he had to sweat over the work that was to be done, and would then have to divide, equally with Lorenzo, the honour and fame it would bring. However, he made up his mind that he would find some way of ensuring that Lorenzo would not last too long on the job, and content with that he continued the work with him, following on the lines of the written description given to the wardens.

In the meantime Filippo conceived the ambition to make a model surpassing anything done previously; he set his hand to making the design, and then he had it executed by a carpenter called Bartolommeo, who lived near the studio. In this model, which was exactly to scale, he made all the difficult structures, such as the lighted and the dark stairways, and all kinds of

round window, door, tie, and buttress, as well as part of the gallery. When he heard of the model Lorenzo tried to see it. But when Filippo refused, he lost his temper and arranged to have his own model made so that it would seem that he was in fact earning his salary and that he was a man who counted for something. For his model Filippo was paid fifty lire and fifteen soldi, as we can see from an entry in the account book of Migliori di Tommaso, dated 3 October 1419, whereas 300 lire are entered to the credit of Lorenzo Ghiberti for the work and expense involved in his model. But Lorenzo was paid more than Filippo because of the favour and friendship he enjoyed rather than because his model would be of any use or benefit to the building itself.

Filippo had to endure this aggravation until 1426. The friends of Lorenzo were claiming that he was the designer equally with Filippo, and Filippo suffered agonies of mind from this annoyance. He had meanwhile thought up various new devices and he determined finally to rid himself of Lorenzo, whom he knew to be of little account in the work. He had already raised the cupola all the way round, including both vaults, to a height of twenty-four feet, and now he had to place on them the wooden and stone ties. This was a difficult operation and so he wanted to discuss it with Lorenzo to find out whether he had given any thought to the problems involved. But he discovered that far from having considered the matter Lorenzo was content to say that he left it to him, as he was the designer. Filippo was delighted to hear this answer because it seemed to him that it showed how he could have Lorenzo taken off the work, reveal that he was not as intelligent and capable as his friends imagined, and expose the favour that had put him where he was.

Now all the masons had stopped work and were waiting to be told to start on the new section above the twenty-four feet, making the vaults and binding them with ties. The cupola had started to be drawn in towards the summit and because of this scaffolding had to be erected so that the workmen and masons could work without risk, seeing that the height was such that even the bravest man felt frightened and terrified on looking down. So there were the masons and

other master-builders waiting for directions as to the ties and the scaffolding, and when neither Lorenzo nor Filippo gave them any instructions they started to grumble, sensing that there was no longer the urgency that had been shown earlier. They were poor people who lived by their hands and they suspected that neither of the architects had the courage to go on with the work; and so as best they knew and were able they found things to do on the site, replastering and retouching all that had been constructed up to then.

One morning or other Filippo failed to put in an appearance on the site; instead, he bandaged his head and took to his bed, and then, groaning all the time, he had everyone anxiously warming plates and cloths while he pretended to be suffering from colic. When they heard what was happening the master-builders who were standing around waiting for their instructions asked Lorenzo what they should do next. He replied that the schedule was Filippo's and that they would have to wait for him. One of the builders asked:

'But don't you know what he has in mind?'

'Yes,' said Lorenzo, 'but I would do nothing without him?'

And he said this to cover himself, because never having seen Filippo's model and never having asked him about the schedule he intended to follow he was compelled to hedge when he talked about the work, in order not to appear ignorant; so his words were always ambiguous, especially as he knew that he was sharing the work against Filippo's will. Meanwhile, after Filippo's illness had already lasted more than two days, the steward and many of the master-builders went to see him and kept asking him to tell them what they should do. But all he answered was: 'You have Lorenzo; let him do something.'

Nor could they persuade him to say anything else. And when this became known the whole project was widely argued over and condemned. Some said that Filippo had taken to his bed from grief because he did not have it in him to raise the cupola, and that he regretted ever having stepped forward; and his friends said in his defence that if he were angry it was because of the way he had been outraged by

being given Lorenzo as a partner in the work, but that he was genuinely ill with a colic that had been brought on by his exertions for the cupola. While all these ideas were being aired operations were at a standstill and almost all the work of the masons and stone-cutters was suspended. The men murmured against Lorenzo, saying: 'He is good enough at drawing his salary, but when it comes to planning the work then there's nothing doing. Now if we did not have Filippo, or if he were ill for a long time, how would Lorenzo manage then? Is it Filippo's fault if he's ill?'

Seeing that they were being shamed by this state of affairs the wardens decided to go and find Filippo; and when they arrived they first sympathized with him over his illness and then told him what great confusion the building had fallen into and what terrible trouble his illness had brought upon them. When he heard this, Filippo's feigned illness and his devotion to the work made him say very heatedly: 'Oh, isn't that fellow Lorenzo there? Can he do nothing? I'm astonished – and at you too!'

The wardens answered: 'He will do nothing without you.'

And then Filippo retorted: 'I would do it well enough without him.'

This sharp, double-edged reply was more than enough for them and they went their way having realized that Filippo had fallen ill because he wanted the work to himself. Then they sent his friends to persuade him to leave his bed, and they firmly resolved to dismiss Lorenzo from the project. And so Filippo returned to the building. But when he discovered that Lorenzo was still very highly favoured and would be paid his salary without having to work for it, he thought of another way to disgrace him and demonstrate conclusively how little knowledge he had of the profession. In the presence of Lorenzo he reasoned with the wardens as follows:

Sirs, if we were as sure about how long we have to live as we are of the fact that we must die then certainly many projects which are started would be finished. But as things are they tend to stay unfinished. My unfortunate illness could have robbed me of my life and stopped this work. So in case I should ever fall ill again, or, which God forbid, in case Lorenzo should, in order to ensure that one or the

other of us would be able to continue with his own part of the work
I suggest that, just as your lordships have divided the salary between
us, so you should also divide the work between us. In this way each
of us will be spurred on to show what he knows and can be sure to
win honour and profit from the republic. Now at the moment there
are two very difficult stages to complete. First the scaffolding must
be put up so that the masons can carry on their work, and it needs to
be erected inside and outside the building to support men, stones, and
lime, and carry the crane for lifting weights and other devices of that
kind. Then we must see to the ties above the twenty-four-foot level
in order to bind the eight sides of the cupola and clamp the framework
together, securing all the mass laid above, preventing the weight
from forcing or stretching the ties, and letting the whole structure press
down firmly on itself. I suggest, therefore, that Lorenzo be allowed
to undertake one of these tasks, the one he thinks he can best carry out,
and I shall undertake to do the other. And we shan't waste any more
time.

After this had been said Lorenzo was compelled for the
sake of his good name not to refuse one of the tasks, and,
though very unwillingly, he decided to take the ties, thinking
this was easier, relying on being given advice by the masons
and remembering that in the vaulting of San Giovanni there
was a chain of stone ties which would give him some if not
all of the design. So Filippo started work on the scaffolding
and Lorenzo on the chain, and eventually they both finished
what they had to do.

Filippo's scaffolding was put up with such intelligence and
skill that it completely belied what people had been saying
before, because the masons stood there, working safely and
drawing up materials, as securely as if they were on solid
earth. (The models of his scaffolding are preserved in the
Office of Works.) Only with the greatest difficulty did
Lorenzo complete the tie for one of the eight sides; and when
it was finished the wardens showed it to Filippo, who made
no comment. However, he did talk about it to some of his
friends, saying that another kind of fastening was needed,
that it should have been placed differently, and that it was not
adequate for the weight to be put above, since it did not bind
the structure as it should. The materials Lorenzo had been
given, he added, along with the chain he had made, had been

as good as thrown away. Filippo's opinion became known, and he was charged to demonstrate the way in which the chain ought to be constructed. At this, he immediately showed them the designs and models which he had already made; and when the wardens and the other artists saw them they at once realized what a mistake they had made in favouring Lorenzo. Wanting to make up for this and to show that they understood what was good, they made Filippo overseer and superintendent for life of the entire building, stipulating that nothing was to be done save on his orders. And to show their approval further they paid Filippo a hundred florins down, which is shown as allocated by the consuls and wardens under an entry dated 13 August 1423, written by the hand of Lorenzo Paoli, notary of the Office of Works, and debited to Gherardo di Filippo Corsini; and they also made him a grant for life of a hundred florins a year.

Having given orders for the work to proceed, Filippo followed its progress so scrupulously and carefully that not a stone was laid without his supervision. As for Lorenzo, after having been defeated and, in effect, disgraced, he was all the same favoured and helped by his friends, continuing, for example, to draw his salary and claiming that he could not be dismissed for another three years.

Filippo, meanwhile, was always, on the slightest excuse, making designs and models of scaffolds for the builders and of machines for lifting weights. But this did not prevent some malicious people (who were friends of Lorenzo) from throwing him into despair by continuously having other models constructed in competition with his; some, which were made by Antonio da Verzelli and other favoured artists, were put forward for attention now by one citizen and now by another, in a way showing how fickle they were, how they knew little and understood less, and how although they had perfect work within their reach they were ready to promote imperfect and worthless things.

By now the ties had been completed all round the eight sides of the cupola and with this encouragement the masons were working vigorously; but they were then harried by Filippo more than usual, and they were especially aggrieved

by some reprimands they received over their work and by other incidents that were a daily occurrence. Spurred on by this and by their greed, the foremen banded together in a faction and declared that they would not build the cupola without higher wages, even though they were already earning more than the average. In this way, they thought, they could revenge themselves on Filippo and do themselves some good at the same time. The wardens and Filippo were angered by this, and, after he had given the matter some thought, Filippo one Saturday evening made up his mind to dismiss every one of them. Realizing the plight they were in and not knowing how matters would end, the foremen were very evilly disposed; and then, the following Monday, Filippo put ten Lombards on their work and by standing over them and saying: 'Do this, now do that . . .', he taught them so much in the space of a day that they were able to carry the work forward for several weeks. For their part, when the masons found themselves dismissed and workless and, after this disgrace, unable to find jobs that paid as well, they sent a go-between to tell Filippo that they would willingly come back, and they threw themselves on his generosity. Filippo kept them in suspense for several days, during which they feared he would refuse to have them, and he took them back for less wages than before; so instead of getting something more, as they thought they would, they suffered a loss, and in venting their spite on Filippo they injured and disgraced themselves.

There was no more murmuring after this, and when the building was seen to be going ahead smoothly Filippo's genius was universally acknowledged. Those who were not already prejudiced maintained that he had demonstrated a boldness such as perhaps no other ancient or modern architect had ever shown. This was because he brought out his model for the cupola and let everyone see the tremendous thought he had given to planning the stairways: there were lights, both inside and out (so that no one might be frightened and injured in the darkness) and several iron guide-rails placed where the ascent was steep. Everything was very carefully arranged. As well as this, he had thought of irons for fixing

scaffolding inside, in case there were a need to do mosaics or paintings; he also placed the different kinds of gutter, some covered and some open, in the least dangerous positions; and along with these he designed various holes and apertures to break the force of the wind and prevent exhalations or movements of the earth from causing any damage. By this he showed how much he had profited from the studies he pursued for so many years in Rome. And when people considered what he had done in dovetailing, inlaying, joining, and binding the stones, it filled them with awe and trembling to think that one man could achieve what Filippo had done. And he continued to make such progress that eventually there was nothing, however difficult and forbidding it might seem, that he did not make easy and simple. For example, by using counter-weights and wheels for lifting he made it possible for a single ox to raise a load so heavy that previously it would hardly have been possible for six pairs of oxen to move it.

The building had now grown so high that it called for great exertions to climb to the top and down again, and the builders were losing a great deal of time in going to eat or drink, as well as suffering intensely from the heat of the day. So Filippo arranged for canteens equipped with kitchens and serving wine to be provided on the cupola itself. No one therefore needed to leave work until it was evening, and this was very convenient both for the men and the work itself. Filippo was so elated when he saw the construction going ahead successfully that he never took any rest; he would often visit the kilns where the bricks were being shaped and demand to see and handle the clay, insisting, when they had been baked, on selecting them very carefully with his own hands. He also inspected the stones being used by the stone-cutters to see if they were hard and unflawed, and he would give them models for the joints and the turnings made of wood or wax, or cut from a turnip; and similarly, he made iron tools for the smiths. He also invented hinges with heads and pivots. Altogether he gave a tremendous impetus to architecture; through him it was raised to a standard probably never before achieved among the Tuscans.

In 1423 Florence could not have been happier or rejoiced more when Filippo was elected to the Signoria for the months of May and June by the district of San Giovanni, Lapo Niccolini being chosen Gonfalonier of Justice by the Santa Croce district. (No one need be surprised to find that he is entered in the register as Filippo di ser Brunellesco Lippi, since he was correctly called after his grandfather, da Lippo, and not de' Lapi. Countless other instances of this kind of usage can be seen in the register and will not disconcert those who have seen the register or know the usage of those times.) Filippo exercised the office to which he was elected, and he also held other magisterial posts in Florence, always conducting himself very seriously and judiciously.

It was now time to start closing the two vaults towards the round window where the lantern was to be erected, and Filippo, who had made several wood and clay models of both the one and the other in Rome and Florence, without showing them to anyone, had finally to make up his mind which of them he wanted to be followed. Having determined to finish the gallery, he made several designs which remained after his death in the Office of Works, but which, through the negligence of those officials, have today disappeared. In our own times, in order to complete the construction, a part of the gallery was built on one of the eight sides, but, because it clashed with Filippo's own design, on the advice of Michelangelo Buonarroti it was rejected and left unfinished.

Filippo also made with his own hand a model for the lantern; this had eight sides and was in proportion with the cupola, and it was beautifully successful in invention, variety, and adornment. He included in his model the stairway leading up to the ball, and this was a marvellous piece of work; but since he had blocked the entrance with a piece of wood inserted from below no one except him knew that it was there. Although he was praised and had now overcome widespread envy and arrogance, this did not deter all the artists in Florence, when they saw what he had done, from setting out to make various models of their own; and finally, a woman of the Gaddi family was bold enough to enter one in competition with Filippo's. However, Filippo laughed at their

presumption, and when many of his friends advised him not to show his model to any other artists, lest they should learn from it, he replied that there was only one good model and that the others were worthless. Some of the artists did incorporate details from Filippo's work in their models, but when he saw an instance of this Filippo would merely comment: 'The next model this man makes will be mine.'

Everyone enthusiastically praised Filippo's own model, only as they could not see the stairway leading to the ball they asserted that it was incomplete. All the same, on condition that Filippo showed where the ascent was to be, the wardens decided to commission the work from him. So Filippo removed the little piece of wood which was down below to reveal in a pilaster the staircase as it is seen today. It took the form of a hollow blow-pipe, having a groove to one side with bronze rungs by which, placing one foot after the other, it is possible to climb to the top. Because he was now old and would not live to see the lantern finished he stipulated in his will that it should be built with the model and the written instructions that he left; otherwise, he insisted, the fabric would collapse because it was vaulted in an ogive and needed the weight pressing down on top in order to strengthen it. He failed to see this edifice completed before he died, but he raised it to a height of several feet and he ensured that nearly all the marble destined for it was properly prepared and polished. When the people saw the marbles ready they were flabbergasted that he should propose to place such a mass on top of the vaulting. And many clever men who considered that it would not bear the weight thought that he had been fortunate to bring it as far as he had, and that it was tempting God to burden it so heavily. Filippo merely laughed to himself at all this, and when all the machines and apparatus to erect it had been prepared he devoted all his time and thought to anticipating, providing, and preparing for every slightest detail, even to seeing that the marbles should not be chipped at the edges when they were being hauled up, by providing the arches of the tabernacles with protective wooden coverings. And for the rest, as I mentioned, he left written instructions and models.

As for how beautiful the edifice is, it is its own witness. From ground-level to the lantern the height is 308 feet, the body of the lantern is seventy-two feet, the copper ball is eight feet, the cross sixteen feet, and the whole is 404 feet;[1] and it can be confidently asserted that the ancients never built to such a height nor risked challenging the sky itself, for it truly appears that this building challenges the heavens, soaring as it does to so great a height that it seems to measure up to the mountains around Florence. Indeed, the heavens themselves seem to be envious of it since every day it is struck by lightning.

While all this work was going on Filippo made several other buildings which we shall now describe in order. For the Pazzi family he made with his own hand the model for the chapter-house in Santa Croce at Florence, a work of great beauty and variety; he made for the Busini the model for their palace for two families; and likewise, he made the model for the house and loggia of the Innocenti, the vaulting for which was completed without scaffolding, a method still universally used today. It is said that Filippo was summoned to Milan to make a model for a fortress for Duke Filippo Maria, and that he left his close friend, Francesco della Luna, in charge of the building for the Innocenti. The story goes that Francesco made the architrave turn downwards, which is an architectural solecism; and when Filippo had returned and scolded him for doing such a thing, he replied that he had taken it from the church of San Giovanni, which is an ancient building. Filippo said: 'There is only one mistake in that building, and you have copied it.'

Filippo's model for the Innocenti building remained many years in the possession of the Guild of Por Santa Maria, where it was carefully treasured since a part of the work had still to be completed; today it is lost.

For Cosimo de' Medici Filippo made the model of the abbey of the Canons-regular of Fiesole, which is a richly decorated piece of architecture, pleasing, commodious, and altogether magnificent. The church, with its barrel vaulting,

1. Here, as elsewhere, the *braccio* – equivalent to about twenty-three inches – is taken as two feet.

is very spacious, and the sacristy, like all the rest of the monastery, is very conveniently laid out. But most worth considering is the way in which, as the building had to be erected properly levelled on the slope of the mountain, Filippo very intelligently made use of the foundation, where he put the cellars, laundries, bakehouses, stables, kitchens, fuel stores, and any number of convenient offices, so that it would be impossible to devise anything better. This enabled him to erect the building on a level base which supported the lodges, the refectory, the infirmary, the noviciate, the dormitory, the library, and the other principal monastic apartments. All of this was paid for by the magnificent Cosimo de' Medici, who was prompted by his constant devotion towards the Christian religion as well as by his affection for Don Timoteo da Verona, a superb preacher of that Order; in order to enjoy the latter's conversation more easily, Cosimo also had built for himself in the monastery several apartments which he used as and when he wanted. As can be seen from an inscription, Cosimo spent a hundred thousand crowns on the building.

Filippo also made a model for the fortress of Vicopisano; he designed the old citadel at Pisa; the Ponte a Mare was fortified by him; and similarly, he provided for the new citadel the plans by which the bridge was closed by the two towers. He also made the model for the fortifications of the harbour at Pesaro; and when he went back to Milan he designed many things for the duke and for those in charge of building the cathedral.

At that time work was started on the church of San Lorenzo at Florence, on the orders of the parishioners who had made the prior superintendent of the building. The prior professed to understand architecture and took great pleasure in practising it in his spare time. They had already made brick piers for the building when it happened that one day Giovanni di Bicci de' Medici (who had promised the parishioners and the prior that he would pay out of his own pocket for the sacristy and one of the chapels) entertained Filippo to dinner. After they had discussed various things, he questioned him about the work that had been started on San Lorenzo and

asked what his opinion was. Giovanni was so pressing that Filippo had to say what he thought, and wanting to be truthful he criticized it on several points, showing that the work had been planned by someone who was perhaps better versed in letters than experienced in that kind of building. Giovanni then asked Filippo whether he could do something finer and better, and Filippo said:

Certainly I could, and I am surprised that you, as the leader in this enterprise, do not donate several thousand crowns and build the body of a church worthy of the district and of the noble families who will have their tombs there. For if the nobles saw an impressive start made on the work they would be keen to commission their own chapels, especially considering that the walls of our buildings are all we leave behind us and that they commemorate those who put them up for hundreds and thousands of years.

Inspired by Filippo's words, Giovanni determined to be responsible for the sacristy and the principal chapel along with all the body of the church. However, only seven other noble families were willing to follow his example, since the others lacked the means; and these were the Rondinelli, Ginori, Dalla Stufa, Neroni, Ciai, Marignolli, Martelli, and Marco di Luca, whose chapels were to be built in the crossing. The first part to be constructed was the chapel and then, little by little, the church itself. And the other chapels along the length of the church were subsequently made over, one by one, to the citizens of the parish. Giovanni de' Medici passed to the other life before the roofing of the sacristy was finished, leaving his son Cosimo who was more magnanimous than his father and delighted in memorials, and who arranged for the work to be continued. It gave him so much satisfaction that from then onwards till the day he died he was for ever building. Cosimo pushed the work on with greater enthusiasm, and before one part was finished he would be making ready to start on another. He took up this work as a pastime, and he started to give almost all his time and attention to it; and it was because of his solicitude that Filippo completed the sacristy and Donatello made the stuccoes and the bronze doors and the stone ornaments for the little doors. Cosimo also had his

father's tomb built under a great slab of marble supported by four little columns in the middle of the sacristy, where the priests vest for the service; and he had tombs built in the same place for his own family, separating the women's from the men's. In one of the two small rooms which are on each side of the sacristy he had a well and a lavabo built in one corner. In short, it can be seen that everything in the building was constructed with excellent judgement.

Giovanni and the others had planned to put the choir in the middle, below the tribune; but Cosimo changed this at the request of Filippo who made the principal chapel (which had originally been designed as a smaller recess) so much bigger that he was able to put the choir where we see it today. When this was done it remained to construct the nave and the rest of the church; the roofing for these, however, was not completed till after Filippo's death. The church is 288 feet long; and one can detect many errors in its construction. The columns, for example, are placed on the ground instead of being raised on a dado as high as the level of the bases supporting the pilasters on the steps. Because the pilaster is shorter than the column the whole structure looks lop-sided. This was the result of the advice given by those who came after Filippo, men who were envious of his reputation and who had made models to discredit him while he was still alive. In return, Filippo had written some scathing sonnets about them. Then, after his death, they took their revenge not only on the work we have been discussing but also on everything left for them to complete. Filippo left the finished model of San Lorenzo and also completed part of the capitular buildings for the priests, making the cloister 288 feet long.

While this building was being erected Cosimo de' Medici made up his mind to build his own palace. He explained what he wanted to Filippo, who put everything else to one side and made him a large and very beautiful model for the palace, which he intended to erect on the piazza opposite San Lorenzo, standing isolated on every side. Filippo lavished his skill on the model to such effect that Cosimo decided the building would be too grand and sumptuous, and so, to escape envy rather than expense, he refrained from going

ahead with it. While working on the model Filippo often said how it was a godsend to be asked and to be able to undertake such a palace, which was something he had wanted to do for years. But when he subsequently heard that Cosimo had decided not to make use of the model he lost his temper and smashed it into smithereens. As it was, when he built the other palace Cosimo deeply regretted not using Filippo's plans; he used to say that he had never spoken to a man of finer spirit and intellect.

Filippo also made the model for that curious church of the Angeli, which was commissioned by the noble Scolari family, and which remained unfinished as we see it today; this, it is said, was because the Florentines spent the money which had been put in the Monte for that purpose to meet some expenses involved in the war against the Lucchesi. (And they did the same with the money left by Niccolò da Uzzano to build the Sapienza, as I explain at length elsewhere.) Certainly, if Brunelleschi's model had been used for the church of the Angeli it would have been one of the most outstanding buildings in Italy, seeing that the work which was done cannot be praised too highly. The drawings in Filippo's hand for the ground-plan and the elevation of this octagonal church are in my book, along with other designs of his. Filippo also designed a rich and magnificent palace for Luca Pitti at a place called Ruciano, outside the San Niccolò gate at Florence; but this fell far short of the palace which was started inside Florence for the same man, and which was carried to the second storey with such grandeur and magnificence that nothing more imposing and outstanding has ever been seen in the Tuscan style. The doors of the palace are double, with the opening thirty-two feet high and sixteen feet wide; the windows on the first and second floors are exactly similar to the doors, and the vaulting is double. The entire structure is a masterpiece of design and it would be impossible to imagine more beautiful or magnificent architecture. The man who built the palace was a Florentine architect called Luca Fancelli; he completed many buildings for Filippo and constructed the principal chapel of the Annunziata at Florence for Leon Battista Alberti, who designed it for

Ludovico Gonzaga. (Subsequently, Ludovico Gonzaga brought Luca to Milan where he erected many buildings; he married and spent the rest of his life there, leaving heirs who still bear the name of Luchi.)

Now not many years ago the palace was bought by the most illustrious Lady Leonora di Toledo, on the advice of her consort, the most illustrious Lord Duke Cosimo. She considerably extended the grounds, by having a very large garden laid out, partly on the plain, partly on the top of the hill, and partly on the slope; and she has filled it with all the different varieties of both garden and forest trees, beautifully arranged, and has laid out delightful little groves with every kind of evergreen, not to mention the waters, the fountains, the conduits, the fishponds, the fowling-places, the espaliers and countless other things worthy of a magnanimous ruler. I shall say nothing about these because no one who does not see them for himself can possibly imagine how magnificent and beautiful they are. And certainly Duke Cosimo could not have obtained anything more worthy of his great and generous spirit than this palace, which, it seems, might have been built expressly for his most illustrious Excellency by Luca Pitti (who used Brunelleschi's plans). Luca left it unfinished because of his work for the State, and his heirs, not having the means to have it completed, were happy to save it from falling to ruin by making it over to the Duchess; and all her life the Duchess spent money on it, although still not enough to hold out any promise that it could soon be finished. It is, however, true, or so I have heard, that she intended to spend forty thousand ducats in one year alone, if she lived, to see it, if not finished, then well on the way to completion. And because Filippo's model has disappeared his excellency has had a new one made by that excellent sculptor and architect, Bartolommeo Ammanati. The work is being continued using his model, and a considerable part of the courtyard is already completed in rustic work, similar to the exterior. Anyone considering this ambitious project cannot but be astonished at Filippo's ability to conceive an edifice of such grandeur, one which is truly magnificent as regards not only the external façade but also the arrangement of all

the apartments. I say nothing of the view, which is extremely beautiful, or of the kind of theatre formed by the lovely hills surrounding the palace in the direction of the walls, because, as I suggested earlier, it would take too long to give a full description, and anyhow, if he has not seen it no one can realize how greatly superior it is to every other royal edifice.

It is also said that the machinery for the Paradise of San Felice in Piazza, in the same city, was invented by Filippo for the miracle play and feast of the Annunciation, in the way that was customary in Florence in ancient times. This was truly marvellous and it demonstrated the ingenuity and skill of the man who devised it. There was a representation of a heaven, crowded with living figures moving on high, and countless lights, flashing on and off like lightning. I will not shirk the task of describing exactly how the apparatus worked, because it has all come to grief and the men who could have described it from their own knowledge are dead; moreover, there is no hope of its being reconstructed since the place is today occupied not by the Camaldolensian monks, who were there formerly, but by the nuns of St Peter Martyr, and what is more the monastery of the Carmine was ruined because the machinery pulled down the timbers supporting the roof.

For the purposes of the play Filippo suspended between two of the beams supporting the roof a half-globe like a bowl or a barber's basin turned upside down. This hemisphere was made of thin laths secured to an iron star which passed round the circumference; the laths narrowed towards a great iron ring in the centre which held the apparatus in balance and around which revolved the iron star bounding the hemisphere. All this machinery was held up by a strong beam of pine-wood, well bound with iron, lying across the timbers of the roof; the ring which held the hemisphere suspended and balanced was fixed in this beam, and from below the hemisphere looked exactly like a heaven. Then inside the lower edge of the hemisphere there were a number of wooden brackets, just big enough to take a person standing; and two feet above these, also on the inside, was another iron clasp. On each of the brackets stood a child of about twelve years, so safely secured by the iron clasp two feet higher up that it could not

fall even if it had wanted to. There were twelve of these *putti*, standing on the brackets and dressed as angels with gilded wings and golden skeins of hair; and when it was time they clasped hands, waved their arms and, especially as the ball itself was continually turning and swaying, they seemed to be dancing together. Inside the hemisphere above the heads of the angels were three circles or garlands of lights, composed of a number of tiny lanterns which could not be overturned; and from the ground these lights looked like stars, and the beams, which were covered with cotton wool, seemed like clouds.

From the ring descended a thick iron bar with a second ring, to which was attached a slender cable falling to the ground, as I shall describe. This thick iron bar had eight arms or branches which revolved in an arc across the entire hemisphere, and at the end of each arm was a flat stand as large as a plate supporting a *putto* of about nine, well secured with an iron clasp soldered to the upper part of the branch, but with freedom of movement to turn in any direction. By means of a winch which was slowly let out these eight angels who were supported by the thick iron bar were lowered from the hemisphere to a distance of sixteen feet below the level of the woodwork holding up the roof, in such a way that they could be seen without obstructing one's view of the angels who were around the inside.

In the middle of the garland of eight angels (as it was very appropriately called) was a copper *mandorla* or circle of lights, hollowed out and perforated with a number of holes which contained some small lamps attached to iron tubes; when a spring was pressed down they stayed concealed in the hollow of the copper *mandorla*, and when the spring was released they could all be seen shining through the holes. When the garland of angels had reached its place this *mandorla*, which was suspended by the slender cable, was lowered very, very gently by another winch to the platform on which the performance was staged; on the platform just where the *mandorla* was to come to rest was a raised part with four steps, like the throne over an altar, which was pierced through the centre to take the iron point of the *mandorla* when it descended.

A man concealed inside the throne bolted the *mandorla* when it was in position, and it then rested securely in place.

Inside the *mandorla*, acting the part of an angel, was a youth of about fifteen; he was bound by an iron clasp to the centre of the *mandorla* and also secured at the foot, so that he could kneel down without falling, because the iron clasp was in three sections which slid easily into each other as he did so. So when the garland had descended and the *mandorla* rested on the throne the man who bolted the *mandorla* also released the iron clasp which secured the angel, and the angel came forward, walked along the platform to where the Virgin stood, and then made the Annunciation. When he had returned to the *mandorla* and the lights which had gone out when he left reappeared, the iron clasp which held him securely was again bolted by the man concealed underneath; then the bolt holding the *mandorla* was released, and it was drawn upwards. Meanwhile, the garland of angels were singing and those in the heaven were moving about and they made it seem a veritable paradise, especially since, as well as the choir of angels and the garland, there was a God-the-Father (near the outer shell of the bowl surrounded by angels, like those already described, secured with iron clasps). And so Paradise was realistically depicted by the heaven, the garland, the God-the-Father, and the *mandorla*, accompanied by countless lights and the most harmonious music.

Moreover, so that the heaven could open and close Filippo had constructed two large doors on either side, each ten feet high, with iron or copper rollers running in grooves underneath; the grooves were well oiled, so that when a slender cable on each side was drawn by a little winch the doors opened or closed as was wanted. These doors achieved two effects: first, they were so heavy that when they moved they made a noise like thunder; and then when they were closed they served as a scaffold for arranging the angels and for seeing to the other things that had to be done offstage.

These and many other machines were made by Filippo, although there are some who assert that they were invented a long time before. However this may be, I thought it right to describe them because they have completely fallen into disuse.

But to return to Filippo: he had become so famous that those who needed to commission important buildings would send for him from great distances to provide his incomparable designs and models; people would make use of friends or bring strong influences to bear to secure his services. One of those who wanted his services was the marquis of Mantua, who wrote very insistently to the Signoria at Florence and had Filippo sent to Mantua. After he arrived there, Filippo prepared plans for the construction of dams on the Po and for various other projects as was ordered by the prince, who treated him very affectionately; and the marquis used to say that Florence deserved to have Filippo for one of its citizens just as he was worthy of having such a noble and beautiful city for his native land. Similarly in Pisa, when Niccolò da Pisa was surpassed by Filippo in the construction of certain fortifications, both he and Count Francesco Sforza praised him to his face and said that if every state had a man like Filippo in its service it would have no need of arms.

Filippo also designed, for Florence, the Barbadori Palace, near the tower of the Rossi in the suburb of San Jacopo, although the work was not carried out; and, in addition, he designed the palace of the Giuntini on the Piazza d'Ognissanti sopr' Arno. Subsequently, when the leaders of the Guelph Party in Florence decided to put up a building with a hall and an audience chamber for their headquarters they commissioned it from Francesco della Luna; but after the building had been raised about twenty feet from the ground the work was seen to be full of mistakes and it was given to Filippo, who completed it as the magnificent structure we can see today. In doing so he had to compete with Francesco, who had many supporters. Indeed, all his life Filippo had to face competition from different men at different times; his rivals often tried to make a name for themselves by using his designs, and in the end Filippo was reduced to keeping everything he did secret and trusting no one. Today the hall of that palace is no longer used by the leaders of the party, for when the papers of the Monte were badly damaged in the flood of 1557 the Lord Duke Cosimo decided for the sake of greater security to put there the papers (which are extremely

important) along with the office of the Monte itself. The leaders went to transact their affairs to another part of the palace, away from the hall now being used for the Monte; but so that they could make use of the old palace his excellency commissioned from Giorgio Vasari the commodious stairway which now leads to the hall of the Monte. The same artist also designed a stone balcony which has now been executed and placed, according to Filippo's plans, on fluted pilasters of macigno.[1]

One year the Lenten sermons in Santo Spirito at Florence were preached by Francesco Zoppo, who was then very popular and who pressed the claims of the convent, the school for young men, and especially the church itself, which had been burned down about that time. Following this the leading men of the district, namely, Lorenzo Ridolfi, Bartolomeo Corbinelli, Neri di Gino Capponi, and Goro di Stagio Dati, and countless other citizens, obtained an order from the Signoria for the church of Santo Spirito to be rebuilt, and they put Stoldo Frescobaldi in charge. And Stoldo, because of the interest he had in the old church (where the principal chapel and the high altar belonged to his family), devoted all his energies to the task. Indeed, at the very beginning, before the money from taxes levied on those who had tombs and chapels there had been collected, he spent many thousands of crowns, which he was later repaid, of his own money.

Now after everything had been discussed Filippo was sent for, and was asked to make a model incorporating all the useful and appropriate features he could devise worthy of a Christian church. He immediately urged that the ground-plan of the church should be turned right round, because he was extremely anxious that the piazza should extend to the bank of the Arno, so that everyone coming from Genoa, from the Riviera, from the Lunigiana, and from the districts of Pisa and Lucca, might be able to see what a magnificent building it was. However, several citizens were reluctant to have this done as it would have meant pulling down their houses; and so Filippo's wishes were ignored.

1. The stone balcony built by Vasari for the Palazzo di Parte Guelfa can still be seen in the Via Capaccio.

He then made the model for the church, along with that for the monastic house, in the form in which it is today. The church was 322 feet long and 108 feet in width, and it was so well planned, in the ordering of the columns and the other decorations, that it would be impossible to construct a more ornate, more charming, or more graceful edifice. Certainly, if it had not been for the malevolence of those whose claims to superior understanding are always leading them to spoil the lovely works which have been begun by others, it would today rank as the most perfect church in the Christian world. As it is, it is more charming and better arranged than any other, although the model has not been followed in every detail. One can see this from some of the external features which do not accord with the order followed in the interior, as should have been the case, for example, with the doors and the frames of the windows. There are some errors, which I shall not describe, attributed to Filippo; but it cannot be believed that he would have tolerated them if he had been able to continue the building himself, because everything he did, with judgement, prudence, intelligence, and skill he brought to perfection. And this church proves him to have had a mind and soul which were truly inspired.

Filippo was a witty talker with great powers of repartee. For example, he once wanted to make a biting comment on Lorenzo Ghiberti, who had bought a farm at Monte Morello, called Lepriano, on which he spent double the money it earned him. Lorenzo became so disgusted by this that he sold the farm. So when Filippo was asked what was the best piece of work Lorenzo had ever done (perhaps being expected to make Lorenzo smart because of the enmity between them) he replied: 'Sell Lepriano.'

At length, after he had grown very old (he was sixty-nine) on 16 April 1446 Filippo went to a better life, having toiled all his life on works which won him honour on earth and a place of rest in heaven. His death brought inexpressible grief to his country (which acknowledged and appreciated him far more after he was dead than when he was alive) and he was buried with great honour and dignity in Santa Maria del

Fiore (although his family tomb was in San Marco) under the pulpit opposite the door, where there is a coat-of-arms with two fig leaves and green waves on a field of gold, since his family came from the Ferrara region, namely, from the township of Ficaruolo on the Po, signified by the leaves, for the place, and the waves, for the river.

He was deeply mourned by countless artists, especially the poorer among them whom he had always helped. He lived like a Christian, and he left the world the memory of his goodness and his noble genius. In my opinion it can be claimed for him that from the time of the ancient Greeks and Romans until now no abler or more distinguished artist has ever lived. And he deserves all the more praise, seeing the unrivalled esteem in which throughout all Italy the German style of art had been held by the old artists, whose use of it may be seen in innumerable buildings. For he rediscovered the use of the antique cornices and restored the Tuscan, Corinthian, Doric, and Ionic orders to their original forms.

Il Buggiano, who came from Borgo a Buggiano, was one of his pupils; he made the font for the sacristy of Santa Reparata, carved with figures of children throwing water, and he also did from life a marble head of his master which was placed after Filippo's death in Santa Maria del Fiore, to the right of the door at the church entrance. The following epitaph can still be found at this spot, where it was put by the people to honour Brunelleschi after his death as he had honoured his country during his life:

D. S.

Quantum Philippus architectus arte Daedalea valuerit, cum huius celeberrimi templi mira testudo, tum plures aliae divino ingenio ab eo adinventae machinae documento esse possunt. Quapropter ob eximias sui animi dotes, singularesque virtutes ejus XV *Kal. Majas anno* MCCCCXLVI *ejus B. M. corpus in hac humo supposita grata patria sepeliri jussit.*[1]

1. Both the magnificent dome of this famous church, and the many other devices contrived by the genius of Filippo the architect, bear witness to his superb skill. Wherefore, in tribute to his exceptional talents and his remarkable virtue, a grateful country has bidden that his body of blessed memory be buried here in this soil below. 17 April 1446.

Notwithstanding, there were others who were anxious to honour him yet more and who added these two lines:

Philippo Brunellesco Antiquae architecturae instauratori
S.P.Q.F. civi suo benemerenti.

And Giovanbattista Strozzi added this:

As stone upon stone, course upon course, endlessly I raised,
So pace by pace ascending higher, I returned to heaven.[1]

Also among Filippo's pupils were Domenico del Lago of Lugano; Geremia da Cremona, who did excellent work in bronze; and a Sclavonian who executed several works at Venice; Simone, who after he had made the Madonna in Orsanmichele for the Apothecaries Guild died while engaged on important work for the count of Tagliacozzo; Antonio and Niccolò of Florence, who made a bronze horse for Duke Borso at Ferrara in 1461; and many others, whom it would take too long to mention by name.

Filippo was in some respects unfortunate: not only was he always having to contend with someone or other, but as well as this several of his works were not completed in his lifetime and have remained unfinished. For example, it was a tragedy that, as I mentioned, the monks of the Angeli could not finish the church which he began. After they had spent over three thousand crowns on what we can see today (the money coming partly from the Merchants Guild and partly from the Monte where the funds were placed) the capital was squandered and the fabric remained and remains imperfect. The lesson to be drawn, as I say in the *Life* of Niccolò da Uzzano, is that whoever wants to leave a memorial of himself of this kind should complete it while he is living and not trust anyone else to do so. And what I have said about this church could be said of many other buildings designed by Filippo Brunelleschi.

1. *Tal, sopra sasso sasso,*
 Di giro in giro eternamente io strussi:
 Che così passo passo
 Alto girando al ciel mi ricondussi.

LIFE OF

DONATELLO

Florentine sculptor, 1386–1466

DONATO, who was called Donatello by his relations and
signed himself as such on several of his works, was born in
Florence in 1386. He devoted his life to art, and he proved
himself an exceptional sculptor and a marvellous statuary as
well as a skilled and competent worker in stucco, in per-
spective, and in architecture, for which he was highly re-
garded. His work showed such excellent qualities of grace
and design that it was considered nearer what was done by the
ancient Greeks and Romans than that of any other artist. He
is therefore rightly recognized as the first to make good use
of the invention of scenes done in low relief, which he exe-
cuted with thoughtfulness, facility, and skill, demonstrating
his intimate knowledge and mastery of the technique and
producing sculptures of unusual beauty. He was superior not
only to his contemporaries but even to the artists of our own
times.

Donatello was brought up from early childhood in the
household of Ruberto Martelli. His fine character and the
way he applied his talents won him the affection of Ruberto
and all his noble family. While still young he executed a num-
ber of works, so many, in fact, that they attracted little atten-
tion. He made his name, however, and showed himself for
what he was, when he carved an Annunciation in grey-stone,
which was put in Santa Croce at Florence, near the altar of the
Cavalcanti Chapel. For this he made an ornament in the
grotesque style, with a base of varied and intertwined work,
surmounted by a quarter-circle, and with six *putti*; these
garlanded *putti* have their arms round each other as if they
are afraid of the height and are trying to steady themselves.
Donatello's ingenuity and skill are especially apparent in the
figure of the Virgin herself: frightened by the unexpected

appearance of the angel she makes a modest reverence with a charming, timid movement, turning with exquisite grace towards him as he makes his salutation. The Virgin's movement and expression reveal both her humility and the gratitude appropriate to an unexpected gift, particularly a gift as great as this. Moreover, Donatello created a masterly flow of folds and curves in the draperies of the Madonna and the angel, suggesting the form of the nude figures and showing how he was striving to recover the beauty of the ancients, which had been lost for so many years. He displayed such skill and facility that, to put it briefly, no one could have bettered his design, his judgement, his use of the chisel, or his execution of the work.

Below the screen in the same church, next to the scene by Taddeo Gaddi, he made a wooden crucifix over which he took extraordinary pains. When he had finished it, convinced that he had produced a very rare work, he asked his close friend, Filippo Brunelleschi, for his opinion. But Filippo, in view of what he had already been told by Donatello, was expecting to be shown something far better; and when he saw what it was he merely smiled to himself. At this Donatello begged him for the sake of their friendship to say what he thought of it. So Filippo, being always ready to oblige, answered that it seemed to him that Donatello had put on the cross the body of a peasant, not the body of Jesus Christ which was most delicate and in every part the most perfect human form ever created. Finding that instead of being praised, as he had hoped, he was being criticized, and more sharply than he could ever have imagined, Donatello retorted: 'If it was as easy to make something as it is to criticize, my Christ would really look to you like Christ. So you get some wood and try to make one yourself.'

Without another word, Filippo returned home and secretly started work on a crucifix, determined to vindicate his own judgement by surpassing Donatello; and after several months he brought it to perfection. Then one morning he asked Donatello to have dinner with him, and Donatello accepted. On their way to Filippo's house they came to the Old Market where Filippo bought a few things and gave them to

Donatello, saying: 'Take these home and wait for me. I shall be along in a moment.'

So Donatello went on ahead into the house, and going into the hall he saw, placed in a good light, Filippo's crucifix. He paused to study it and found it so perfect that he was completely overwhelmed and dropped his hands in astonishment; whereupon his apron fell and the eggs, the cheeses, and the rest of the shopping tumbled to the floor and everything was broken into pieces. He was still standing there in amazement, looking as if he had lost his wits, when Filippo came up and said laughingly:

'What's your design, Donatello? What are we going to eat now that you've broken everything?'

'Myself,' Donatello answered, 'I've had my share for this morning. If you want yours, you take it. But no more, please. Your job is making Christs and mine is making peasants.'

In the Baptistry of San Giovanni in the same city Donatello made a tomb for Pope John Coscia, who had been deposed from the pontificate by the Council of Constance. This tomb was commissioned by Cosimo de' Medici, a very close friend of Coscia; and Donatello made for it with his own hand the effigy of the dead man in gilded bronze, together with the marble statues of Hope and Charity, and his pupil, Michelozzo, made the statue of Faith. In the same church, opposite the tomb, can be seen a wooden statue of Mary Magdalen in Penitence, a finely executed and impressive work. She is portrayed as wasted away by her fastings and abstinence, and Donatello's expert knowledge of anatomy is demonstrated by the perfect accuracy of every part of the figure. In the Old Market, standing on a column of granite, is a statue of Abundance carved by Donatello in grey-stone and standing by itself; and this is so perfect that it wins the highest praise from all those who practise or understand the art of sculpture. The column was formerly in the Baptistry, where it served with the other granite columns to hold up the gallery; it was taken away and replaced by a fluted column from the middle of the church which once supported the statue of Mars, before the Florentines were converted to the Christian faith and had it removed.

While he was still a young man Donatello also made a
marble statue of the prophet Daniel for the façade of Santa
Maria del Fiore, and subsequently one of St John the Evangel-
ist, seated, eight feet high and clothed in a simple garment,
which is very highly praised. In the same place one can see, at
the corner on the side which faces the Via del Cocomero, the
statue of an old man standing between two columns. This
shows more similarities to the ancient style than any other
work left by Donatello; the man's head expresses the thoughts
of one bowed down over the years by time and toil. Dona-
tello also made inside Santa Maria del Fiore the ornament for
the organ which is over the door of the old sacristy, with
the figures so strongly carved, as has been said, that they look
as if they are really alive and moving. And this work demon-
strates that he worked as much with his mind as with his
hands. Many works of art seem beautiful when they are being
made, but, after they have been moved from the workshop
and put in place, in a different light or higher from the
ground, they present another aspect and seem altogether
different; but Donatello made his statues so well that in the
room where he was working they never appeared half as
good as they turned out to be when they were put into
position.

For the new sacristy of Santa Maria del Fiore, Donatello
made the design for those little boys who hold up the festoons
that go round the frieze, as well as the design for the figures
wrought in the glass of the round window which is below the
cupola, namely the one showing the Coronation of Our
Lady. As can be seen quite clearly, his was far better than
those done for the other windows.

Donatello also made for the Butchers Guild a wise and
splendid figure of St Peter in a marble statue that may be seen
at Florence in San Michele in Orto.[1] And for the Cloth
Guild he carved the statue of St Mark the Evangelist which,
by agreement with Filippo Brunelleschi, he finished himself,
though the commission had been given to both of them.
Donatello displayed such great judgement in this work that
those who lacked judgement of any kind quite failed to

1. Better known as Orsanmichele.

perceive its excellence, and the consuls of the guild were
reluctant to have it set up. Whereupon Donatello urged them
to let him set it up on high, saying that he would work on it
and show them an altogether different statue. When they
agreed, he merely covered it up for a fortnight and then,
having done nothing to it, he uncovered it and amazed them
all.

For the Armourers Guild he made a very spirited figure of
St George in armour, expressing in the head of this saint
the beauty of youth, courage and valour in arms, and a
terrible ardour. Life itself seems to be stirring vigorously
within the stone. And to be sure no modern statues have the
vivacity and spirit produced by nature and art, through the
hand of Donatello, in this marble. On the base of the shrine
he carved a low relief in marble of St George killing the
dragon, with a horse that is very highly praised and re-
garded; and in the frontal he made a half-length figure of
God-the-Father, again in low relief. Opposite the oratory of
Orsanmichele he made for the Mercatanzia[1] a marble taber-
nacle in which he broke completely with the German style
to use the ancient order known as Corinthian; this shrine
was meant to house two statues, but he refused to make them
because of a disagreement over the price. After Donatello's
death they were made in bronze by Andrea del Verrocchio,
as I describe in his biography.

For the main front of the Campanile of Santa Maria del
Fiore Donatello made four marble figures, each ten feet
high, of which the two in the middle were portrayed from
life, one being Francesco Soderini as a young man and the
other Giovanni di Barduccio Cherichini, now known as Il
Zuccone. The latter was regarded as an outstanding work,
finer than anything else he had ever made; and so whenever
Donatello wanted to swear convincingly to the truth of any-
thing he used to protest 'by the faith I have in my Zuccone'.

And while he was working on this statue he would look at
it and keep muttering: 'Speak, damn you, speak!'

Over the door of the Campanile facing the Canon's house
he represented Abraham about to sacrifice Isaac, with another

1. The commercial tribunal of Florence.

of the prophets; and these figures were placed between two other statues.

For the Signoria of Florence Donatello made a casting in metal, showing Judith cutting off the head of Holofernes, which was placed in the piazza under one of the arches of their loggia. This is an excellent and accomplished work in which, by the appearance of Judith and the simplicity of her garments, Donatello reveals to the onlooker the woman's hidden courage and the inner strength she derives from God. Similarly, one can see the effect of wine and sleep in the expression of Holofernes and the presence of death in his limbs which, as his soul has departed, are cold and limp. Donatello worked so well that the casting emerged very delicate and beautiful, and then he finished it so carefully that it is a marvel to see. The base, which is a simply designed granite baluster, is also pleasing to the eye and very graceful. Donatello was so satisfied with the results that he decided, for the first time, to put his name on one of his works; and it is seen in these words: *Donatello Opus*.

In the courtyard on the palace of the Signoria[1] stands a bronze statue of David, a nude figure, life-size; having cut off the head of Goliath, David is raising his foot and placing it on him, and he has a sword in his right hand. This figure is so natural in its vivacity and softness that artists find it hardly possible to believe it was not moulded on the living form. It once stood in the courtyard of the house of the Medici, but was moved to its new position after Cosimo's exile. In our own time Duke Cosimo had the statue moved again to make way for a fountain, and it is being kept for another large courtyard which he intends to build at the rear of the palace, where the lions used to stand. In the hall containing the clock of Lorenzo della Volpaia, on the left, there stands a very fine David in marble, straddling the head of the dead Goliath and holding in his hand the sling with which he killed him.

In the first courtyard of the house of the Medici there are eight marble medallions, in which there are copies of ancient cameos and of the reverse sides of medals, with several

1. The Palazzo Vecchio.

beautiful scenes by Donatello; these are built into the frieze between the windows and the architrave above the arches of the loggias. Donatello also restored an ancient statue of Marsyas in white marble, which was placed at the entrance to the garden; and very many antique heads, which were placed over the doors, were restored and embellished by him with wings and diamonds (the emblem of Cosimo) skilfully executed in stucco. He made two very lovely vessels of granite for pouring water, one of which was for the Pazzi garden in Florence. And in the Medici Palace there are also various Madonnas in marble and bronze, in low relief, and other scenes wonderfully carved in flat relief in marble, containing some exquisite figures. Cosimo thought so highly of Donatello's talent that he kept him continually occupied; and in return Donatello loved Cosimo so well that he could understand all he wanted, from the slightest sign, and he never disappointed him.

It is said that a Genoese merchant ordered from Donatello a life-size head of bronze, a beautiful piece of work which was made very light, since it had to be carried a long distance, and that Donatello obtained the commission through Cosimo's recommendation. Now when the head was finished and the merchant wanted to pay for it, he objected that Donatello was asking too much. So the dispute was referred to Cosimo, who had the head carried to the upper court of the palace and placed between the battlements overlooking the street, where it could be better seen. Then, when Cosimo tried to settle the matter, he found what the merchant was offering a long way from what Donatello was asking, and so he remarked that in his opinion the offer was too small. And at this the merchant, who thought it was too much, complained that, since he had finished the work in a month or a little over, Donatello would be making over half a florin a day. Donatello considered himself grossly insulted by this remark, turned on the merchant in a rage, and told him that he was the kind of man who could ruin the fruits of a year's toil in a split second; and with that he suddenly shoved the head down on to the street where it shattered into pieces and added that the merchant had shown he was more used to bargaining for beans

than for bronzes. The merchant at once regretted what he had done and promised to pay twice as much if Donatello would do the head again; but neither his promises, nor the entreaties of Cosimo, could persuade Donatello to do so.

In the houses belonging to the Martelli family there are many scenes in marble and bronze, and among them are a number of works, including a David standing six feet high, which Donatello presented to them as tokens of his love and devotion. And notably there is a marble St John in the round, six feet high, a very rare work which can be seen today in the house of the heirs of Ruberto Martelli. This statue was left in trust with the stipulation that under heavy penalties it should neither be pledged or sold or given away; and this was done as a proof and pledge of the affection in which they held Donatello and which he reciprocated from gratitude for the opportunities and shelter they had given to his talent.

Donatello also made, for one archbishop, a marble tomb which was sent to Naples and is now in Sant'Angelo di Seggio di Nido. In this tomb there are three figures in the round supporting the sarcophagus with their heads, and on the sarcophagus itself is a scene in low relief so beautiful that no praise is too extravagant for it. In the same city, in the house of the count of Matalone is the head of a horse by Donatello which is so fine that many people believe it is an antique.

In the township of Prato he did the marble pulpit where the Girdle is shown, carving in its compartments the figures of dancing children with such beautiful and expressive skill that here, no less than in his other work, he can be said to have executed sculpture that is absolutely perfect. In addition, to support the pulpit he made two bronze capitals, of which one is still there and the other was looted by the Spaniards when they sacked the place.

It happened that at that time, hearing of his fame, the Signoria of Venice sent for him to make the memorial for Gattamelata in the city of Padua. He went there very readily and executed the bronze horse which is on the piazza of Sant'Antonio: the horse is shown snorting and quivering, and Donatello has expressed very vividly the great courage and

pride of its rider. Indeed, he proved himself such a master in the proportions and excellence of this huge cast that he challenges comparison with any of the ancient craftsmen in expressing movement, in design, skill, diligence, and proportion. The work astounded everyone who saw it then and it continues to astound anyone who sees it today. It induced the Paduans to do their utmost to make him take up citizenship and they used every kind of affectionate restraint to keep him with them. To this end, they commissioned from him some scenes from the life of St Anthony of Padua for the predella of the high altar of the church of the Friars Minor. These are in low relief and they show such discrimination that the best sculptors stand before them almost dumb with astonishment at their beautiful and varied composition, the great abundance of extraordinary figures, and the diminishing perspectives. Also very beautiful are the Marys that he made, lamenting the dead Christ, on the altar-dossal. And in the house of one of the Capodilista counts he made in wood the skeleton of a horse (which can still be seen today, without its head) in which the parts are jointed with such method that anyone who studies the manner in which this work was made can appreciate Donatello's intellectual stature and ingenuity.

One of Donatello's works was a St Sebastian in wood which he made for a convent at the request of the chaplain, a Florentine, who was a friend of the nuns and of Donatello himself. He brought Donatello the old ugly statue which the nuns already had and begged him to make one like it. So to please the chaplain and the nuns Donatello forced himself to copy it. But even though he imitated an ugly piece of work, he could not help making the statue with his usual excellence and skill. Together with this statue he made many other figures in clay and stucco, and on one end of an old piece of marble which the nuns had in one of their gardens he carved a very beautiful Madonna. Countless works by Donatello are scattered throughout Padua, and he was regarded there by everyone with any discernment as a marvel. However, despite their praise, he made up his mind that he would go back to Florence, saying that if he stayed where he was any longer he would forget all he knew because of their flattery, and that

he was only too anxious to return to his own land, where he would be constantly criticized and so would have an incentive for studying and winning even greater glory. So he left Padua and returned to Florence through Venice, where as a mark of his benevolence he left as a gift for the Florentine colony a St John the Baptist in wood. This was executed by him for the Florentine chapel in the church of the Friars Minor, and he did it with the greatest care and diligence. In the city of Faenza he carved in wood two statues, a St John and a St Jerome, which are esteemed as highly as any of his works.

Subsequently, after his return to Tuscany, Donatello made a marble tomb, decorated with a very beautiful scene, in the parish church at Montepulciano, and, for the sacristy of San Lorenzo at Florence, a marble lavabo on which Andrea Verrocchio also worked; and in the house of Lorenzo della Stufa he made some very lifelike and vivacious heads and figures.

Donatello then left Florence for Rome in order to imitate as many as possible of the works of the ancient world. While he was studying there he made a stone tabernacle for the Blessed Sacrament, which is now in St Peter's. On his way back to Florence he passed through Siena, where he promised to make a bronze door for the Baptistry of San Giovanni. He made the wooden model and had almost finished the wax moulds and successfully covered them with the outer shell ready for casting, when a close friend of his, a Florentine gold-smith called Bernardetto di Mona Papera, came by on his way from Rome and was so persuasive in one way and another that, for his own purposes or other reasons, he got Donatello to return with him to Florence. So the door was hardly started, let alone finished. All that Donatello left behind in that city, in the Office of Works of the Duomo, was a bronze figure of St John the Baptist, with its right arm missing below the elbow; and this, it is said, was because he had not been fully paid for it.

On his return to Florence, Donatello did some work in stucco for Cosimo de' Medici in the sacristy of San Lorenzo, namely four medallions on the pendentives of the vault, with their grounds in perspective, partly painted and partly

in low relief and containing scenes from the lives of the evangelists. For the same place he made two very fine little doors in low relief, showing the Apostles, Martyrs, and Confessors; and over these he made some shallow niches, one containing the figures of SS. Laurence and Stephen and the other SS. Cosmas and Damian. In the crossing of the church in a very practised style he made four saints in stucco, each ten feet high. He also designed the bronze pulpits that contain the Passion of Christ, producing a work of great strength, design, and invention with abundant figures and buildings. However, he was prevented by old age from completing these, and they were brought to perfection by his pupil, Bertoldo. At Santa Maria del Fiore Donatello made two giant figures in bricks and stucco which were placed as ornaments on the sides of the chapels outside the church. And over the door of Santa Croce there is still to be seen a St Louis, standing ten feet high, made by Donatello in bronze. Someone told Donatello that he had bungled this statue and that it was perhaps the worst he had ever done, and he retorted that he had done it deliberately, since the saint himself had bungled when he abandoned a kingdom for a monastery. He also made a bronze head of Cosimo de' Medici's wife, which is preserved in the wardrobe of the Lord Duke Cosimo where there are many other of Donatello's works in bronze and in marble. Among them is a Madonna and Child, a very low relief in marble, which is one of the most beautiful things imaginable, especially as it is framed with miniature scenes by Fra Bartolommeo which, as I shall describe in his *Life*, are truly astonishing. Duke Cosimo also has from Donatello's hand a Crucifixion, so beautiful that it seems miraculous, which he keeps in his studio along with innumerable rare antiquities and beautiful medals. And also in his wardrobe is a bronze panel of the Passion of Our Lord, in low relief, containing a great many figures, as well as another panel, again in bronze, containing a Crucifixion. Then in the house belonging to the heirs of Jacopo Capponi, who was a fine citizen and a true gentleman, is a marble carved in half relief with the figure of Our Lady, which is considered to be an outstanding work of art. Antonio de' Nobili, who was his excellency's trustee,

also owned a Madonna by Donatello, a half-figure carved on marble in low relief and so beautiful that he valued it as much as all his other possessions put together; and it is treasured no less by his son Giulio, a young man of unusual merit and discernment and a friend to all artists and all men of worth. In the house of Giovanbattista d'Agnol Doni, a Florentine nobleman, is a bronze Mercury by Donatello, standing three feet high in full relief and clothed in a curious fashion, which is extremely attractive and no less outstanding than the other works which adorn that beautiful house. Bartolommeo Gondi, who is mentioned in the *Life* of Giotto, owns a Madonna in half relief, executed by Donatello with so much love and care that it is impossible to find anything better or to imagine any lighter touch in the pose of Our Lady's head and the graceful clothes that she wears.

Lelio Torelli, the Lord Duke's chief auditor and secretary, a friend of the noble professions and of the arts and sciences and an eminent jurist, also has a marble panel of the Madonna which is by Donatello.

But whoever wanted to tell the full story of Donatello's life and works would have to write far more than I intend in narrating the lives of our artists; for apart from his major works, which I have noted in some detail, Donatello set his hand to the smallest things of his art. For instance, he made coats-of-arms to go on the chimney-pieces and fronts of town houses, a very fine example of which can be seen on the house of the Sommai opposite the tower of the Vacca. He also made, for the Martelli family, a wicker-work chest, shaped like a cradle, to serve as an urn; this is below the church of San Lorenzo since no tombs of any kind appear above, although one can see there the epitaph on Cosimo de' Medici's tomb, which, like the others, has its opening beneath.

It is said that after he had finished the model for the tomb of Pope Martin V, Donatello's brother, Simone, sent for him to see it before it was cast. So Donatello left for Rome, and he arrived there at the very time that the Emperor Sigismund went to be crowned by Pope Eugene IV. As a result, Donatello had to busy himself along with his brother in preparing the principal decorations for the festival, for which he won great

honour and fame. In the wardrobe of the Lord Duke Guido-baldo of Urbino is a very beautiful marble head by Donatello which, it is thought, was given to the duke's ancestors by Giuliano de' Medici when he was received at that brilliant court.

In short, Donatello aimed so high and achieved so much that he may be said to have been one of the first in modern times to shed light, by his practice, judgement, and knowledge, on the art of sculpture and good design. He deserves all the more praise inasmuch as in his time no antiquities had been discovered and unearthed, apart from the columns, sarcophagi, and triumphal arches. And it was largely because of him that Cosimo de' Medici grew ambitious to introduce to Florence the antiquities which are still in the house of the Medici, all of which he restored with his own hand. Donatello was a man of great generosity, graciousness, and courtesy, more considerate towards his friends than towards himself. Nor did he ever set much store by money; what he had, he kept in a basket suspended by a cord from the ceiling, and all his workmen and friends could take what they wanted without asking. He was very happy in his old age, but when he became senile and was no longer able to work he had to be assisted by Cosimo and by other of his friends.

It is said that when Cosimo was about to die he recommended Donatello to the care of his son Piero, who, anxious to carry out dutifully what his father wanted, gave him a farm at Cafaggiuolo which provided an income on which he could live comfortably. This made Donatello very content, since it meant that he was at least saved from the prospect of dying of hunger. All the same he had not held it a year before he returned to Piero and publicly made the farm over to him again, insisting that he did not want to lose peace of mind by having to worry about running a household and being molested by the tenant, a peasant who was always getting in his way and complaining now because the wind had blown away the roof of his dovecot, now because his cattle had been confiscated by the Commune for taxes, or because a storm had destroyed his wine and his fruit. Donatello grew so sick and tired of all this that he said he would rather die of hunger

than have to think about so many things. Piero laughed at his simplicity, and then, to free him from his torments, he accepted the farm, as Donatello insisted, and assigned him from his own bank an allowance worth at least as much as the farm had brought him, but paid in cash every week. Donatello was more than satisfied with this arrangement and, as a friend and servant of the Medici family, he lived carefree and happy all the rest of his life, although when he reached the age of eighty he became so palsied that he could no longer work at all, and he had to keep to his bed in a poor little house which he had in the Via del Cocomero, near the nunnery of San Niccolò. He grew worse from day to day and gradually wasted away until he died on 13 December 1466. He was buried in the church of San Lorenzo, near Cosimo's own tomb, as he himself had directed, so that just as he had always been near Cosimo in spirit while alive so his body might be near him after death.

Donatello's death plunged into mourning the citizens and artists of Florence and all who had known him. Honouring him more after his death than they did while he lived, they buried him honourably in San Lorenzo, and all the painters, architects, sculptors, and goldsmiths, the whole city almost, assisted at his funeral. And for a long time afterwards various verses in different languages were continually composed in his praise, as can be adequately seen in the few examples that I give below.

Before I come to these epitaphs, however, it would be wrong not to record the following. When Donatello was ill, shortly before he died, some relations of his came to see him. After the usual greetings and condolences they told him that it was his duty to bequeath them a farm that he owned at Prato; and although it was small and yielded very little they begged him for it very insistently. When he heard this Donatello, who had a great sense of fairness, said:

I am afraid I cannot satisfy you, because it seems only right to me to leave it to the peasant who has always worked it, and who has toiled there, rather than to you, who have not given anything to it but always thought that it would be yours, and now hope to make it so just by this visit. Now go away, and God bless you.

This is certainly the way to treat relations whose love is given only because of what they gain or hope to gain. Anyhow, Donatello called the notary and left the farm to the labourer who had always worked it and who had certainly behaved better towards him in his need than those relations had done.

Donatello left his professional belongings to his pupils. These were Bertoldo, a Florentine sculptor, who imitated his work very closely, as can be seen from a very fine bronze battle-scene of men on horseback that is now in Duke Cosimo's wardrobe; Nanni d'Anton di Banco, who died before him; Rossellino; Desiderio; and Vellano of Padua. But, indeed, it can be said that since Donatello's death anyone wanting to do good work in relief has been his pupil.

His draughtsmanship was strong and he made his designs so skilfully and boldly that they have no equal. This can be seen in my book of drawings, where I have both nude and draped figures drawn by his hand, various animals which astound anyone who sees them, and other beautiful things of the same kind.

His portrait was done by Paolo Uccello, as I described in my *Life* of Uccello. And these are the epitaphs:

Sculptura H. M. a Florentinis fieri voluit Donatello, utpote homini, qui ei, quod jamdiu optimis artificibus, multisque saeculis, tum nobilitatis tum nominis acquisitum fuerat, injuriave tempor., perdiderat ipsa, ipse unus, una vita, infinitisque operibus cumulatiss. restituerit: et patriae benemerenti hujus restitutae virtutis palmam reportarit.[1]

> *Excudit nemo spirantia mollius aera:*
> *Vera cano: cernes marmora viva loqui.*
> *Graecorum sileat prisca admirabilis aetas,*
> *Compedibus statuas continuisse Rhodon.*
> *Nectere namque magis fuerant haec vincula digna*
> *Istius egregias artificis statuas.[2]*

1. The Goddess of Sculpture wished that Donatello should receive the highest honour from the people of Florence, inasmuch as he alone, in his one lifetime, had by his boundless works most amply restored to her that splendour and renown, earned for her of old by great artists over long centuries, which through the damage wrought by time's passing she had lost; and had won for his most worthy country the glory of this restoration.

What many skilled hands once did for sculpture, Donatello has accomplished alone. To the marble he has given life, emotion, movement. What more can nature give, save speech?[1]

The world remained so full of Donatello's works that it may be said with confidence that no artist has ever produced more than he did. He delighted in everything, and so he tried his hand at everything, without worrying whether what he was doing was worthwhile or not. Nevertheless, this tremendous activity of Donatello's, in every kind of relief, full, half, low, and the lowest, was indispensable to sculpture. For whereas in the good times of the ancient Greeks and Romans sculpture was brought to a state of perfection by many hands, he alone by his many works restored its magnificence and perfection in our own age. Artists should, therefore, trace the greatness of the art back to him rather than to anyone born in modern times. For as well as solving the problems of sculpture by executing so many different kinds of work, he possessed invention, design, skill, judgement, and all the other qualities that one may reasonably expect to find in an inspired genius. Donatello was very determined and quick, and he executed his works with the utmost facility, always accomplishing much more than he promised.

All his work on hand he left to his pupil Bertoldo, chiefly the bronze pulpits in San Lorenzo, which were then for the greater part polished by Bertoldo and brought to their present state.

I must not omit to mention that the very learned and Very Reverend Don Vincenzo Borghini, whom I have mentioned

1. *Quanto con dotta mano alla scultura*
 Già fecer molti, or sol Donato ha fatto:
 Renduto ha vita a' Marmi, affetto, ed atto:
 Che più, se non parlar, può dar natura?

2. More finely none has ever shap'd the breathing bronze;
 True is my song; thou see'st the living marble speak.
 No more the glorious olden age of Greece should boast
 The isle of Rhodes had need to hold its statues chain'd;
 Those bonds to guard this later master's wondrous works
 Were better us'd.

in another connexion, having collected in a big book innumerable designs by outstanding painters and sculptors, ancient as well as modern, has very appositely written in the margin, where there are two pages facing each other with drawings by Donatello and Michelangelo Buonarroti, these two Greek phrases: for Donatello: ῍Η Δωνατὸς Βοναρρωτίζει; and for Michelangelo: ἢ Βοναρρωτὸς Δωνατίζει. In Latin, they read as follows: *Aut Donatus Bonarrotum exprimit et refert, aut Bonarrotus Donatum.* And when translated, they run: Either the spirit of Donatello moves Buonarroti, or that of Buonarroti first moved Donatello.

LIFE OF

PIERO DELLA FRANCESCA

Painter of Borgo San Sepolcro, 1410/20–92

ONE of the worst things that can happen to a man is for him
to work and study hard in order to benefit others and make
his own name and then be prevented by sickness, or perhaps
death itself, from finally completing what he has begun. All
too often he leaves behind him works that are nearly finished
or that are shaping well, only to have them usurped by pre-
sumptuous donkeys trying to dress themselves up in the noble
skin of a lion. Admittedly, time is said to be the father of
truth, and sooner or later it reveals the truth; nevertheless, it
can happen that for some while the one who has done the
work is cheated of the honour due to him. And this was what
happened to Piero della Francesca of Borgo San Sepolcro.
He was regarded as a great master of the problems of regular
bodies, both arithmetical and geometrical, but he was pre-
vented by the blindness that overtook him in his old age,
and then by death, from making known his brilliant re-
searches and the many books he had written, which are still
preserved in Borgo, his native town.[1] The man who should
have done his utmost to enhance Piero's reputation and fame,
since Piero taught him all he knew, shamefully and wickedly
tried to blot out his teacher's name and to usurp for himself
the honour which belonged entirely to Piero; for he published
under his own name, which was Fra Luca dal Borgo,[2] all the
researches done by that admirable old man, who was a great
painter as well as an expert in the sciences I mentioned.

Piero della Francesca was born at Borgo San Sepolcro,
which has since grown into a city; he was given the name

1. Piero based the relationships in his paintings on the laws of Euclidean
geometry. The regular bodies were theoretically perfect forms which, it was
thought, could provide the artist with certain, or precisely measurable, relation-
ships through which art could reveal and reproduce the order of nature.
2. Luca Pacioli.

Francesca, after his mother, because his father died while she was pregnant, and it was she who brought him up and enabled him to reach the eminence to which his destiny called him. In his youth Piero applied himself to mathematics, and although when he became fifteen it was decided that he should be a painter he nevertheless always kept up his earlier studies. Indeed, it was because of his accomplishments both as a mathematician and a painter that he was employed by Guidobaldo da Montefeltro, the earlier duke of Urbino, for whom he made many very beautiful panel pictures with little figures, which have for the most part come to grief on one or other of the many occasions when that state has been ravaged by war. However, some of Piero's writings on geometry and perspective have been preserved there, and these show that he was in no way inferior in those sciences to anyone of his own or indeed of any other time. And this is illustrated by all his works, which are full of perspectives, and especially by a vase he drew on a system of squares, showing the mouth and base from the front, the back, and from the sides; in this amazing piece of work he drew every little detail with great subtlety, foreshortening in a very graceful way the curves of all the circles.

Then, having won a good name for himself at the court of Urbino, Piero wanted to make himself known elsewhere and so he went to Pesaro and Ancona. He was at his busiest there when Duke Borso summoned him to Ferrara where he decorated many of the palace rooms. These, however, were afterwards destroyed by Duke Ercole the elder when he renovated the palace; and so there is nothing by Piero left in Ferrara, save the frescoes he did in a chapel in Sant'Agostino, and even they have suffered badly from damp.

Piero was then summoned to Rome by Pope Nicholas V, and there, in competition with Bramante of Milan, he painted two scenes in the upper rooms of the palace; but these, too, were destroyed by Pope Julius II and their place taken by Raphael of Urbino's paintings of the liberation of St Peter from prison, the miracle of the Mass at Bolsena, and other scenes that had previously been depicted by Bramantino.[1]

1. Bartolomeo Suardi.

This Bramantino was an excellent painter in his time, and I propose to say something about him here; all his work has been lost and so there would be no point in writing at length about his life and works. I have heard that among the lost works were some heads copied from life which were so beautiful and so well executed that all they lacked was the faculty of speech. Many of these heads, however, have been preserved thanks to Raphael, who had copies made of them because they all commemorated very famous people. Among them were the heads of Niccolò Fortebraccio, Charles VIII, king of France, Antonio Colonna, prince of Salerno, Francesco Carmignuola, Giovanni Vitellesco, Cardinal Bessarion, Francesco Spinola, and Battista da Canetto; portraits of all these were given to Giovio by Giulio Romano, the pupil and heir of Raphael of Urbino, and were deposited by Giovio in his museum at Como. Over the door of San Sepolcro at Milan I have seen a foreshortened painting of the dead Christ, done by the same man; even though the picture is only about two feet high, he had done the impossible by including the whole length of the body, which he painted with great facility and judgement. In the same city there are some other works by Bramantino at the house of the young Marquis Ortanesia, where he decorated various rooms and loggias very skilfully, achieving some very forceful foreshortening of his figures. And outside the Vercellina gate, near the castle, he decorated some stables, which have now been demolished, with pictures of horses being groomed; one of these was so well done and so lifelike that one of the horses thought it was real and kicked it repeatedly with its hoofs.

But to return to Piero della Francesca. He finished his work in Rome, and then after his mother had died he went back to Borgo. In the parish church, on the inside of the middle door, he painted two saints in fresco which are greatly admired. In the convent of the Augustinians he painted a panel picture for the high altar, which was also enthusiastically praised. And he painted in fresco a picture of Our Lady of Mercy which was commissioned by a guild or, as they say, a confraternity. In the Conservators' Palace he painted a Resurrection which is

considered the best work he did either in Borgo or anywhere else.

In company with Domenico Veneziano, Piero started to decorate the vault of the sacristy of Santa Maria at Loreto; but they left it unfinished because of their fear of the plague and the painting was subsequently completed, as I shall describe later, by Luca of Cortona,[1] Piero's pupil.

From Loreto Piero went to Arezzo where, for one of the citizens called Luigi Bacci, he painted the chapel of the high altar of San Francesco, the vaulting of which had already been started by Lorenzo di Bicci. This fresco cycle shows scenes depicting the story of the True Cross, from when Adam's sons bury him and place under his tongue the seed of the tree from which the wood of the cross was to come down to the Exaltation of the cross performed by the Emperor Heraclius, who with the cross on his shoulders walks barefooted into Jerusalem. The work is full of admirable ideas and attitudes. The clothes of the women attending the queen of Sheba, for example, are depicted in a very delightful and novel way; there are many very true and lifelike portraits of people of the ancient world; there is a row of Corinthian columns, magnificently well proportioned; and there is a peasant who, while the three crosses are being disinterred, is leaning with his hands on his spade and listening with such an attentive air to the words of St Helena that the effect could not be more convincing. Also very well executed is the figure of the dead man being brought back to life at the touch of the cross, with a joyful St Helena and a group of amazed onlookers who are kneeling down in adoration. But above every other consideration of skill and art is Piero's representation of Night, where he depicts an angel in flight, foreshortened with his head downwards, bringing the signs of victory to Constantine who is sleeping in his tent guarded by a servant and some armed men faintly discerned through the darkness of the night; the light coming from the angel illuminates the tent, the men-at-arms, and all the surroundings. This composition is marvellously thought out, for in his portrayal of darkness Piero makes us understand how important it is to copy things

1. Luca Signorelli.

as they are in nature and to refer constantly to what is being copied. This he himself did so well that he has been followed by our modern artists who have been able to reach the perfection we see today. In the same story, Piero used a battle-scene to express very effectively fear, animosity, alertness, vehemence, and the other emotions typical of men in combat. He also showed the various incidents of the battle, depicting the wounded, the fallen, and the dead in scenes of almost incredible carnage. This work, in which Piero also counterfeited in fresco the gleam of the combatants' arms, merits the highest praise, as does the group of horses shown in foreshortening in a picture of the flight and submersion of Maxentius which is on the other wall; the horses are so splendidly executed that one can almost say they were too beautiful and too excellent for those times. In the same picture he painted a man, riding on a lean horse, half nude and half clothed in the Saracen fashion; and he displayed a knowledge of anatomy that was rare in those days. For this work he was generously rewarded by Luigi Bacci (whose portrait, along with those of Carlo and other of his brothers as well as of many Aretines, who were well-known men of letters, he included in a scene showing the beheading of a king). Piero well deserved the love and admiration which from then on were always shown to him in Arezzo, a city made illustrious by his works.

In Arezzo also, for the bishop's palace, Piero painted St Mary Magdalen in fresco beside the door of the sacristy; and for the confraternity of the Annunciation he painted a banner for carrying in procession. At the head of a cloister in Santa Maria delle Grazie, outside the town, he did a painting in perspective of St Donatus seated in his episcopal robes and surrounded by *putti*; and for the monks of Monte Oliveto, in San Bernardo, in a niche high up in the wall, a St Vincent which is greatly admired by artists. And at Sargiano, outside Arezzo, in a chapel belonging to the Calced Franciscans he did a very beautiful painting of Christ praying in the Garden at night.

He also did many works in Perugia that can still be seen there. For example, in the church of the Nuns of St Anthony

of Padua he painted a panel in tempera showing Our Lady with the Child in her lap, St Francis, St Elizabeth, St John the Baptist, and St Anthony of Padua. Above is a very fine Annunciation with an angel who really seems to have come straight from heaven and, in addition, a beautifully painted row of columns diminishing in perspective. In the predella there are some scenes with little figures showing St Anthony restoring a boy to life, St Elizabeth saving a child who has fallen into a well, and St Francis receiving the stigmata. In San Ciriaco at Ancona, for the altar of St Joseph, he painted a very fine picture of the marriage of the Virgin.

As I said earlier, Piero made an intense study of painting and perspective. He acquired an intimate knowledge of Euclid, understanding better than any other geometrician the nature of the perfect curves drawn on a basis of regular bodies; and the clearest elucidations of these matters come from his pen. The Franciscan, Luca dal Borgo, who wrote about the regular geometrical bodies, was his pupil; and when Piero died at an advanced age, having written many books, this Luca arrogated them to himself and published as his own work what had fallen into his hands after his master's death.[1] Piero was, by the way, very fond of making clay models which he would drape with wet cloths arranged in innumerable folds, and then use for drawing and similar purposes.

Piero Lorentino d'Angelo of Arezzo was a pupil of his who imitated his style in the many pictures he did in Arezzo, and who finished the works which Piero left uncompleted at his death. Near the St Donatus which Piero did in Santa Maria delle Grazie Lorentino painted some frescoes of scenes from the life of St Donatus, and he was very active in other places in Arezzo and the district around, partly because he could never stop working anyway, and partly for the sake of his family, which was then very poor. This same Lorentino did another picture for Santa Maria delle Grazie showing Pope Sixtus IV, standing between the cardinal of Mantua and Cardinal Piccolomini (afterwards Pius III) and granting an

1. This is hard on Luca Pacioli who is regarded as having edited rather than plagiarized Piero.

indulgence to that place. In this scene Lorenzo included life portraits of Tommaso Marzi, Piero Traditi, Donato Rosselli, and Giuliano Nardi, citizens and wardens of the church, who are shown kneeling in prayer. And for the hall of the palace of the Priors he did portraits from life of Galeotto, cardinal of Pietramala, Bishop Guglielmino degli Ubertini, and Angelo Albergotti, doctor of law; and there are many other works of his scattered throughout the city.

It is said that once, when it was near carnival time, Lorentino's sons begged him to slaughter a pig, as was the traditional thing to do in that part of the world. And knowing that the wherewithal was lacking, they asked him: 'But how will papa manage to buy one if he hasn't got the money?'

To this, Lorentino merely said: 'Well now, some saint will be sure to help us.'

But after they had heard this several times, and carnival time had come and gone, the children gave up hope. Then, however, a countryman turned up from Pieve a Quarto and asked Lorentino to paint him a picture of St Martin so that he could fulfil a vow he had made; but he had nothing with which to pay for the picture except a pig worth five lire. So when he sought out Lorentino and told him what he wanted he added that he would have to offer a pig for the painting. They struck a bargain; Lorentino did him his St Martin and he brought Lorentino the pig. So the saint did after all find a pig for the painter's poor children.

Another pupil of Piero's was Piero da Castel della Pieve who painted an arch above Sant'Agostino and for the nuns of St Catherine at Arezzo a St Urban which was recently destroyed when the church was rebuilt. Another of his followers was Luca Signorelli of Cortona, who did him more credit than all the others.

Piero himself, whose pictures were painted about 1458, went blind through an attack of catarrh at the age of sixty, but lived on until he was eighty-six. He left in the Borgo a very fine property and some houses he had built himself, which were burned down and destroyed in the civil strife of 1536. He was buried honourably by his fellow citizens in the

principal church, which was then in the care of the Camolden-
sian monks and is now the cathedral. His books, for the most
part, are in the library of Federigo II, duke of Urbino; their
qualities are such that because of them he has justifiably
acquired the reputation of being the leading geometrician of
his day.

FRA GIOVANNI OF FIESOLE (FRA ANGELICO)

of the Order of Friars Preachers, painter, c. 1400-1455

FRA GIOVANNI ANGELICO of Fiesole (known in the world as Guido) was both an accomplished painter and illuminator, and also a worthy priest; and for the one reason as much as the other he should be honoured by posterity. He could have lived very prosperously as a layman, satisfying all his material ambitions through the practice of those arts in which he was proficient even when young. But for his own peace and satisfaction and, above all, for the sake of his soul, being by nature serious and devout, he chose to join the Order of Friars Preachers. For although it is possible to serve God in all walks of life, there are those who believe that they must seek their salvation inside a monastery rather than in the world. (And in the case of upright men the choice is justified, although when a man becomes a priest for the wrong reasons the outcome is invariably shameful and unhappy.)

In Fra Angelico's convent of San Marco at Florence there are several choir books with breath-taking illuminations from his hand, like some others in San Domenico at Fiesole on which he worked with incredible diligence. (It is true that he was helped by an elder brother who was himself an illuminator and an experienced painter.)

One of the first paintings done by Fra Angelico was a panel for the Carthusian Monastery at Florence which was placed in the principal chapel of Cardinal degli Acciaiuoli and which showed the Madonna and Child with some lovely angels at her feet, playing music and singing. Beside her are St Lawrence, St Mary Magdalen, St Zenobius, and St Benedict, and the predella is adorned with scenes from the lives of those saints containing small figures executed with exquisite care. On the screen of the same chapel there are two more panel

paintings by Fra Angelico, one depicting the Coronation of Our Lady and the other the Madonna with two saints, beautifully executed in ultramarine blue. Subsequently, he did a fresco painting in the gallery of Santa Maria Novella, beside the door opposite the choir, showing St Dominic, St Catherine of Siena, and St Peter Martyr, as well as some small scenes for the chapel, depicting the Coronation of Our Lady. For the doors of the old organ he painted an Annunciation on canvas which is now opposite the door of the lower dormitory between the cloisters of the convent.

Cosimo de' Medici was among those who loved and admired Fra Angelico, and so, after he had completed the church and convent of San Marco, Cosimo asked him to paint the entire Passion of Jesus Christ on a wall in the chapterhouse. This showed on one side, sorrowful and weeping at the foot of the cross, all those saints who have founded or been the heads of religious orders, and on the other side the figure of St Mark the Evangelist with the Mother of God, who has fainted at the sight of the Crucifixion of the Saviour, the Marys, who are lamenting as they hold her up, and SS. Cosmas and Damian. (It is said that as St Cosmas, Fra Angelico portrayed his friend, the sculptor Nanni d'Antonio di Banco.) Below this scene, in a frieze over the dado he painted St Dominic at the foot of a tree in whose branches are several medallions containing portraits of all the popes, cardinals, bishops, saints, and theologians that the Order of Friars Preachers had produced up to then. The friars helped him by sending for portraits from various parts, and so many of them are true to life; they include St Dominic, who is in the centre holding the branches of the tree, the French Pope Innocent V, Blessed Ugolino the Order's first cardinal, Blessed Paolo patriarch of Florence, St Antoninus archbishop of Florence, Giordano the German the second general of the Order, and Blessed Niccolò Boninsegno, Florentine martyr. All these are on the right. Then on the left he painted Benedict XI of Treviso, the Florentine Cardinal Giandomenico, Pietro da Palude patriarch of Jerusalem, Albertus Magnus the German, Blessed Raymond of Catalonia third general of the Order, Blessed Chiaro of Florence provincial of Rome, St Vincent of

Valencia, and Blessed Bernard of Florence. All these heads are very beautiful and graceful. Then over some lunettes in the first cloister he painted a number of very fine figures in fresco and a crucifix with St Dominic at the foot, which is very highly regarded. And as well as many other things in the friars' cells, and on the surface of the walls in the dormitory, he painted an indescribably beautiful scene from the New Testament. Even more lovely, however, is the wonderful altarpiece he did for the high altar with a Madonna whose simplicity inspires devotion in the onlooker, as do the saints who surround her; moreover the predella, containing scenes of the martyrdom of SS. Cosmas and Damian and others, is so beautiful that one cannot imagine ever seeing anything executed with more diligence or containing little figures as delicate or as skilfully realized.

He also painted the altarpiece for the high altar of San Domenico at Fiesole, which has suffered from being retouched by other artists, perhaps because it was deteriorating. The predella and the ciborium of the Blessed Sacrament, however, are in a better state of preservation, and the host of little figures that can be seen there, in a Celestial Glory, are so exquisite that they really seem to be in Paradise and one could stand gazing at them for ever. In one of the chapels of the same church there is a panel painting by Fra Angelico of the Annunciation, showing Our Lady and the angel Gabriel in profile, their features being so well executed, so delicate and devout, that they seem to have been made in heaven rather than in this world. In the landscape one can see Adam and Eve, because of whom the Redeemer was to be born from the Virgin. The predella also contains several other very fine scenes.

However, of all the paintings he did, the one in which Fra Angelico surpassed himself and which displayed to perfection his talent and knowledge as a painter was a panel picture found in San Domenico on the left hand as one enters the church. This shows the Coronation of Our Lady by Jesus Christ, with a choir of angels and a multitude of male and female saints, so many in number, so beautifully depicted, with such variety in their attitudes and expressions that in

looking at them one is overwhelmed with pleasure and delight. Those blessed spirits, one imagines, must appear in heaven just as Fra Angelico has painted them, or rather would appear so if they had bodies; because all the saints that are there, male and female, are full of life, their expressions are gentle and charming, and, moreover, the colouring could well be the work of one of the angels or saints themselves. So we can understand why the good friar was always called Fra Giovanni Angelico.[1] There are, in addition, some inspired stories of Our Lady and St Dominic in the predella; and I for my part can truthfully say that whenever I see this painting it seems to be for the first time, and that I can never have my fill of it. There are other paintings by Fra Angelico containing a number of small, very carefully executed figures, on the doors of the cupboard (where the silver is kept) in Piero de' Medici's chapel of the Annunziata at Florence.

In the houses of Florence there are so many paintings by Fra Angelico that I am often amazed to think that one man alone, even over so many years, could have done so much perfect work. One of his pictures, a small and very lovely Madonna, is in the possession of the Very Reverend don Vincenzo Borghini, prior of the Innocenti; and Bartolommeo Gondi (whose love of the arts is equal to that of any other Florentine gentleman) owns a large and a small picture by Fra Angelico and also a cross. Fra Angelico also painted the pictures in the arch over the doorway of San Domenico; and in the sacristy of Santa Trinità there is a panel picture, showing the Deposition, which he painted with such diligence that it ranks with the best work he ever did. Then in San Francesco, outside the San Miniato gate, there is an Annunciation by his hand; and in Santa Maria Novella, in addition to the works already mentioned, he adorned with little histories the Paschal candle and some reliquaries which are placed on the altar on solemn occasions. In the abbey of Florence, over the door of the cloister, Fra Angelico did a painting of St Benedict enjoining silence. He also did a painting for the Cloth Guild which is now in their office, and in Cortona he painted a little arch over the door of the Dominican church as well as the

1. Brother Angelic.

panel for the high altar. At Orvieto, on a section of the vault-
ing of the Lady Chapel in the cathedral, he started to paint
some prophets which were later finished by Luca Signorelli.
For the confraternity of the Temple at Florence he did a panel
picture of the dead Christ; and for Santa Maria degli Angeli
he painted a picture of the Inferno and Paradise containing a
number of small figures which are brilliantly interpreted, for
the blessed are shown as beautiful and exultant in the joy of
heaven and the damned as ready for the pains of hell, bearing
the mark of their sins and unworthiness on their faces, and
depicted in various doleful attitudes: the blessed are seen en-
tering the gates of Paradise in a celestial dance, while the damned
are being dragged by demons into the everlasting torments of
hell. This painting is at the right of the church as one goes
towards the high altar, at the place where the priest retires
during a sung Mass. For the nuns of St Peter Martyr (who
now live in the monastery of San Felice in Piazza which used
to belong to the Camaldolesi) he painted a panel picture show-
ing Our Lady, St John the Baptist, St Dominic, St Thomas,
and St Peter Martyr, and a number of small figures. And
another panel by Fra Angelico can be seen in the gallery of
Santa Maria Nuova.

These works spread Fra Angelico's fame through all Italy,
and he was sent for by Pope Nicholas V, for whom he decor-
ated the private chapel of the Vatican, where the Pope hears
Mass, with a Deposition and some very fine scenes from the life
of St Lawrence, as well as illuminating some extremely
beautiful books.[1] In addition, while he was in Rome Fra
Angelico painted the altarpiece of the high altar of Santa
Maria sopra Minerva and an Annunciation which is now on
a wall beside the main chapel. For the same Pope he also de-
corated the chapel of the Blessed Sacrament in the Vatican
(which was subsequently demolished by Paul III in order to
put his stairs there). He carried out this task superbly, in his
own distinctive style, painting some scenes from the life of
Christ in fresco as well as executing the portraits of many dis-
tinguished contemporaries. These might also have been lost

1. He was sent for, in fact, by Eugene IV. Here, and elsewhere, the Papal
palazzo is translated (anachronistically) as the Vatican.

had not Giovio saved them for his museum. They were of
Pope Nicholas V, the Emperor Frederick, who visited Italy
at that time, Fra Antoninus, who later became archbishop of
Florence, Biondo of Forlì and Ferrante of Aragon. Now the
Pope saw that Fra Angelico was a modest and peaceable man
of great holiness of life, and so he decided that he would be a
suitable candidate for the archbishopric of Florence, which had
fallen vacant. But when he heard this, the friar begged his
holiness to find someone else; he did not, he said, feel himself
able to rule over others, but there was another friar of his
order, a learned and God-fearing man who was a friend of the
poor and who knew how to govern, on whom the dignity
would be conferred far more appropriately. When he was
told this the Pope remembered that what Fra Angelico said was
true, and he granted his request and made Fra Antoninus of
the Friars Preachers the new archbishop of Florence; the latter
was justly renowned for his sanctity and learning and was de-
servedly canonized in our own time by Adrian VI. For his
part, Fra Angelico showed great and unusual qualities in de-
clining the Supreme Pontiff's offer of an office of such emi-
nence and dignity in favour of someone who, as his own clear
judgement and sincerity perceived, was far more worthy of
it than himself.

Instead of taking on responsibilities which they cannot
worthily fulfil, the religious of our own times should learn
from that holy man to give way to those who are fully
worthy of them. And without offence to the good ones,
would to God that all the religious spent their time as did
that truly angelic Father, whose entire life was devoted to the
service of God and the benefit of the world and his neighbour!
What more can or should a man want than to win the king-
dom of heaven through a virtuous life and, by the quality of
his work, to secure everlasting fame on earth? The rare and
perfect talent which Fra Angelico enjoyed neither can nor
should be granted to anyone who does not lead a thoroughly
holy life. Artists who devote themselves to work of a re-
ligious or holy kind ought themselves to be genuinely holy
and religious, seeing that pictures done by those who have
little regard for their religion and little faith often fill the mind

with unworthy desires and impure longings, with the result
that the work is censured for its impurity but praised for its
craftsmanship and skill. However, I do not want to be under-
stood as meaning that ugly and clumsy works are therefore
devout, and that fine and beautiful works are to be condemned
as lascivious, as do some people who when they see beautifully
embellished pictures of unusually attractive youths or women
immediately denounce them as pornographic. What they do
not realize is that they are wrongfully condemning the good
judgement of the painter himself, who considers that the
beauty of the saints in heaven must be as much superior to
human beauty as is heaven itself to the things of this world.
Worse than this, they reveal the diseased and corrupt state of
their own minds in finding evil and impure intentions in
works which (if they were in love with the truth as much as
in their blind zeal they would like to be thought) would re-
veal to them the painter's longing for heaven and his desire
to make his figures acceptable to the creator of all things,
from whose most perfect and beautiful nature all perfection
and beauty are derived. What would such men do – what can
we think of them doing – if they were to find themselves in
the presence of beautiful living creatures with lascivious ways,
soft words, graceful movements, and ravishing, inviting eyes,
seeing that they are stirred so greatly merely by the image
and, as it were, the shadow of beauty? All the same, I do not
want anyone to think that I would approve of the all but nude
figures which are painted in churches, because these show that
the painter has not paid sufficient attention to his surroundings.
When an artist wishes to display his skill he should do so with
full regard for circumstances of time, place, and persons.

Fra Angelico led a simple and devout life. It was characteris-
tic of his good way of life, for example, that one morning,
when Pope Nicholas wished him to dine with him, he ex-
cused himself from eating meat without the permission of his
prior, the Pope's authority in this matter not occurring to him.
He shunned all worldly intrigues, lived in purity and holiness,
and befriended the poor as much as his soul is now, I believe,
befriended by heaven. He worked continuously at his paint-
ing, and he would choose only holy subjects. He could have

become rich, but he was not interested in wealth; indeed, he used to say that true wealth consists in being content with just a little. He could have had authority over many people, but he refused it on the grounds that there was less trouble and error in obeying others. If he had wanted he could have risen to high rank in his Order and in the world, but he spurned this, saying that the only dignity he wanted was to escape hell and to enter paradise. And, indeed, what dignity can compare with the dignity, which every religious or rather every man ought to seek, of finding God and living a virtuous life? Fra Angelico was most gentle and temperate and he lived chastely, withdrawn from the snares of the world. He would often comment that anyone practising the art of painting needed a quiet and untroubled life and that the man who occupies himself with the things of Christ should live with Christ. What seems to me extraordinary and almost unbelievable is that the friars never once saw him angry; if he needed to admonish his friends he did it smilingly, without fuss, and to anyone who wanted work from him he would say with great charm that they should first secure the consent of the prior and then he himself would not fail them.

But it is impossible to bestow too much praise on this holy father, who was so humble and modest in all he did and said and whose pictures were painted with such facility and piety. In their bearing and expression, the saints painted by Fra Angelico come nearer to the truth than the figures done by any other artist. He would never retouch or correct his pictures, leaving them always just as they had been painted since that, as he used to say, was how God wanted them. It is also said that Fra Angelico would never take up his brushes without a prayer. Whenever he painted a Crucifixion the tears would stream down his face; and it is no wonder that the faces and attitudes of his figures express the depth and sincerity of his Christian piety.

Fra Angelico died at the age of sixty-eight in the year 1455. The pupils whom he left were Benozzo of Florence, who always imitated his style, and Zanobi Strozzi, who painted pictures and panels for a great many private houses in Florence, notably including a panel which is now in the gallery

of Santa Maria Novella, beside the one by Fra Angelico, and another in San Benedetto (the ruined monastery outside the Pinti gate which used to belong to the Camaldolesi). This painting is now in the monastery of the Angeli, in the chapel of San Michele, before one enters the principal church, on the right-hand wall on the way to the altar. Zanobi Strozzi also painted a panel picture for the chapel of the Nasi in Santa Lucia and another for San Romeo. In the duke's wardrobe is a single picture by his hand containing the portraits of Giovanni de' Bicci de' Medici and Bartolommeo Valori. Also among Fra Angelico's pupils were Gentile da Fabriano and Domenico di Michelino, who did the altarpiece of St Zenobius in Sant'Apollonia at Florence as well as many other paintings.

Fra Angelico was buried by the friars in the Minerva at Rome, by the side entrance near the sacristy, in a round marble tomb with his effigy above it. On the marble is carved this epitaph:

> *Non mihi sit laudi, quod eram velut alter Apelles,*
> *Sed quod lucra tuis omnia, Christe, dabam:*
> *Altera nam terris opera extant, altera coelo.*
> *Urbs me Joannem flos tulit Etruriae.*[1]

In Santa Maria del Fiore there are two very large books, with inspired illuminations by Fra Angelico, which are held in great reverence; they are richly ornamented, and brought out only on solemn occasions.

[1.]
> In praise of me, O Lord, be it not said
> That I did match Apelles, but that I
> My wages to thy people gave entire;
> For different are the deeds that count on earth
> From those in heaven.
> In that city was I, John, born
> That is the flower of Tuscany.

LIFE OF
LEON BATTISTA ALBERTI
Florentine architect, 1404–72

ARTISTS who are fond of reading invariably derive the great-
est benefit from their studies, especially if they are sculptors
or painters or architects. Book learning encourages craftsmen
to be inventive in their work; and certainly, whatever their
natural gifts, their judgement will be faulty unless it is backed
by sound learning and theory. Everyone knows, for example,
that when choosing a site for a new building one must take
account of what natural science has to say about avoiding
places where there are destructive winds, an unhealthy atmo-
sphere, or stench and exhalations from impure and stagnant
waters. But everyone knows, too, that when he is at work the
artist himself must decide after careful consideration what to
reject and what to accept, using his own judgement and not
relying on the theories of others, which are rarely of any value
when divorced from practice. When theory and practice co-
incide then nothing could be more fruitful, since artistic skills
are enhanced and perfected by learning and the advice and
writings of knowledgeable artists carry more weight and
are more efficacious than the words or work of those who
(whatever the quality of their results) are merely practical
men.

The truth of these remarks is clearly demonstrated by Leon
Battista Alberti. He devoted himself to the study of Latin and
the practice of architecture, perspective, and painting, and he
left to posterity a number of books which he wrote himself.
Now none of our modern craftsmen has known how to write
about these subjects, and so even though very many of them
have done better work than Alberti, such has been the in-
fluence of his writings on the pens and speech of scholarly
men that he is commonly believed to be superior to those who
were, in fact, superior to him. So we see that as far as fame

and reputation are concerned the written word is more endur-
ing and influential than anything else; for, provided they are
honest and innocent of lies, books travel freely and are trusted
wherever they go.

It's not surprising, therefore, that the famous Leon Battista
Alberti is better known for what he wrote than for the work
of his hands. He was born in Florence, into the noble Alberti
family (of which I spoke elsewhere). He spent his time finding
out about the world and studying the proportions of anti-
quities; but above all, following his natural genius, he con-
centrated on writing rather than on applied work. He was an
accomplished mathematician and geometrician and he wrote
in Latin a work on architecture, in ten books, which he pub-
lished in 1481. (It can be read today in a translation, into the
Florentine language, by the Reverend Cosimo Bartoli, pro-
vost of San Giovanni of Florence.) He left a work on painting
in three books which were translated into Tuscan by Ludovico
Domenichi. Alberti also composed a treatise on traction and
the rules for calculating heights, as well as the books on the
vita civile and some erotic works in prose and verse; and he
was the first to use Latin prosody for verse written in Italian,
as may be seen from one of his letters:

> *Questa per estrema miserabile pistola mando*
> *A te che spregi miseramente noi.*[1]

Leon Battista happened to arrive in Rome during the ponti-
ficate of Nicholas V, who had been turning the city upside
down with all his building projects, and through the good
offices of his close friend Biondo da Forlì he was befriended by
his holiness. Nicholas had previously sought advice on archi-
tectural matters from the Florentine sculptor and architect,
Bernardo Rossellino (as I shall mention in my life of his
brother Antonio); but after he had started to restore the

1. Alberti was born in Genoa, to which his family had fled from political
strife in Florence. His work on architecture – *De Re Aedificatoria* – was published
in 1485; his work on painting – *De Pictura* – was published at Venice in the
translation by Ludovico Domenichi, in 1547. His work on the 'civil life' was
the *Della Famiglia* in four books, a dialogue on education, marriage, household
management, and friendship. The two lines from the letter quoted by Vasari
run: 'I send this most wretched letter, to you who so cruelly scorn us.'

Vatican and to do some work in Santa Maria Maggiore, following the Pope's wishes, from then on Rossellino always went to Leon Battista for advice. And using one of them to carry out the ideas supplied by the other, the Pope went ahead with many useful and commendable projects. These included the restoration of the ruined aqueduct of the Acqua Vergine fountain, and the construction of the fountain in the Piazza de' Trevi, with its still surviving marble ornamentation including the arms of Nicholas V and of the Roman people.

Subsequently, Alberti went to serve Sigismondo Malatesta, ruler of Rimini, for whom he designed the church of San Francesco, notably its marble façade, as well as the arcade of large arches facing the south and containing the sarcophagi for illustrious citizens. Such was the quality of Alberti's work for San Francesco that it ranks without question as one of the foremost churches in Italy. It has six very lovely chapels, the one dedicated to St James being extremely ornate and containing many relics which originally came from Jerusalem. This chapel also houses the tombs of Sigismondo and his wife which were built very richly in marble in 1450; over one of them is the portrait of Sigismondo, and on another part of the same work appears the likeness of Leon Battista himself. Then in 1457, the year when the German Johann Gutenberg discovered his very useful method for printing books, Alberti similarly discovered a way of tracing natural perspectives and effecting the diminution of figures, as well as a method of reproducing small objects on a larger scale: these were very ingenious and fascinating discoveries, of great value for the purposes of art.

In Leon Battista's time, meanwhile, Giovanni di Paolo Rucellai wished to build in marble, at his own expense, the principal façade of Santa Maria Novella; he consulted Alberti, who was a close friend of his, and receiving not only advice but a model as well Rucellai finally determined to have the work done as a memorial for himself. So a start was made, and the façade was finished in 1477, to the great satisfaction of the people who were especially delighted with the door; and so it is clear that Alberti took exceptional trouble over this project.

For Cosimo Rucellai, Alberti designed the palace which was being built in the street called La Vigna and also the loggia which is opposite the palace. In this loggia he turned the arches over the closely spaced columns in the façade and also over the corbels, in order both to have a series of arches on the outside and to follow the same pattern internally. He had to make projections at the inside corners because he had put a space at each corner between the arches. When he came to vault the interior he was unable to use a semi-circular barrel-vault, which would have looked mean and awkward, and so he resolved to throw small arches across from corner to corner. Here he showed a lack of judgement and design, demonstrating very clearly that theoretical knowledge must be accompanied by experience: no one can develop perfect judgement unless his learning is tempered by practical application.

It is said that Alberti also designed the house and garden belonging to the Rucellai family in the Via della Scala. The building is made with great judgement and is very commodious, containing among other features two loggias, one facing south and the other west, which in this instance dispense with the use of arches. This is the true and correct method as it was employed in the ancient world: it is impossible to rest the four edges of a curving arch on a round column without throwing the corners out, whereas architraves can rest snugly along the capitals of a row of columns. In fact, good building demands that architraves should be used for columns, and if arches are required then pilasters should take the place of columns.

For the Rucellai family Alberti also made, in a similar style, a chapel in San Pancrazio which rests on great architraves supported by two columns and two pilasters piercing the wall of the church below; this was a difficult but sound piece of work and one of the best that Alberti ever did. In the middle of the chapel is a marble tomb of an elongated oval shape and resembling, as is written on it, the sepulchre of Jesus Christ in Jerusalem.

About that time Ludovico Gonzaga, marquis of Mantua, determined that he would have the tribune of the principal chapel of the Servite church of the Annunziata in Florence

built after Alberti's plans and model. So he demolished a square chapel standing at the head of the church (which was old and small, and adorned in the ancient style) and built the new tribune in its place. This is a very ingenious and difficult structure, taking the form of a circular temple with a ring of nine chapels on the circumference which opened off like niches; this meant that the entrance arches over the pilasters of these chapels, which ornament the walls, have to adapt themselves to the concave shape of the tribune as a whole, curving – as it does – in a different plane. In turn, this means that if you look sideways at the entrance arches they seem to lean forward and they look awkward (as indeed they are) even though the rules have been observed and it is a very difficult feat to perform. It is true that Leon Battista would have been better advised not to try it, in spite of its difficulty, because it is not a good thing in either small or large works, and it can never be made to succeed. In large things, such as the very big entrance arch to the tribune from the nave, it is splendid from the nave, but on the inner side, where it has to follow the curve of the tribune wall, it appears to lean and looks extremely clumsy. Perhaps Alberti would not have done this if his practical experience of architecture had matched his theoretical knowledge. Another man would have avoided the difficulty and been content to construct a graceful and more beautiful building. The work is otherwise in itself very fine, ingenious, and intricate, and Alberti showed great courage for his time in raising the tribune in the way that he did.

Ludovico then brought Alberti to Mantua itself, where he made for him a model for the church of Sant'Andrea and several other things. Travelling from Mantua to Padua one can see also various churches built after Alberti's style. Many of Alberti's designs and models were used by Silvestro Fancelli, a Florentine architect and sculptor of some talent,[1] who following Alberti's wishes executed with judgement and painstaking diligence all the works that he undertook in Florence. For his work in Mantua Alberti employed a Florentine called Luca Fancelli, who subsequently settled in that

1. In fact, Luca Fancelli.

city and died there, leaving his name, according to Filarete, to the Luchi family, which is still there today. Alberti was extremely fortunate to have friends who understood him and who were able and willing to serve him, because architects cannot always stand over their work, and it is a great help if they can find someone to execute it faithfully and lovingly; and I (if anyone) know the truth of this from personal experience.

In painting Alberti achieved nothing of any great importance or beauty. The very few paintings of his that are extant are far from perfect, but this is not surprising since he devoted himself more to his studies than to draughtsmanship. All the same he expressed his ideas very ably in his drawings, as can be seen from some sketches of his in our own book, showing the bridge of Sant'Angelo and the covering that he designed for it in the form of a loggia to give protection from the sun in summer and the rain and wind in winter. He was commissioned to do the work by Pope Nicholas, who had intended to carry out many similar projects throughout Rome but was prevented by his death. There is a work by Alberti in a little chapel dedicated to Our Lady on the abutment on the Ponte alla Carraia in Florence, namely, an altar-predella containing three little scenes with some perspectives which he described (with his pen) much better than he painted them with his brush. Again in Florence, in the house of the Palla Rucellai family, there is Alberti's self-portrait which he did with the help of a mirror, and a panel with fairly large figures in chiaroscuro. He also painted a picture of Venice, in perspective, showing St Mark's, although the figures were done by other artists; and this is one of the best of his paintings that we have.

Leon Battista was an admirable citizen, a man of culture who was the friend of talented men and very open and courteous with everyone; and he always lived honourably and like the gentleman he was. Finally, having reached a good old age, in tranquillity and contentment he left for a better life, leaving behind him a most honourable name and reputation.

LIFE OF
FRA FILIPPO LIPPI
Florentine painter, c. 1406–69

FRA FILIPPO DI TOMMASO LIPPI, a Carmelite, was born in
Florence, in a street called Ardiglione, below the Canto alla
Cucilia and behind the Carmelite Convent. The death of his
father left him, at the age of two, a sad and solitary orphan,
since his mother had died not long after he was born. He was
put under the care of his aunt, Mona Lapaccia, Tommaso's
sister, but she found it a struggle to bring him up and, when
she could no longer manage, sent him, at the age of eight, to
be a friar in the Carmelite Convent. At the convent he showed
himself dexterous and ingenious in any work he had to do
with his hands, but equally dull and incapable of learning
when it came to his books; so he never spent any time study-
ing his letters, which he regarded with great distaste. The boy
(who was called by his secular name, Filippo) was placed with
the other novices in the charge of the master teaching gram-
mar to see what he could learn; but instead of studying he
spent all his time scrawling pictures on his own books and
those of others, and so eventually the prior decided to give
him every chance and opportunity of learning to paint.

At that time the chapel of the Carmine had been freshly
painted by Masaccio and its great beauty attracted Fra Filippo
so much that he used to go every day in his spare time and
practise in company with many other young artists who were
always drawing there. He showed himself so superior to the
rest in skill and knowledge that it was held for certain that
one day he would do marvellous things; indeed, it was
astounding how many fine works he did produce before his
maturity, while he was still in his salad days. Before very long
he did a painting in *terra verde* in the cloister, near to Masac-
cio's *Consecration*, of a pope approving the Rule of the Car-
melites, and he executed various frescoes on walls in many

parts of the church, notably a St John the Baptist with some
scenes from his life. His work improved every day and he
came to understand Masaccio's style so well that his own
pictures resembled those of Masaccio, and it was often said
that Masaccio's soul had entered into his body. On a pilaster
in the church, near the organ, he did a painting of St Marziale
which bore comparison with Masaccio's work and which
made his reputation. Then, in response to the praises he heard
from all sides, at the age of seventeen he boldly threw off his
friar's habit.

Now one day he happened to be enjoying himself with
some of his friends in a little boat on the sea off the March of
Ancona when they were all seized by the Moorish galleys that
were scouring those parts, taken captive to Barbary, and put
in chains. He stayed in this wretched condition for eighteen
months. But one day when the opportunity presented itself
he took it into his head to do a portrait of his master, with
whom he was very familiar, and using a piece of dead coal
from the fire he drew him on a white wall, full length in his
Moorish costume. The other slaves reported this to his
master, and since neither drawing nor painting were known
in those parts everyone was astounded by what he had accom-
plished and he was, as a result, freed from the chains in which
he had been kept so long. It was a glorious thing for the art
of painting that it caused someone with the lawful authority
to condemn and punish to do the opposite, giving his slave
affection and liberty in the place of torture and death.

So, after he had done some painting in colour for his
master, Fra Filippo was brought safely to Naples where for
King Alfonso, then duke of Calabria, he painted a panel in
tempera for the castle chapel, where the guardroom is now.
He then determined to return to Florence, where he stayed
for several months, executing a very beautiful altarpiece for
the nuns of Sant'Ambrogio. This won him the affection of
Cosimo de' Medici who became a close friend of his.

Fra Filippo also did a panel picture for the chapter-house of
Santa Croce and another, which was placed in the chapel in
the house of the Medici, showing the Nativity of Christ. As
well as this, for the wife of Cosimo de' Medici he painted a

panel picture of the Nativity of Christ with St John the Baptist, which was to be placed in the hermitage of Camaldoli in one of the hermits' cells dedicated to St John the Baptist which she had had built as an act of devotion. And he painted some little scenes that Cosimo sent as a gift to Pope Eugene IV, the Venetian. This work won Fra Filippo the favour of the Pope himself.

It is said that Fra Filippo was so lustful that he would give anything to enjoy a woman he wanted if he thought he could have his way; and if he couldn't buy what he wanted, then he would cool his passion by painting her portrait and reasoning with himself. His lust was so violent that when it took hold of him he could never concentrate on his work. And because of this, one time or other when he was doing something for Cosimo de' Medici in Cosimo's house, Cosimo had him locked in so that he wouldn't wander away and waste time. After he had been confined for a few days, Fra Filippo's amorous or rather his animal desires drove him one night to seize a pair of scissors, make a rope from his bed-sheets and escape through a window to pursue his own pleasures for days on end. When Cosimo discovered that he was gone, he searched for him and eventually got him back to work. And after that he always allowed him to come and go as he liked, having regretted the way he had shut him up before and realizing how dangerous it was for such a madman to be confined. Cosimo determined for the future to keep a hold on him by affection and kindness and, being served all the more readily, he used to say that artists of genius were to be treated with respect, not used as hacks.

For the church of Santa Maria Primerana, on the piazza at Fiesole, Fra Filippo did a panel picture of the Annunciation of Our Lady, finished with wonderful care, in which the figure of the angel is so beautiful that one can hardly doubt it has come from heaven. He did two panel pictures for the Murate, the convent of the enclosed Order of nuns: one for the high altar, showing the Annunciation, and the other over another altar in the same church containing scenes from the lives of SS. Benedict and Bernard. And in the palace of the Signoria he executed a panel picture of the Annunciation which is over one

of the doors, and a painting of St Bernard which is over another. For the sacristy of Santo Spirito at Florence he did a panel picture showing Our Lady surrounded by angels and with saints on either side. This is an outstanding work which our leading artists have always held in reverence.

In the chapel of the wardens in San Lorenzo Fra Filippo painted a panel picture again showing the Annunciation, as well as another for the Della Stufa Chapel which was left unfinished. In Santi Apostoli at Florence, for one of the chapels, he painted a panel with various figures, grouped round Our Lady, and in Arezzo he was commissioned by Carlo Marsuppini to paint for the monks of Monte Oliveto the altarpiece for the chapel of St Bernard, showing the Coronation of Our Lady with a number of saints. When he painted this picture (which is still so fresh that it looks as if it has only just been finished) Fra Filippo was told by Carlo to pay special attention to the rendering of the hands, as his work had been adversely criticized in this respect. So from then onwards Filippo always covered the hands he painted with draperies or else used some other technique to escape censure. In this particular work he did a portrait of Carlo Marsuppini from life. Meanwhile, for the nuns of the Annalena at Florence he painted a panel picture showing Christ in the Manger; and there are also some paintings of his in Padua. To Cardinal Barbo at Rome he sent two small scenes with tiny figures which were skilfully executed and very carefully finished: it may be said here, in fact, that his paintings were always done with astonishing grace and finely composed and finished, and, consequently, he has always won the most lavish praise and respect from our artists, both living and dead. So long as his innumerable works are left undamaged by the ravages of time, their qualities will always command the highest respect.

In Prato near Florence, where he had some relations, Fra Filippo stayed for many months doing a great deal of work in various parts of the district in company with Fra Diamante of the Carmelite convent at Prato, who had been his companion when they were novices together. Subsequently, he was asked by the nuns to paint the altarpiece for the high altar of Santa Margherita, and it was when he was working at this that he

one day caught sight of the daughter of Francesco Buti of Florence, who was living there as a novice or ward. Fra Filippo made advances to the girl, who was called Lucrezia and who was very beautiful and graceful, and he succeeded in persuading the nuns to let him use her as a model for the figure of Our Lady in his painting. This opportunity left him even more infatuated, and by various ways and means he managed to steal her from the nuns, taking her away on the very day that she was going to see the exposition of the Girdle of Our Lady, one of the great relics of Prato. This episode disgraced the nuns, and Francesco, the girl's father, never smiled again. He did all he could to get her back, but either from fear or some other reason she would never leave Fra Filippo; and by him she had a son, Filippo, who became, like his father, a famous and accomplished painter.[1]

There are two of Fra Filippo's panel pictures in San Domenico of Prato; and a Madonna in the gallery of the church of San Francesco. It proved possible to move this painting from its original position to where it is now without damaging it by cutting away the wall and giving the section a wooden framework. There is also a little panel by Fra Filippo, over a well in the courtyard of the alms-house of Francesco di Marco, which contains the portrait of Francesco, who was the creator and founder of that pious foundation. And in the parish church at Prato there is a small panel of his, over the side door as one ascends the steps, showing the death of St Bernard, by the touch of whose bier many cripples are being restored to health. In this painting are a number of friars lamenting their dead master; and it is marvellous to see how skilfully and truthfully Fra Filippo has expressed grief and sadness in the attitudes of their heads. The draperies in this picture, namely, the friars' robes, are shown with a number of very beautiful folds, and their excellent design, colouring, and composition deserve every praise, as do the grace and proportion with which Fra Filippo delicately executed the whole work.

To have some memorial of him, the wardens of the parish church commissioned Fra Filippo to paint the chapel of the high altar; and he fully demonstrated his capabilities in

1. Filippino Lippi (1457/8–1504).

the excellence and artistry of the work as a whole and, in particular, in its marvellous draperies and heads. In these frescoes Fra Filippo made his figures larger than life, thus showing the way to modern artists to achieve the grandeur of the style of our own day. They contain also various figures dressed in clothes which were not contemporary, and by this departure Fra Filippo prompted the artists of that time to abandon the kind of simplicity which, far from reflecting the style of the ancient world, was simply old-fashioned. The work includes scenes from the life of St Stephen, the patron saint of the church, covering the right-hand wall, namely, the Disputation, the Stoning, and the Death of the first martyr. Fra Filippo showed such zeal and fervour in St Stephen's face as he disputes with the Jews that it is difficult to imagine let alone to describe; and this is to say nothing of the contempt and hatred, and the anger at being vanquished, expressed in the faces and the various attitudes of those Jews. He depicted even more convincingly the fury and brutality of St Stephen's executioners, who are seizing stones of all sizes, with a fearsome grinding of teeth and with cruel and outrageous gestures. Yet St Stephen stands serene before this terrible onslaught, his face lifted towards heaven, praying with great charity and fervour to the Eternal Father for the very men who are murdering him. These concepts are all extremely fine, and they show other painters how important it is to be able to express new ideas and to convey the emotions. Fra Filippo was so expert in this respect that one cannot look at the grief-stricken attitudes of those burying St Stephen and the sad and afflicted expressions of some of the mourners without being deeply moved.

On the other side of the chapel he painted scenes from the life of John the Baptist: the Nativity, the Preaching in the Wilderness, the Baptism, the Feast of Herod, and the Beheading. The light of divine inspiration shines from the face of the preacher and the various gestures of the crowd express the joy and sorrow of the men and women held and absorbed by the ministrations of St John. Beauty and goodness are apparent in the Baptism scene; and in the picture of Herod's banquet we see depicted all the sumptuousness of this occasion, along

with the skill of Herodias, the stupor of the guests and the horrified consternation caused when the head is offered on a charger. About the table Fra Filippo painted a great many figures, in very expressive poses, with beautifully executed draperies and expressions. Among them he included a portrait of himself, drawn with a mirror, clothed in the black habit of a priest; and in the scene showing the mourning for St Stephen he showed his pupil, Fra Diamante. (This work was certainly his best for the reasons I have already given and also because in it he made the figures somewhat larger than life; and this prompted those who came after him to paint with more grandeur. Fra Filippo was so highly regarded for his good qualities and his virtuosity that the many blameworthy circumstances in his life were passed over in silence.) He also portrayed in the work I have been discussing Cosimo de' Medici's natural son, Carlo, at that time the provost of the church, which received many benefactions from him and his family.

After he had finished these frescoes, Fra Filippo, in 1463, painted a panel in tempera for the church of San Jacopo at Pistoia, containing a very beautiful Annunciation, with a lively portrait of Jacopo Bellucci, who commissioned the work. In the house of Pulidoro Bracciolini there is a picture by Fra Filippo of the Birth of Our Lady; and for the hall of the Tribunal of the Eight at Florence he painted in tempera a Madonna and Child on a lunette. There is a very beautiful Madonna from his hand in the house of Lodovico Capponi; and in the possession of Bernardo Vecchietti, a Florentine gentleman of outstanding accomplishment and merit, is a beautiful little picture of his, showing St Augustine at his studies. Finer still is the St Jerome in Penitence, a picture of the same size which is in Duke Cosimo's wardrobe.

All Fra Filippo's work was outstanding, but in his smaller paintings he excelled even himself, producing pictures of incomparable grace and beauty, as we can see in all the predellas he did for his panels. His stature as a painter was such that none of his contemporaries and few modern painters have surpassed him. Michelangelo himself has always sung his praises and in many particulars has even imitated him. One of

the paintings Fra Filippo did was for the church of San Domenico Vecchio at Perugia, a panel (subsequently placed on the high altar) containing a Madonna, St Peter, St Paul, St Louis, and St Anthony Abbot. And Alessandro degli Alessandri, a knight of that time and a friend of Fra Filippo's, commissioned from him, for the church of his villa at Vincigliata on the hillside of Fiesole, a panel depicting St Lawrence and other saints, among whom he painted Alessandro and two sons of his.

Fra Filippo liked to have cheerful people as his friends and himself lived a very merry life. He taught the art of painting to Fra Diamante, who executed many pictures for the Carmine at Prato and by imitating his master's style very closely achieved the highest perfection. Among those who studied with Fra Filippo in their youth were Sandro Botticelli, Pesellino, and Jacopo del Sellaio of Florence, who painted two panel pictures for San Frediano and one for the Carmine, in tempera. There were countless other artists to whom he affectionately taught the art of painting. He lived honourably from his work and he spent extravagantly on his love affairs, which he pursued all his life until the day he died.

Through the mediation of Cosimo de' Medici, Fra Filippo was asked by the commune of Spoleto to decorate the chapel in their principal church, dedicated to Our Lady. Working with Fra Diamante he made excellent progress, but he died before he could finish: they say that in one of those sublime love affairs he was always having the relations of the woman concerned had him poisoned. At any rate, Fra Filippo ended this life at the age of fifty-seven in the year 1438.

In his will he left his son Filippo, who was then ten years old, to the care of Fra Diamante, who brought the boy back to Florence and taught him the art of painting. On his return to Florence Fra Diamante took with him three hundred ducats that were owing from the commune, giving some of them to the boy and using the rest to buy things for himself. Filippo was placed with Sandro Botticelli, who was then regarded as a first-rate artist; and Fra Filippo himself was buried in a tomb of red-and-white marble erected by the people of Spoleto in the church he had painted.

Fra Filippo's death deeply grieved his many friends, especially Cosimo de' Medici and Pope Eugene. When he was alive the Pope wanted to give him a dispensation so that he could make Lucrezia, Francesco Buti's daughter, his legitimate wife; but as he wanted to stay free and give full rein to his desires Fra Filippo refused the offer. During the lifetime of Sixtus IV, Lorenzo de' Medici, who had been made an ambassador of Florence, went to Spoleto to ask the citizens for permission to remove Fra Filippo's body to Santa Maria del Fiore at Florence; but they told him that Spoleto lacked any great marks of distinction and especially the adornment of eminent men; and so they asked him as a favour to allow them to keep Filippo's body to honour Spoleto, adding that Florence had countless famous citizens, almost a superfluity, and so it could do without this one. So Lorenzo failed to get what he wanted. However, subsequently he determined to pay him the greatest honour he could, and he sent his son, Filippino, to Rome to decorate a chapel in his father's memory for the cardinal of Naples. On his way through Spoleto, Filippino was commissioned by Lorenzo to construct a marble tomb under the organ over the sacristy; and on this he spent a hundred gold ducats which were paid by Nofri Tornabuoni, director of the Medici Bank. He obtained from Angelo Politian the following epigram, which was carved on the tomb in antique letters:

> *Conditus hic ego sum picturae fama Philippus,*
> *Nulli ignota meae est gratia mira manus.*
> *Artifices potuit digitis animare colores,*
> *Sperataque animos fallere voce diu.*
> *Ipsa meis stupuit natura expressa figuris,*
> *Meque suis fassa est artibus esse parem.*
> *Marmoreo tumolo Medices Laurentius hic me*
> *Condidit, ante humili pulvere tectus eram.*[1]

1. Here in this place do I, Filippo, rest
 Enshrin'd in token of my art's renown.
 All know the wondrous beauty of my skill;
 My touch gave life to lifeless paint, and long
 Deceiv'd the mind to think the forms would speak.

Fra Filippo was a first-rate draughtsman, as can be seen in our book of drawings by the most famous painters, notably in some sheets containing his design for the picture of Santo Spirito and others showing the chapel of Prato.

> Nature herself, as I reveal'd her, own'd
> In wonderment that I could match her arts.
> Beneath the lowly soil was I interr'd
> Ere this; but now Lorenzo Medici
> Hath laid me here within this marble tomb.

LIFE OF
SANDRO BOTTICELLI

Florentine painter, c. 1445–1510

IN the time of the elder Lorenzo de' Medici, Lorenzo the Magnificent, truly a golden age for men of talent, there flourished an artist called Alessandro (which we shorten to Sandro), whose second name, for reasons we shall see later, was Botticelli. He was the son of a Florentine, Mariano Filipepi, who brought him up very conscientiously and had him instructed in all those things usually taught to young children before they are apprenticed. However, although he easily mastered all that he wanted to, the boy refused to settle down or be satisfied with reading, writing, and arithmetic; and finally, exasperated by his son's restless mind, his father apprenticed him as a goldsmith to a close companion of his own called Botticelli, who was a very competent craftsman. Now at that time there was a very close connexion – almost a constant intercourse – between the goldsmiths and the painters, and so Sandro, who was a very agile-minded young man and who had already become absorbed by the arts of design, became entranced by painting and determined to devote himself to it. He told his father about his ambition, and Mariano, seeing the way his mind was inclined, took him to Fra Filippo of the Carmine, a great painter of that time, and, as Sandro himself wished, placed him with Fra Filippo to study painting.

Botticelli threw all his energies into his work, following and imitating his master so well that Fra Filippo grew very fond of him and taught him to such good effect that very soon his skill was greater than anyone would have anticipated. While still a young man Botticelli painted in the Mercanzia of Florence, among the pictures of virtues executed by Antonio and Piero Pollaiuolo, a figure representing Fortitude. In Santo Spirito in Florence, for the Bardi Chapel, he did a panel picture, very carefully painted and beautifully finished, with some

olive trees and palms depicted with loving care. He also painted a panel picture for the Convertite Convent and another for the nuns of Santa Barnaba. In the church of Ognissanti, in the gallery by the door leading to the choir, he painted for the Vespucci family a fresco of St Augustine, over which he took very great pains in an attempt to surpass all his contemporaries but especially Domenico Ghirlandaio, who had painted a St Jerome on the other side. This work was very favourably received, for Botticelli succeeded in expressing in the head of the saint that air of profound meditation and subtle perception characteristic of men of wisdom who ponder continuously on difficult and elevated matters. As I said in my *Life* of Ghirlandaio, this year (1564) this painting of Botticelli's was removed safe and sound from its original position.

Because of the credit and reputation he acquired through his St Augustine, Botticelli was commissioned by the Guild of Porta Santa Maria to do a panel picture for San Marco showing the Coronation of Our Lady surrounded by a choir of angels, which he designed and executed very competently. He also carried out many works in the house of the Medici for Lorenzo the Magnificent, notably a life-size Pallas on a shield wreathed with fiery branches, and a St Sebastian. And in Santa Maria Maggiore at Florence, beside the chapel of the Panciatichi, there is a very beautiful Pietà with little figures.

For various houses in Florence Botticelli painted a number of round pictures, including many female nudes, of which there are still two extant at Castello, Duke Cosimo's villa, one showing the Birth of Venus, with her Cupids, being wafted to land by the winds and zephyrs, and the other Venus as a symbol of spring, being adorned with flowers by the Graces; all this work was executed with exquisite grace. In the Via de' Servi around a room in Giovanni Vespucci's house (which now belongs to Piero Salviati) Botticelli painted several pictures showing many beautiful and very vivacious figures, which were enclosed in walnut panelling and ornamentation. In the house of the Pucci he illustrated – with various little figures in four paintings of considerable charm and beauty – Boccaccio's story about Nastagio degli Onesto,[1] and he also

1. *Decameron*, 5th day, *novella* 8.

did a circular picture of the Epiphany. For a chapel belonging to the monks of Cestello he did a panel picture of the Annunciation. Then for San Piero Maggiore, by the side door, he did a panel for Matteo Palmieri, with a vast number of figures, showing the Assumption of Our Lady and the circles of heaven, the patriarchs, prophets and apostles, the evangelists, martyrs, confessors, doctors, virgins, and the hierarchy of angels, all taken from a drawing given to him by Matteo, a very learned and talented man. Botticelli painted this work with exquisite care and assurance, introducing the portraits of Matteo and his wife kneeling at the foot. Although the painting is so great that it should have silenced envy, it provoked some malevolent critics to allege, not being able to fault it on any other score, that both Matteo and Sandro had fallen into the sin of heresy. Whether this was so or not I am not the one to say; it is enough for me that the figures which Sandro painted in this picture are admirable for the care lavished on them, and the manner in which he has shown the circles of the heavens, introducing foreshortenings and intervals between his variously composed groups of angels and other figures, and executing the whole work with a fine sense of design.

At that time Sandro was commissioned to paint a small panel, with figures a foot and a half in length, which was placed in Santa Maria Novella between two doors in the principal façade on the left as one goes in by the centre door. The subject is the Adoration of the Magi, and the picture is remarkable for the emotion shown by the elderly man as he kisses the foot of Our Lord with wonderful tenderness and conveys his sense of relief at having come to the end of his long journey. This figure, the first of the kings, is a portrait of the elder Cosimo de' Medici, and it is the most convincing and natural of all the surviving portraits. The second king (a portrait of Giuliano de' Medici, the father of Pope Clement VII) is shown doing reverence with utterly absorbed devotion as he offers his gift to the Child. The third, also on his knees, is shown gratefully adoring the Child whom he acknowledges as the true Messiah; and this is Cosimo's son, Giovanni. The beauty of the heads that Sandro painted in this picture defies description: they are shown in various poses, some full-face,

some in profile, some in three-quarters, some looking down, with a great variety of expressions and attitudes in the figures of young and old, and with all those imaginative details that demonstrate the artist's complete mastery of his craft. For Botticelli clearly distinguished the retinues belonging to each of the three kings, producing in the completed work a marvellous painting which today amazes every artist by its colouring, its design, and its composition.

His Adoration of the Magi made Botticelli so famous, both in Florence and elsewhere, that Pope Sixtus IV, having finished the building of the chapel for his palace at Rome and wanting to have it painted, decided that he should be put in charge of the work. So Botticelli himself painted the following scenes for the chapel: Christ tempted by the devil; Moses slaying the Egyptian and accepting drink from the daughters of Jethro the Midianite; fire falling from heaven on the sacrifice of the sons of Aaron; and several portraits of canonized Popes in the niches above. Having won even greater fame and reputation among the many competitors who worked with him, artists from Florence and elsewhere, Botticelli was generously paid by the Pope; but living in his usual haphazard fashion he spent and squandered all he earned during his stay in Rome. Then, when he had finished and unveiled the work he had been commissioned, he immediately returned to Florence where, being a man of inquiring mind, he completed and printed a commentary on a part of Dante, illustrating the *Inferno*. He wasted a great deal of time on this, neglecting his work and thoroughly disrupting his life. He also printed many of his other drawings, but the results were inferior because the plates were badly engraved; the best was the Triumph of the Faith of Fra Girolamo Savonarola of Ferrara. Botticelli was a follower of Savonarola's, and this was why he gave up painting and then fell into considerable distress as he had no other source of income. None the less, he remained an obstinate member of the sect, becoming one of the *piagnoni*, the snivellers, as they were called then, and abandoning his work; so finally, as an old man, he found himself so poor that if Lorenzo de' Medici (for whom he had among other things done some work at the little hospital at

Volterra) and then his friends and other worthy men who loved him for his talent had not come to his assistance, he would have almost died of hunger.

One of Sandro's paintings, a very highly regarded work to be found in San Francesco outside the Porta a San Miniato, is a Madonna in a circular picture with some angels, all life-size.

He was a very good-humoured man and much given to playing jokes on his pupils and friends. For example, the story goes that one of his pupils, called Biagio, painted a circular picture exactly like the one of Botticelli's mentioned above, and that Sandro sold it for him to one of the citizens for six gold florins; then he found Biagio and told him:

'I've finally sold this picture of yours. So now you must hang it up high this evening so that it looks better, and then tomorrow morning go along and find the man who bought it so that you can show it to him properly displayed in a good light, and then he'll give you your money.'

'Oh, you've done marvellously,' said Biagio, who then went along to the shop, hung his picture at a good height, and left. In the meantime, Sandro and another of his pupils, Jacopo, had made several paper hats (like the ones the citizens wore) which they stuck with white wax over the heads of the eight angels that surrounded the Madonna in his picture. Then, when the morning came, Biagio arrived with the citizen who had bought the painting (and who had been let into the joke). They went into the shop, where Biagio looked up and saw his Madonna seated not in the midst of angels but in the middle of the councillors of Florence, all wearing their paper hats! He was just about to roar out in anger and make excuses when he noticed that the man he was with had said nothing at all, and was in fact starting to praise the picture . . . so Biagio kept quiet himself. And at length he went home with him and was given his six florins, as the price agreed by Botticelli. Then he went back to the shop, a moment or two after Sandro and Jacopo had removed those paper hats, and he found that the angels he had painted were angels after all and was so stupefied that he was at a loss for words. Eventu-ally he turned to Sandro and said:

'Sir, I don't know if I'm dreaming or if this is reality, but when I was here earlier those angels were wearing red hats, and now they're not. What's the meaning of it?'

'You've taken leave of your senses,' said Sandro. 'All that money has gone to your head. If what you say were true, do you think he'd have bought your picture?'

'That's so,' said Biagio, 'He didn't say a word. But all the same it struck me as very strange.'

Then all the other apprentices flocked round him and convinced him that he had had some kind of giddy spell.

Another time, a cloth-weaver moved into the house next to Sandro's and set up no less than eight looms which when they were working not only deafened poor Sandro with the noise of the treadles and the movement of the frames but also shook his whole house, the walls of which were no stronger than they should be. What with one thing and the other, he couldn't work or even stay in the house. Several times he begged his neighbour to do something about the nuisance, but the weaver retorted that in his own home he could and would do just what he liked. Finally, Sandro grew very angry, and on top of his roof, which was higher than his neighbour's and not all that substantial, he balanced an enormous stone (big enough to fill a wagon) which threatened to fall at the least movement of the wall and wreck the man's roof, ceilings, floors, and looms. Terrified at the prospect the cloth-weaver ran to Sandro only to be told, in his own words, that in his own house Botticelli could and would do just what he wanted to. So there being nothing else for it the man was obliged to come to reasonable terms and make himself a good neighbour.

According to another anecdote, for a joke Sandro once denounced one of his friends to the vicar as a heretic. The man appeared and demanded to know who had accused him and of what. When he was told that his accuser was Sandro, who had alleged that he believed with the Epicureans that the soul dies with the body, he demanded to see him before the judge. And when Sandro appeared on the scene, he said:

'Certainly that is what I believe as far as this man is concerned, seeing that he's a brute. But apart from that, isn't it he

who is the heretic, since although he scarcely knows how to read and write he did a commentary on Dante and took his name in vain?'

It is also said of Sandro that he was extraordinarily fond of any serious student of painting, and that he earned a great deal of money but wasted it all through carelessness and lack of management. Anyhow, after he had grown old and useless, unable to stand upright and moving about with the help of crutches, he died, ill and decrepit, at the age of seventy-eight, and he was buried in Ognissanti in Florence.[1]

In Duke Cosimo's wardrobe there are two very beautiful female heads in profile by Botticelli, one of which is said to be the mistress of Lorenzo's brother, Giuliano de' Medici, and the other, Madonna Lucrezia de' Tornabuoni, Lorenzo's wife. In the same place there is a Bacchus of Sandro's, a very graceful figure shown raising a cask with both hands and putting it to its lips. In the Duomo at Pisa, in the chapel of the Impagliata, he started an Assumption with a choir of angels, but it displeased him and he left it unfinished. In San Francesco at Montevarchi he did the panel for the high altar, and he also did two angels for the parish church at Empoli, on the same side as Rossellino's St Sebastian.

Botticelli was one of the first to find out how to make standards and other draperies by plaiting the material so that the colours show on both sides without running. That was how he made the baldachin of Orsanmichele, full of Madonnas, all different and all beautiful. It is clear that this method of treating the cloth preserves the work better than the use of acids, which eat the material away, even though because of its relative cheapness the latter is nowadays the more usual technique.

Sandro was an uncommonly good draughtsman and, in consequence, for some time after his death artists used to search out his drawings, and I have some of them in my book which show great skill and judgement. In the scenes he did he made a lavish use of figures, as can be seen in the decorative work he designed for the frieze of the processional cross of the friars of Santa Maria Novella.

1. Botticelli died in 1510, aged sixty-five.

Altogether, Sandra Botticelli's pictures merited the highest praise; he threw himself into his work with diligence and enthusiasm, as can be seen in the Adoration of the Magi in Santa Maria Novella, which I described earlier and which is a marvellous painting. Also very fine is the small circular picture by Sandro that can be seen in the prior's room in the Angeli at Florence, the figures being tiny but very graceful and beautifully composed. A Florentine gentleman, Fabio Segni, has in his possession a painting of the same size as the panel picture of the Magi; the subject is Apelles' Calumny. He himself gave this unimaginably beautiful painting to his close friend, Antonio Segni, and underneath it can be read these lines by Fabio:

> Iudicio quemquam ne falso laedere tentent
> Terrarum reges, parva tabella monet.
> Huic similem Aegypti regi donavit Apelles;
> Rex fuit et dignus munere, munus eo.[1]

1. This little picture warns the rulers of the earth
 To shun the tyranny of judgement false.
 Apelles gave its like to Egypt's king; that king
 Was worthy of the gift, and it of him.

ANDREA DEL VERROCCHIO

Florentine painter, sculptor, and architect, c. 1435–88

ANDREA DEL VERROCCHIO of Florence was at once a gold-
smith, a master of perspective, a sculptor, a woodcarver, a
painter, and a musician. It must be admitted that the style of
his sculpture and painting tended to be hard and crude, since
it was the product of unremitting study rather than of any
natural gift or facility. But because of his intense studies and
diligence even if he had completely lacked any natural facility
Andrea would have excelled in those arts. To produce perfect
work, painters and sculptors need both application and
natural talent: unless both these are present, the artist very
rarely reaches the first rank. All the same, application is the
more important of the two, and as Andrea possessed it in
abundance, more than any other craftsman, he is counted
among our finest and most outstanding artists.

When he was young Andrea studied the sciences, and es-
pecially geometry. Among the many other things he made
while he was working as a goldsmith were some morses
which are to be found in Santa Maria del Fiore in Florence;
and he also made some larger works, notably a cup, decorated
with great numbers of animals and garlands and with other
imaginative details, the mould of which still exists and is used
by all the goldsmiths. On another cup that he made there is a
very beautiful group of dancing children. After he had pro-
vided these examples of what he could do, the Merchants
Guild commissioned from him two silver reliefs for the ends
of the altar of San Giovanni which when they were finished
won him great praise and fame.

Now at that time there was a need to replace some of the
large statues of the apostles belonging to the altar of the Pope's
Chapel in Rome, as well as several other works in silver that
had been destroyed. So Pope Sixtus sent for Andrea and did

him the honour of commissioning from him all that was wanted; and Andrea did the work perfectly, with wonderful care and judgement. While he was in Rome, Andrea saw the very high value that was put on the many statues and other antiques being discovered there and the way the Pope had the bronze horse set up in St John Lateran, as well as the attention given to even the bits and pieces, let alone the complete works of sculpture, that were being unearthed every day.[1] So he made up his mind to devote himself to sculpture and abandon his work as a goldsmith. He first cast some small figures in bronze and was then encouraged by the praise they received to do some work in marble. Just at that time, the wife of Franceso Tornabuoni died in childbirth and her husband, who had loved her dearly and wanted to honour her memory as best he could, asked Andrea to make her monument. He carved her effigy in stone on a marble sarcophagus, representing her confinement and her departure to another life and showing the three Virtues, which were regarded as very fine since this was his first work in marble. The tomb was afterwards placed in the Minerva.

Andrea then returned with money, fame, and honour to Florence, where he was commissioned to make a bronze statue of David, five feet in height, which after it was finished was placed, much to his credit, at the head of the staircase in the Palazzo della Signoria, where the chain used to be. While he was working on this he also made that marble statue of Our Lady which is over the tomb of Leonardo Bruni of Arezzo, in Santa Croce. He did this while he was still a young man for the architect and sculptor Bernardo Rossellino, who, as I said elsewhere, carried out the entire work in marble. Andrea also made a half-length Madonna and Child in half relief on a marble panel which used to be in the house of the Medici and is now kept, as a work of great beauty, over one of the doors in the apartment of the duchess of Florence. He also did two separate bronze heads in half relief, one of Alexander the Great in profile, the other a fanciful portrait of Darius, with contrasted crests, armour, and so forth. Both

1. This 'bronze horse' was the equestrian statue of Marcus Aurelius, which Michaelangelo subsequently had removed to the Capitol.

these heads along with various other works were sent by
Lorenzo the Magnificent to King Matthias Corvinus of
Hungary.

These works (and especially the bronze sculpture which he
loved doing) greatly enhanced Andrea's reputation, and then
for Giovanni and Piero de' Medici he made a bronze tomb in
San Lorenzo, completely in the round, with a porphyry
sarcophagus supported by four bronze corner-pieces with
twisting foliage, finely wrought and finished with wonderful
care. This tomb stands between the chapel of the Blessed
Sacrament and the sacristy, and it would be impossible for
anyone to make a better bronze cast, especially as Andrea also
displayed his talent as an architect by placing the tomb within
the embrasure of a window about ten feet wide and twenty
feet in height and setting it on a base that divides the chapel
of the Blessed Sacrament from the old sacristy. Over the sarco-
phagus, closing the embrasure up to the vaulting, he con-
structed a network of bronze ropes in the form of *mandorle*, all
very natural looking, and adorned here and there with
festoons and other remarkable and imaginative ornaments,
devised with great skill, judgement and invention. Meanwhile
Donatello had made for the Tribunal of Six of the Mercanzia
the marble shrine which is now opposite the St Michael in the
oratory of Orsanmichele; but nothing was done about the
bronze statue of St Thomas feeling for the wound in the side
of Christ because some of the men responsible wanted the
work to go to Donatello whereas others wanted Lorenzo
Ghiberti to do it. Matters stayed like this as long as Donatello
and Lorenzo were alive, but eventually Andrea was asked to
make the two statues. So he made models and moulds and
cast them very successfully, producing figures that were solid,
complete, and beautifully fashioned. Then he polished and
finished them, bringing them to the incomparable perfection
we can see today. In the figure of St Thomas the artist has
expressed incredulity and impatience to know the truth, along
with the love that compels the saint to place his hand, with
beautiful effect, in the side of Christ; and in Christ himself,
who with a gesture of wonderful spontaneity is raising one
arm and opening his garment to dispel the doubts of his

incredulous disciple, there is seen, so to say, all the grace and divinity that art can convey. The drapery of these statues, so beautiful and well-arranged, convinces one that Andrea understood the craft as much as Donatello, Lorenzo, and the others who had lived before him. This work was certainly worthy of being set up in a shrine made by Donatello and of the honour and praise that have always been accorded it.

By now Andrea had such a fine reputation as a sculptor that there was nothing left for him to achieve; and as he was a man who could never be content with excelling in only one of the arts but wanted to win distinction in others, he began to study painting. He made some excellent cartoons for a scene of nude figures in combat to be painted on a wall. Then he did the cartoons for some pictures which he started to paint himself; but for whatever reason they were not finished. In my book I have some of his drawings, made with the greatest patience and judgement, among which are several female heads with lovely expressions and hair which Leonardo da Vinci was always imitating for their beauty. I also have two drawings of horses, with the measures and protractors for reproducing them in the right proportions on a larger scale, as well as a very precious horse's head in terracotta copied from the antique. The Very Reverend Don Vincenzo Borghini has some other drawings on paper in his book which I mentioned earlier. Among these is the design for a tomb which Andrea did for one of the doges in Venice, a picture of the Magi adoring Christ, and an extremely charming female head, painted on paper.

For the fountain of Lorenzo de' Medici's villa at Careggi Andrea made the bronze figure of a boy hugging a fish which, as we can see today, the Lord Duke Cosimo has had erected on the fountain in the courtyard of his palace and which is truly a marvellous piece of work.

Now after the cupola of Santa Maria del Fiore had been finished it was resolved, following a great deal of discussion, that work should start on the copper ball which, according to the instructions left by Filippo Brunelleschi, was to be placed on the summit. Andrea was given the commission, and he made the ball eight feet high, balancing it securely on a boss,

so that it could safely support the cross. When everything was ready the ball was put in place, to the great joy and satisfaction of the people. The work required a great deal of care and ingenuity, so that it would be possible, as it is, to enter the ball from below and to make it proof against any damage from the wind.

Andrea never gave himself a moment's rest from painting or sculpture, very often leaving one kind of work for the other to avoid growing weary, as so many do, of always working at the same thing. Although he never used the cartoons I mentioned, he did paint several pictures, including a panel picture for the nuns of San Domenico of Florence, with which he was more than pleased. So shortly afterwards he did another panel picture, this time in San Salvi for the monks of Vallombrosa, showing the Baptism of Christ by St John. In this work he was assisted by the young Leonardo da Vinci, who was then his pupil. The angel which Leonardo painted was so superior to the rest of the work that Andrea resolved he would never take up a brush again, seeing that the young Leonardo had shown himself to be a far better craftsman.

On one occasion Cosimo de' Medici, having received a number of antiquities from Rome, set up inside the door of his garden, or rather courtyard, which opens on the Via de' Ginori, a very beautiful Marsyas of white marble, bound to a tree and ready to be flayed. His grandson Lorenzo had come into possession of the head and torso of another very ancient statue of Marsyas, in red stone, which was far more beautiful than the first, and he wanted to place the two together; but he could not do so as the second figure was so imperfect. So he gave the statue to Andrea to be restored and completed; and Andrea made the missing legs, thighs, and arms out of pieces of red marble so skilfully that Lorenzo was more than satisfied and was able to place it opposite the other, on the other side of the door. This antique torso, showing the flayed body of Marsyas, was made with such care and judgement that some slender white veins in the red stone were brought out, by skilful carving, in exactly the right places, appearing like the tiny sinews that are revealed when a human body is

flayed. When it had its original finish, this work must have been absolutely true to life.

Meanwhile, the Venetians resolved to do honour to the prowess of Bartolommeo da Bergamo, who had won many victories for them, in order to encourage others to emulate him; and having heard of Andrea's fame they persuaded him to visit Venice, where he was given instructions to make a bronze equestrian statue of that captain for the piazza di SS. Giovanni e Paolo. Andrea made the model for the horse and had started to construct the armature to cast it in bronze when, thanks to the influence of certain gentlemen, it was decided that Vallano da Padova should make the figure and Andrea the horse. When he heard this Andrea smashed the legs and head of his model and returned in a rage to Florence without saying a word. And when the Signoria heard what had happened they gave him to understand that he had better not return to Venice or they would cut his head off. To this Andrea wrote in reply that he would take good care not to, seeing that once they had cut it off they had no way of putting a man's head back again, certainly not one like this; whereas he would have been able to replace the head of the horse, and with something more beautiful at that. After they received this answer (which did not displease them) they brought him back to Venice and doubled his salary. Andrea then restored the first model and cast it in bronze, without, however, finishing it completely, for when he was casting it he caught a chill and died within a few days, while still in Venice. He left unfinished not only the bronze horse (which was nearly ready, however, and was set up in its appointed place) but also another work which he was doing in Pistoia, namely, the tomb of Cardinal Forteguerri, with the three theological virtues and God-the-Father, which was subsequently finished by the Florentine sculptor, Lorenzo Lotti.

Andrea was fifty-six when his death plunged into grief his many friends and pupils, and especially Nanni Grosso the sculptor, a very eccentric person both as a man and an artist. It is said that Grosso would never accept a commission if it meant leaving his workshop, especially if it were for the monks or friars, unless he were given free access to their

vaults or cellar, so that he could go and drink whenever he wanted without asking permission. According to another story, he recovered his health after he had been suffering from some illness or other at Santa Maria Novella only to tell his friends, when they visited him and asked how he was, that he was very poorly.

'But you've been cured,' they protested.

To which he retorted: 'That's just why I have to be poorly, because I need a touch of fever to stay in hospital nice and comfortable.'

Then when he came to die in the hospital they brought him a badly made crucifix, but he begged them to take the ugly thing away and instead bring him one made by Donatello, insisting that if they didn't do so he would die in despair, he so detested the sight of bad works of art.

Other pupils of Andrea were Piero Perugino, Leonardo da Vinci (who will be discussed later) and Francesco di Simone of Florence, who made for the church of San Domenico in Bologna a marble tomb with numerous little figures, which from their style might be by Andrea. This tomb was made for Alessandro Tartagni, a doctor of law of Imola, and Francesco did another like it between the sacristy and one of the chapels of San Pancrazio in Florence for a knight called Pier Minerbetti.

Agnolo di Polo was also trained by Andrea. He was a skilful worker in clay who filled the city with his productions and would have done some very fine work if he had attended to sculpture seriously.

But most of all Andrea loved Lorenzo di Credi. It was Lorenzo who brought his remains from Venice and laid them in Sant'Ambrogio, in the tomb of Michele di Cione over whose monument are carved these words:

> Ser Michaelis de Cionis et suorum;

and then:

> Hic ossa jacent Andreae Verrocchii qui obiit
> Venetiis MCCCCLXXXVIII.[1]

1. The tomb of Michele di Cione, and his kin.
 Here lie the bones of Andrea Verrocchio, who died at Venice, 1488.

Andrea was very fond of making plaster casts, for which he used a soft stone quarried in the districts of Volterra and Siena and in many other parts of Italy. When this stone is baked in the fire, and then crushed and made into a paste with tepid water, it becomes so soft that it can be fashioned into whatever shape is wanted, and then when it has dried out it sets so hard that whole figures can be cast from it. In the moulds he made from this stone Andrea used to cast various natural forms, such as knees, legs, arms, and torsos, which he kept by him for copying purposes. Then, during Andrea's ifetime, the custom started of doing inexpensive casts of the heads of those who died; and so one can see in every house in Florence, over the chimney-pieces, doors, windows, and cornices, endless examples of such portraits, so well made and natural that they seem alive. This practice has been continued until the present day and has proved extremely useful in making available to us the portraits of many of those who appear in the scenes painted in Duke Cosimo's palace. For this we are greatly indebted to the talents of Andrea, who was one of the first to use such casts.

From Andrea also came the technique of making far more perfect images not only in Florence but also in every centre of devotion where the faithful come in thanksgiving with their votive offerings or 'miracle pictures' as they are called. Formerly these were small and made in silver, or on small painted panels or crudely fashioned in wax; then in Andrea's time a far better style was introduced. What happened was that Andrea was very friendly in Florence with a skilful craftsman in waxwork called Orsino, who started to teach him how to attain perfection in that craft. Then when Giuliano de' Medici was killed and his brother Lorenzo wounded in Santa Maria del Fiore, Lorenzo's friends and relations ordered that, in thanksgiving to God for his preservation, images of him should be set up throughout the city. So for his part Orsino, with the help and advice of Andrea, made three life-size figures in wax with a wooden framework (as I describe elsewhere) completed with split canes and a covering of waxed cloth, folded and arranged so well that the result was wonderfully attractive and lifelike. He then made the heads, hands,

and feet, using a coating of thicker wax, copying the features from life, and painting them in oils with the hair and other adornments. The results of this skilful work were so natural that the wax figures seemed real and alive, as can be seen today from the three figures themselves. One of them is in the church of the nuns of Chiarito, in Via di San Gallo, in front of the miraculous crucifix. This statue is dressed exactly as Lorenzo was when, bandaged and wounded at the throat, he stood at the windows of his house and showed himself to the people who had come to see whether, as they hoped, he was alive or whether they would have to avenge his death.

The second of the statues, dressed in the citizen's gown worn in Florence, is in the church of the Servites (the Annunziata) above the lower door by the table where the candles are sold. And the third was sent to Santa Maria degli Angeli in Assisi and set up in front of the Madonna. This was where (as I described elsewhere) Lorenzo de' Medici had the street running from Santa Maria to the gate facing San Francesco paved with bricks; he also restored the fountains that his grandfather Cosimo had erected there.

But to return to the waxwork figures: in the church of the Servites all those made by Orsino are marked at the base with a large O with an R inside and a cross above, and they are all so beautifully made that there have been few to compare with them since. The craft has been kept alive until the present day but it is now falling into disuse, either through lack of devotion or for some other reason.

However, I must return to Verrocchio himself. As well as all the work I have mentioned, he did some wooden crucifixes and various other things in terracotta in which he certainly excelled, as we can see from the models for the reliefs that he did for the altar of San Giovanni and from some very beautiful *putti*, as well as from a head of St Jerome which is regarded as truly marvellous. Verrocchio also made the boy on the clock in the New Market whose arms are raised to sound the hours with a hammer held in his hands; at the time, this was considered very attractive and novel. And now we have come to the end of the biography of that most distinguished sculptor, Verrocchio.

LIFE OF

ANDREA MANTEGNA

Painter of Mantua, c. 1431–1506

As is known by every ambitious and reasonably successful artist, generosity is a powerful spur to talent. Craftsmen work all the harder, ignoring fatigue and discomfort, when they can hope for the rewards and honours which foster their talents and make them better known. It is certainly true that genius is not always recognized and rewarded as it was in the case of Andrea Mantegna, an artist who was born of very humble stock in the Mantua district, working in the fields as a boy and yet (as I shall describe) rising to the rank of a knight through his own efforts and good fortune.

When he was nearly grown up Andrea was taken to the city, where he studied painting under Jacopo Squarcione,[1] a Paduan painter, who welcomed him into his house, and shortly afterwards, perceiving the boy's intelligence, adopted him as his own son, as Girolamo Campagnuola writes in a letter written in Latin to Leonido Tomeo, in which he tells him about some of the old painters who used to serve the Carrara dynasty in Padua. Squarcione knew that he himself was not the world's greatest painter, and so in order to help Andrea learn more than he could teach he made him study from casts taken from antique statues and from pictures painted on canvas which he sent for from various places, but especially Tuscany and Rome. Andrea learned a great deal by this and other means while he was still young. And he was also given no little help and incentive by the competition he met from Marco Zoppo of Bologna, Dario da Treviso, and Niccolò Pizzolo of Padua, who were all pupils of his master and adoptive father.

Now before he was even seventeen Andrea painted the panel for the high altar of Santa Sofia in Padua, producing a

1. In fact, under Francesco Squarcione.

picture worthy of a mature and experienced craftsman. And when Squarcione was commissioned to decorate the chapel of St Christopher, in the Eremitani Church of Sant'Agostino in Padua, he handed the work over to Niccolo Pizzolò and Andrea. Niccolò depicted God-the-Father seated in majesty between the Doctors of the Church, and his paintings were subsequently regarded as the equal of anything that Andrea did there. Indeed, although his output was meagre it was all excellent, and if he had enjoyed handling a brush as much as he did a sword, Niccolò would have been a great and almost certainly a longer-lived artist; but he always went about armed and he had many enemies, and one day on his way home from work he was treacherously attacked and killed. The only other work of his that I know of is another painting of God-the-Father in the chapel of the city governor.

Left to finish the work by himself, Andrea did a fresco painting of the four evangelists, which was very highly regarded. Because of this and his other paintings great things were expected of him, and the success he eventually achieved was confidently predicted. The Venetian painter, Jacopo Bellini (the father of Gentile and Giovanni and a rival of Squarcione) contrived to get Andrea to marry his daughter, Gentile's sister. But when Squarcione heard of this he was so angry with Andrea that they were enemies from then on; and just as before he was always praising Andrea's paintings, so now he spent all his time criticizing them unfavourably in front of everyone. He singled out for attack the paintings that Andrea had done in the chapel of St Christopher, saying that they were inferior work since when he did them Andrea had imitated marble statues. Stone, said Squarcione, was essentially a hard substance and it could never convey the softness and tenderness of flesh and natural objects, with their various movements and folds. Andrea would have done far better, he suggested, if he had painted his figures not in various colours but just as if they were made of marble, seeing that his pictures resembled ancient statues and suchlike things rather than living creatures.

This censure enraged Andrea, but all the same it proved very useful because he realized that there was a lot of truth in

what Squarcione said and he started to practise portraying living people. He made so much progress that in one of the scenes he still had to do in the chapel his use of nature and living things was as effective as his derivations from art. None the less, Andrea still held to the opinion that the statues of antiquity were more perfect and composed of more beautiful elements than anything in living nature; it was his theory, confirmed by what he saw with his own eyes, that the sculptors of the ancient world had used several living models to create the perfection and beauty which nature rarely brings together in a single form: they found it necessary to take one part from one body and another from another. As well as this, the statues he copied seemed to Andrea to be more detailed and clearly defined as regards the muscles, veins, nerves, and so forth which nature conceals with a soft covering of flesh, except in the case of the old or the emaciated whom artists anyhow for other reasons will not use as models. Andrea's fondness for this theory can be seen in his works, whose style is in fact quite sharp and sometimes suggests stone rather than living flesh.

Anyhow, in the last scene he painted for the chapel (which gave great satisfaction) Andrea portrayed Squarcione as an ugly pot-bellied figure carrying a lance and sword. He also included portraits of the Florentine Noferi, the son of Palla Stozzi, of Girolamo della Valle, a first-rate physician, of Bonifazio Frigimelica, doctor of law, Niccolò, Pope Innocent VIII's goldsmith, and Baldassare da Leccio, all close friends of his. He painted them all in a beautiful style dressed in white armour, burnished and resplendent as if it were real. He also portrayed the knight Borromeo, and a certain Hungarian bishop. (The bishop was a mad eccentric who used to wander about the streets of Rome begging all day, and lie down to sleep like an animal at night.) He introduced as well the portrait of Marsilio Pazzo, in the person of the executioner who is beheading St James, and a self-portrait. Altogether, the excellence of this work vastly increased his reputation.

While he was working on the chapel Mantegna also painted a panel picture, which was placed on the altar of St Luke in Santa Justina; and afterwards he did in fresco the arch over

the door of Sant'Antonino, where he signed his name. In Verona he painted a panel for the altar of SS. Christopher and Anthony, and he did some figures at the corner of the Piazza della Paglia. In Santa Maria in Organo, for the monks of Monte Oliveto, Andrea painted the very beautiful panel for the high altar, and he also did the altarpiece for San Zeno. Among the pictures he did, while he was working in Verona, and sent to various places, was a painting which came into the hands of the abbot of Fiesole, his friend and relation, containing a half-length Madonna and Child and the heads of some angels, who are singing. This picture, which was painted with exquisite grace, is today in the library of the monastery, where it has always been treasured. Now when he lived in Mantua Andrea had devoted himself to the service of the Marquis Lodovico Gonzaga, and that ruler, who always valued and patronized Andrea's talents, commissioned from him a little panel for the chapel of the castle of Mantua containing some small but very beautiful scenes with figures. Also in the castello of Mantua Andrea painted many figures, which he foreshortened from below upwards and which have won high praise, since although his treatment of the draperies was rather crude and finicky and his style somewhat arid the work as a whole was executed with considerable skill and diligence.[1]

For the same marquis in the hall of the Palazzo di San Sebastiano Andrea did a picture of the Triumph of Caesar, his best work ever. In this painting we can see grouped and cleverly arranged in the Triumph the ornate and beautiful chariot, the figure of a man cursing the victorious leader, the victor's relations, the perfumes, incense and sacrifices, the priests, the bulls crowned for sacrifice, the prisoners, the booty captured by the troops, the ranks of the squadrons, the elephants, the spoils, the victories, and the cities and fortresses represented in various chariots, along with a mass of trophies on spears, and with helmets and armour, headgear of all kinds, ornaments and countless pieces of plate. Among the great crowd looking on stands a woman holding by the hand a boy

1. The figures 'foreshortened from below upwards' were painted *di sotto in su* – a technique first fully developed by Mantegna – to give the illusion of bodies floating in space over the head of the spectator.

whose foot has been pierced by a thorn and who is tearfully showing it to his mother in a most graceful and natural manner. As I may have pointed out already, in this scene Andrea applied a very fine and attractive idea, setting the plane on which his figures are posed above eye-level and then placing the feet of the foremost figures on the outer edge and making the others recede gradually, so that their feet and legs vanished from view exactly in the proportions demanded. In the same way, following the laws of perspective, he showed only the lower parts of the spoils and bases and other implements and ornaments, letting the upper parts vanish from view. Andrea del Castagno very diligently took the same considerations into account when painting his Last Supper, which is in the refectory of Santa Maria Novella. So we see that at that time accomplished artists were setting themselves to the intelligent investigation and zealous imitation of the true properties of the natural world. Anyhow, in a word, Andrea's Triumph could not have been more beautiful or better executed; and if the marquis had loved him before, now he loved and honoured him beyond measure.

What is more Andrea became so famous that, after he had heard of his excellence as a painter and of the other fine qualities with which he was so marvellously endowed, Pope Innocent VIII sent for him (just as he was sending for many others) to decorate the walls of the Belvedere, which had just been built. So, very favourably recommended by the marquis (who had made him a knight in order to honour him still more) Andrea went to Rome where the Pope received him affectionately and immediately asked him to paint a little chapel in the Belvedere. Andrea's work on the chapel was so painstaking and he paid such loving attention to every detail that the walls and vaulting appear to have been illuminated rather than painted. The largest figures, painted like the rest in fresco, are over the altar and they represent St John baptizing Christ with a group of people showing their eagerness for baptism by taking off their clothes. Among them is the figure of a man trying to take off a stocking which has stuck to his leg with the sweat; he is drawing it off inside out, one leg crossed over the other, with the pain and exertion clearly reflected

in his face. This ingenious detail amazed everyone who saw the painting in those days.

It is said that because of the many demands made on the Pope, his holiness did not pay Mantegna as often as the artist would have liked. Then when he was painting some of the Virtues in monochrome in the chapel, Andrea introduced the figure of Prudence and was asked by the Pope, who came along one day to see the work, what it represented. When he told him, the Pope commented: 'If you want a suitable companion for her, show us Patience . . .'

The painter understood the Holy Father's meaning, and he never said another word. And when the work was finished, the Pope sent him back to the duke well favoured and rewarded.

During his stay in Rome, besides the chapel Andrea painted a small picture showing Our Lady with her Son sleeping in her arms. The background is formed by a mountain with caves in which some stone-cutters are quarrying; and Andrea depicted this scene with great patience and delicacy. Indeed, it hardly seems possible for such fine work to have been done with the brush. Today the picture is in the possession of the most illustrious lord, Don Francesco Medici, prince of Florence, who keeps it among his most treasured belongings.

I have in my book half a folio sheet with a drawing by Andrea finished in chiaroscuro and showing Judith putting the head of Holofernes into a bag held by one of her Moorish slaves. The chiaroscuro is done in a style which is no longer used, for Andrea left the paper white to serve for the lights in place of white lead, and he executed the separate hairs and other details so delicately that they might have been carefully painted with a brush. One could say, in fact, that it is a work in colour rather than a drawing.

Andrea, like Pollaiuolo, used to love doing copper engravings; and among other things he reproduced his own Triumphs in engravings which were highly valued since they were better than anything seen before.

One of the last works that Mantegna did was a panel picture for Santa Maria della Vittoria, a church built to his plans and instructions by the Marquis Francesco to commemorate

his victory on the River Taro when he commanded the Venetian forces against the French. This painting, which was done in tempera and placed on the high altar, shows the Madonna and Child seated on a pedestal, over the figures of St Michael the Archangel, St Anne, and Joachim presenting to Our Lady (who is holding her hand out to him) the marquis himself realistically portrayed from life. This work, which has never failed to give pleasure, pleased the marquis so much that he rewarded Andrea's talent and labours very generously: it was, in fact, because of the recognition he won at the courts of princes that Andrea was able all his life to maintain honourably his rank as a knight.

Among Andrea's rivals was Lorenzo da Lendinara, an artist with a considerable reputation in Padua who did some things in clay for the church of Sant'Antonio, and some other work of little consequence. And Andrea kept up a warm friendship with Dario da Trevisi and Marco Zoppo of Bologna, having trained with them under Squarcione. Marco painted a loggia for the Friars Minor at Padua, which they use for their chapter-house, and, when he was in Pesaro, a panel which is now in the new church of San Giovanni Evangelista; and he also painted a portrait of Guidobaldo da Montefeltro when Guidobaldo was a military commander for the Florentines.

Another friend of Mantegna's was the painter Stefano of Ferrara, whose works were few but good. It was he who did the ornamentation of the arch of Sant'Antonio at Padua as well as a Madonna, called the Virgin of the Pillar.

But to return to Andrea. In Mantua, he built and painted a lovely house for his own use, and he lived there happily until his death in 1517 at the age of sixty-six. He was buried honourably in Sant'Andrea, with the following epitaph placed on his tomb, over which is his portrait in bronze:

> *Esse parem hunc noris, si non praeponis, Apelli,*
> *Aenea Mantineae qui simulacra vides.*[1]

1.
 Who dost behold the statues bronze
 Of Mantegna, thou shalt know
 That verily this master ranks
 Apelles' peer, if not yet more.

Andrea was so kind and lovable that he will always be remembered not only in his own country but all over the world. He was rightly praised by Ariosto (as much for his courteous manners as for the excellence of his paintings) at the beginning of Canto XXXIII where the poet places him among the greatest painters of his time:

> Leonardo, Andrea Mantegna, Gian Bellino.

Andrea discovered a vastly improved way of painting figures in perspective from below upwards, and this was a very difficult and ingenious invention. And, as I said, he loved making copper engravings, making use of a really remarkable process which has made it possible for everyone to study not only the Bacchanalia, the battle of the sea-monsters, the Deposition of Christ, his Entombment, and his Resurrection, with Longinus and St Andrew (all works by Mantegna himself) but also the personal style of all the artists who have ever lived.

PREFACE TO PART THREE

THE distinguished artists described in the second part of these *Lives* made an important contribution to architecture, sculpture, and painting, adding to what had been achieved by those of the first period the qualities of good rule, order, proportion, design, and style. Their work was in many ways imperfect, but they showed the way to the artists of the third period (whom I am now going to discuss) and made it possible for them, by following and improving on their example, to reach the perfection evident in the finest and most celebrated modern works.

But to clarify the nature of the progress that these artists made, I would like to define briefly the five qualities that I mentioned above and discuss the origins of the excellence that has made modern art even more glorious than that of the ancient world.

By rule in architecture we mean the method used of measuring antiques and basing modern works on the plans of ancient buildings. Order is the distinction made between one kind of architectural style and another, so that each has the parts appropriate to it and there is no confusion between Doric, Ionic, Corinthian, and Tuscan. Proportion is a universal law of architecture and sculpture (and also of painting) which stipulates that all bodies must be correctly aligned, with their parts properly arranged. Design is the imitation of the most beautiful things in nature, used for the creation of all figures whether in sculpture or painting; and this quality depends on the ability of the artist's hand and mind to reproduce what he sees with his eyes accurately and correctly on to paper or a panel or whatever flat surface he may be using. The same applies to works of relief in sculpture. And then the artist achieves the highest perfection of style by copying the most beautiful things in nature and combining the most perfect members, hands, head, torso, and legs, to produce the finest

possible figure as a model for use in all his works; this is how he achieves what we know as fine style.

Now the work of Giotto and the other early craftsmen did not possess these qualities, although they did discover the right principles for solving artistic problems and they applied them as best they could. Their drawing, for example, was more correct and truer to nature than anything done before, as was the way they blended their colours, composed their figures, and made the other advances I have already discussed. However, although the artists of the second period made further progress still, they in turn fell short of complete perfection, since their work lacked that spontaneity which, although based on correct measurement, goes beyond it without conflicting with order and stylistic purity. This spontaneity enables the artist to enhance his work by adding innumerable inventive details and, as it were, a pervasive beauty to what is merely artistically correct. Again, when it came to proportion the early craftsmen lacked that visual judgement which, disregarding measurement, gives the artist's figures, in due relation to their dimensions, a grace that simply cannot be measured. They also failed to realize the full potentialities of design; for example, although their arms were rounded and their legs straight, they missed the finer points when they depicted the muscles, ignoring the charming and graceful facility which is suggested rather than revealed in living subjects. In this respect their figures appeared crude and excoriated, offensive to the eye and harsh in style. Their style lacked the lightness of touch that makes an artist's figures slender and graceful, and particularly those of his women and children, which should be as realistic as the male figures and yet possess a roundness and fullness derived from good judgement and design rather than the coarseness of living bodies. Their works also lacked the abundance of beautiful clothes, the imaginative details, charming colours, many kinds of building and various landscapes in depth that we see depicted today. Certainly many of those artists, such as Andrea Verrocchio, Antonio Pollaiuolo, and others who followed, endeavoured to refine their figures, to improve the composition of their works, and to make them conform more closely to nature. None the less, they fell short

of perfection, although indubitably they were going in the right direction, and what they produced certainly invited comparison with the works of the ancient world. This was evident, for instance, when Verrocchio restored the legs and arms of the marble Marsyas for the Casa Medici in Florence, although even so his work lacked polish, and absolute perfection escaped him in the feet, hands, hair, and beard. All the same what he did was consistent with the original and was correctly proportioned. If those craftsmen had mastered the detailed refinements which constitute the greatest achievement of art they would have created strong and robust work, with the delicacy, polish, and superb grace essential to the finest painting and sculpture. However, for all their diligence, their figures lacked these qualities. Indeed, it is not surprising that they never achieved these elusive refinements, seeing that excessive study or diligence tends to produce a dry style when it becomes an end in itself.

Success came to the artists who followed, after they had seen some of the finest works of art mentioned by Pliny dug out of the earth: namely, the Laocoon, the Hercules, the great torso of Belvedere, as well as the Venus, the Cleopatra, the Apollo, and countless others, all possessing the appeal and vigour of living flesh and derived from the finest features of living models. Their attitudes were entirely natural and free, exquisitely graceful and full of movement. And these statues caused the disappearance of the dry, hard, harsh style that art had acquired through the excessive study of Piero della Francesca, Lazzaro Vasari, Alesso Baldovinetti, Andrea del Castagno, Pesello, Ercole Ferrarese, Giovanni Bellini, Cosimo Rosselli, the abbot of San Clemente, Domenico Ghirlandaio, Sandro Botticelli, Andrea Mantegna, Filippino Lippi, and Luca Signorelli. These artists forced themselves to try and do the impossible through their exertions, especially in their ugly foreshortenings and perspectives which were as disagreeable to look at as they were difficult to do. Although the greater part of their work was well designed and free from error, it still lacked any sense of liveliness as well as the harmonious blending of colours which was first seen in the works of Francia of Bologna and Piero Perugino (and which made

the people run like mad to gaze on this new, realistic beauty, as if they would never see the like again).

But how wrong they were was then demonstrated for all to see in the work of Leonardo da Vinci. It was Leonardo who originated the third style or period, which we like to call the modern age; for in addition to the force and robustness of his draughtsmanship and his subtle and exact reproduction of every detail in nature, he showed in his works an understanding of rule, a better knowledge of order, correct proportion, perfect design, and an inspired grace. An artist of great vision and skill and abundant resources, Leonardo may be said to have painted figures that moved and breathed. Somewhat later followed Giorgione of Castel Franco, whose pictures convey a gradual blending of tones and a tremendous impression of movement achieved through the finely handled use of shadow. In no way inferior to his in strength, relief, charm, and grace were the paintings of Fra Bartolommeo of San Marco. But the most graceful of all was Raphael of Urbino, who studied what had been achieved by both the ancient and the modern masters, selected the best qualities from all their works, and by this means so enhanced the art of painting that it equalled the faultless perfection of the figures painted in the ancient world by Apelles and Zeuxis, and might even be said to surpass them were it possible to compare his work with theirs. His colours were finer than those found in nature, and his invention was original and unforced, as anyone can realize by looking at his scenes, which have the narrative flow of a written story. They bring before our eyes sites and buildings, the ways and customs of our own or of foreign peoples, just as Raphael wished to show them. In addition to the graceful qualities of the heads shown in his paintings, whether old or young, men or women, his figures expressed perfectly the character of those they represented, the modest or the bold being shown just as they are. The children in his pictures were depicted now with mischief in their eyes, now in playful attitudes. And his draperies are neither too simple nor too involved but appear wholly realistic.

Raphael's style influenced Andrea del Sarto; and although Andrea's work was less robust and his colours softer, it was

remarkably free from error. Similarly, it is almost impossible to describe the charming vivacity of the paintings executed by Antonio Correggio: this artist painted hair, for example, in an altogether new way, for whereas in the works of previous artists it was depicted in a laboured, hard, and dry manner, in his it appears soft and downy, with each golden strand finely distinguished and coloured, so that the result is more beautiful than in real life. Similar effects were achieved by Francesco Mazzola of Parma (Parmigianino), who in several respects – as regards grace and ornamentation, and fine style – even surpassed Correggio, as is shown by many of his pictures, in which the effortless facility of his brush enabled him to depict smiling faces and eloquent eyes, and in which the very pulses seem to beat. And then anyone who examines the wall-paintings done by Polidoro and Maturino will discover figures that are incredibly expressive and will be astonished at how they were able to describe not in speech, which is easy enough, but with the brush scenes that demonstrate tremendous powers of invention, skill, and ingenuity, showing the deeds of the Romans as they occurred in life. There are countless other artists, now dead, whose colours brought to life the figures they painted: Rosso, Sebastiano, Giulio Romano, Perino del Vaga, not to speak of the many outstanding artists still living. What matters is that these artists have brought their art to such fluent perfection that nowadays a painter who understands design, invention, and colouring can execute six paintings in a year, whereas the earliest artists took six years to finish one painting. I can vouch for this, both from observation and personal experience: and I would add that many works today are more perfect and better finished than were those of the great masters of the past.

But the man whose work transcends and eclipses that of every other artist, living or dead, is the inspired Michelangelo Buonarroti, who is supreme not in one art alone but in all three. He surpasses not only all those whose work can be said to be superior to nature but also the artists of the ancient world, whose superiority is beyond doubt. Michelangelo has triumphed over later artists, over the artists of the ancient world, over nature itself, which has produced nothing,

however challenging or extraordinary, that his inspired genius, with its great powers of application, design, artistry, judgement, and grace, has not been able to surpass with ease. He has shown his genius not only in painting and colouring (in which are expressed all possible forms and bodies, straight and curved, tangible and intangible, accessible and inaccessible) but also in the creation of sculptural works in full relief. And his fruitful and inspiring labours have already spread their branches so wide that the world has been filled with an abundance of delectable fruits, and the three fine arts have been brought to a state of complete perfection. He has so enhanced the art of sculpture that we can say without fear of contradiction that his statues are in every aspect far superior to those of the ancient world. For if their work were put side by side, the heads, hands, arms, and feet carved by Michelangelo being compared with those made by the ancients, his would be seen to be fashioned on sounder principles and executed with more grace and perfection: the effortless intensity of his graceful style defies comparison. And the same holds true of Michelangelo's pictures: if it were possible to place them beside the paintings of those celebrated Greeks and Romans they would be even more highly valued and regarded as being as much superior to the antiques as is his sculpture.

We rightly admire the celebrated artists of the past who created great work, knowing their prize would be a happy life and a generous reward. How much more, then, should we praise and exalt those rare men of genius who create priceless work and who live not merely unrewarded but in circumstances of wretched poverty! It is undeniably true that if the artists of our own time were justly rewarded they would produce even greater works of art, far superior to those of the ancient world. Instead, the artist today struggles to ward off famine rather than to win fame, and this crushes and buries his talent and obscures his name. This is a shame and disgrace to those who could come to his help but refuse to do so.

But that is enough on this subject, for it is time to return to the *Lives* and give separate accounts of all those who have done distinguished work in the third period. The first of these, with whom I shall now start, was Leonardo da Vinci.

LIFE OF
LEONARDO DA VINCI
Florentine painter and sculptor, 1452–1519

In the normal course of events many men and women are born with various remarkable qualities and talents; but occasionally, in a way that transcends nature, a single person is marvellously endowed by heaven with beauty, grace, and talent in such abundance that he leaves other men far behind, all his actions seem inspired, and indeed everything he does clearly comes from God rather than from human art.

Everyone acknowledged that this was true of Leonardo da Vinci, an artist of outstanding physical beauty who displayed infinite grace in everything he did and who cultivated his genius so brilliantly that all problems he studied he solved with ease. He possessed great strength and dexterity; he was a man of regal spirit and tremendous breadth of mind; and his name became so famous that not only was he esteemed during his lifetime but his reputation endured and became even greater after his death.

This marvellous and divinely inspired Leonardo was the son of Piero da Vinci. He would have been very proficient at his early lessons if he had not been so volatile and unstable; for he was always setting himself to learn many things only to abandon them almost immediately. Thus he began to learn arithmetic, and after a few months he had made so much progress that he used to baffle his master with the questions and problems that he raised. For a little while he attended to music, and then he very soon resolved to learn to play the lyre, for he was naturally of an elevated and refined disposition; and with this instrument he accompanied his own charming improvised singing. All the same, for all his other enterprises Leonardo never ceased drawing and working in relief, pursuits which best suited his temperament.

Realizing this, and considering the quality of his son's

intelligence, Piero one day took some of Leonardo's drawings along to Andrea del Verrocchio (who was a close friend of his) and earnestly begged him to say whether it would be profitable for the boy to study design.[1] Andrea was amazed to see what extraordinary beginnings Leonardo had made and he urged Piero to make him study the subject. So Piero arranged for Leonardo to enter Andrea's workshop. The boy was delighted with this decision, and he began to practise not only one branch of the arts but all the branches in which design plays a part. He was marvellously gifted, and he proved himself to be a first-class geometrician in his work as a sculptor and architect. In his youth Leonardo made in clay several heads of women, with smiling faces, of which plaster casts are still being made, as well as some children's heads executed as if by a mature artist. He also did many architectural drawings both of ground plans and of other elevations, and, while still young, he was the first to propose reducing the Arno to a navigable canal between Pisa and Florence. He made designs for mills, fulling machines, and engines that could be driven by water-power; and as he intended to be a painter by profession he carefully studied drawing from life. Sometimes he made clay models, draping the figures with rags dipped in plaster, and then drawing them painstakingly on fine Rheims cloth or prepared linen. These drawings were done in black and white with the point of the brush, and the results were marvellous, as one can see from the examples I have in my book of drawings. Besides this, Leonardo did beautiful and detailed drawings on paper which are unrivalled for the perfection of their finish. (I have an example of these in a superb head in coloured silverpoint.) Altogether, his genius was so wonderfully inspired by the grace of God, his powers of expression were so powerfully fed by a willing memory and intellect, and his writing conveyed his ideas so precisely, that his arguments and reasonings confounded the most formidable critics. In addition, he used to make models and plans showing how to excavate and tunnel through mountains without difficulty, so as to pass from one level to another; and

1. Andrea del Verrocchio (see above), painter and goldsmith, and the chief sculptor in Florence after Donatello's death.

he demonstrated how to lift and draw great weights by means of levers, hoists, and winches, and ways of cleansing harbours and using pumps to suck up water from great depths. His brain was always busy on such devices, and one can find drawings of his ideas and experiments scattered among our craftsmen today; I myself have seen many of them. He also spent a great deal of time in making a pattern of a series of knots, so arranged that the connecting thread can be traced from one end to the other and the complete design fills a round space. There exists a splendid engraving of one of these fine and intricate designs, with these words in the centre: *Leonardus Vinci Academia.*

Among his models and plans there was one which Leonardo would often put before the citizens who were then governing Florence – many of them men of great discernment – showing how he proposed to raise and place steps under the church of San Giovanni without damaging the fabric. His arguments were so cogent that they would allow themselves to be convinced, although when they all went their several ways each of them would realize the impossibility of what Leonardo suggested.

Leonardo's disposition was so lovable that he commanded everyone's affection. He owned, one might say, nothing and he worked very little, yet he always kept servants as well as horses. These gave him great pleasure as indeed did all the animal creation which he treated with wonderful love and patience. For example, often when he was walking past the places where birds were sold he would pay the price asked, take them from their cages, and let them fly off into the air, giving them back their lost freedom. In return he was so favoured by nature that to whatever he turned his mind or thoughts the results were always inspired and perfect; and his lively and delightful works were incomparably graceful and realistic.

Clearly, it was because of his profound knowledge of painting that Leonardo started so many things without finishing them; for he was convinced that his hands, for all their skill, could never perfectly express the subtle and wonderful ideas of his imagination. Among his many interests was

included the study of nature; he investigated the properties of plants and then observed the motion of the heavens, the path of the moon, and the course of the sun.

I mentioned earlier that when he was still young Leonardo entered the workshop of Andrea del Verrocchio. Now at that time Verrocchio was working on a panel picture showing the Baptism of Christ by St John, for which Leonardo painted an angel who was holding some garments; and despite his youth, he executed it in such a manner that his angel was far better than the figures painted by Andrea. This was the reason why Andrea would never touch colours again, he was so ashamed that a boy understood their use better than he did. Leonardo was then commissioned to make a cartoon (for a tapestry to be woven of gold and silk in Flanders and sent to the king of Portugal) showing the sin of Adam and Eve in the Garden of Paradise. For this he drew with the brush in chiaroscuro, with the lights in lead-white, a luxuriant meadow full of different kinds of animals; and it can truthfully be said that for diligence and faithfulness to nature nothing could be more inspired or perfect. There is a fig tree, for example, with its leaves foreshortened and its branches drawn from various aspects, depicted with such loving care that the brain reels at the thought that a man could have such patience. And there is a palm tree, the radiating crown of which is drawn with such marvellous skill that no one without Leonardo's understanding and patience could have done it. The work was not carried any farther and so today the cartoon is still in Florence, in the blessed house of the Magnificent Ottaviano de' Medici to whom it was presented not long ago by Leonardo's uncle.

The story goes that once when Piero da Vinci was at his house in the country one of the peasants on his farm, who had made himself a buckler out of a fig tree that he had cut down, asked him as a favour to have it painted for him in Florence. Piero was very happy to do this, since the man was very adept at snaring birds and fishing and Piero himself very often made use of him in these pursuits. He took the buckler to Florence, and without saying a word about whom it belonged to he asked Leonardo to paint something on it. Some days later

Leonardo examined the buckler, and, finding that it was warped, badly made, and clumsy, he straightened it in the fire and then gave it to a turner who, from the rough and clumsy thing that it was, made it smooth and even. Then having given it a coat of gesso and prepared it in his own way Leonardo started to think what he could paint on it so as to terrify anyone who saw it and produce the same effect as the head of Medusa. To do what he wanted Leonardo carried into a room of his own, which no one ever entered except himself, a number of green and other kinds of lizards, crickets, serpents, butterflies, locusts, bats, and various strange creatures of this nature; from all these he took and assembled different parts to create a fearsome and horrible monster which emitted a poisonous breath and turned the air to fire. He depicted the creature emerging from the dark cleft of a rock, belching forth venom from its open throat, fire from its eyes and smoke from its nostrils in so macabre a fashion that the effect was altogether monstrous and horrible. Leonardo took so long over the work that the stench of the dead animals in his room became unbearable, although he himself failed to notice because of his great love of painting. By the time he had finished the painting both the peasant and his father had stopped inquiring after it; but all the same he told his father that he could send for the buckler when convenient, since his work on it was completed. So one morning Piero went along to the room in order to get the buckler, knocked at the door, and was told by Leonardo to wait for a moment. Leonardo went back into the room, put the buckler on an easel in the light, and shaded the window; then he asked Piero to come in and see it. When his eyes fell on it Piero was completely taken by surprise and gave a sudden start, not realizing that he was looking at the buckler and that the form he saw was, in fact, painted on it. As he backed away, Leonardo checked him and said:

'This work certainly serves its purpose. It has produced the right reaction, so now you can take it away.'

Piero thought the painting was indescribably marvellous and he was loud in praise of Leonardo's ingenuity. And then on the quiet he bought from a pedlar another buckler,

decorated with a heart pierced by a dart, and he gave this to the peasant, who remained grateful to him for the rest of his days. Later on Piero secretly sold Leonardo's buckler to some merchants in Florence for a hundred ducats; and not long afterwards it came into the hands of the duke of Milan, who paid those merchants three hundred ducats for it.

Leonardo then painted a Madonna, a very fine work which came into the possession of Pope Clement VII; one of the details in this picture was a vase of water containing some flowers, painted with wonderful realism, which had on them dewdrops that looked more convincing than the real thing.

For his very close friend Antonio Segni, Leonardo drew on a sheet of paper a Neptune executed with such fine draughtsmanship and diligence that it was utterly convincing. In this picture could be seen the restless ocean and Neptune's chariot drawn by sea-horses, and the sprites, the sea-monsters, and the winds, along with some very beautiful heads of sea-gods. This was presented by Antonio's son Fabio to Giovanni Gaddi, with this epigram:

> Pinxit Virgilius Neptunum, pinxit Homerus,
> Dum maris undisoni per vada flectit equos.
> Mente quidem vates illum conspexit uterque,
> Vincius ast oculis; jureque vincit eos.[1]

Leonardo then took it in mind to do a painting in oils showing the head of Medusa attired with a coil of serpents, the strangest and most extravagant invention imaginable. But this was a work that needed time, and so as with most of the things he did it was never finished. Today it is kept among the fine works of art in the palace of Duke Cosimo, along with the head of an angel raising one arm, which is foreshortened as it comes forward from the shoulder to the elbow, and lifting a hand to its breast with the other.

One of the remarkable aspects of Leonardo's talent was the extremes he went to, in his anxiety to achieve solidity of

1. Virgil and Homer both have shown us Neptune guide
 His steeds amid the billows of the roaring main.
 These poets, though, have seen him but with mental gaze,
 Vinci with vision real; and 'tis truth to hail
 Vinci as victor.

modelling, in the use of inky shadows. Thus to get the darkest possible grounds Leonardo selected blacks that made deeper shadows and were indeed blacker than any other, endeavouring to make his lights all the brighter by contrast. However, he eventually succeeded so well that his paintings were wholly devoid of light and the subjects looked as if they were being seen by night rather than clearly defined by daylight. All this came from his striving to obtain ever more relief and to bring his art to absolute perfection. I must mention another habit of Leonardo's: he was always fascinated when he saw a man of striking appearance, with a strange head of hair or beard; and anyone who attracted him he would follow about all day long and end up seeing so clearly in his mind's eye that when he got home he could draw him as if he were standing there in the flesh. There are many drawings of both male and female heads which he did in this way, and I have several examples of them in the book of drawings mentioned so often before, such as the sketch of Amerigo Vespucci, which shows the head of a very handsome old man drawn in charcoal, or of Scaramuccia, the leader of the gipsies, which Giambullari subsequently left to Donato Valdambrini of Arezzo, canon of San Lorenzo.

Leonardo also started work on a panel picture showing the Adoration of the Magi and containing a number of beautiful details, especially the heads; this painting, however, which was in the house of Amerigo Benci, opposite the Loggia de' Peruzzi, like so many of his works remained unfinished.

Meanwhile in Milan, following the death of Duke Gian Galeazzo, Ludovico Sforza took over the state (in the year 1494) and did Leonardo the honour of inviting him to visit Milan so that he could hear him play the lyre, an instrument of which the new duke was very fond.[1] Leonardo took with him a lyre that he had made himself, mostly of silver, in the shape of a horse's head (a very strange and novel design) so that the sound should be more sonorous and resonant. Leonardo's performance was therefore superior to that of all the other musicians who had come to Ludovico's court. Leonardo

1. Leonardo probably went to Milan in 1482, when Ludovico was already in control of the state.

was also the most talented improviser in verse of his time. Moreover, he was a sparkling conversationalist, and after they had spoken together the duke developed almost boundless love and admiration for his talents. He begged Leonardo to paint for him an altarpiece containing a Nativity, which he then sent to the emperor.

Leonardo also executed in Milan, for the Dominicans of Santa Maria delle Grazie, a marvellous and beautiful painting of the Last Supper. Having depicted the heads of the apostles full of splendour and majesty, he deliberately left the head of Christ unfinished, convinced he would fail to give it the divine spirituality it demands. This all but finished work has ever since been held in the greatest veneration by the Milanese and others. In it Leonardo brilliantly succeeded in envisaging and reproducing the tormented anxiety of the apostles to know who had betrayed their master; so in their faces one can read the emotions of love, dismay, and anger, or rather sorrow, at their failure to grasp the meaning of Christ. And this excites no less admiration than the contrasted spectacle of the obstinacy, hatred, and treachery in the face of Judas or, indeed, than the incredible diligence with which every detail of the work was executed. The texture of the very cloth on the table is counterfeited so cunningly that the linen itself could not look more realistic.

It is said that the prior used to keep pressing Leonardo, in the most importunate way, to hurry up and finish the work, because he was puzzled by Leonardo's habit of sometimes spending half a day at a time contemplating what he had done so far; if the prior had had his way, Leonardo would have toiled like one of the labourers hoeing in the garden and never put his brush down for a moment. Not satisfied with this, the prior then complained to the duke, making such a fuss that the duke was constrained to send for Leonardo and, very tactfully, question him about the painting, although he showed perfectly well that he was only doing so because of the prior's insistence. Leonardo, knowing he was dealing with a prince of acute and discerning intelligence, was willing (as he never had been with the prior) to explain his mind at length; and so he talked to the duke for a long time about the art of painting.

He explained that men of genius sometimes accomplish most when they work the least; for, he added, they are thinking out inventions and forming in their minds the perfect ideas which they subsequently express and reproduce with their hands. Leonardo then said that he still had two heads to paint: the head of Christ was one, and for this he was unwilling to look for any human model, nor did he dare suppose that his imagination could conceive the beauty and divine grace that properly belonged to the incarnate Deity. Then, he said, he had yet to do the head of Judas, and this troubled him since he did not think he could imagine the features that would form the countenance of a man who, despite all the blessings he had been given, could so cruelly steel his will to betray his own master and the creator of the world. However, added Leonardo, he would try to find a model for Judas, and if he did not succeed in doing so, why then he was not without the head of that tactless and importunate prior. The duke roared with laughter at this and said that Leonardo had every reason in the world for saying so. The unfortunate prior retired in confusion to worry the labourers working in his garden, and he left off worrying Leonardo, who skilfully finished the head of Judas and made it seem the very embodiment of treachery and inhumanity. The head of Christ remained, as was said, unfinished.

This noble painting was so finely composed and executed that the King of France subsequently wanted to remove it to his kingdom. He tried all he could to find architects to make cross-stays of wood and iron with which the painting could be protected and brought safely to France, without any regard for expense, so great was his desire to have it. But as the painting was done on a wall his majesty failed to have his way and it remained in the possession of the Milanese. While he was working on the Last Supper, in the same refectory where there is a painting of the Passion done in the old manner, on the end wall, Leonardo portrayed Ludovico himself with his eldest son, Massimiliano; and on the other side, with the Duchess Beatrice, his other son Francesco, both of whom later became dukes of Milan; and all these figures are beautifully painted.

While he was engaged on this work Leonardo proposed to the duke that he should make a huge equestrian statue in bronze as a memorial to his father; then he started and carried the work forward on such a scale that it was impossible to finish it. There have even been some to say (men's opinions are so various and, often enough, so envious and spiteful) that Leonardo had no intention of finishing it when he started. This was because it was so large that it proved an insoluble problem to cast it in one piece; and one can realize why, the outcome being what it was, many came to the conclusion they did, seeing that so many of his works remained unfinished. The truth, however, is surely that Leonardo's profound and discerning mind was so ambitious that this was itself an impediment; and the reason he failed was because he endeavoured to add excellence to excellence and perfection to perfection. As our Petrarch has said, the desire outran the performance. In fact, those who saw the great clay model that Leonardo made considered that they had never seen a finer or more magnificent piece of work. It was preserved until the French came to Milan under King Louis and smashed it to pieces. Also lost is a little wax model which was held to be perfect, together with a reference book which Leonardo composed on the anatomy of horses. Leonardo then applied himself, even more assiduously, to the study of human anatomy, in which he collaborated with that excellent philosopher Marc Antonio della Torre, who was then lecturing at Pavia and who wrote on the subject. Della Torre, I have heard, was one of the first to illustrate the problems of medicine by the teachings of Galen and to throw true light on anatomy, which up to then had been obscured by the shadows of ignorance. In this he was wonderfully served by the intelligence, work, and hand of Leonardo, who composed a book annotated in pen and ink in which he did meticulous drawings in red chalk of bodies he had dissected himself. He showed all the bone structure, adding in order all the nerves and covering them with the muscles: the first attached to the skeleton, the second that hold it firm and the third that move it. In the various sections he wrote his observations in puzzling characters (written in reverse with the left hand) which cannot be

deciphered by anyone who does not know the trick of reading
them in a mirror.

Many of Leonardo's manuscripts on human anatomy are in
the possession of Francesco Melzi, a Milanese gentleman who
was a handsome boy when Leonardo was alive and who was
greatly loved by him. Francesco cherishes and preserves these
papers as relics of Leonardo, together with the portrait of that
artist of such happy memory. Reading Leonardo's writings
one is astonished at the brilliant way in which this inspired
artist discussed so thoroughly art and anatomy (the muscles,
nerves, and veins) and indeed every kind of subject. There are
also some of his papers in the possession of a Milanese painter
(again written in reverse with the left hand) which discuss
painting and methods of drawing and colouring. Not long
ago this man came to Florence to see me with the object of
having the work printed, and later he went to Rome to put
this into effect; but I do not know what happened then.

Anyhow, to return to Leonardo's works: when during his
lifetime the king of France came to Milan, Leonardo was
asked to devise some unusual entertainment, and so he con-
structed a lion which after walking a few steps opened its
breast to reveal a cluster of lilies. It was in Milan that Leonardo
took for his servant a Milanese called Salai, a very attractive
youth of unusual grace and looks, with very beautiful hair
which he wore curled in ringlets and which delighted his
master. Leonardo taught Salai a great deal about painting,
and some of the works in Milan which are attributed to him
were retouched by Leonardo.

Then Leonardo went back to Florence where he found that
the Servite friars had commissioned Filippino to paint the
altarpiece for the high altar of the Annunziata. Leonardo re-
marked that he would gladly have undertaken the work him-
self, and when he heard this, like the good-hearted person he
was, Filippino decided to withdraw. Then the friars, to secure
Leonardo's services, took him into their house and met all
his expenses and those of his household. He kept them waiting
a long time without even starting anything, and then finally
he did a cartoon showing Our Lady with St Anne and the
Infant Christ. This work not only won the astonished

admiration of all the artists but when finished for two days it attracted to the room where it was exhibited a crowd of men and women, young and old, who flocked there, as if they were attending a great festival, to gaze in amazement at the marvels he had created. For in the face of Our Lady are seen all the simplicity and loveliness and grace that can be conferred on the mother of Christ, since Leonardo wanted to show the humility and the modesty appropriate to an image of the Virgin who is overflowing with joy at seeing the beauty of her Son. She is holding him tenderly on her lap, and she lets her pure gaze fall on St John, who is depicted as a little boy playing with a lamb; and this is not without a smile from St Anne, who is supremely joyful as she contemplates the divinity of her earthly progeny. These ideas were truly worthy of Leonardo's intellect and genius. As I shall describe, this cartoon was subsequently taken to France.

Leonardo also did a portrait of Ginevra, the wife of Amerigo Benci, a very beautiful painting. He abandoned the work he was doing for the friars and they went back to Filippino, who, however, died before he could finish it.

For Francesco del Giocondo Leonardo undertook to execute the portrait of his wife, Mona Lisa. He worked on this painting for four years, and then left it still unfinished; and today it is in the possession of King Francis of France, at Fontainebleau. If one wanted to see how faithfully art can imitate nature, one could readily perceive it from this head; for here Leonardo subtly reproduced every living detail. The eyes had their natural lustre and moistness, and around them were the lashes and all those rosy and pearly tints that demand the greatest delicacy of execution. The eyebrows were completely natural, growing thickly in one place and lightly in another and following the pores of the skin. The nose was finely painted, with rosy and delicate nostrils as in life. The mouth, joined to the flesh-tints of the face by the red of the lips, appeared to be living flesh rather than paint. On looking closely at the pit of her throat one could swear that the pulses were beating. Altogether this picture was painted in a manner to make the most confident artist – no matter who – despair and lose heart. Leonardo also made use of this device: while he

was painting Mona Lisa, who was a very beautiful woman, he employed singers and musicians or jesters to keep her full of merriment and so chase away the melancholy that painters usually give to portraits. As a result, in this painting of Leonardo's there was a smile so pleasing that it seemed divine rather than human; and those who saw it were amazed to find that it was as alive as the original.

The great achievements of this inspired artist so increased his prestige that everyone who loved art, or rather every single person in Florence, was anxious for him to leave the city some memorial; and it was being proposed everywhere that Leonardo should be commissioned to do some great and notable work which would enable the state to be honoured and adorned by his discerning talent, grace, and judgement. As it happened the great hall of the council was being constructed under the architectural direction of Giuliano Sangallo, Simone Pollaiuolo (known as Cronaca), Michelangelo Buonarroti, and Baccio d'Agnolo, as I shall relate at greater length in the right place. It was finished in a hurry, and after the head of the government and the chief citizens had conferred together, it was publicly announced that a splendid painting would be commissioned from Leonardo. And then he was asked by Piero Soderini, the Gonfalonier of Justice, to do a decorative painting for the council hall. As a start, therefore, Leonardo began work in the Hall of the Pope, in Santa Maria Novella, on a cartoon illustrating an incident in the life of Niccolò Piccinino, a commander of Duke Filippo of Milan. He showed a group of horsemen fighting for a standard, in a drawing which was regarded as very fine and successful because of the wonderful ideas he expressed in his interpretation of the battle. In the drawing, rage, fury, and vindictiveness are displayed both by the men and by the horses, two of which with their forelegs interlocked are battling with their teeth no less fiercely than their riders are struggling for the standard, the staff of which has been grasped by a soldier who, as he turns and spurs his horse to flight, is trying by the strength of his shoulders to wrest it by force from the hands of four others. Two of them are struggling for it with one hand and attempting with the other to cut the staff with their raised swords;

and an old soldier in a red cap roars out as he grips the staff with one hand and with the other raises a scimitar and aims a furious blow to cut off both the hands of those who are gnashing their teeth and ferociously defending their standard. Besides this, on the ground between the legs of the horses there are two figures, foreshortened, shown fighting together; the one on the ground has over him a soldier who has raised his arm as high as possible to plunge his dagger with greater force into the throat of his enemy, who struggles frantically with his arms and legs to escape death.

It is impossible to convey the fine draughtsmanship with which Leonardo depicted the soldiers' costumes, with their distinctive variations, or the helmet-crests and the other ornaments, not to speak of the incredible mastery that he displayed in the forms and lineaments of the horses which, with their bold spirit and muscles and shapely beauty, Leonardo portrayed better than any other artist. It is said that to draw the cartoon Leonardo constructed an ingenious scaffolding that he could raise or lower by drawing it together or extending it. He also conceived the wish to paint the picture in oils, but to do this he mixed such a thick composition for laying on the wall that, as he continued his painting in the hall, it started to run and spoil what had been done. So shortly afterwards he abandoned the work.

Leonardo was very proud and instinctively generous. According to one story, he once went along to the bank to draw his usual monthly salary from Piero Soderini and the cashier wanted to give him a few packets of pennies which he refused to take, saying that he was no 'penny painter'. As the painting had not been finished, he was accused of cheating Piero Soderini and there were murmurings against him. So Leonardo went round his friends and got the money together to repay Soderini; but Piero would not accept it.

Leonardo went to Rome with Duke Giuliano de' Medici on the election of Pope Leo who was a great student of natural philosophy, and especially of alchemy. And in Rome he experimented with a paste made out of a certain kind of wax and made some light and billowy figures in the form of animals which he inflated with his mouth as he walked along and

which flew above the ground until all the air escaped.[1] To the back of a very odd-looking lizard that was found by the gardener of the Belvedere he attached with a mixture of quicksilver some wings, made from the scales stripped from other lizards, which quivered as it walked along. Then, after he had given it eyes, horns, and a beard he tamed the creature, and keeping it in a box he used to show it to his friends and frighten the life out of them. Again, Leonardo used to get the intestines of a bullock scraped completely free of their fat, cleaned and made so fine that they could be compressed into the palm of one hand; then he would fix one end of them to a pair of bellows lying in another room, and when they were inflated they filled the room in which they were and forced anyone standing there into a corner. Thus he could expand this translucent and airy stuff to fill a large space after occupying only a little, and he compared it to genius.[2] He perpetrated hundreds of follies of this kind, and he also experimented with mirrors and made the most outlandish experiments to discover oils for painting and varnish for preserving the finished works.

At that time for Baldassare Turini of Pescia, who was Pope Leo's datary, Leonardo executed with extraordinary diligence and skill a small picture of the Madonna and Child. But either because of the mistakes made by whoever primed the panel with gesso, or because of his own capricious way of mixing any number of grounds and colours, it is now spoilt. In another small picture he did the portrait of a little boy which is wonderfully beautiful and graceful. And both of these pictures are now in the possession of Giulio Turini at Pescia.

Once, when he was commissioned a work by the Pope, Leonardo is said to have started at once to distil oils and various plants in order to prepare the varnish; and the Pope is supposed to have exclaimed: 'Oh dear, this man will never do anything. Here he is thinking about finishing the work before he even starts it!'

1. Literally, 'which by blowing into, he made fly through the air, but then when the wind (*vento*) ceased, they fell to the ground'. There has been considerable speculation as to what these figures really were. More than likely, Leonardo simply flew some little kites.

2. To *virtù* – possibly meaning 'virtue'.

Leonardo and Michelangelo strongly disliked each other, and so Michelangelo left Florence because of their rivalry (with permission from Duke Giuliano) after he had been summoned by the Pope to discuss the completion of the façade of San Lorenzo; and when he heard this Leonardo also left Florence and went to France. The king had obtained several of his works and was very devoted to him, and he asked Leonardo to paint the cartoon of St Anne. But, characteristically, Leonardo for a long time put him off with mere words.

Finally, in his old age Leonardo lay sick for several months, and feeling that he was near to death he earnestly resolved to learn about the doctrines of the Catholic faith and of the good and holy Christian religion. Then, lamenting bitterly, he confessed and repented, and, although he could not stand up, supported by his friends and servants he received the Blessed Sacrament from his bed. He was joined by the king, who often used to pay him affectionate visits, and having respectfully raised himself in his bed he told the king about his illness and what had caused it, and he protested that he had offended God and mankind by not working at his art as he should have done. Then he was seized by a paroxysm, the forerunner of death, and, to show him favour and to soothe his pain, the king held his head. Conscious of the great honour being done to him, the inspired Leonardo breathed his last in the arms of the king; he was then seventy-five years old.[1]

All who had known Leonardo were grieved beyond words by their loss, for no one had ever shed such lustre on the art of painting.

In appearance he was striking and handsome, and his magnificent presence brought comfort to the most troubled soul; he was so persuasive that he could bend other people to his own will. He was physically so strong that he could withstand any violence; with his right hand he would bend the iron ring of a doorbell or a horseshoe as if they were lead. He was so generous that he sheltered and fed all his friends, rich or poor, provided they were of some talent or worth. By his every action Leonardo adorned and honoured the meanest and

1. Leonardo died aged sixty-seven.

humblest dwelling-place. Through his birth, therefore, Florence received a very great gift, and through his death it sustained an incalculable loss. In painting he brought to the technique of colouring in oils a way of darkening the shadows which has enabled modern painters to give great vigour and relief to their figures. He showed his powers as a sculptor in the three bronze figures over the north door of San Giovanni which were executed by Giovanfrancesco Rustici, under Leonardo's direction, and which as far as design and finish are concerned are the finest casts yet seen in modern times.

Because of Leonardo we have a deeper knowledge of human anatomy and the anatomy of the horse. And because of his many wonderful gifts (although he accomplished far more in words than in deeds) his name and fame will never be extinguished. This was written in praise of Leonardo by Giovan Battista Strozzi:

> *Vince costui pur solo*
> *Tutti altri, e vince Fidia e vince Apelle,*
> *E tutto lor vittoriosi stuolo.*[1]

One of Leonardo's pupils was Giovanni Antonio Boltraffio of Milan, a very skilful and discerning artist who in 1500 in the church of the Misericordia, outside Bologna, painted in oils a carefully finished picture of the Madonna and Child, St John the Baptist, and a nude St Sebastian, with a portrait of the donor kneeling in prayer. On this very beautiful panel he signed his name, adding that he was a pupil of Leonardo. He did other works at Milan and elsewhere, but it is enough to have described the best of them.

Another of Leonardo's pupils was Marco Uggioni, who in Santa Maria della Pace painted the Assumption of the Virgin and the Marriage of Cana in Galilee.

1. Da Vinci vanquished alone all others, he vanquished Phidias and Apelles, and all their victorious followers.

LIFE OF
GIORGIONE DA CASTELFRANCO
Venetian painter, c. 1476/8–1510

WHILE Florence was winning fame through the works of Leonardo no less glory was conferred on Venice by the talents and achievements of one of her citizens, who greatly surpassed not only the Bellini (whom the Venetians regarded so highly) but also every other Venetian painter up to that time.[1]

This artist was called Giorgio; he was born in 1478 at Castelfranco near Treviso, when the doge was Giovanni Mocenigo, Doge Piero's brother. Because of his physical appearance and his moral and intellectual stature he later came to be known as Giorgione; and although he was of humble origin throughout his life he was nothing if not gentle and courteous. He was brought up in Venice. He was always a very amorous man and he was extremely fond of the lute, which he played so beautifully to accompany his own singing that his services were often used at music recitals and social gatherings. He also studied and derived tremendous pleasure from the arts of design, in which he was highly gifted by nature; and he fell so deeply in love with the beauties of nature that he would represent in his works only what he copied directly from life. He always imitated and followed nature so faithfully that he was recognized not only as having surpassed Gentile and Giovanni Bellini but also as rivalling those who were working in Tuscany and creating the modern style.

It happened that Giorgione saw some of Leonardo's works with their subtle transitions of colour and tone and their extraordinary relief, conveyed, as I described, by means of shadows. This style attracted him so much that all his life he referred to it and based his own work on it; and he imitated it above all in

1. The Bellini were three Venetian painters: Jacopo (*c.* 1400–70/1) and his sons Gentile and Giovanni.

his oil paintings. Delighting in craftsmanship, Giorgione sought after the most beautiful and varied subjects to put into his works. He was an artist of great natural discernment and talent; and so in his oil paintings and frescoes he created living forms and other representations which were so soft, so well harmonized, and so subtly shaded and blended that many of the great artists of his time admitted that he had been born to infuse life into painted figures and to represent the freshness of living forms more convincingly than any other painter, in Venice or anywhere else.

To begin with, in Venice Giorgione painted many Madonnas and portraits. These were vigorous and beautiful pictures, as is shown by three lovely heads in oils to be found in the study of the Very Reverend Grimani, patriarch of Venice. One of these heads, in which the hair is depicted falling to the shoulders, as was the fashion in those days, is said to be Giorgione's self-portrait. The portrait represents David, who is depicted with wonderful vigour and realism. His breast is protected by armour as is the arm with which he holds the severed head of Goliath. The second, larger head is a portrait from life of a man holding a commander's red beret in his hand and wearing a fur cape over a tunic in the antique style; it is thought that he represents a commander-in-chief. The third extremely beautiful painting shows a boy depicted with hair like fleece. And these works bear witness both to Giorgione's skill and to the enduring devotion of that great patriarch who has always, and rightly, cherished them.

In Florence, in the house of the sons of Giovanni Borgherini, there is a portrait by Giorgione of Giovanni himself, painted when he was a young man in Venice, which also shows Giovanni's tutor; these two heads are executed with incomparably fine flesh-tints and shadows. In the house of Anton de' Nobili is another head of a captain in armour, very lively and animated, who is said to be one of the captains whom Gonsalvo Ferrante took with him to Venice when he visited Doge Agostino Barberigo. And it is said that on this occasion Giorgione portrayed the great Gonsalvo himself in his armour, producing an incomparably fine and remarkable work which Gonsalvo is supposed to have taken away with

him. Giorgione did many other portraits which are scattered throughout Italy, very fine works as is shown, for example, by the portrait of Leonardo Loredano (whom Giorgione painted when he was doge). I myself saw this on show one Ascension Day; and that serene ruler seemed to be there himself in the flesh. Another of Giorgione's portraits is to be found in Faenza, in the house of Giovanni da Castel Bolognese, a skilled engraver of cameos and crystals; it was painted for his father-in-law and it is truly an inspired work of art, for the harmonious transition of the tones from light to dark makes it look more like a work in relief than a painting.

Giorgione loved to paint frescoes, and among the many that he executed was the entire façade of Cá Soranzo on the Piazza di San Polo, where in addition to many pictures, scenes, and fantasies he did on the plaster a picture painted in oils which has withstood rain, sun, and wind to remain fresh up to our own time. There is also a picture of Spring, which I consider one of Giorgione's finest frescoes, and it is a great pity that time has dealt with it so cruelly. (For myself, I know nothing more harmful to fresco painting than the sirocco, especially near to the sea where it carries a salt moisture with it.)

Then in the year 1504 a terrible fire broke out in Venice, near the Rialto bridge, in the Fondaco dei Tedeschi, which was completely burnt out with all its stocks of merchandise, to the great loss of the merchants.[1] So the Signoria of Venice decreed that it should be rebuilt, and this was done very quickly, with far better accommodation and with greater magnificence, adornment, and beauty. Meanwhile, in view of Giorgione's mounting reputation, those in charge of the project, after discussing the matter, ordered that he should colour it in fresco as he wished, provided only that he did all in his power to create a first-rate work, seeing that it was for the most beautiful place and the finest site in the city. So Giorgione started work. But he thought only of demonstrating his technique as a painter by representing various figures according to his own fancy. Indeed, there are no scenes to be found

1. The Fondaco dei Tedeschi – the headquarters of the German trading community, with offices, warehouses, and living accommodation – was destroyed in 1505.

there with any order or representing the deeds of any distinguished person, of either the ancient or the modern world. And I for my part have never been able to understand his figures nor, for all my asking, have I ever found anyone who does. In these frescoes one sees, in various attitudes, a man in one place, a woman standing in another, one figure accompanied by the head of a lion, another by an angel in the guise of a cupid; and heaven knows what it all means. Then over the main door which opens into the Merceria there is the seated figure of a woman who has at her feet the head of a dead giant, as if she were meant to be a Judith; she is raising the head with a sword and speaking to a German standing below her. I have not been able to interpret the meaning of this, unless Giorgione meant her to stand for Germania. All the same, one can see clearly that the figures he painted are well grouped and that he was continually improving his work: there are heads and parts of figures very finely painted and vivaciously coloured; and in everything he was careful to work directly from nature and avoid copying what any other painter had done. The building is renowned throughout Venice, no less for Giorgione's frescoes than for its convenience for commerce and its usefulness to the state.

Giorgione did a painting showing Christ carrying the cross with a Jew who is tugging him, which was eventually placed in the church of San Rocco, and which now, because of great devotion that is paid to it, works miracles, as anyone can see for himself.

Giorgione worked in various places, including Castelfranco and the territory of Treviso; he executed many portraits for various Italian rulers; and many of his works were exported from Italy, for they were considered as worthy evidence of the fact that, if Tuscany had an abundance of artists in every age, the region beyond, near the mountains, was not always forgotten and neglected by heaven.

The story goes that at the time Andrea Verrocchio was making his bronze horse Giorgione fell into an argument with some sculptors who maintained that since a statue showed to anyone walking round it different aspects and poses, sculpture was superior to painting, which could represent only one

aspect of any given subject. Giorgione argued to the contrary that in a single scene the painter could show to an observer standing still in one place various aspects of the one figure by depicting a number of different gestures; whereas for a work of sculpture to produce the same effect, he said, the observer must change his position and viewpoint. Moreover, he offered to show in a single view of one picture the front, back, and two profiles of a painted figure. After he had made those sculptors rack their brains, Giorgione solved the problem in this way. He painted a man in the nude with his back turned and, at his feet, a limpid stream of water bearing his reflection. To one side was a burnished cuirass that the man had taken off, and this reflected his left profile (since the polished surface of the armour revealed everything clearly); on the other side was a mirror reflecting the other profile of the nude figure. This was a very fine and fanciful idea, and Giorgione used it to prove that painting requires more skill and effort and can show in one scene more aspects of nature than is the case with sculpture. The picture was greatly praised and admired for its beauty and ingenuity.

Giorgione also did a portrait from life of Catherine, queen of Cyprus, which I once saw in the possession of that distinguished gentleman, Giovanni Cornaro. And in my book of drawings I have a head painted in oils, which is the portrait of a German of the Fugger family, who at that time was one of the leading German merchants in Venice. Along with this admirable work I have some of his pen-and-ink sketches and drawings.

While Giorgione was occupied in winning honour for himself and his homeland, in the course of the busy social life that he led, entertaining his many friends with his music, he fell in love with a certain lady, and they carried on a very pleasurable affair. However, in the year 1511 she became infected with the plague and when, without knowing this, Giorgione sought her company as usual he, too, became dangerously infected; and soon afterwards, at the age of thirty-four, he passed to the other life. His death brought great sorrow to the many whose friendship and affection his abilities had won, and, indeed, it was a grievous loss for the whole world.

However, the pain of this loss was made tolerable because of the accomplished pupils he left behind him: Sebastiano the Venetian, who subsequently became friar of the Piombo at Rome,[1] and Titian of Cadore, whose work far surpassed let alone equalled what was done by Giorgione.

1. The signet-office (*il Piombo*) provided a papal sinecure, that of Keeper of the Papal Seal, given to Sebastiano del Piombo in 1531.

LIFE OF
ANTONIO CORREGGIO
Painter, c. 1489–1534

I DO not want to leave that region of Italy where nature, to avoid being accused of unfairness, brought into the world marvellously talented men of the kind with which for many, many years it had adorned the region of Tuscany. Among them was Antonio Correggio, an outstanding and superbly accomplished painter who acquired the modern style so perfectly that within a few years, through his natural gifts and practice in art, he became a craftsman of tremendous distinction. He was a very mild man and all his life, for the sake of his family, he was a slave to his work, which brought him great distress. He was motivated by his inherent goodness of soul, but in supporting the inevitable sorrows of his fellow men he did more than was reasonable.

Moreover, Correggio was very melancholy in the practice of his art, at which he toiled unceasingly. He was a zealous student of artistic problems, as is clearly shown by the host of figures which he painted in fresco in the cathedral in Parma. These skilfully finished figures, foreshortened from below to give an effect of extraordinary grandeur, are to be seen in the great cupola of the church. Correggio was also the first artist in Lombardy to work in the modern style; and if this accomplished painter had left Lombardy for Rome he would certainly have worked miracles and given a run for their money to the many contemporaries of his with big reputations. What is more, seeing what he produced without ever having set eyes on any antiques or any good modern work, it inevitably follows that if he had done so his style would have gained immeasurably and he would eventually have reached absolute perfection. Certainly, as it is no one ever handled colours better than Correggio or produced paintings of greater delicacy and relief, such was the softness of the figures he

painted and the grace with which he imbued his finished works.

In Parma Correggio also executed two large oil-paintings, one of which contained various figures including a Dead Christ, which was very highly praised. And in San Giovanni Evangelistica in the same city he painted the cupola in fresco, showing Our Lady ascending into heaven amidst a multitude of angels and saints.[1] It seems impossible not so much that he should have been able to put this work into execution but that he should even have been able to conceive it in his imagination, so beautiful were the flowing draperies and the expressions of his figures. I have some drawings of these in my book, done by Correggio in red chalk, with some very fine borders of *putti* and other borders with various fanciful scenes of sacrifices in the ancient manner, which he added as ornamentation. However, if Antonio had not given his finished works the perfection they have, his drawings (despite their excellent style, their delicacy, and their craftsmanship) would not in themselves have won him the reputation he enjoys. Painting is so difficult and has so many different branches that very often an artist cannot be equally proficient in all of them. There are many artists whose drawings have been inspired, but whose use of colours has been faulty; others have used colours magnificently, but have not drawn half as well. It depends on the choice the artist made when young and on whether he gives his time to the study of colouring or of drawing. Whatever an artist's inclination, however, his object is to create perfect works in all of which good colouring is matched by good design. And Correggio must certainly be praised for the perfection he attained in the works he painted in oil or fresco. For example, in the church of the Calced Franciscans in Parma he painted an Annunciation in fresco so well that when it became necessary to pull it down, because of some changes that had to be made in the building, the friars had the surrounding wall fortified with timber bound with iron and kept the picture intact by cutting round it little by little. Then they built it into a more secure place in the same convent.

1. In fact, in the cathedral at Parma.

Over the gates of the same city Correggio also painted a Madonna and Child; and it is astonishing to see the lovely colouring of this fresco which has won him the most enthusiastic praise, even from passing strangers who have seen nothing else of his. In Sant'Antonio in Parma he painted a panel picture showing the Madonna and St Mary Magdalen, with a boy near by in the guise of a little angel, who is holding a book in his hand and smiling so naturally that anyone looking at him has to smile as well, and even the most melancholy person cannot help responding cheerfully. This work, which also contains a St Jerome, is especially admired by other painters for its astonishing and beautiful colouring, and it is difficult to imagine anything better.

Correggio also executed various pictures and paintings for many local rulers in Lombardy; among these were two that he did in Mantua for Duke Federigo II, to be sent to the emperor as a gift truly worthy of so great a ruler. When Giulio Romano saw these works he said that he had never seen any colouring that reached such perfection. One showed the nude figure of Leda and the other was a Venus, both so soft in colouring and with the shadows of the flesh so skilfully painted that they looked like flesh and blood rather than paint.[1] One of the pictures contained a marvellous landscape, and indeed Correggio painted landscapes better than any other Lombard. Similarly, it would be impossible to improve on the way he painted the hair, represented with meticulous care and delicacy and beautifully coloured. There were also several Cupids, depicted with superb craftsmanship, who were shooting their arrows, some of gold and some of lead, at a stone. And the grace of the Venus was especially enhanced by the clear and limpid stream which flowed over some stones and bathed her feet, without, however, concealing from the onlooker all their white and delicate beauty. So Antonio certainly deserved gratitude and honour during his lifetime and every kind of written and spoken tribute after his death.

In Modena he painted a panel picture of Our Lady, which is admired by all painters and regarded as the best painting in the city. In Bologna, in the house of the noble Ercolani family,

1. The paintings are of Leda and Danaë.

there is a painting by Correggio showing Christ appearing in the Garden to Mary Magdalen; and this is a very beautiful work.

In Reggio also there was a rare and beautiful picture by Correggio; and not so long ago this was seen when he was passing through that city by Luciano Pallavicino, who delights in fine paintings, and who regardless of cost sent it, as something very precious, to his house in Genoa. There is also a panel painting in Reggio of the Nativity, in which the splendour radiating from the figure of Christ throws light all around on the shepherds and on those who are contemplating him. Among the features of this painting is the figure of a woman who is trying to gaze intently at Christ but who because her mortal eyes cannot bear rays of supernatural light is shielding them with her hand; and it is a marvel to see how perfectly the idea is expressed. Above the manger there is a choir of angels singing, so beautifully painted that they seem to have come straight down from heaven rather than to have been created by the hand of an artist.

The same city possesses the most rare and beautiful of all Correggio's works; it is a small picture, about a foot square, with several little figures, showing Christ in the Garden, and it is intended to create the effect of night. The angel is seen appearing to Christ and illuminating him with the splendour of his radiance, and the scene is so realistic that nothing could be better conceived or expressed. Lower down, on the plain at the foot of the mountain on which Christ is praying, are the three apostles asleep; and the shadow cast by the mountain lends these figures an indescribable force. Dawn is breaking over the landscape in the distant background, and from one side appear some soldiers accompanied by Judas. This scene in miniature is so well conceived that no other work of the same kind can compare with it either for patient craftsmanship or study. I could go on discussing the works of this master but I shall say nothing more, seeing that everything he did is regarded as truly inspired by the eminent artists of our own time. I have tried my hardest to obtain his portrait, but without any success since he never painted it himself and, as he always lived apart, he was never portrayed by any other artist. Indeed, he had no great opinion of himself nor, knowing the

difficulties involved, was he persuaded that he could attain the perfection he wished for as a painter. He contented himself with very little, and he led a good Christian life.

Burdened as he was by family cares, Antonio was always anxious to economize and eventually he became a great miser. It is said that one day subsequently he received a payment of sixty crowns all in small coin, and wanting to transfer the money from Parma to Correggio to meet some of his expenses he started the journey on foot, carrying the coins on his back. Then as he was suffering from the heat of the sun he drank some water to refresh himself, and this brought on a raging fever which forced him to take to his bed; and he never raised his head again.

Correggio was about forty when he died. His paintings date from about 1512, and through his use of colours, which he handled like a true master, he made a major contribution to the art of painting. His work clarified the nature of good painting for the artists of Lombardy where he was followed by many talented painters who have also produced excellent and memorable pictures. For example, Correggio taught his fellow artists, all of whom he put permanently in his debt, how to depict hair, which he himself, overcoming every difficulty, painted with great facility. At their instance Fabio Segni, a Florentine nobleman, wrote the following epigram:

> *Hujus cum regeret mortales spiritus artus*
> *Pictoris, Charites supplicuere Iovi:*
> *Non alia pingi dextra, Pater alme, rogamus:*
> *Hunc praeter, nulli pingere nos liceat.*
> *Annuit his votis summi regnator Olympi,*
> *Et juvenem subito sydera ad alta tulit,*
> *Ut posset melius Charitum simulacra referre*
> *Praesens, et nudas cerneret inde Deas.*[1]

1. While still life's spirit mov'd this painter's earthly limbs
 The Graces Jove besought: 'Dear Father, we implore
 That we be painted by no hand but his; this task
 To all but him forbid.' Their plea won the assent
 Of high Olympus' king, who thus did snatch the youth
 Upon a sudden to the stars above, that so
 From close at hand he might more finely render yet
 The Graces' likeness, and uncloth'd their beauty see.

Another painter who lived at that time was a Milanese called Andrea del Gobbo, a charming colourist, many of whose works are to be found in various private houses in Milan. For the Carthusian Monastery at Pavia he did a large panel picture of the Assumption of Our Lady; he died before he could finish it, but it shows his competence as a painter and his love of the art.[1]

1. Andrea Solari, brother of the sculptor Cristoforo.

LIFE OF

RAPHAEL OF URBINO

Painter and architect, 1483–1520

WITH wonderful indulgence and generosity heaven some-times showers upon a single person from its rich and inex-haustible treasures all the favours and precious gifts that are usually shared, over the years, among a great many people. This was clearly the case with Raphael Sanzio of Urbino, an artist as talented as he was gracious, who was endowed by nature with the goodness and modesty to be found in all those exceptional men whose gentle humanity is enhanced by an affable and pleasing manner, expressing itself in courteous behaviour at all times and towards all persons.

Nature sent Raphael into the world after it had been van-quished by the art of Michelangelo and was ready, through Raphael, to be vanquished by character as well. Indeed, until Raphael most artists had in their temperament a touch of un-couthness and even madness that made them outlandish and eccentric; the dark shadows of vice were often more evident in their lives than the shining light of the virtues that can make men immortal. So nature had every reason to display in Raphael, in contrast, the finest qualities of mind accompanied by such grace, industry, looks, modesty, and excellence of character as would offset every defect, no matter how serious, and any vice, no matter how ugly. One can claim without fear of contradiction that artists as outstandingly gifted as Raphael are not simply men but, if it be allowed to say so, mortal gods, and that those who leave on earth an honoured name in the annals of fame may also hope to enjoy in heaven a just reward for their work and talent.

Raphael was born in Urbino, a notable Italian city, on Good Friday in the year 1483, at three o'clock in the night. His father was Giovanni Santi, a mediocre painter but an intelli-gent man who knew how to set his children on the right path

which, through bad fortune, he himself had not been shown
when young. Giovanni also understood how important it was
that children should be reared on the milk of their own
mothers rather than of wet-nurses; and so he insisted that
Raphael (the name he chose, very felicitously, for the baptism)
should, being his first child (and as it happened his last), be
suckled by his own mother and should be trained in childhood
in the family ways at home rather than in the houses of peas-
ants or common people with their less gentle, indeed, their
rough manners and behaviour. And as Raphael grew up
Giovanni began to instruct him in painting, because he saw
that the boy was attracted by the art and was very intelligent.
So before many years passed Raphael came to be of great help
to his father in the numerous works that Giovanni executed
in the state of Urbino.

Eventually Raphael's kind and devoted father, knowing that
his son could make little progress under him, resigned himself
to placing him with Pietro Perugino who, as he had heard,
was the most outstanding painter of the time.[1] He went, there-
fore, to Perugia, but he failed to find Perugino, and so to
occupy his time usefully he started work on some paintings
for San Francesco.

After Pietro had returned from Rome, Giovanni, who was
a man of good breeding and manners, struck up a friendship
with him, and when the time seemed ripe he told him what he
wanted as tactfully as he could. Pietro who was also very
courteous and a great admirer of talent agreed to take Raphael;
and so Giovanni returned in high spirits to Urbino and then
took the boy back with him to Perugia, not without many
tears from his mother who loved him dearly. When Pietro
saw how well Raphael could draw and what fine manners and
character he had he formed a high opinion of him, which in
time proved to be completely justified.

Is is very remarkable that, in studying Pietro's style, Raphael
imitated his work so exactly in every detail that it was im-
possible to tell the difference between the copies he made and
his master's originals. And it was also impossible to distin-
guish clearly between Raphael's own original works and

1. Pietro Perugino (c. 1445/50–1523).

Pietro's, as is evident from some figures that he painted in oils on a panel in San Francesco in Perugia for Maddalena degli Oddi; these represent the Assumption of Our Lady into heaven and her Coronation by Jesus Christ, and among them are the twelve apostles standing about the tomb of Our Lady and contemplating the celestial vision. At the foot of the panel, in a predella divided into three scenes, are some little figures enacting the Annunciation, with Our Lady and the angel, the Adoration of Christ by the Magi, and the Presentation in the Temple, where Simeon takes the Child in his arms. This work was executed with marvellous diligence, and anyone who is not an expert would swear that it was by Pietro and not, as it undoubtedly is, by Raphael.

After Pietro had gone to Florence on business, Raphael left Perugia in company with some friends for Città di Castello, where he painted a panel for Sant'Agostino in the same style as the picture he had just finished. For San Domenico he did a similar work, showing the crucifixion, and if his name were not written on it everyone would think it was by Pietro. For the church of San Francesco in the same city he painted a small panel picture of the Marriage of Our Lady which shows very forcefully the way his own style was improving as he surpassed the work of Pietro. This painting contains a temple in perspective drawn with great care and devotion and showing what amazingly difficult problems Raphael was ready to tackle.

The pictures he did in the style of Perugino brought Raphael considerable fame, and in the meanwhile it happened that Pope Pius II commissioned Pintoricchio to decorate the library of the cathedral at Siena; so being a friend of Raphael's and knowing his excellence as a draughtsman Pintoricchio took him to Siena, where he did some of the drawings and cartoons for the library.[1] The reason he left what he was doing unfinished was that while in Siena he heard some painters enthusiastically praising the fine cartoon for the great hall that Leonardo had drawn in the Hall of the Pope at Florence and the nudes that Michelangelo Buonarroti had executed in

1. Bernardino Pintoricchio (c. 1454–1513) left as his chief works fresco cycles in the Borgia Apartments at the Vatican and in the Piccolomini library at Siena.

rivalry with Leonardo, and with even better results. And so, because of his love of painting, Raphael became so anxious to see these works that he put aside what he was doing and, ignoring his own immediate interest, went off to Florence.

On his arrival the city pleased him as much as did the works of Leonardo and Michelangelo (which indeed came as a revelation to him) and he made up his mind to stay in Florence for some time. He became friendly with a group of painters including Ridolfo Ghirlandaio, Aristotile Sangallo, and others, and he was held in great respect in Florence, especially by Taddeo Taddei, who liked to see him always in his house or at his table, being a great admirer of talented men. In order not to be outdone in kindness Raphael, who was courtesy itself, painted for Taddei two pictures executed in his original style derived from Pietro but also in the manner he was then starting to adopt and which, as I shall explain, was far superior. (These pictures are still in the house belonging to Taddeo Taddei's heirs.) Raphael also became a close friend of Lorenzo Nasi, and as Lorenzo had just got married he painted for him a picture which showed Our Lady and between her legs the Christ-Child to whom a laughing St John is offering a bird, to the great joy and delight of them both. The children are shown in an attitude of youthful simplicity, which is lovely to see, and, moreover, the figures are so well coloured and finished so meticulously that they seem to be made of living flesh rather than paint. Our Lady as well seems truly full of grace and divinity; and lastly, the foreground, the landscape, and all the rest of this painting are extremely beautiful. It was held in great veneration by Lorenzo Nasi as long as he lived, as much in memory of Raphael, whose dear friend he had been, as for its majesty and excellence. But subsequently, on 17 November 1548, it came to grief when a landslide on the hill of San Giorgio destroyed Lorenzo's house along with other nearby dwellings, including the ornate and beautiful houses belonging to the heirs of Marco del Nero. However, the pieces were found among the debris of the ruined house and they were put together again as best he could by Lorenzo's son, Battista, who was very devoted to the art.

After he had done these works, Raphael had to leave Florence

and go to Urbino as both his father Giovanni and his mother had died, and so all the family affairs were in a muddle. And while he was living in Urbino, for Guidobaldo da Monte-feltro (then commander of the Florentine troops) he painted two small but very beautiful Madonnas (in his second style), which are today in the possession of Guidobaldo, the most illustrious duke of Urbino. For the same patron he also exe-cuted a picture of Christ praying in the Garden with the three apostles sleeping some distance away. This painting is so finely finished that it is like an exquisite miniature. For a long time it was owned by Francesco Maria, duke of Urbino, and then it was presented by the most illustrious Signora Leonora, his consort, to the Venetians Don Paolo Giustiniano and Don Pietro Quirini, hermits at the holy hermitage of Camaldoli. In her honour they afterwards placed it (as being a relic and a rare work of art, in a word as being by Raphael of Urbino) in the room of the father superior of the hermitage, where it is treated with the reverence it deserves.

After he had executed this work and put his affairs in order, Raphael went back to Perugia, where in the church of the Servites, for the chapel of the Ansidei, he painted a panel pic-ture of Our Lady, St John the Baptist, and St Nicholas; and for the Lady Chapel in San Severo (a small monastery of the Order of Camaldoli) he did a fresco painting of Christ in Glory and a God-the-Father with angels around him and six seated figures of saints: St Benedict, St Romuald, St Lawrence, St Jerome, St Maurus, and St Placid, three on each side. On this work, which was at that time regarded as an extremely beautiful example of fresco, Raphael signed his name in big, very legible characters. In the same city he was also com-missioned by the nuns of St Anthony of Padua to paint a panel picture of Our Lady with Jesus Christ sitting on her lap and (as pleased those simple, holy women) fully clothed, and with St Peter, St Paul, St Cecilia, and St Catherine on either side of the Madonna. Raphael depicted the two saintly virgins with the most beautiful and graceful expressions and the most wonderfully varied head-dresses anywhere to be seen; and this was an unusual thing in those days. In a lunette over the panel he painted a very fine God-the-Father and in the

.predella of the altar he did three scenes with little figures: Christ praying in the Garden, carrying the cross (and in this scene the gestures of the soldiers dragging him along are beautifully expressed) and lying dead in the lap of his mother. This is certainly a marvellous and devout work of art, held in great honour by those nuns and highly admired by all painters. I must record that it was recognized, after Raphael had been in Florence, that influenced by the many works he saw painted by the great masters he changed and improved his style of painting so much that it had nothing to do with his earlier manner; in fact, the two styles seemed to be the work of two different artists, one of whom was more proficient than the other.

Before Raphael left Perugia, Madonna Atalanta Baglioni begged him to consent to paint a panel picture for her chapel in the church of San Francesco; however, as he could not do it then he promised that after returning from Florence (where he had to go to see to his affairs) he would not disappoint her. And so after he had arrived in Florence, where he devoted himself to intense study of the art of painting, he prepared the cartoon, with the intention, which he fulfilled, of going back to execute the picture as soon as he had the chance.

While Raphael was living in Florence, Agnolo Doni (who was very cautious with his money in other things, but spent it readily, although still as economically as possible, on works of painting and sculpture, which gave him immense pleasure) commissioned Raphael to paint the portraits of himself and his wife; and these, in Raphael's new style, may be seen in the possession of his son Giovanbattista, in the beautiful and spacious house that Agnolo built on the Corso de' Tintori in Florence, near the Canto degli Alberti.

For Domenico Canigiano, Raphael painted a picture of Our Lady, with the Infant Jesus welcoming a little St John brought to him by St Elizabeth who, as she holds him forward, is gazing with a most animated expression at St Joseph, who stands there with both hands resting on a staff and inclines his head towards her, as if praising the greatness of God and marvelling that at her age she should have such a young child. All the

figures are shown wondering at the feeling and reverence with which, despite their tender years, the two cousins are caressing each other; not to mention that every stroke of colour made by the brush in the heads, hands, and feet appears to be living flesh rather than mere paint applied by the hand of an artist. Today this magnificent picture belongs to Domenico Canigiano's heirs, who treasure it with the respect due to a work by Raphael of Urbino.

This great painter studied the old paintings of Masaccio in the city of Florence; and what he saw in the works of Leonardo and Michelangelo inspired him to study even more intensely, so that there followed a striking improvement in his style and skill. Raphael was especially fond of Fra Bartolommeo of San Marco, who was among his circle of friends in Florence and whose use of colours he greatly admired and tried hard to imitate. In return, Raphael taught this good priest the principles of perspective, of which the friar had formerly been ignorant.

However, when their friendship was at its height Raphael was recalled to Perugia, where he first of all finished the painting for Madonna Atalanta Baglioni, the cartoon for which, as I said earlier, he had drawn while in Florence. In this inspired painting there is a dead Christ being carried to the sepulchre, executed with such loving care and so fresh that it appears to have been only just finished. In composing this work Raphael imagined to himself the grief as they lay him to rest felt by the nearest and dearest relations of some much loved person, who had sustained the happiness, dignity and well-being of a whole family. One sees the swooning figure of Our Lady and the graceful heads of other weeping figures, notably St John who, with his hands clasped, drops his head in a way that would move the hardest heart to pity. The diligence, the skill, the devotion, and the grace expressed in this work are really marvellous, and everyone who sees it is amazed at the attitudes of its figures, the beauty of the draperies and, in brief, the perfection of its every detail.

After he had finished this work, Raphael went back to Florence where the Dei, a Florentine family, commissioned him to paint an altarpiece for their chapel in Santo Spirito.

He almost completed the sketch for this work, but in the meantime he did a painting which was subsequently sent to Siena. (This picture remained with Domenico Ghirlandaio, so that he could finish a piece of blue drapery, when Raphael left Florence.) At that time Bramante of Urbino, who was working for Julius II, because he was distantly related to Raphael and came from the same part of the world wrote to him saying that he had persuaded the Pope to build some new apartments where Raphael would have the chance to show what he could do.

Raphael found the proposal agreeable and so he left for Rome, abandoning his work in Florence and leaving the panel for the Dei family in the unfinished condition in which Baldassare later, after Raphael's death, had it placed in the parish church of his native town. When he arrived in Rome Raphael found several artists at work decorating the rooms in the Vatican, some of which were already finished. Piero della Francesca had completed a scene in one room, Luca da Cortona had nearly finished a wall in another, and Don Pietro della Gatta, abbot of San Clemente, had started several paintings. Moreover, Bramantino of Milan had executed a number of figures, mostly portraits from life, which were regarded as being extremely beautiful. However, after he had been welcomed very affectionately by Pope Julius, Raphael started to paint in the Stanza della Segnatura a fresco showing the theologians reconciling Philosophy and Astrology with Theology, in which there are portraits of all the sages of the world shown disputing among themselves in various ways.[1] Standing apart are some astrologers who have drawn various kinds of figures and characters relating to geomancy and astrology on some little tablets which, by the hands of some very beautiful angels, they are sending to the evangelists to expound.

1. Vasari's account of Raphael's work is very muddled. Very briefly: Raphael was working in the Stanza della Segnatura (part of the series of rooms that Julius was having decorated) by 1509. Here, the two chief frescoes are known as the *School of Athens* and the *Disputation concerning the Blessed Sacrament*. In the Stanza d'Elidoro the chief subjects are the *Expulsion of Heliodorus from the Temple*, the *Liberation of St Peter*, and the *Miracle of the Mass at Bolsena*. The scenes in the Stanza dell'Incendio (containing the *Fire in the Borgo*) and the Sala di Constantino were mostly executed by Raphael's assistants.

Among them is Diogenes with his cup, lying deep in thought on the steps: this is a finely conceived figure which deserves high praise for its beauty and the appropriate negligence of its clothing. There, also, are Aristotle and Plato, one holding the *Timaeus*, the other with the *Ethics*; and round them in a circle is a great school of philosophers. The astrologers and geometers are using compasses to draw innumerable figures and characters on their tablets; and it is hardly possible to describe how splendid they look. Among them is a handsomely built young man who is inclining his head and throwing out his arms in admiration: this is a portrait of Duke Federigo II of Mantua, who was in Rome at that time. Similarly, there is a figure stooping down and holding in its hand a pair of compasses with which it is making a circle on one of the tablets; and this, they say, is the architect Bramante, portrayed so realistically that he seems to be alive. Beside a figure with its back turned, holding a globe of the heavens, is a portrait of Zoroaster, and next to him is Raphael, the artist himself, in a self-portrait drawn with the help of a mirror. He is shown with a youthful head, an air of great modesty, and a gracious and attractive manner, and he is wearing a black cap. Also defying description are the beauty and goodness shown in the heads and figures of the evangelists, in whose faces Raphael depicted a very lifelike air of intentness and concentration, notably in those who are writing. Thus behind St Matthew, who is copying into a book the characters from the inscribed tablets held out to him by an angel, is an old man who had put a sheaf of papers on his knee and is now copying everything that St Matthew is writing; as he concentrates in this awkward position he seems to be twisting his jaws and his head up and down with the strokes of his pen. As well as the many fine details with which Raphael expressed his ideas, one must remark the composition of the entire scene; for it is convincingly arranged with such order and proportion that by the genius shown in this work Raphael clearly demonstrated his determination to be the undisputed master among all those using the brush. He also embellished the picture with a view in perspective and with a number of figures, executed in such a soft and delicate style that Pope Julius was

persuaded to demolish all the scenes painted by the other artists, both the new and the old, so that Raphael alone might be honoured before all those who had laboured there previously.

The painting by Giovanni Antonio Sodoma of Vercelli, which was above Raphael's work, was to be destroyed on the Pope's orders, but Raphael decided to make use of its compartments and arabesques. There were also some medallions, four in number, and in each of these Raphael painted a figure symbolizing the scenes beneath. Each figure was on the same side as the story it represented. For the first scene, where Raphael had depicted Philosophy, Astrology, Geometry, and Poetry making their peace with Theology, there is a woman representing Knowledge, seated on a throne supported on either side by a figure of the goddess Cybele shown wearing the many breasts with which the ancients used to depict Diana Polymastes. Her dress is composed of four colours representing the various elements: from the head down the colour of fire; below the girdle the colour of air; from her sex to her knees the colour of earth, and from there to the feet the colour of water. Shown with her are several very beautiful *putti*.

In another tondo towards the window overlooking the Belvedere Raphael depicted Poetry, in the person of Polyhymnia crowned with laurel; with her legs crossed, she is holding an archaic musical instrument in one hand and a book in the other. Her expression and posture are of supernatural beauty, and she stands with her eyes raised up to heaven, accompanied by two vivacious and spirited *putti* who with her and the other figures form a group of great beauty and variety. And also on this side, over the window, he later painted Mount Parnassus.

In another of the medallions, over the scene where the Doctors of the Church are deciding the form of the Mass, Raphael depicted Theology surrounded by books and other appropriate objects and also accompanied by many beautiful *putti*. And above the other window overlooking the courtyard, in the fourth medallion, he depicted Justice with her scales and uplifted sword and with the same *putti* as accompany

the other figures. The effect is extremely beautiful, for, as I shall describe in the appropriate place, on the wall below Raphael painted the giving of the civil and canon law.

Similarly, on the same ceiling in the angles of the pendentives he did four scenes meticulously drawn and coloured, but with figures of no great size. Near the picture of Theology, in a delicately executed scene he depicted Adam sinning by eating the apple. In the second scene, near the Astrology, he showed the figure of Astrology setting the fixed stars and the planets in their places. Then, near Mount Parnassus, he showed Marsyas bound to a tree and flayed at the command of Apollo. And near the scene showing the promulgation of the decretals he depicted the Judgement of Solomon, who is proposing that the child be cut in two. The four scenes are full of expression and feeling, executed with excellent draughtsmanship and in charming and graceful colours.

But now, having finished with the vaulting, or rather the ceiling of the apartment, it remains for me to describe wall by wall what Raphael painted below.

Surrounding the mountain on the wall towards the Belvedere, where he showed Mount Parnassus and the fountain of Helicon, Raphael depicted a laurel wood of deep shadows in whose verdure one can almost see the leaves trembling before the gentle zephyrs, while in the air a host of naked cupids, with charming features and expressions, are gathering branches of laurel to make garlands to scatter here and there about the mountain. The whole scene seems to be imbued with the supernatural, so beautiful are the figures and so noble is the composition. No one can study it carefully without being amazed at the way in which a human intelligence, through the imperfect medium of colours, brought painted objects to life. Thus, extremely lifelike are the poets dispersed about the mountain, some standing, some seated, some writing, others discoursing and yet others singing and talking together, in groups of four or six, as Raphael chose to arrange them. Portrayed from life are all the most celebrated poets of modern and ancient times, including several still alive in Raphael's time. Some were copied from statues or medals, many others from old paintings, or if still living directly from life by Raphael

himself. Starting from one side, we can see Ovid, Virgil, Ennius, Tibullus, Catullus, Propertius, and the blind Homer, who with his head raised up is reciting verses which are being written down by a boy sitting at his feet. Then there are the nine Muses in one group, together with Apollo; and these figures are so incredibly beautiful that they seem to breathe with grace and life. Then again, we see the learned Sappho and the inspired Dante, the gracious Petrarch and the amorous Boccaccio, all vivaciously depicted; there also is Tebaldi with innumerable other modern poets. And this scene was executed with wonderful grace and diligence.

On another wall Raphael painted a heaven with Christ and Our Lady, St John the Baptist, the apostles, and the evangelists and martyrs, all enthroned above the clouds, with God-the-Father sending down the Holy Ghost, notably to a great crowd of saints who are settling the form of the Mass and disputing on the nature of the Host which lies on the altar. Among the figures are the four Doctors of the Church who are surrounded by innumerable saints including Dominic, Francis, Thomas Aquinas, Bonaventura, Scotus, Nicholas of Lyra, Dante, Fra Girolamo Savonarola of Ferrara, and all the Christian theologians, great numbers of whom are portrayed from life. Hovering in the air are four children holding open the four gospels. And no painter could create figures more graceful or more perfect than these. The saints seated in a circle in the air are coloured so beautifully as to appear alive, and are shown receding and foreshortened in such a way as to seem in relief. Moreover, they wear many different kinds of vestments, the draperies are depicted with the most beautiful folds, and the expressions of the figures are truly celestial. In the head of Christ, for example, can be seen all the divine mercy and holiness that it is possible for painting to convey to mortal men. Raphael, indeed, was endowed by nature with the ability to paint heads with wonderfully sweet and gracious expressions. This is shown again by the figure of Our Lady who, with her hands on her breast, contemplates her son and clearly cannot refuse any favour asked of her. Moreover, this work powerfully demonstrated Raphael's fine sense of decorum; for he showed old age in the expressions of the holy

patriarchs, simplicity in the apostles and faith in the martyrs. He displayed even more skill and talent in the way he depicted the Doctors of the Church, who are standing here and there, occupied in disputation, in groups of six or three or two. Their expressions reveal their intellectual curiosity and their anxiety to establish the truth of what is in question: they are gesticulating with their hands, making various movements with their bodies, inclining their ears to listen, knitting their brows and expressing astonishment in many different ways, all of which are truly varied and appropriate. Standing apart are the four Doctors of the Church who, enlightened by the Holy Ghost, are unravelling and expounding by means of the holy scriptures all the problems of the gospels, which are held in the hands of the boys hovering in the air.

On the wall with the other window Raphael painted on one side Justinian giving the laws to be revised by the Doctors; and above he depicted Temperance, Fortitude, and Prudence. On the other side he showed the Pope issuing the canonical decretals; and he included a portrait taken from life of Pope Julius accompanied by Cardinal Giovanni de' Medici (who subsequently became Pope Leo), Cardinal Antonio di Monte, and Cardinal Alessandro Farnese (later Pope Paul III) as well as other portraits.

The Pope was very satisfied with this work, and to make the panelling worthy of the paintings he sent to Monte Oliverto di Chiusuri in the Siena district for Fra Giovanni da Verona, who in those days was a great master of perspective-views in wood inlays. Fra Giovanni executed not only the surrounding panelling but also some very fine doors and chairs, with perspective studies, which won him generous praise and rewards from the Pope. To be sure, Fra Giovanni designed and executed this kind of work incomparably well, as is proved by a very fine sacristy with perspective inlays in Santa Maria in Organo (in his own birthplace, Verona), by the choirs of Monte Oliveto in Chiusuri and of San Benedetto in Siena, as well as the sacristy of Monte Oliveto in Naples, and, in the same part of the world, the chapel of Paolo da Tolosa. His work rightly earned him the praise and respect of his brothers in religion. He died in 1537, at the age of sixty-eight. (I have

mentioned this excellent and outstanding artist since his talent demanded it and, as I shall describe later, was responsible for much fine work by other craftsmen.)

But to return to Raphael, he made such progress that the Pope commissioned him to go on to paint a second room that was near the Great Hall. And at that time, when his reputation was very high indeed, Raphael did an oil-painting of Pope Julius. This portrait was so true and lifelike that everyone who saw it trembled as if the Pope were standing there in person. Today it is in Santa Maria del Popolo, together with a very beautiful painting of Our Lady executed at the same time, which shows the Birth of Jesus Christ with the Virgin laying a veil over her son. The attitude of the child's head and every part of his body are so beautiful that he is clearly the true son of God; and no less fine are the head and face of the Madonna whose serene beauty wonderfully expresses her piety and joy. St Joseph is shown, his hands resting on a staff, contemplating the king and queen of Heaven with the devout wonder of a holy old man. Both these works are exhibited on important feast days.

By now Raphael had made a great name for himself in Rome. He had developed a smooth and graceful style that everyone admired, he had seen any number of antiquities in that city, and he studied continuously; none the less, his figures still lacked the indefinable grandeur and majesty that he now started to give them.

What happened was that Michelangelo at that time made his terrifying outburst against the Pope in the Sistine Chapel (as I shall describe in his *Life*) and was forced to run away to Florence. So then Bramante, who had the keys of the chapel, being a friend of Raphael brought him to see Michelangelo's work and study his technique. And this was the reason why, though it was already finished, Raphael immediately repainted the prophet Isaiah which is to be seen in Sant'Agostino in Rome, above the St Anne by Andrea Sansovino; and what he had seen of Michelangelo's paintings enabled him to give his own style more majesty and grandeur, so that he improved the picture out of all recognition. When Michelangelo saw Raphael's work later on he was convinced, and rightly, that

Bramante had deliberately done him that wrong for the sake
of Raphael's reputation and benefit.

Then, not long after this, Agostino Chigi, a very rich
Sienese merchant who was a true friend of accomplished men,
commissioned Raphael to decorate a chapel for him; and he
did this because, shortly before, Raphael had painted for him
in a loggia of his palace (now called the Chigi, in the Traste-
vere) in his softest manner a Galatea in a chariot on the sea
drawn by two dolphins and surrounded by many sea-gods
and Tritons. After he had made the cartoon for the chapel
(which is at the entrance of the church of Santa Maria della
Pace, at the right hand of the main entrance) he executed it in
fresco in his new style, which was appreciably grander and
more magnificent than his earlier manner. In this painting,
done before Michelangelo's chapel was open to the public
although after he himself had seen it, Raphael represented
several prophets and sibyls. It is held to be the best of his
works, and the most beautiful among so many that are beauti-
ful; the women and children, for example, are most vivacious
and perfectly coloured. As the finest and most outstanding
work he ever did, it won him great praise both during his
lifetime and after.

Next, spurred on by the entreaties of one of Pope Julius's
chamberlains, Raphael painted the panel for the high altar
of the Ara Coeli, and he represented Our Lady in the clouds
of heaven, with a very beautiful landscape, a St John, a St
Francis, and a St Jerome portrayed as a cardinal. In the figure
of Our Lady he conveyed the modesty and humility belong-
ing to the mother of Christ, and he showed the child making a
beautiful gesture as he plays with his mother's robe; and in the
face of St John is seen the penitential air usually resulting from
fasting, and in his head the deep sincerity and strong assurance
characteristic of those who have withdrawn from the world
and despise it and who in their dealings with others spurn lies
and speak only the truth. Meanwhile, St Jerome is shown with
his head uplifted, gazing in contemplation at Our Lady, and
in his eyes one can perceive all the learning and wisdom he dis-
played in his writings; with a gesture of his hands he is seeking
Our Lady's protection for the chamberlain, whose own

portrait could not be more lifelike. The same holds true for the portrait of St Francis who is kneeling on the ground with one arm outstretched and his head lifted up towards Our Lady; his expression is glowing with love and the features and colouring of his face express his deep emotion as he draws comfort and inspiration from the Madonna's gentle and beautiful gaze and the animated beauty of her son. In the middle of the panel, below the figure of Our Lady, Raphael painted a little boy who, as he stands there, is raising his head towards her and holding an inscription; and this figure is so handsome and beautifully proportioned that one cannot imagine anything finer or more gracious. And in addition there is a landscape of singular beauty and perfection.

Afterwards, continuing to work on the apartments of the palace, Raphael painted a scene showing the miracle of the corporal at Orvieto, or as is sometimes said, at Bolsena. One sees the priest, as he says Mass, flushing with shame as he realizes that through his disbelief he has made the Host on the corporal turn to blood. With terror in his eyes, distraught and dumbfounded in the presence of the congregation, he hardly knows what to do; and in the movements of his hands one can almost see the fear and trembling to be expected in such circumstances. In this picture Raphael painted a number of different figures: some are assisting at the Mass, others are kneeling on a flight of steps; and all of them, disconcerted by the strangeness of what has happened, are making various beautiful movements and gestures, while many of them, men and women, appear to believe that they themselves must be guilty. Among the women is one seated on the ground at the foot of the scene who is holding a child in her arms. She is listening to someone explaining what has happened to the priest, and as she does so she turns her body in a wonderful manner, with a womanly grace which is completely natural and lifelike. On the other side Raphael painted Pope Julius hearing the Mass, in a marvellous scene which contains the portraits of Cardinal San Giorgio and of countless others. And he made use of the window-opening to depict a flight of steps, which rounds off the composition perfectly, making it seem, in fact, that if the opening had not been there the

picture would have been incomplete. This proves the justice of the claim that in the art of composition, no matter what the subject, Raphael surpassed everyone else in facility, skill, and ability.

He demonstrated this again, in the same place, in a scene opposite the one I have just described which shows St Peter in the hands of Herod, guarded in prison by armed men. The grasp of architecture shown in this picture and the effect he achieved in the prison building are such that the work of the painters who came after Raphael seems in comparison to be as confused as his was beautiful. For Raphael always endeavoured to paint his scenes as if they were written stories and to embellish them with interesting decorative details, as is shown in this particular painting by the horror of the prison. Here Raphael showed the elderly St Peter bound in iron chains between two armed guards, the guards themselves sunk in sleep, and the dazzling splendour of the angel which pierces the dark shadows of the night to light up every detail of the prison and make the arms of the soldiers shine so resplendently that their burnished lustre appears more lifelike than the real thing. He displayed comparable skill and genius in describing the action of St Peter when, freed from his chains, the apostle leaves prison escorted by the angel: St Peter appears to believe that he must be in a dream, while the faces of some other armed guards standing outside the prison express terror and dismay as they hear the clanging of the iron door, and a sentinel with a torch in his hand rouses the others. As he gives them light, the blaze of the sentry's torch is reflected in their armour, and where this fades its place is taken by the light of the moon. Raphael painted this composition over the window, where the wall happened to be darkest; so when one looks at the painting the light strikes one in the face, the natural light contends with the various lights of the night in the painting itself, and the smoke of the torch, the splendour of the angel, and the dark shadows appears so natural and lifelike, that one can hardly believe this is merely a painting, so perfectly did Raphael express his complex ideas. In the armour shown in this painting he depicted so skilfully the play of the shadows, the flickering reflection of the lights and the vaporous glare

of the torches mingling with the surrounding gloom that he can truly be said to be the master of every other painter. As a work reproducing the effect of night this picture is truer than any other, and it is universally regarded as outstanding and inspired.

On one of the bare walls Raphael depicted the Divine Worship of the Hebrews, with the Ark and the Candlestick, and also the figure of Pope Julius driving Avarice out of the Temple. This scene is as beautiful and excellent as the Night described above. It includes the portraits of some papal bearers alive at that time, who are shown carrying a very lifelike Pope Julius in his litter; as the people, with some women among them, make way for the Pope one sees the furious onset of an armed man on horseback, accompanied by two others on foot; with great ferocity he is riding down and smiting the proud Heliodorus, who is seeking, on the orders of Antiochus, to plunder the Temple of the wealth stored for the widows and orphans. One sees the riches and treasures being seized and carried away; then, because of the panic caused by the strange fate of Heliodorus in being trampled and violently assaulted by the three figures mentioned above (in a visitation that only Heliodorus himself can see) the spoils are all overturned and poured out on the ground. The plunderers are thrown to the ground by the sudden horror and fear that has seized all the followers of Heliodorus. Moreover, one can see the holy Onias, the high priest, dressed in his vestments, with his eyes and hands raised towards heaven as he prays with great fervour, because of his compassion for the unhappy innocents who were about to lose their possessions; and he rejoices at the same time because he senses that help has already been sent by God. Besides this, on an inspired impulse Raphael showed a crowd of people who have climbed on to the socles of the columns, which they clasp with their arms as they strain to see what is happening. And all the onlookers show their astonishment in different ways as they wait to see what the outcome will be.

This work was so magnificent in every respect that even the cartoons are regarded as precious. Thus some pieces of the cartoon that Raphael prepared for the Heliodorus are in the

possession of Francesco Masini, a gentleman of Cesena who, lacking any teacher but guided from childhood by his natural instincts, has from his studies of drawing and painting produced pictures which have been highly praised by discriminating critics. Masini treasures these fragments as they deserve among his rich collection of drawings and antique marble reliefs. I must add that Niccolò Masini, who told me these things, is himself versatile and accomplished and greatly devoted to the arts.

But to return to Raphael, on the ceiling above he then painted four scenes as follows: God appearing to Abraham and promising to multiply his seed; the Sacrifice of Isaac; Jacob's Ladder; and the Burning Bush of Moses. In these may be recognized no less art, invention, draughtsmanship, and grace than in Raphael's other works.

While this favoured artist was producing such marvellous work, through the envy of fortune Julius II, a patron of genius and a lover of all good art, was overtaken by death. He was succeeded by Leo X who showed himself anxious for the work that had been done to be continued and thus enabled the genius of Raphael to soar even higher. Raphael, indeed, received countless favours from Leo, because he had been brought into the orbit of a great prince who followed the traditions of the Medici family in being devoted to the art of painting. So having been encouraged to continue his work, Raphael painted on the other wall the descent of Attila on Rome and his encounter at the foot of Monte Mario with Pope Leo III, whose benediction alone succeeded in driving him away. In this scene Raphael depicted St Peter and St Paul with swords in their hands flying through the air to defend the Church. (This is not in the history of Leo III, but it was perhaps Raphael's idea to tell the story so, for it often happens that pictures, like poems, stray from the subject to make the composition more elaborate without, however, destroying its central truth.) In the two apostles may be seen the supernatural wrath and zeal that the divine justice usually imparts to the features of God's ministers when they are charged with defending our holy religion. An indication of this is given by Attila (seen riding a black horse with white feet and a star on its

forehead), for he is throwing up his head in terror and turning his body in flight. Raphael painted several other fine horses, notably a dappled jennet which is mounted by a figure covered with scales like a fish; this was copied from Trajan's Column, where there are figures wearing armour believed to have been made of crocodile skin. And then one can see Monte Mario itself, covered with flames to show that when soldiers strike camp their quarters are always deliberately destroyed by fire. For this picture Raphael also portrayed some mace-bearers accompanying the Pope who are extremely realistic, as are the horses they ride; and the same is true of the train of cardinals and of some grooms who are holding the palfrey on which, accompanied by a crowd of courtiers, the Pope is riding. This is a portrait, as lifelike as all the others, of Leo X in full pontifical robes; and the whole episode makes a charming spectacle, in keeping with the rest of the work and very useful for other painters, especially those who cannot easily find the subjects Raphael depicted.

At this time Raphael painted a panel picture to be sent to Naples, where it was subsequently placed in the church of San Domenico, in the chapel containing the crucifix that spoke to St Thomas Aquinas. This altarpiece contains Our Lady, St Jerome robed as a cardinal, and the Angel Raphael accompanying Tobias.

For Leonello da Carpi, ruler of Meldola (who is still living, though over ninety) Raphael painted a picture of marvellous colouring and outstanding beauty. This is a work of such strength and such enchanting delicacy that I cannot see how it could ever be surpassed. Nothing could be finer than the supernatural expression shown in the countenance of Our Lady and the modesty of her attitude; she sits with her hands clasped, adoring her son who is sitting in her lap and caressing the little St John who is also worshipping him, as are St Elizabeth and Joseph. This picture once belonged to the Very Reverend Cardinal da Carpi, the son of Leonello and a great lover of the arts; and today it must be in the possession of his heirs.

Subsequently, when Lorenzo Pucci, cardinal of Santi Quattro, was created Grand Penitentiary, he favoured Raphael

with a commission to paint an altarpiece for San Giovanni in Monte in Bologna. Today this panel is in the chapel containing the body of the Blessed Elena dall'Olio. It is a wonderful example of the grace and art that flowed from Raphael's subtle workmanship. In it is a St Cecilia who stands enraptured by a choir of angels on high and, as she listens to their singing, is wholly absorbed by the music. One can see in her face the abstracted expression found in those in ecstasy; and scattered on the ground there are various musical instruments which seem real rather than merely painted, as do the veils that St Cecilia is wearing along with vestments woven in silk and gold covering a marvellously painted hair-shirt. Then again, in the expression of St Paul, standing with his right hand resting on a naked sword and his head on his hand, Raphael depicted the apostle's profound air of knowledge no less than the dignity into which his fierce pride has been transformed. St Paul is cloaked in a simple red garment covering a green tunic, in the manner of an apostle, and his feet are bare. There is also a St Mary Magdalen shown in an enchanting pose, with a delicate vase of stone in her hand, and turning her head with an expression of great joy over her repentance; and indeed, I can think of no better example of this kind of painting. Extremely beautiful also are the heads of St Augustine and of St John the Evangelist.

In fact, whereas pictures by others may be called simply pictures, those painted by Raphael are truth itself: for in his figures the flesh seems to be moving, they breathe, their pulses beat, and they are utterly true to life. Thus, having already won great praise Raphael became even more renowned, and many Latin verses were composed in his honour. I shall quote just two lines, to avoid making this *Life* even longer than it is:

> Pingant sola alii referantque coloribus ora;
> Caeciliae os Raphael atque animum explicuit.[1]

After the St Cecilia, Raphael painted a small picture with little figures, which is also to be found in Bologna in the house of Count Vincenzio Ercolano. This contained the figure of

1. Others may paint the sitter's face, and catch its hues; Raphael has shown Cecilia's face and very mind.

Christ in Glory, in the manner of Jove, surrounded by the four evangelists as they are described by Ezekiel: one in the form of a man, the other a lion, the third an eagle, and the fourth an ox. Below there is a miniature landscape, and the whole picture in its small proportions is as rare and beautiful as Raphael's other works in their greatness.

Raphael sent to the counts of Canossa in Verona a large picture of comparable excellence which contained a very beautiful Nativity with a daybreak that is regarded very highly, as is the figure of St Anne and, indeed, the whole work, which can be best praised merely by saying that it is by Raphael. So those noblemen treat it with great reverence, and despite the vast sums offered them by many princes they have always refused to part with it. Raphael also painted a portrait of Bindo Altoviti as a young man, and he presented Bindo with a painting that is regarded as an astonishing work.

Another fine painting, of the Madonna, was sent by Raphael to Florence. Today it is in Duke Cosimo's palace, in the chapel of the new apartments which were built and decorated by me, where it serves as an altarpiece. This picture contains a very old St Anne, seated and holding out to Our Lady her naked son whose body is so beautiful and whose face is so lovely that his smile lightens the heart of anyone who looks at him. And in the figure of Our Lady herself Raphael showed all the beauty that belongs to an image of the Virgin Mary: modesty in her eyes, honour in the brow, grace in the nose, and virtue in the mouth; not to mention that Our Lady's garment reflects her infinite simplicity and purity. I do not believe any other painting of this kind could possibly be better. Moreover, the picture contains a nude St John, seated, and a female saint who is also beautifully depicted. For background there is a building in which Raphael painted a linen-covered window to give light to the room where he placed the figures.

While in Rome, Raphael painted a large picture in which he portrayed Pope Leo, Cardinal Giulio de' Medici, and Cardinal de' Rossi. In this work the figures appear to be truly in the round rather than painted. One can see the pile of the velvet, with the Pope's damask robes rustling and shining, the

soft and natural fur of the linings, and the gold and silk imitated so skilfully that they seem to be real gold and silk rather than paint. Then there is an illuminated book of parchment which is utterly realistic and an inexpressibly beautiful little bell of wrought silver. Among the other details there is also, on the Pope's throne, a ball of burnished gold which is so bright that like a mirror it reflects the light from the windows, the Pope's shoulders, and the walls around the room. Indeed, everything in this picture is executed so diligently that no other painter could ever possibly surpass it. The Pope was moved to reward him very generously; and today, it may be seen in Florence, in the duke's wardrobe.

Raphael also executed portraits of Duke Lorenzo and Duke Giuliano, which are coloured with incomparable grace; and these perfect works now belong to the heirs of Ottaviano de' Medici and are also in Florence.

Raphael won greater rewards and glory than ever before, and he now decided that he should leave a memorial of himself. So in the Borgo Nuovo at Rome he built a palace with columns made of cast stucco under Bramante's direction. This and his other work spread his fame as far as France and Flanders, and he influenced the work of Albrecht Dürer, the marvellous German painter and master of fine copper engravings, who sent his own self-portrait. This was a head executed in gouache on transparent cambric, so that the design appeared the same on both sides; he used water-colours for the ground and colours, and the white of the cloth to provide the lights. Raphael considered this a wonderful work, and in return he sent several of his own drawings which Dürer kept and treasured. (The head used to be among the belongings of Giulio Romano, Raphael's heir, in Mantua.) Meanwhile, after he had seen Albrecht Dürer's method of engraving, Raphael became anxious to discover what could be done for his own work with this craft, and so he caused Marcantonio of Bologna to undertake a very thorough study. Marcantonio became so proficient that Raphael commissioned him to make prints of his first works, namely, the drawing of the Holy Innocents, a Last Supper, the Neptune, and a St Cecilia being boiled alive in oil. Then Marcantonio made for him a

series of engravings which he afterwards gave to Baverio, his boy-servant, who looked after one of his mistresses. Raphael made a beautifully lifelike portrait of this woman (whom he loved until he died)which is now in Florence in the possession of the distinguished Florentine merchant, Matteo Botti, the friend and intimate of all talented men and especially of painters. Matteo cherishes this portrait because of his love of art and above all his devotion to Raphael himself. His brother Simone Botti is no less fond of painting and painters; and as well as being regarded as one of the finest patrons of art he is especially esteemed by me as the best and closest friend I have ever known, not to mention his sound artistic knowledge and judgement. But to return to the subject of engravings: the favour Raphael showed to Baverio so encouraged Marco of Ravenna and countless others that from being rarely seen copper engravings became as common as they are today. And then Ugo da Carpi, an artist whose head was full of splendid and ingenious ideas and inventions, discovered the art of engraving on wood in three pieces for showing the half-tints, the lights, and the shadows, and giving the effect of shaded drawings. This was certainly a fine and ingenious discovery and today there are an abundance of these prints to be seen, as I shall describe more fully in the *Life* of Marcantonio of Bologna.

For the monastery of the monks of Monte Oliveto at Palermo, called Santa Maria dello Spasmo, Raphael then made a panel picture showing Christ carrying the cross. This is acknowledged as a marvellous work of art. It shows the brutal profanity of those who are about to crucify Our Lord as they lead him to death on Calvary, and the Passion of Christ, agonized by the approach of death, as after he has fallen to the ground under the weight of the cross, bathed in sweat and blood, he turns towards the Marys who are weeping bitterly. Raphael depicted also the figure of Veronica as with a gesture of tender love she extends her arm and offers him a cloth; not to mention that the painting is full of armed men on horseback and on foot, who in various most beautiful attitudes are pouring forth from the gate of Jerusalem with the standards of justice in their hands.

Before the finished picture was delivered it nearly came to grief because (the story goes) when it was being taken by sea to Palermo a violent tempest sprang up and drove the ship on to a rock. The vessel was smashed to pieces and its crew and cargo were lost, save for the altarpiece which, securely packed in its case, was washed by the sea on to the beach at Genoa. There it was fished out of the water on to dry land, where immediately it was seen to be a miraculous work and put in a safe place. It had remained undamaged, without any hurt or blemish, since even the fury of the wind and waves had respected its beauty. After the news of what had happened had spread abroad, the monks took steps to recover the painting; and after it had been secured for them, through the good offices of the Pope, they generously rewarded those who had salvaged it. It was put on ship once more and taken to Sicily, where they set it up in Palermo; and in that part of the world it enjoys more fame and reputation than Mount Etna itself.

While Raphael was doing these paintings (having to serve great and distinguished persons and also, because of his own needs, being unable to say no) he carried on, despite everything else, with the series of pictures that he had started in the papal apartments and halls. He kept in his service various assistants who continued the work from his designs while he supervised everything and gave this great project all the help he could. And after no long time he threw open the apartment of the Borgia Tower in which he had painted a scene on every wall, two above the windows and two others on the sides.

One of the scenes showed the burning of the Borgo Vecchio at Rome, when the fire was finally extinguished by the benediction of St Leo IV, given from the loggia of the Vatican. Various perils are represented in this work. In one part we see a number of women whose hair and clothes are blown about by the terrible fury of the wind as carrying vessels full of water on their heads and in their hands they hurry to put out the fire. There are others bewildered and blinded by the smoke as they try to throw water on the flames. On the other side is depicted an infirm old man, distraught by his weakness and the flames of the fire, being carried (as Virgil describes

Anchises being carried by Aeneas) by a young man whose face expresses his strength and courage and whose body shows the strain of carrying the figure slumped on his back. He is followed by a dishevelled, bare-footed old woman fleeing from the fire, and going before them is a naked child. On the top of some ruins is another naked figure, a woman wholly distracted, who is throwing her child to one of her family who has escaped from the flames and is standing on tiptoe in the street, arms outstretched to receive the infant which is still in swaddling clothes. The anxiety of the woman to save the child shows in her face no less clearly than her panic as the raging fire draws near, just as in the face of the man receiving the child can be seen an expression of tenderness struggling with the fear of death. Again, it is almost impossible to describe in words the imaginative skill with which this great and ingenious artist depicted a mother bare-footed and dishevelled, who has thrust her children in front of her and, clutching a part of her clothing in her hands, is beating them to make them hurry away from the falling masonry and the devouring flames. There are also some women kneeling before the Pope and begging his holiness to stay the fire.

In the other scene, which also features St Leo, Raphael has depicted the port of Ostia attacked by an armada of the Turks who have come to take the Pope captive. We see the Christians engaging the enemy at sea. Meanwhile, a host of prisoners are already being taken back to the harbour; they are coming out of a boat, dragged by splendid-looking soldiers striking bold attitudes, and in their diverse galley-slave costumes they are being taken before St Leo, who is represented by a portrait of Pope Leo X, shown in his pontifical robes between Cardinal Santa Maria in Portico (namely, Bernardo Dovizi of Bibbiena) and Cardinal Giulio de' Medici (subsequently Pope Clement). It is impossible to convey adequately the brilliant ideas that Raphael expressed in the appearance of the prisoners, who silently convey the emotions of grief, fear, and death.

There are two other scenes: one shows Pope Leo X consecrating the Most Christian King, Francis I of France, singing Mass in his pontifical robes, and blessing the holy oils and the

royal crown. Raphael included a throng of cardinals and bishops assisting in their vestments as well as the portraits of a number of ambassadors and other observers, some of whom are dressed in the contemporary French fashion.

In the other scene Raphael depicted the coronation of Francis I, with portraits of the Pope and Francis, the one wearing his pontifical robes and the other in armour. He also showed all the cardinals, bishops, chamberlains, squires, and grooms of the chamber, robed and seated in the accustomed way, according to their rank. These are all portraits from life, including, for example, Giannozzo Pandolfini, bishop of Troyes, who was a close friend of Raphael's, and many other distinguished men of that time. Near the king there is a boy kneeling and holding the royal crown; and this is a portrait of Ippolito de' Medici, who later became a cardinal and vice-chancellor. This highly esteemed man was a patron of all the arts, and I am especially indebted to his memory since to him I owe, such as it was, the start of my own career. As for Raphael, I cannot possibly describe all the finer points of his work, whose very silence indeed is eloquent enough. Beneath the scenes I described are figures of the defenders and benefactors of the Church each surrounded by a different border and executed with great thought and feeling and subtlety and with a harmony of colours that could not be improved on. As the ceiling of this apartment had been painted by Pietro Perugino, Raphael left it untouched as a tribute to his master's memory and because of the devotion he felt towards the man who had set him on the path of greatness.

Such was Raphael's stature that he had draughtsmen working for him throughout all Italy, at Pozzuolo and even in Greece; and he was always looking for good designs which he could use in his work. He now decorated a hall in which there were some tabernacles containing clay figures of the apostles and other saints; here he had his pupil Giovanni da Udine (who is unrivalled as a painter of animals) depict all the animals owned by Pope Leo, namely the chameleon, the civet cats, the apes, the parrots, the lions, the elephants, and other even more exotic beasts.

Besides adorning the palace with many grotesques and

variegated pavements, Raphael also made designs for the papal staircases and the loggias which Bramante had started but left unfinished because of his death. Their construction was continued with the new design and plan produced by Raphael, who made a wooden model which was more ornate and stylistically purer than Bramante's work. The Pope was anxious to show the world further examples of his magnificence and generosity, and so he asked Raphael to make the designs for the stucco ornaments and the scenes that were to be painted there, and also for the various compartments. Raphael put Giovanni da Udine in charge of the stuccoes and the grotesques, and Giuliano Romano (although he worked there only a little) in charge of the figures. He also employed Giovanni Francesco, Bologna, Perin del Vaga, Pellegrino da Modena, Vincenzio da San Gimignano, Polidoro da Caravaggio, and many other painters who supplied various of the scenes and figures and other details that were wanted. Raphael went to such pains to finish this work perfectly that he even sent to Florence for pavements by Luca della Robbia. And certainly it is difficult to imagine anything finer than the paintings, the stucco ornaments, the general architecture, or the various inventions. This work was so beautiful that Raphael was then put in charge of all the works of painting and architecture being done in the Vatican.

As an example of Raphael's generous nature, it is said that for the convenience of some of his friends he asked the masons not to build solid, blank walls but to leave various openings and spaces above the old rooms in the basement where they could store their casks, jars, and wood. However, this weakened the base of the walls and subsequently when cracks started to appear the openings had to be filled in. For all the charming and beautifully executed inlays of the doors and wainscots Raphael employed Giovanni Barile.

Raphael also provided architectural drawings for the Pope's Villa Madama and for several houses in the Borgo, notably for the very fine palace belonging to Giovanni Battista dall'Aquila. He designed another palace for the bishop of Troyes, who had it built in Florence in the Via di San Gallo.

For the Black Friars of San Sisto in Piacenza he painted for

their high altar a panel showing the Madonna with St Sixtus and St Barbara, a rare and outstanding work.

Raphael also painted many pictures to be sent to France, notably, for the king, a painting of St Michael fighting the devil. In this remarkable picture, to represent the centre of the earth he depicted a rock scorched by fire with flames and sulphur pouring from its fissures. And in the figure of Lucifer, whose burned members are coloured with various flesh-tints, he reveals all the shades of anger that the devil's swollen and venomous pride directs against the God who has cast him down, robbed him of any peaceful dominion, and condemned him to everlasting punishment. In contrast, St Michael, dressed in armour of iron and gold, although depicted as a supernatural being, conveys terrifying audacity and force as he stands erect, having hurled Lucifer down from heaven with his spear. This painting more than deserved the great reward Raphael received from the king.

Raphael also painted portraits of Beatrice of Ferrara and very many other courtesans, including his own mistress. He was indeed a very amorous man with a great fondness for women whom he was always anxious to serve. He was always indulging his sexual appetites; and in this matter his friends were probably more indulgent and tolerant than they should have been. When his close friend Agostino Chigi commissioned him to decorate the first loggia in his palace, Raphael could not give his mind to the work because of his infatuation for his mistress. Agostino was almost in despair when with great difficulty he managed with the help of others to arrange for the woman to go and live with Raphael in the part of the house where he was working; and that was how the painting was finished.

Raphael made all the cartoons for this work and he himself also coloured many of the figures in fresco. In the vaulting he showed the Council of the Gods in heaven, and here he introduced many costumes and forms borrowed from the antique executed with lively draughtsmanship and grace. In the same way he depicted the marriage of Psyche, with the ministers of Jove and the Graces scattering flowers. In the pendentives he did various scenes, including Mercury with his flute, who

seems to be cleaving the sky in his flight. He also showed Jove kissing Ganymede with celestial dignity, and below this the chariot of Venus and the Graces who, in company with Mercury, are taking Psyche to heaven. And he did many other beautiful scenes in the other pendentives. Between the pendentives and over the arches he painted several beautiful *putti*, foreshortened and hovering in the air with the various implements of the Gods: one carries the thunderbolts and arrows of Jove, another the helmet, sword, and target of Mars; there are the hammers of Vulcan, the club and lion's skin of Hercules, the wand of Mercury, the pipes of Pan, and the rakes of Vertumnus. Each of the Gods is accompanied by an animal appropriate to his nature; and the whole composition forms a wonderfully beautiful poem and painting. Raphael asked Giovanni da Udine to make for these scenes a border of festoons of flowers, leaves, and fruits which proved incomparably beautiful.

Raphael was also responsible for the architecture of the Chigi stables and Agostino's chapel in the church of Santa Maria del Popolo. As well as painting this chapel, he designed for it a marvellous tomb for which he commissioned the Florentine sculptor Lorenzetto to make two figures, which are still to be found in his house in the Macello di Corvi in Rome. Because of the death of Raphael, however, followed by that of Agostino, the work was given to Sebastiano del Piombo.

Meanwhile, Raphael had risen to such heights that Leo X gave orders that he should set to work on the Great Hall on the upper floor, where are depicted the Victories of Constantine. Raphael made a start on this, and meanwhile the Pope decided he would have some very rich tapestries made in gold and floss-silk. So Raphael drew and coloured in his own hand all the cartoons, in the exact form and size needed, and these were sent to be woven in Flanders. After they had been finished, the tapestries were sent back to Rome. The completed work was of such wonderful beauty that it astonishes anyone who sees it to think that it could have been possible to weave the hair and the beards so finely and to have given such softness to the flesh merely by the use of threads.

The tapestries seem to have been created by a miracle rather than by human skill, for they contain expanses of water, animals, and buildings which are so finely executed that they look as if they were painted. This work cost seventy thousand crowns, and it is still kept in the Sistine Chapel.

For Cardinal Colonna, Raphael painted a St John on canvas. As this was a beautiful work the cardinal was extremely fond of it. But then, after he was struck down by illness, he was asked for it by the doctor who cured him, Jacopo da Carpi. Since Jacopo had set his heart on the painting, and the cardinal thought he was greatly in his debt, he gave it to him; and today it is in Florence in the possession of Francesco Benintendi.

For Giulio de' Medici, cardinal and vice-chancellor, Raphael painted a panel picture, to be sent to France, of the Transfiguration of Christ. He himself worked ceaselessly on this painting, which he brought to complete perfection. The scene shows Christ transfigured on Mount Tabor, with the eleven disciples waiting for him below. There is a young man, possessed by a devil, who has been brought so that Christ may heal him after he has come down from the mountain. The possessed man's body is all contorted and he is groaning and rolling his eyes; his suffering is revealed in his flesh, his veins, and the beat of his pulse, which are all infected by the evil spirit. He is deathly pale as he gesticulates with fearsome violence. This figure is held up by an old man who, having embraced him and taken heart, with his eyes wide open and staring, reveals both fear and resolve as he screws up his forehead and arches his brows. He keeps his eyes fixed on the apostles, and he seems to draw strength from the hope he places in them. Among the many women to be seen there is one, the principal figure in the panel, who kneels before the apostles and turns her head towards them, gesturing with her arms in the direction of the possessed man to draw attention to his misery. Beyond her, the apostles, some of them standing, others seated or kneeling, show that they are moved to great compassion by such misery. And, indeed, in this scene Raphael created heads and figures of exceptional beauty. They are so varied and original that it is the accepted opinion of artists that of all the many works he made this painting is the most glorious,

the loveliest, and the most inspired. Whoever wants to imagine and then express in paint the Transfiguration of Christ should study him in this work, where he is depicted floating in the luminous air above the mountain. The foreshortened figure of Christ is shown between Moses and Elias who are bathed in light and who reflect his radiance. Peter, James, and John are shown prostrate on the ground, in attitudes of great variety and beauty: one rests his head on the earth, another is covering his eyes with his hand to protect them from the rays and the intense light of Christ's splendour. Clothed in snow-white garments, Christ himself extends his arms and raises his head, and he reveals the Essence and Godhead of all three Persons of the Trinity, fused in him by the perfect art of Raphael. And Raphael seems to have summoned up all his powers to demonstrate the strength and genius of his art in his countenance; for having finished this, the last thing he was to do, he died without taking up the brush again.

Now that I have described the works of this talented painter I must, before giving further details of his life and death, take the trouble, for the benefit of our artists, to discuss the various styles in which he painted. In his boyhood, then, he imitated the style of his master, Pietro Perugino; and after he had vastly improved on it as regards drawing, colouring, and invention, he considered that he had accomplished enough. But when he was more mature, he realized that he was still a long way from the truth. Then he saw the works of Leonardo da Vinci, who had no equal in the expressions of heads, both of men and women, and who in giving grace and movement to his figures surpassed all other painters. Leonardo's paintings left Raphael amazed and entranced; and, in brief, liking Leonardo's manner more than any he had seen hitherto, he began to study it. Gradually abandoning what he had learned from Perugino, although only with great difficulty, Raphael tried to the best of his ability and knowledge to imitate Leonardo's style. However, for all his diligence and study, in certain problems he was never able to surpass Leonardo. And although there were many who considered that he surpassed Leonardo in sweetness and in a kind of natural facility, none the less,

Raphael never achieved the sublimity of Leonardo's basic conceptions or the grandeur of his art. In this context, however, where few can stand comparison with Leonardo, Raphael came nearer to him than any other painter, notably in grace of colouring.

But to return to Raphael himself: in time the style he had adopted so effortlessly from Pietro when he was a young man started to impede and restrict his development, since it was pedantic, harsh, and feeble in draughtsmanship. Because he could not rid himself of it he experienced great difficulty in learning the finer points of the nude and the technique for doing difficult foreshortenings from the cartoon that Michelangelo Buonarroti made for the Council Hall in Florence. No other artist, no matter how talented, would have been able to do what, convinced that he had so far been wasting his time, Raphael was then able to accomplish. For he rid himself completely of the burden of Pietro's manner to learn from the work of Michelangelo a style that was immensely difficult in every particular; and he turned himself, as it were, from a master into a pupil once more. Taking immense pains, he forced himself as a grown man to learn within the space of a few months something which demanded the easy aptitude of youth and years of study. To be sure, the artist who does not learn early on the principles and the style that he intends to adopt and who does not gradually solve the problems of his art by practice, striving to learn and master every aspect of it, will rarely become perfect. If he does, it will take far longer and considerably more effort.

At the time when Raphael determined to change and improve his style he had never studied the nude as intensely as it requires, for he had only copied it from life, employing the methods he had seen used by Perugino, although he gave his figures a grace that he understood instinctively. So he began to study the nude form and to compare the muscles as revealed in anatomical drawings or dissected corpses with them as they are seen, less starkly defined, in the living body. He saw how the soft and fleshy parts are formed and how from different viewpoints various graceful convolutions appear, and also the visual effects of inflating, raising, and lowering the

whole body or one of its members. He also studied the articulation of the bones, nerves, and veins, and he mastered all
the points that a great painter needs to know.

None the less, Raphael realized that in this matter he could
never rival the accomplishments of Michelangelo, and therefore, like the judicious man he was, he reflected that painters
are not confined to making numerous studies of naked men
but can range over a very wide field. Among the finest
painters could also be included those who knew how to express with skill, facility, and judgement their various scenes,
inventions, and ideas, and who in composing their pictures
knew how to avoid crowding them with too much detail or
impoverishing them by putting in too little, and produced
works of fine stylistic purity and order. They, too, must be
regarded as being skilled and judicious artists. As well as these
qualities the artist must be able to embellish his paintings with
varied and unusual perspectives, of buildings and landscapes,
with lovely draperies, with figures that fade into the shadows
or are thrown into prominence by the clear light, with beautifully executed heads of young men and old, women and
children, endowed with suitable vigour and movement.
Raphael also considered how important it was to be able to
show the flight of horses in a battle and the fierceness of the
soldiers, to know how to depict all kinds of animals, and
above all to be able to paint portraits so faithful that they are
wholly lifelike and immediately recognizable. Then it was
important to be able to depict countless other things, namely,
draperies, shoes, helmets, armour, women's head-dresses,
hair, beards, vases, trees, grottoes, rocks, fires, skies overcast
or clear, clouds, rain, lightning, fine weather, night-time,
moonlight, bright sunshine, and countless other subjects
which are used by painters nowadays.

Having considered all this, therefore, Raphael, being unable to compete with Michelangelo in the branch of painting
to which he had set his hand, resolved to emulate and perhaps
surpass him in other respects. So he decided not to waste his
time by imitating Michelangelo's style but to attain a catholic
excellence in the other fields of painting that have been described. His example might well have been followed by many

contemporary artists who, because they have confined them-
selves to studying the works of Michelangelo, have failed to
imitate him or reach his standard of perfection; if they had
followed Raphael, instead of wasting their time and creating a
style that is very harsh and laboured, that lacks charm and is
defective in colouring and invention, they would, by aiming
at a catholic excellence and trying to become proficient in the
other fields of painting, have benefited themselves and every-
one else.

When he had decided what to do, Raphael turned his atten-
tion to the work of Bartolommeo di San Marco. Fra Barto-
lommeo was a competent painter and a sound draughtsman
with a pleasant style of colouring, although sometimes for the
sake of greater relief he made too much use of shadows. From
this painter Raphael took what suited his needs and inclination,
namely, a middle course as regards drawing and colouring;
and to this he added various methods chosen from the finest
works of other painters to form from many different styles a
single manner which he made entirely his own and which
always was and always will be the object of tremendous ad-
miration. He brought this style to perfection when he painted
the sibyls and prophets for the work executed, as I mentioned,
for Santa Maria della Pace. And when he did this it was of
great benefit to him to have seen Michelangelo's paintings in
the Sistine Chapel.

If Raphael had rested content with his own style and not
tried to show by striving to give his work more variety and
grandeur that he understood how to depict the nude as well as
Michelangelo he would not have lost some of his fine reputa-
tion; for despite their many qualities the nudes that he painted
in the room in the Borgia Tower (where the Fire in the Borgo
was represented) fall short of perfection. Nor are those that
Raphael made on the ceiling of the palace of Agostino Chigi
in the Trastevere completely satisfying, since they lack his
characteristic grace and sweetness. To a large extent this was
because he had them coloured by others after his designs.
However, regretting his mistake, like the judicious man he
was he then made up his mind to paint without the assistance
of anyone else the altarpiece for San Pietro in Montorio, show-

ing the Transfiguration of Christ, where are displayed all the qualities which, as I described, a good picture needs and must have. And if he had not on some whim or other used printer's black (which, as has often been pointed out, becomes gradually darker with time and damages the other colours with which it is mixed) this work would be as fresh as when it was first executed, whereas today it seems to be a mass of shadowy tints.

I wanted to discuss these matters towards the end of Raphael's *Life* to show the painstaking study and diligence with which that renowned artist applied himself and, above all, to assist other painters to learn how to avoid the mistakes from which Raphael was rescued by his wisdom and genius. Let me say this as well: that everyone should be content to do what he feels is natural to him and should never, merely to emulate others, want to try his hand at something for which he has no natural gift; otherwise he will labour in vain, and often to his own shame and loss. Moreover, when he has done his best a painter should not try to do even better in order to surpass those whom God and nature have made so gifted that their work seems almost miraculous. For if he lacks the ability, whatever his efforts he will never be able to achieve what another painter, with the help of nature, can take in his stride.

Among the early painters we have as an instance of this Paolo Uccello, who worked in opposition to his natural talents in order to improve his painting and who succeeded merely in slipping back. In our own time (only a short while ago) the same misfortune befell Jacopo Pontormo; and, as I have said already and shall say again, there are many other artists to whom the same thing has clearly happened. And perhaps this is so everyone may be satisfied with the talent he is born with.

But now that I have discussed these questions, perhaps at too great a length, I must return to the life and death of Raphael. It happened that he was very friendly with Cardinal Bernardo Dovizi of Bibbiena, who for many years kept pestering him to get married. Without giving the cardinal a direct yes or no, Raphael had delayed the issue for a good while by

saying that he wanted to wait for three or four years. So the years passed, and then when he was not expecting it the cardinal reminded him of his promise. Thinking himself under an obligation, like the courteous man he was Raphael refused to go back on his word and he agreed to marry a niece of the cardinal's. But he resented this entanglement and kept putting things off; and after several months still the wedding had not taken place. All the same, his motives were not dishonourable; for the truth of the matter was that as he had served the court for many years and Pope Leo owed him a great deal of money he had been dropped the hint that, when the hall he was painting was finished, to reward him for his labour and talent the Pope would give him a red hat. (For the Pope had already decided to create a number of new cardinals, among whom there were several less deserving than Raphael.)

Meanwhile, Raphael kept up his secret love affairs and pursued his pleasures with no sense of moderation. And then on one occasion he went to excess, and he returned home afterwards with a violent fever which the doctors diagnosed as having been caused by heat-stroke. Raphael kept quiet about his incontinence and, very imprudently, instead of giving him the restoratives he needed they bled him until he grew faint and felt himself sinking. So he made his will: and first, as a good Christian, he sent his mistress away, leaving her the means to live a decent life. Then he divided his belongings among his disciples, Giulio Romano, whom he had always loved dearly, the Florentine Giovanni Francesco, called Il Fattore, and a priest I know nothing about who was a relation of his and came from Urbino. Next he stipulated that some of his wealth should be used for restoring with new masonry one of the ancient tabernacles in Santa Maria Rotonda and for making an altar with a marble statue of Our Lady; and he chose this church, the Pantheon, as his place of rest and burial after death. He left all the rest of his possessions to Giulio and Giovanni Francesco, and he appointed as his executor Baldassare da Pescia, then the Pope's datary. Having made his confession and repented, Raphael ended his life on Good Friday, the same day he was born. He was thirty-seven when he died; and we

can be sure that just as he embellished the world with his talent so his soul now adorns heaven itself.

As he lay dead in the hall where he had been working they placed at his head the picture of the Transfiguration which he had done for Cardinal de' Medici; and the sight of this living work of art along with his dead body made the hearts of everyone who saw it burst with sorrow. In memory of Raphael, the cardinal later placed this picture on the high altar of San Pietro in Montorio, where because of the nobility of everything that Raphael ever did it was afterwards held in great reverence. Raphael was given the honourable burial that his noble spirit deserved, and there was no artist who did not weep with sorrow as he followed him to the grave.

His death also plunged into grief the entire papal court, first since when he was alive he had held the office of Groom of the Chamber, and then because of the affection in which he had been held by the Pope, who wept bitterly when he died. How blessed and happy is the soul of Raphael! Everyone is glad to talk of him and to celebrate his actions and admire all the drawings that he left. When this noble craftsman died, the art of painting might well have died with him; for when Raphael closed his eyes, painting was left as if blind.

For those of us who survive him, it remains to imitate the good, or rather the supremely excellent method that he left for our example and, as is our duty and as his merits demand, always to remember what he did with gratitude and to pay him the highest honour in what we say. For to be sure, because of Raphael, art, colouring, and invention have all three been brought to a pitch of perfection that could scarcely have been hoped for; nor need anyone ever hope to surpass him. Apart from the benefits that he conferred on painting, as a true friend of the art, while he was alive he never ceased to show us how to conduct ourselves when dealing with great men, with those of middle rank or station, and with the lowest. And among his exceptional gifts I must acknowledge one of great value that fills me with amazement; namely, that heaven gave him the power to bring about in our profession a phenomenon

completely alien to our character as painters. What happened
was that craftsmen who worked with Raphael began to live
in a state of natural harmony and agreement. (This was true
not only of artists of ordinary talent but also of those who
made some pretence to be great men, and painting produces
any number of those.) At the sight of Raphael, all their bad
humour died away, and every base and unworthy thought left
their minds. This harmony was never greater than while
Raphael was alive; and this state of affairs came about because
the artists were won over by his accomplishments and his
courteous behaviour, and above all by the loving-kindness of
his nature. Raphael was so gentle and so charitable that even
animals loved him, not to speak of men.

It is said that if any painter who knew Raphael (and even
any who did not) asked him for a drawing, he would leave
what he was doing himself in order to help. And he always
kept employed a vast number of artists whom he helped and
instructed with a love that belonged rather to children of his
own than to his fellow craftsmen. He was never seen leaving
his house to go to court but that he was accompanied by fifty
painters, all able and excellent artists, going with him to do
him honour.

In short, Raphael lived more like a prince than a painter.
The art of painting was supremely fortunate in securing the
allegiance of a craftsman who, through his virtues and his
genius, exalted it to the very skies. It is fortunate also in having
disciples today who follow in the footsteps of Raphael. For
he showed them how to live and how to combine virtue and
art; and in him these qualities prevailed on the magnificent
Julius II and the munificent Leo X, despite their exalted dig-
nity and rank, to make him their intimate friend and show
him every mark of favour. Because of their favours and re-
wards Raphael was able to win great honour both for himself
and his art. Happy, too, may be called all those who were em-
ployed in Raphael's service and worked under him; for who-
ever followed him discovered that he had arrived at a safe
haven. Just so, those who follow Raphael in the future will
win fame on earth, and if they follow also the example of his
life they will be rewarded in heaven.

This epitaph was written for Raphael by Bembo:

D.O.M.

RAPHAELI . SANCTIO . IOAN . F . VRBINAT .

PICTORI . EMINENTISS . VETERVMQ . AEMVLO

CVIVS . SPIRANTEIS . PROPE . IMAGINEIS

SI . CONTEMPLERE

NATVRAE . ATQVE . ARTIS . FOEDVS

FACILE . INSPEXERIS

IVLII . II . ET LEONIS . X . PONTT . MAXX .

PICTVRAE . ET . ARCHITECT . OPERIBVS

GLORIAM . AVXIT

VIXIT . AN . XXXVII . INTEGER . INTEGROS

QVO . DIE . NATVS . EST . EO . ESSE . DESIIT

VIII . ID . APRIL . MDXX

ILLE . HIC . EST . RAPHAEL . TIMVIT . QVO . SOSPITE . VINCI
RERVM . MAGNA . PARENS . ET . MORIENTE . MORI .[1]

1. To The Glory of God

In memory of Raphael son of Giovanni Santi Urbino : The great painter and
rival of the ancients : Whose almost-breathing likenesses if thou beholdest,
thou shalt straightway see Nature and Art in league : Who by his deeds in
painting and in architecture did swell the glory of the Sovereign Pontiffs
Julius II and Leo X : Who lived in goodness thirty-seven good years, and died
on his birthday, April 6 1520.

> This is that Raphael, by whom in life
> Our mighty mother Nature fear'd defeat;
> And in whose death did fear herself to die.

Pietro Bembo (1470–1547) was a cardinal, poet, and literary legislator.

And Count Baldesar Castiglione wrote on the death of Raphael in this manner:

> *Quod lacerum corpus medica sanaverit arte,*
> *Hippolytum Stygiis et revocarit aquis,*
> *Ad Stygias ipse est raptus Epidaurius undas;*
> *Sic precium vitae mors fuit artifici.*
> *Tu quoque dum toto laniatam corpore Romam*
> *Componis miro, Raphael, ingenio,*
> *Atque Urbis lacerum ferro, igni, annisque cadaver*
> *Ad vitam, antiquum jam revocasque decus;*
> *Movisti Superum invidiam, indignataque mors est,*
> *Et quod longa dies paullatim aboleverat, hoc te*
> *Mortali spreta lege parare iterum.*
> *Sic miser heu! prima cadis intercepte juventa,*
> *Deberi et morti nostraque nosque mones.*[1]

1. Because with physic skill the body torn
 He heal'd, and did Hippolytus recall
 From Styx's waters, Epidaurus' pride
 Himself was snatch'd to the Stygian stream;
 The master's own death thus life's ransom paid.
 So thou too, Raphael: thy wondrous skill
 Rome's riven frame hath mended, and with fire
 And sword and years our city's body rent
 Reviving ancient beauty hath restor'd.
 But thou didst rouse the Gods to jealousy
 And Death grew wroth, that in his law's despite
 What Time's slow march had cancell'd, now once more
 Thou should'st renew; so, hapless! thou dost fall
 In youth's first flowering sever'd, and dost warn
 That we with all we own are pledg'd to Death.

Baldesar Castiglione (1478–1529), author of *The Book of the Courtier.*

LIFE OF

MICHELANGELO BUONARROTI

Florentine painter, sculptor, and architect, 1475–1564

ENLIGHTENED by what had been achieved by the renowned
Giotto and his school, all artists of energy and distinction were
striving to give the world proof of the talents with which
fortune and their own happy temperaments had endowed
them. They were all anxious (though their efforts were in
vain) to reflect in their work the glories of nature and to attain,
as far as possible, perfect artistic discernment or understand-
ing. Meanwhile, the benign ruler of heaven graciously looked
down to earth, saw the worthlessness of what was being done,
the intense but utterly fruitless studies, and the presumption
of men who were farther from true art than night is from day,
and resolved to save us from our errors. So he decided to send
into the world an artist who would be skilled in each and every
craft, whose work alone would teach us how to attain perfec-
tion in design (by correct drawing and by the use of contour
and light and shadows, so as to obtain relief in painting) and
how to use right judgement in sculpture and, in architecture,
create buildings which would be comfortable and secure,
healthy, pleasant to look at, well-proportioned and richly
ornamented. Moreover, he determined to give this artist the
knowledge of true moral philosophy and the gift of poetic
expression, so that everyone might admire and follow him as
their perfect exemplar in life, work, and behaviour and in
every endeavour, and he would be acclaimed as divine. He
also saw that in the practice of these exalted disciplines and
arts, namely, painting, sculpture, and architecture, the Tuscan
genius has always been pre-eminent, for the Tuscans have
devoted to all the various branches of art more labour and
study than all the other Italian peoples. And therefore he
chose to have Michelangelo born a Florentine, so that one
of her own citizens might bring to absolute perfection

the achievements for which Florence was already justly renowned.

So in the year 1474 in the Casenino, under a fateful and lucky star, the virtuous and noble wife of Lodovico di Leonardo Buonarroti gave birth to a baby son. That year Lodovico (who was said to be related to the most noble and ancient family of the counts of Canossa) was visiting magistrate at the township of Chiusi and Caprese near the Sasso della Vernia (where St Francis received the stigmata) in the diocese of Arezzo. The boy was born on Sunday, 6 March, about the eighth hour of the night; and without further thought his father decided to call him Michelangelo, being inspired by heaven and convinced that he saw in him something supernatural and beyond human experience. This was evident in the child's horoscope which showed Mercury and Venus in the house of Jupiter, peaceably disposed; in other words, his mind and hands were destined to fashion sublime and magnificent works of art. Now when he had served his term of office Lodovico returned to Florence and settled in the village of Settignano, three miles from the city, where he had a family farm. That part of the country is very rich in stone, especially in quarries of greystone which are continuously worked by stone-cutters and sculptors, mostly local people; and Michelangelo was put out to nurse with the wife of one of the stone-cutters. That is why once, when he was talking to Vasari, he said jokingly:

'Giorgio, if my brains are any good at all it's because I was born in the pure air of your Arezzo countryside, just as with my mother's milk I sucked in the hammer and chisels I use for my statues.'

As time passed and Lodovico's family grew bigger he found himself, as he enjoyed only a modest income, in very difficult circumstances and he had to place his sons in turn with the Wool and Silk Guilds. When Michelangelo was old enough he was sent to the grammar school to be taught by Francesco of Urbino; but he was so obsessed by drawing that he used to spend on it all the time he possibly could. As a result he used to be scolded and sometimes beaten by his father and the older members of the family, who most likely considered it unworthy of their ancient house for Michelangelo to give his

time to an art that meant nothing to them. It was about this time that Michelangelo became friendly with the young Francesco Granacci, who had been sent as a boy to learn the art of painting from Domenico Ghirlandaio.[1] Francesco saw that Michelangelo had a great aptitude for drawing, and as he was very fond of him he used to supply him every day with drawings by Ghirlandaio, who was then regarded, throughout all Italy let alone in Florence, as one of the finest living masters. As a result Michelangelo grew more ambitious with every day that passed, and when Lodovico realized that there was no hope of forcing him to give up drawing he resolved to put his son's aspirations to some use and make it possible for him to learn the art properly. So on the advice of friends he apprenticed him to Domenico Ghirlandaio.

When this happened Michelangelo was fourteen years old. And incidentally, the author of a biography of Michelangelo which was written after 1550 (when I wrote these *Lives* the first time) says that some people, because they did not know Michelangelo personally, have said things about him that were never true and have left out others that deserved to be mentioned.[2] For instance, he himself taxes Domenico with envy and alleges that he never gave any help to Michelangelo. But this accusation is plainly false, as can be judged from something written by Michelangelo's father, Lodovico, in one of Domenico's record books, which is now in the possession of his heirs. The entry reads as follows:

1488. This first day of April I record that I, Lodovico di Leonardo Buonarroti, do apprentice my son Michelangelo to Domenico and David di Tommaso di Currado for the next three years, under the following conditions: that the said Michelangelo must stay for the stipulated time with the above-named to learn and practise the art of painting, and that he should obey their orders, and that the same Domenico and David should pay him in those three years twenty-four florins of full weight: six in the first year, eight in the second year, and ten in the third year, to a total of ninety-six lire.

1. Domenico Ghirlandaio (1449–94), a competent painter, chiefly in fresco, who ran a large family studio in Florence.

2. Ascanio Condivi, Michelangelo's pupil, whose *Life of Michelangelo*, closely supervised by Michelangelo himself, was published in 1553.

And below this, also in Lodovico's handwriting, is the following entry or record:

The above-named Michelangelo received this sixteenth day of April two gold florins, and I, Lodovico di Leonardo, his father, received twelve lire and twelve soldi on his account.

I have copied these entries straight from the book in order to show that everything I wrote earlier and am writing now is the truth; nor am I aware that anyone was more familiar with Michelangelo than I or can claim to have been a closer friend or more faithful servant, as can be proved to anyone's satisfaction. Moreover, I do not believe there is anyone who can produce more affectionate or a greater number of letters than those written by Michelangelo and addressed to me. I made this digression for the sake of truth, and it must suffice for the rest of his *Life*. And now let us go back to Michelangelo himself.

The way Michelangelo's talents and character developed astonished Domenico, who saw him doing things quite out of the ordinary for boys of his age and not only surpassing his many other pupils but also very often rivalling the achievements of the master himself. On one occasion it happened that one of the young men studying with Domenico copied in ink some draped figures of women from Domenico's own work. Michelangelo took what he had drawn and, using a thicker pen, he went over the contours of one of the figures and brought it to perfection; and it is marvellous to see the difference between the two styles and the superior skill and judgement of a young man so spirited and confident that he had the courage to correct what his teacher had done. This drawing is now kept by me among my treasured possessions. I received it from Granaccio, along with other drawings by Michelangelo, for my book of drawings; and in 1550, when he was in Rome, Giorgio Vasari showed it to Michelangelo who recognized it and was delighted to see it again. He said modestly that as a boy he had known how to draw better than he did now as an old man.

Another time, when Domenico was working on the principal chapel of Santa Maria Novella, Michelangelo came along

and started to draw the scaffolding and trestles and various implements and materials, as well as some of the young men who were busy there. When Domenico came back and saw what Michelangelo had done he said: 'This boy knows more about it than I do.' And he stood there astonished at the originality and skill in imitation that his inborn sense of judgement enabled so young an artist to display. Certainly, the work showed all the qualities to be expected of an artist with years of experience. This was because the instinctive grace of Michelangelo's work was enhanced by study and practice; and every day he produced work that was still more inspired. For example, it was at that time that he made the copy of an engraving by Martin the German that brought him considerable fame.[1] Michelangelo did a perfect pen-and-ink copy of this copper engraving, which showed St Anthony being tormented by devils, soon after it had been brought to Florence. He also did the scene in colours; and for this purpose in order to copy some of the strange-looking demons in the picture he went along to the market and bought some fishes with fantastic scales like theirs. The skill with which he did this work won him a considerable reputation. Michelangelo also copied the works of other masters, with complete fidelity; he used to tinge his copies and make them appear black with age by various means, including the use of smoke, so that they could not be told apart from the originals. He did this so that he could exchange his copies for the originals, which he admired for their excellence and which he tried to surpass in his own works; and these experiments also won him fame.

At that time the custodian or keeper of all the fine antiques that Lorenzo the Magnificent had collected at great expense and kept in his garden on the Piazza di San Marco was the sculptor Bertoldo.[2] He had been a pupil of Donatello's, and the chief reason why Lorenzo kept him in his service was because he had set his heart on establishing a school of first-rate painters and sculptors and wanted Bertoldo to teach and look after them. Bertoldo was now too old to work; nevertheless, he was very experienced and very famous, not only for

1. Martin Schongauer (1453–91), a painter and engraver of Colmar.
2. Giovanni di Bertoldo (c. 1420–91).

having polished the bronze pulpits cast by Donatello but also for the many bronze casts of battle-scenes and the other small things he had executed himself with a competence that no one else in Florence could rival. So Lorenzo, who was an enthusiastic lover of painting and sculpture, regretting that he could find no great and noble sculptors to compare with the many contemporary painters of ability and repute, determined, as I said, to found a school himself. For this reason he told Domenico Ghirlandaio that if he had in his workshop any young men who were drawn to sculpture he should send them along to his garden, where they would be trained and formed in a manner that would do honour to himself, to Domenico, and to the whole city. So Domenico gave him some of the best among his young men, including Michelangelo and Francesco Granacci. And when they arrived at the garden they found Torrigiano (a young man of the Torrigiani family) working there on some clay figures in the round that Bertoldo had given him to do.[1] After he had seen these figures, Michelangelo was prompted to make some himself; and when he saw the boy's ambitious nature Lorenzo started to have very high hopes of what he would do. Michelangelo was so encouraged that some days later he set himself to copy in marble an antique faun's head which he found in the garden; it was very old and wrinkled, with the nose damaged and a laughing mouth. Although this was the first time he had ever touched a chisel or worked in marble, Michelangelo succeeded in copying it so well that Lorenzo was flabbergasted. Then, when he saw that Michelangelo had departed a little from the model and followed his own fancy in hollowing out a mouth for the faun and giving it a tongue and all its teeth, Lorenzo laughed in his usual charming way and said:

'But you should have known that old folk never have all their teeth and there are always some missing.'

In his simplicity Michelangelo, who loved and feared that lord, reflected that this was true, and as soon as Lorenzo had gone he broke one of the faun's teeth and dug into the gum so that it looked as if the tooth had fallen out; then he waited

1. Pietro Torrigiano (1472–1528), a Florentine sculptor who worked in England, notably on the tomb of Henry VII.

anxiously for Lorenzo to come back. And after he had seen the result of Michelangelo's simplicity and skill, Lorenzo laughed at the incident more than once and used to tell it for a marvel to his friends. He resolved that he would help and favour the young Michelangelo; and first he sent for his father, Lodovico, and asked whether he could have the boy, adding that he wanted to keep him as one of his own sons. Lodovico willingly agreed, and then Lorenzo arranged to have Michelangelo given a room of his own and looked after as one of the Medici household. Michelangelo always ate at Lorenzo's table with the sons of the family and other distinguished and noble persons who lived with that lord, and Lorenzo always treated him with great respect. All this happened the year after Michelangelo had been placed with Domenico, when he was fifteen or sixteen years old; and he lived in the Medici house for four years, until the death of Lorenzo the Magnificent in 1492. During that period, as salary and so that he could help his father, Michelangelo was paid five ducats a month; and to make him happy Lorenzo gave him a violet cloak and appointed his father to a post in the Customs. As a matter of fact all the young men in the garden were paid salaries varying in amount through the generosity of that noble and magnificent citizen who supported them as long as he lived. It was at this time that, with advice from Politian, a distinguished man of letters, Michelangelo carved from a piece of marble given him by Lorenzo the Battle of Hercules with the Centaurs. This was so beautiful that today, to those who study it, it sometimes seems to be the work not of a young man but of a great master with a wealth of study and experience behind him. It is now kept in memory of Michelangelo by his nephew Lionardo, who cherishes it as a rare work of art. Not many years ago Lionardo also kept in his house in memory of his uncle a marble Madonna in bas-relief, little more than two feet in height. This was executed by Michelangelo when he was still a young man after the style of Donatello, and he acquitted himself so well that it seems to be by Donatello himself, save that it possesses more grace and design. Lionardo subsequently gave this work to Duke Cosimo de' Medici, who regards it as

unique, since it is the only sculpture in bas-relief left by
Michelangelo.

To return to the garden of Lorenzo the Magnificent: this
place was full of antiques and richly furnished with excellent
pictures collected for their beauty, and for study and pleasure.
Michelangelo always held the keys to the garden as he was far
more earnest than the others and always alert, bold, and reso-
lute in everything he did. For example, he spent many months
in the church of the Carmine making drawings from the
pictures by Masaccio; he copied these with such judgement
that the craftsmen and all the others who saw his work were
astonished, and he then started to experience envy as well as
fame.

It is said that Torrigiano, who had struck up a friendship
with Michelangelo, then became jealous on seeing him more
honoured than himself and more able in his work. At length
Torrigiano started to mock him, and then he hit him on the
nose so hard that he broke and crushed it and marked Michel-
angelo for life. Because of this, Torrigiano, as I describe else-
where, was banished from Florence.

When Lorenzo the Magnificent died, Michelangelo went
back to live with his father, filled with sorrow at the death of
a great man who had befriended every kind of talent. While
he was with his father he obtained a large block of marble
from which he carved a Hercules eight feet high, which stood
for many years in the Palazzo Strozzi. This work, which was
very highly regarded, was later (when Florence was under
siege) sent to King Francis in France by Giovanbattista della
Palla. It is said that Piero de' Medici, who had been left heir to
his father, Lorenzo, often used to send for Michelangelo, with
whom he had been intimate for many years, when he wanted
to buy antiques such as cameos and other engraved stones.
And one winter, when a great deal of snow fell in Florence, he
had him make in his courtyard a statue of snow, which was
very beautiful. Piero did Michelangelo many favours on
account of his talents, and Michelangelo's father, seeing his
son so highly regarded among the great, began to provide him
with far finer clothes than he used to.

For the church of Santo Spirito in Florence Michelangelo

made a crucifix of wood which was placed above the lunette of the high altar, where it still is.[1] He made this to please the prior, who placed some rooms at his disposal where Michelangelo very often used to flay dead bodies in order to discover the secrets of anatomy; and in this way he started to perfect the great powers of design that he subsequently enjoyed.

It happened that a few weeks before the Medici were driven out of Florence Michelangelo had left for Bologna and then gone on to Venice, since he feared, when he saw the insolence and bad government of Piero de' Medici, that because of his connexion with the Medici family he would run into trouble himself. Being unable to find any means of living in Venice, he went back to Bologna. But thoughtlessly he failed to find out when he entered through the gate the password for going out again. (As a precaution, Giovanni Bentivogli had ordered that foreigners who could not give the password should pay a penalty of fifty Bolognese lire.) Now when he found himself in this predicament, without the money to pay the fine, by chance Michelangelo was seen by Giovanfrancesco Aldovrandi, one of the Sixteen of the Government, who felt sorry for him, and after he had heard his story secured his release and then gave him hospitality in his own home for more than a year. One day Aldovrandi took Michelangelo to see the tomb of St Dominic which had been executed (as I describe elsewhere) by the early sculptors, Giovanni Pisano and, later, Niccolò dell'Arca. There were two figures missing: an angel holding a candelabrum and a St Petronius, both about two feet high. Aldovrandi asked Michelangelo if he had the courage to do them, and he answered yes. So he had the marble given to Michelangelo, who executed the two figures, which proved to be the finest on the tomb. Aldovrandi paid him thirty ducats for this work.

Michelangelo stayed in Bologna just over a year, and he would have stayed longer in order to repay Aldovrandi for his kindness. (Aldovrandi loved him for his skill as an artist and also because of his Tuscan accent, which he enjoyed when Michelangelo read him work by Dante, Petrarch, Boccaccio,

1. This is the crucifix (disputedly) discovered in Florence in 1963, carved in white poplar.

and other poets.) However, as he realized that he was wasting time, Michelangelo was only too happy to return to Florence. And there, for Lorenzo di Pierfrancesco de' Medici, he made a little St John in marble, and then immediately started work on another marble figure, a sleeping Cupid, life-size. When this was finished, Baldassare del Milanese showed it as a beautiful piece of work to Lorenzo di Pierfrancesco, who agreed with his judgement and said to Michelangelo:

'If you were to bury it and treat it to make it seem old and then send it to Rome, I'm sure that it would pass as an antique and you would get far more for it than you would here.'

Michelangelo is supposed to have then treated the statue so that it looked like an antique; and this is not to be marvelled at seeing that he was ingenious enough to do anything. Others insist that Milanese took it to Rome and buried it in a vineyard he owned and then sold it as an antique for two hundred ducats to Cardinal San Giorgio. Others again say that Milanese sold the cardinal the statue that Michelangelo had made for him, and then wrote to Pierfrancesco saying that he should pay Michelangelo thirty crowns since that was all he had got for the Cupid; and in this way he deceived the cardinal, Lorenzo di Pierfrancesco, and Michelangelo himself. But then afterwards, the cardinal learned from an eye-witness that the Cupid had been made in Florence, discovered the truth of the matter through a messenger, and compelled Milanese's agent to restore his money and take back the Cupid. The statue later came into the possession of Duke Valentino who presented it to the marchioness of Mantua; and she took it back to her own part of the world where it is still to be seen today. Cardinal San Giorgio cannot escape censure for what happened, since he failed to recognize the obviously perfect quality of Michelangelo's work. The fact is that, other things being equal, modern works of art are just as fine as antiques; and there is no greater vanity than to value things for what they are called rather than for what they are. However, every age produces the kind of man who pays more attention to appearances than to facts.

All the same this work did so much for Michelangelo's reputation that he was immediately summoned to Rome to

enter the service of Cardinal San Giorgio, with whom he stayed nearly a year, although the cardinal, not understanding the fine arts very much, gave him nothing to do.[1] At that time the cardinal's barber, who had been a painter and worked very studiously in tempera, though he had no draughtsmanship, struck up a friendship with Michelangelo, who drew for him a cartoon showing St Francis receiving the stigmata; and this was very carefully painted by the barber on a panel which is to be found in the first chapel on the left, as one enters the church of San Pietro in Montorio. Michelangelo's abilities were then clearly recognized by a Roman gentleman called Jacopo Galli, and this discerning person commissioned from him a marble life-size statue of Cupid and then a Bacchus, ten spans high, holding a cup in his right hand and the skin of a tiger in his left, with a bunch of grapes which a little satyr is trying to nibble. In this figure it is clear that Michelangelo wanted to obtain a marvellous harmony of various elements, notably in giving it the slenderness of a youth combined with the fullness and roundness of the female form. This splendid achievement showed that Michelangelo could surpass every other sculptor of the modern age. Through the studies he undertook while in Rome he acquired such great skill that he was able to solve incredibly difficult problems and to express in a style of effortless facility the most elevated concepts, to the sheer amazement not only of those who lacked the experience to judge but also of men accustomed to excellent work. All the other works then being created were regarded as trivial compared with what Michelangelo was producing. As a result the French cardinal of Saint-Denis, called Cardinal Rouen,[2] became anxious to employ his rare talents to leave some suitable memorial of himself in the great city of Rome; and so he commissioned Michelangelo to make a Pietà of marble in the round, and this was placed, after it was finished, in the chapel of the Madonna della Febbre in St Peter's, where

1. Michelangelo went to Rome first in 1496. The Popes he served were Julius II (1503–13), Leo X (1513–21), Clement VII (1523- 34), Paul III (1534–49), Julius III (1550–5), Paul IV (1555–9), and Pius IV (1559–65).

2. This was Jean Villier de la Grolaie, abbot of Saint-Denis and cardinal of Santa Sabina.

the temple of Mars once stood. It would be impossible for any craftsman or sculptor no matter how brilliant ever to surpass the grace or design of this work or try to cut and polish the marble with the skill that Michelangelo displayed. For the Pietà was a revelation of all the potentialities and force of the art of sculpture. Among the many beautiful features (including the inspired draperies) this is notably demonstrated by the body of Christ itself. It would be impossible to find a body showing greater mastery of art and possessing more beautiful members, or a nude with more detail in the muscles, veins, and nerves stretched over their framework of bones, or a more deathly corpse. The lovely expression of the head, the harmony in the joints and attachments of the arms, legs, and trunk, and the fine tracery of pulses and veins are all so wonderful that it staggers belief that the hand of an artist could have executed this inspired and admirable work so perfectly and in so short a time. It is certainly a miracle that a formless block of stone could ever have been reduced to a perfection that nature is scarcely able to create in the flesh. Michelangelo put into this work so much love and effort that (something he never did again) he left his name written across the sash over Our Lady's breast. The reason for this was that one day he went along to where the statue was and found a crowd of strangers from Lombardy singing its praises; then one of them asked another who had made it, only to be told: 'Our Gobbo from Milan.'[1]

Michelangelo stood there not saying a word, but thinking it very odd to have all his efforts attributed to someone else. Then one night, taking his chisels, he shut himself in with a light and carved his name on the statue. And a fine poet has aptly described the Pietà, which is full of truth and life, as follows:

> Bellezza ed onestate,
> E doglia, e pieta in vivo marmo morte,
> Deh, come voi pur fate,
> Non piangete sì forte,
> Che anzi tempo risveglisi da morte.

1. Cristoforo Solari.

E pur, mal grado suo,
Nostro Signore, e tuo
Sposo, figliuolo e padre,
Unica sposa sua figliuola e madre.[1]

This work did wonders for Michelangelo's reputation. To be sure, there are some critics, more or less fools, who say that he made Our Lady look too young. They fail to see that those who keep their virginity unspotted stay for a long time fresh and youthful, just as those afflicted as Christ was do the opposite. Anyhow, this work added more glory and lustre to Michelangelo's genius than anything he had done before.

Then some of his friends wrote to him from Florence urging him to return there as it seemed very probable that he would be able to obtain the block of marble that was standing in the Office of Works. Piero Soderini, who about that time was elected Gonfalonier for life,[2] had often talked of handing it over to Leonardo da Vinci, but he was then arranging to give it to Andrea Contucci of Monte Sansovino, an accomplished sculptor who was very keen to have it. Now, although it seemed impossible to carve from the block a complete figure (and only Michelangelo was bold enough to try this without adding fresh pieces) Buonarroti had felt the desire to work on it many years before; and he tried to obtain it when he came back to Florence. The marble was eighteen feet high, but unfortunately an artist called Simone da Fiesole had started to carve a giant figure, and had bungled the work so badly that he had hacked a hole between the legs and left the block completely botched and misshapen. So the wardens of Santa Maria del Fiore (who were in charge of the undertaking) threw the block aside and it stayed abandoned for many years and seemed likely to remain so indefinitely. However, Michelangelo measured it again and calculated whether he

1. The verse was by Giovan Battista Strozzi il Vecchio, poet and madrigalist, and is very obscure. Roughly and literally: 'Beauty and goodness, And grief and pity, alive in the dead marble, Do not, as you do, weep so loudly, Lest before time should awake from death, In spite of himself, Our Lord, and thy Spouse, son and father, Oh virgin, only spouse, daughter and mother.'

2. Soderini was elected *Gonfaloniere di Justizia* for life (in effect, head of the Florentine Republic) in 1502.

could carve a satisfactory figure from the block by accommo-
dating its attitude to the shape of the stone. Then he made up
his mind to ask for it. Soderini and the wardens decided that
they would let him have it, as being something of little value,
and telling themselves that since the stone was of no use to their
building, either botched as it was or broken up, whatever
Michelangelo made would be worthwhile. So Michelangelo
made a wax model of the young David with a sling in his
hand; this was intended as a symbol of liberty for the Palace,
signifying that just as David had protected his people and
governed them justly, so whoever ruled Florence should
vigorously defend the city and govern it with justice. He
began work on the statue in the Office of Works of Santa
Maria del Fiore, erecting a partition of planks and trestles
around the marble; and working on it continuously he
brought it to perfect completion, without letting anyone see it.

As I said, the marble had been flawed and distorted by
Simone, and in some places Michelangelo could not work it as
he wanted; so he allowed some of the original chisel marks
made by Simone to remain on the edges of the marble, and
these can still be seen today. And all things considered,
Michelangelo worked a miracle in restoring to life something
that had been left for dead.

After the statue had been finished, its great size provoked
endless disputes over the best way to transport it to the Piazza
della Signoria. However, Giuliano da Sangallo, with his
brother Antonio, constructed a very strong wooden frame-
work and suspended the statue from it with ropes so that
when moved it would sway gently without being broken;
then they drew it along by means of winches over planks laid
on the ground, and put it in place. In the rope which held the
figure suspended he tied a slip-knot which tightened as the
weight increased: a beautiful and ingenious arrangement. (I
have a drawing by his own hand in my book showing this
admirable, strong, and secure device for suspending weights.)

When he saw the David in place Piero Soderini was deligh-
ted; but while Michelangelo was retouching it he remarked
that he thought the nose was too thick. Michelangelo,
noticing that the Gonfalonier was standing beneath the Giant

and that from where he was he could not see the figure properly, to satisfy him climbed on the scaffolding by the shoulders, seized hold of a chisel in his left hand, together with some of the marble dust lying on the planks, and as he tapped lightly with the chisel let the dust fall little by little, without altering anything. Then he looked down at the Gonfalonier, who had stopped to watch, and said:

'Now look at it.'

'Ah, that's much better,' replied Soderini. 'Now you've really brought it to life.'

And then Michelangelo climbed down, feeling sorry for those critics who talk nonsense in the hope of appearing well informed. When the work was finally finished he uncovered it for everyone to see. And without any doubt this figure has put in the shade every other statue, ancient or modern, Greek or Roman. Neither the Marforio in Rome, nor the Tiber and the Nile of the Belvedere, nor the colossal statues of Monte Cavello can be compared with Michelangelo's David, such were the satisfying proportions and beauty of the finished work. The legs are skilfully outlined, the slender flanks are beautifully shaped and the limbs are joined faultlessly to the trunk. The grace of this figure and the serenity of its pose have never been surpassed, nor have the feet, the hands, and the head, whose harmonious proportions and loveliness are in keeping with the rest. To be sure, anyone who has seen Michelangelo's David has no need to see anything else by any other sculptor, living or dead.

The David (for which Piero Soderini paid Michelangelo four hundred crowns) was put in position in the year 1504. It established Michelangelo's reputation as a sculptor and he went on to make for the Gonfalonier a very fine David in bronze, which Soderini sent to France. At this time Michelangelo also blocked out (without ever finishing) two marble roundels, one for Taddeo Taddei (which is to be found in his house today) and the other for Bartolommeo Pitti (and this was given by Fra Miniato Pitti of Monte Oliveto, a great student of cosmography and other subjects, especially painting, to his dear friend Luigi Guicciardini). These works were highly admired and appreciated. In addition, Michelangelo

blocked out in the Office of Works of Santa Maria del Fiore a marble statue of St Matthew. Rough as it is, this is a perfect work of art which serves to teach other sculptors how to carve a statue out of marble without making any mistakes, perfecting the figure gradually by removing the stone judiciously and being able to alter what has been done as and when necessary.

Michelangelo also made a bronze tondo of Our Lady which he cast at the request of certain Flemish merchants of the Mouscron family, men of great distinction in their own country, who paid him a hundred crowns and sent the work to Bruges. Then Angelo Doni, a Florentine who loved to own beautiful things by ancient or modern artists, decided he would like his friend to make something for him. So Michelangelo started work on a round painting of the Madonna. This picture shows Our Lady kneeling down and holding out the child to St Joseph. The mother of Christ turns her head and gazes intently on the supreme beauty of her son with an air of marvellous contentment lovingly shared with the venerable St Joseph, who takes the child with similar affection, tenderness, and reverence, as we can see from a glance at his face. Not content with this achievement, to show his superb mastery of painting, Michelangelo depicted in the background several nude figures, some leaning, others standing and seated. He executed this work with such care and diligence that it is held beyond doubt as the most beautiful and perfect of the few panel pictures he painted. When it was ready he sent it under wrappings to Angelo's house with a note asking for payment of seventy ducats. Now Angelo, who was careful with his money, was disconcerted at being asked to spend so much on a picture, even though he knew that, in fact, it was worth even more. So he gave the messenger forty ducats and told him that that was enough. Whereupon Michelangelo returned the money with a message to say that Angelo should send back either a hundred ducats or the picture itself. Then Angelo, who liked the painting, said: 'Well, I'll give him seventy.'

However, Michelangelo was still far from satisfied. Indeed, because of Angelo's breach of faith he demanded double what he had asked first of all, and this meant that to get the

picture Angelo was having to pay a hundred and forty ducats.

It happened that while the great painter Leonardo da Vinci was working in the Council Chamber (as I related in his biography) Piero Soderini, who was then Gonfalonier, recognizing Michelangelo's abilities, had part of the hall allocated to him; and this was why Michelangelo painted the other wall in competition with Leonardo, taking as his subject an episode in the Pisan War. For this project Michelangelo used a room in the Dyers' Hospital at Sant'Onofrio, where he started work on a vast cartoon which he refused to let anyone see. He filled it with naked men who are bathing because of the heat in the River Arno when suddenly upon an attack by the enemy the alarm is raised in the camp. And as the soldiers rush out of the water to dress themselves Michelangelo's inspired hand depicted some hurrying to arm themselves in order to bring help to their comrades, others buckling on their cuirasses, many fastening other pieces of armour on their bodies, and countless more dashing into the fray on horseback. Among the rest was the figure of an old man wearing a garland of ivy to shade his head; he is sitting down to pull on his stockings, but he cannot do so because his legs are wet from the water, and as he hears the cries and tumult of the soldiers and the beating of the drums he is straining to draw on one stocking by force. The nerves and muscles of his face and his contorted mouth convey the frenzied effort and exertion he is making with his whole body. There were some drummers and other naked figures, with their clothes bundled up, hurrying to get to the fighting, and drawn in various unusual attitudes: some upright, some kneeling or leaning forward, or half-way between one position and another, all exhibiting the most difficult foreshortenings. There were also many groups of figures drawn in different ways: some outlined in charcoal, others sketched with a few strokes, some shaded gradually and heightened with lead-white. This Michelangelo did to show how much he knew about his craft. When they saw the cartoon, all the other artists were overcome with admiration and astonishment, for it was a revelation of the perfection that the art of painting could reach. People who have seen these

inspired figures declare that they have never been surpassed by Michelangelo himself or by anyone else, and that no one can ever again reach such sublime heights. And this may readily be believed, for after the cartoon had been finished and, to the glory of Michelangelo, carried to the Sala del Papa, with tremendous acclamations from all the artists, those who subsequently studied it and made copies of the figures (as was done for many years in Florence by local artists and others) became excellent painters themselves. As we know, the artists who studied the cartoon included Aristotile da Sangallo (Michelangelo's friend), Ridolfo Ghirlandaio, Raphael Sanzio of Urbino, Francesco Granacci, Baccio Bandinelli, and the Spaniard Alonso Beruguete. They were followed by Andrea del Sarto, Franciabigio, Jacopo Sansovino, Rosso, Maturino, Lorenzetto, and Tribolo, when he was a child, and by Jacopo da Pontormo and Perin del Vaga. All these men were outstanding Florentine artists.

The cartoon having thus become a school for craftsmen, it was taken to the great upper room of the house of the Medici. But this meant that it was unwisely left in the hands of the craftsmen; and when Duke Giuliano fell ill, without warning it was torn into pieces. And now it is dispersed in various places. For example, there are some fragments still to be seen at Mantua in the house of Uberto Strozzi, a Mantuan gentleman, who preserves them with great reverence; and certainly anyone who sees them is inclined to think them of divine rather than human origin.

Michelangelo had become so famous because of his Pietà, the colossal statue of David at Florence, and the cartoon, that when in 1503 Alexander VI died and Julius II was elected Pope (at which time Buonarroti was about twenty-nine years old) Julius very graciously summoned him to Rome to build his tomb; and to meet the expenses of the journey he was paid a hundred crowns by the Pope's agent. After he had arrived in Rome, however, many months were let go by before he was asked to do any work. But eventually the Pope chose for his tomb the design made by Michelangelo. This design was an eloquent proof of Michelangelo's genius, for in beauty and magnificence, wealth of ornamentation and richness of

statuary it surpassed every ancient or imperial tomb ever made. When he saw it Pope Julius grew more ambitious and resolved to set about rebuilding the church of St Peter's at Rome, and to raise his tomb inside.

So Michelangelo started work with very high hopes, going first of all with two of his assistants to Carrara to excavate all the marble, on account of which he received a thousand crowns from Alamanni Salviati in Florence. He had nothing more by way of money or supplies for the eight months he spent in the mountains, where inspired by the masses of stone he conceived many fantastic ideas for carving giant statues in the quarries, in order to leave there a memorial of himself, as the ancients had done. After he had chosen all the marble that was wanted he had it loaded on board ship and taken to Rome, where the blocks filled half the square of St Peter's around Santa Caterina and between the church and the corridor leading to Castel Sant'Angelo. In the castle Michelangelo had prepared his room for executing the figures and the rest of the tomb; and so that he could come and see him at work without any bother the Pope had ordered a drawbridge to be built from the corridor to the room. This led to great intimacy between them, although in time the favours he was shown brought Michelangelo considerable annoyance and even persecution, and stirred up much envy among his fellow craftsmen.

Of this work Michelangelo executed during the lifetime and after the death of Julius four statues completed, and eight which were only blocked out, as I shall describe. Since the design of the tomb illustrates Michelangelo's extraordinary powers of invention, we shall describe here the plan that he followed. To give a sense of grandeur he intended the tomb to be free-standing so as to be seen from all four sides. The sides measured twenty-four feet in one direction and thirty-six in the other, the dimensions therefore being a square and a half. All round the outer side of the tomb were a range of niches, divided one from the other by terminal figures (clothed from the middle upwards) which supported the first cornice with their heads; and each of these figures had fettered to it, in a strange and curious attitude, a nude captive standing on a

projection of the base. These captives were meant to represent all the provinces subjugated by the Pope and made obedient to the Apostolic Church; and there were various other statues, also fettered, of all the liberal arts and sciences, which were thus shown to be subject to death no less than the pontiff himself, who employed them so honourably. On the corners of the first cornice were to go four large figures, representing the Active and the Contemplative Life, St Paul, and Moses. The tomb rose above the cornice in gradually diminishing steps, with a decorated bronze frieze, and with other figures, *putti*, and ornaments all around; and at the summit, completing the structure, were two figures, one of which was Heaven, smiling and supporting a bier on her shoulder, and the other, Cybele, the goddess of the Earth, who appeared to be grief-stricken at having to remain in a world robbed of all virtue through the death of such a great man, in contrast to Heaven who is shown rejoicing that his soul had passed to celestial glory. The tomb was arranged so that one might enter and come out between the niches at the ends of the quadrangle; and the interior was in the shape of an oval, curving like a temple. The sarcophagus to take the Pope's dead body was to go in the middle. Finally, the tomb was to have forty marble statues, not to mention the other scenes, *putti*, and ornamentation, and the richly carved cornices and other architectural elements. To hurry the work on, Michelangelo arranged that some of the marble should be taken to Florence, where he intended at times to pass the summer in order to avoid the malaria of Rome; and there he executed one side of the work in several sections down to the last detail. With his own hand he finished in Rome two of the captives, which were truly inspired, and other statues which have never been surpassed. As they were never used for the tomb, these captives were given by Michelangelo to Roberto Strozzi, when he happened to be lying ill in his house. Subsequently they were sent as a gift to King Francis, and they are now at Ecouen in France. In Rome he also blocked out eight statues, and in Florence another five, along with a Victory surmounting the figures of a captive, which are now in the possession of Duke Cosimo, to whom they were given by Michelangelo's

nephew, Lionardo. His excellency has put the Victory in the Great Hall of his palace, which was painted by Vasari. Michelangelo also finished the Moses, a beautiful statue in marble ten feet high. With this no other modern work will ever bear comparison (nor, indeed, do the statues of the ancient world). For, seated in an attitude of great dignity, Moses rests one arm on the tablets that he is grasping in one hand, while with the other he is holding his beard, which falls in long ringlets and is carved in the marble so finely that the hairs (extremely difficult for the sculptor to represent) are downy and soft and so detailed that it seems that Michelangelo must have exchanged his chisel for a brush. Moreover, the face of Moses is strikingly handsome, and he wears a saintly and regal expression; indeed, one cries out for his countenance to be veiled, so dazzling and resplendent does it appear and so perfectly has Michelangelo expressed in the marble the divinity that God first infused in Moses' most holy form. In addition, the draperies worn by Moses are carved and finished with beautiful folds in the skirt; and the arms with their muscles and the hands with their bones and tendons are so supremely beautiful, the legs, knees, and feet are covered with such carefully fashioned hose and sandals, and every part of the work is finished so expertly, that today more than ever Moses can truly be called the friend of God. For, through the skill of Michelangelo, God has wanted to restore and prepare the body of Moses for the Resurrection before that of anyone else. And well may the Jews continue to go there (as they do every Sabbath, both men and women, like flocks of starlings) to visit and adore the statue, since they will be adoring something that is divine rather than human.

Eventually everything was agreed and the work approached completion; and subsequently, of the four, one of the shorter sides was erected in San Pietro in Vincoli. It is said that while Michelangelo was working on the tomb, the marbles which had remained at Carrara were brought to the Ripa Grande port at Rome and then conveyed to St Peter's square to join the rest. As those who had brought them had to be paid Michelangelo went (as he usually did) to see the Pope. But because that day his holiness was transacting some important

business concerning Bologna, Michelangelo returned home and paid for the marble himself, thinking that he would straight away be repaid by his holiness. Then he went back another time to talk to the Pope about it, but he found difficulty in getting in for one of the grooms told him that he would have to be patient and that he had received orders not to admit him. At this a bishop who happened to be there said to the groom: 'You can't know who this man is.'

'I know him only too well,' replied the groom. 'But it's my job to do what I'm told to by my superiors and by the Pope.'

This attitude incensed Michelangelo, who had never experienced such treatment before, and he angrily told the groom that he should let his holiness know that if ever he wanted to see him in future he would find he had gone elsewhere. Then he went back to his workplace, and at the second hour of the night he set out on post-horses, leaving two servants to sell everything in the house to the Jews and then follow him to Florence. After he had arrived at Poggibonzi, in the territory of Florence, Michelangelo felt safe; but shortly afterwards five couriers arrived with instructions from the Pope to bring him back. For all their entreaties, and despite the letter which ordered him to return to Rome under threat of punishment, he refused to listen to a word. Eventually, however, the couriers persuaded him to write a word or two in answer to his holiness, in which he asked to be forgiven but added that he would never again return to his presence, since he had had him driven off like a criminal, that his faithful service had not deserved such treatment, and that the Pope should look for someone else to serve him.

Having arrived at Florence, Michelangelo devoted himself during the three months he stayed there to finishing the cartoon for the Great Hall, which Piero Soderini wanted him to carry into execution. However, during that time three papal briefs arrived at the Signoria commanding that Michelangelo be sent back to Rome; and when he saw the Pope's vehemence, as he distrusted him, Michelangelo contemplated, so it is said, going off to Constantinople to serve the Grand Turk, who was anxious to secure his services (through the agency of certain Franciscans) to build a bridge from Con-

stantinople to Pera. However, against his will he was per-
suaded by Piero Soderini to go and meet the Pope as a public
servant of Florence, protected by the title of ambassador.
Finally, the Gonfalonier recommended him to his brother,
Cardinal Soderini, for presentation to the Pope and sent him
to Bologna, where his holiness had already arrived from Rome.

(Another explanation is given for Michelangelo's flight
from Rome: namely, that the Pope became angry with him
because he would not allow any of his work to be seen; that
Michelangelo distrusted his own men and suspected that the
Pope, as did in fact happen more than once, disguised himself
to see what was being done when he was away himself; and
that on one of these occasions the Pope bribed his assistants to
let him in to see the chapel of his uncle Sixtus, which as I
describe later he was having painted by Michelangelo, only
for Michelangelo, who had suspected this treachery and hid-
den himself, to hurl planks at him when he came in, without
considering who it might be, and make him retreat in a fury.
Anyhow, whatever happened, one way or another he quar-
relled with the Pope and then grew afraid and had to run
away.)

Michelangelo arrived at Bologna, where no sooner had he
taken off his riding-boots than he was escorted by the Pope's
servants to his holiness who was in the Palace of the Sixteen.
As Cardinal Soderini was ill he sent one of his bishops to
accompany him, and when they arrived in front of the Pope
and Michelangelo knelt down, his holiness looked at him
askance as if he were angry and said:

'So instead of your coming to meet us you have waited for
us to meet you?' (By this he meant that Bologna was nearer to
Florence than to Rome.)

With a courteous gesture, and speaking in a firm voice,
Michelangelo humbly begged the Pope's forgiveness, saying
to excuse himself that he had acted as he did in anger, not
having been able to bear being dismissed like that, but that if
he had done wrong his holiness should forgive him once more.
Then the bishop who had presented Michelangelo to the Pope
began to make excuses for him, saying to his holiness that such
men were ignorant creatures, worthless except for their art,

and that he should freely pardon him. The Pope lost his temper at this and whacked the bishop with a mace he was holding, shouting at him: 'It's you that are ignorant, insulting him in a way we wouldn't dream of.'

Then, when the groom had driven the bishop out with his fists, the Pope, having exhausted his anger, gave Michelangelo his blessing. And Michelangelo was detained in Bologna with gifts and promises, until his holiness ordered him to make a bronze figure of himself, ten feet high. In this statue of Julius, Michelangelo produced a beautiful work of art, expressing in its attitude both grandeur and majesty, adding rich and magnificent draperies, and in the countenance displaying courage, resolution, alertness, and an awesome dignity. When ready, the statue was placed in a niche over the door of San Petronio.

It is said that while Michelangelo was working on it he was visited by an accomplished goldsmith and painter called Francia who wanted to see what he was doing, as he had heard so much praise of Buonarroti and his works but had never seen any of them. Francia was given permission to inspect the statue, and the necessary arrangements were made. When at last he saw Michelangelo's artistry at first hand he was truly astonished. But then, on being asked what he thought of the figure, he remarked that it was a lovely casting, in a very fine material. Having heard Francia praise the statue for its bronze rather than its craftsmanship, Michelangelo said:

'Well, I owe as much to Pope Julius who gave me the bronze as you owe to the chemists who give you your colours for painting.'

Then, losing his temper, in the presence of all the gentlemen standing around he called Francia a fool. As part of the same story, when a son of Francia's was introduced to him as a very handsome young man Michelangelo said to him:

'The living figures your father makes are better than those he paints.'

Among the gentlemen present was one (I don't know his name) who asked Michelangelo what he thought was bigger, the statue of Julius or a pair of oxen. Michelangelo retorted:

'Well, it depends on the oxen. You see, an ox from Florence isn't as big as one from Bologna.'

Michelangelo finished the statue in clay before the Pope left Bologna for Rome, and so his holiness went to see it. The Pope did not know what was to be placed in the statue's left hand, and when he saw the right hand raised in an imperious gesture he asked whether it was meant to be giving a blessing or a curse. Michelangelo replied that the figure was admonishing the people of Bologna to behave sensibly. Then he asked the Pope whether he should place a book in the left hand, and to this his holiness replied:

'Put a sword there. I know nothing about reading.'

In the bank of Anton Maria da Lignano the Pope left a thousand crowns for the completion of the statue which was then, after Michelangelo had toiled on it for sixteen months, placed on the frontispiece in the main façade of San Petronio. (Later it was destroyed by the Bentivogli and the bronze was sold to Duke Alfonso of Ferrara, who used it to make a piece of artillery which was called *La Giulia*. All that was saved was the head, which is now in the duke's wardrobe.)

Meanwhile, the Pope had returned to Rome while Michelangelo remained in Bologna to finish the statue. In his absence Bramante was constantly plotting with Raphael of Urbino to remove from the Pope's mind the idea of having Michelangelo finish the tomb on his return. Bramante did this (being a friend and relation of Raphael and therefore no friend of Michelangelo's) when he saw the way his holiness kept praising and glorifying Michelangelo's work as a sculptor. He and Raphael suggested to Pope Julius that if the tomb were finished it would bring nearer the day of his death, and they said that it was bad luck to have one's tomb built while one was still alive. Eventually they persuaded his holiness to get Michelangelo on his return to paint, as a memorial for his uncle Sixtus, the ceiling of the chapel that he had built in the Vatican. In this way Bramante and Michelangelo's other rivals thought they would divert his energies from sculpture, in which they realized he was supreme. This, they argued, would make things hopeless for him, since as he had no experience of colouring in fresco he would certainly, they believed, do less creditable work as a painter. Without doubt, they thought, he would be compared unfavourably with Raphael, and even if

the work were a success being forced to do it would make him angry with the Pope; and thus one way or another they would succeed in their purpose of getting rid of him. So when Michelangelo returned to Rome he found the Pope resolved to leave the tomb as it was for the time being, and he was told to paint the ceiling of the chapel. Michelangelo, being anxious to finish the tomb, and considering the magnitude and difficulty of the task of painting the chapel, and his lack of experience, tried in every possible way to shake the burden off his shoulders. But the more he refused, the more determined he made the Pope, who was a wilful man by nature and who in any case was again being prompted by Michelangelo's rivals, and especially Bramante. And finally, being the hot-tempered man he was, his holiness was all ready to fly into a rage.

However, seeing that his holiness was persevering, Michelangelo resigned himself to doing what he was asked. Then the Pope ordered Bramante to make the ceiling ready for painting, and he did so by piercing the surface and supporting the scaffolding by ropes. When Michelangelo saw this he asked Bramante what he should do, when the painting was finished, to fill up the holes. Bramante said: 'We'll think of it when it's time.' And he added that there was no other way. Michelangelo realized that Bramante either knew nothing about the matter or else was no friend of his, and he went to the Pope and told him that the scaffolding was unsatisfactory and that Bramante had not known how to make it; and the Pope replied, in the presence of Bramante, that Michelangelo should do it himself in his own way. So he arranged to have the scaffolding erected on props which kept clear of the wall, a method for use with vaults (by which many fine works have been executed) which he subsequently taught to various people, including Bramante. In this instance he enabled a poor carpenter, who rebuilt the scaffolding, to dispense with so many of the ropes that when Michelangelo gave him what was over he sold them and made enough for a dowry for his daughter.

Michelangelo then started making the cartoons for the vaulting; and the Pope also decided that the walls that had

been painted by previous artists in the time of Sixtus should be scraped clean and that Michelangelo should have fifteen thousand ducats for the cost of the work, the price being decided through Giuliano da Sangallo. Then being forced reluctantly, by the magnitude of the task, to take on some assistants, Michelangelo sent for help to Florence. He was anxious to show that his paintings would surpass the work done there earlier, and he was determined to show modern artists how to draw and paint. Indeed, the circumstances of this undertaking encouraged Michelangelo to aim very high, for the sake both of his own reputation and the art of painting; and in this mood he started and finished the cartoons. He was then ready to begin the frescoes, but he lacked the necessary experience. Meanwhile, some of his friends, who were painters, came to Rome from Florence in order to assist him and let him see their technique. Several of them were skilled painters in fresco, and they included Granaccio, Giuliano Bugiardini, Jacopo di Sandro, the elder Indaco, Angelo di Donnino, and Aristotile. Having started the work, Michelangelo asked them to produce some examples of what they could do. But when he saw that these were nothing like what he wanted he grew dissatisfied, and then one morning he made up his mind to scrap everything they had done. He shut himself up in the chapel, refused to let them in again, and would never let them see him even when he was at home. So, when they thought the joke was wearing thin, they accepted their dismissal and went back ashamed to Florence.

Thereupon, having arranged to do all the work by himself, Michelangelo carried it well on the way to completion; working with the utmost solicitude, labour, and study he refused to let anyone see him in case he would have to show what he was painting. As a result every day the people became more impatient.

Pope Julius himself was always keen to see whatever Michelangelo was doing, and so naturally he was more anxious than ever to see what was being hidden from him. So one day he resolved to go and see the work, but he was not allowed in, as Michelangelo would never have consented. (This was the cause of the quarrel described earlier, when

Michelangelo had to leave Rome as he would not let the Pope see what he was painting.) Now when a third of the work was completed (as I found out from Michelangelo himself, to clear up any uncertainty) during the winter when the north wind was blowing several spots of mould started to appear on the surface. The reason for this was that the Roman lime, which is white in colour and made of travertine, does not dry very quickly, and when mixed with pozzolana,[1] which is a brownish colour, forms a dark mixture which is very watery before it sets; then after the wall has been thoroughly soaked, it often effloresces when it is drying. Thus this salt efflorescence appeared in many places, although in time the air dried it up. When Michelangelo saw what was happening he despaired of the whole undertaking and was reluctant to go on. However, his holiness sent Giuliano da Sangallo to see him and explain the reason for the blemishes. Sangallo explained how to remove the moulds and encouraged him to continue. Then, when the work was half finished, the Pope who had subsequently gone to inspect it several times (being helped up the ladders by Michelangelo) wanted it to be thrown open to the public. Being hasty and impatient by nature, he simply could not bear to wait until it was perfect and had, so to say, received the final touch.

As soon as it was thrown open, the whole of Rome flocked to see it; and the Pope was the first, not having the patience to wait till the dust had settled after the dismantling of the scaffolds. Raphael da Urbino (who had great powers of imitation) changed his style as soon as he had seen Michelangelo's work and straight away, to show his skill, painted the prophets and sibyls of Santa Maria della Pace; and Bramante subsequently tried to persuade the Pope to let Raphael paint the other half of the chapel. When Michelangelo heard about this he complained of Bramante and revealed to the Pope, without reserve, many faults in his life and in his architectural works. (He himself, as it happened, was later to correct the mistakes made by Bramante in the fabric of St Peter's.) However, the Pope recognized Michelangelo's genius more clearly every day and wanted him to carry on the work himself; and after

1. A volcanic dust found near Pozzuoli.

he had seen it displayed he was of the opinion that Michelangelo would do the other half even better. And so in twenty months Michelangelo brought the project to perfect completion without the assistance even of someone to grind his colours. Michelangelo at times complained that because of the haste the Pope imposed on him he was unable to finish it in the way he would have liked; for his holiness was always asking him importunately when it would be ready. On one of these occasions Michelangelo retorted that the ceiling would be finished 'when it satisfies me as an artist'.

And to this the Pope replied: 'And we want you to satisfy us and finish it soon.'

Finally, the Pope threatened that if Michelangelo did not finish the ceiling quickly he would have him thrown down from the scaffolding. Then Michelangelo, who had good reason to fear the Pope's anger, lost no time in doing all that was wanted; and after taking down the rest of the scaffolding he threw the ceiling open to the public on the morning of All Saints' Day, when the Pope went into the chapel to sing Mass, to the satisfaction of the entire city.

Michelangelo wanted to retouch some parts of the painting *a secco*, as the old masters had done on the scenes below, painting backgrounds, draperies, and skies in ultramarine, and in certain places adding ornamentation in gold, in order to enrich and heighten the visual impact.[1] The Pope, learning that this ornamentation was lacking, and hearing the work praised so enthusiastically by all who saw it, wanted him to go ahead. However, he lacked the patience to rebuild the scaffolding, and so the ceiling stayed as it was. His holiness used to see Michelangelo often and he would ask him to have the chapel enriched with colours and gold, since it looked impoverished. And Michelangelo would answer familiarly:

'Holy Father, in those days men did not bedeck themselves in gold and those you see painted there were never very rich. They were holy men who despised riches.'

For this work Michelangelo was paid by the Pope three thousand crowns in several instalments, of which he had to

1. *Fresco secco* – as opposed to *buon fresco* – is painted on dry plaster and was rarely used, even for retouching, by Michelangelo's time.

spend twenty-five on colours. He executed the frescoes in great discomfort, having to work with his face looking upwards, which impaired his sight so badly that he could not read or look at drawings save with his head turned backwards; and this lasted for several months afterwards. I can talk from personal experience about this, since when I painted five rooms in the great apartments of Duke Cosimo's palace if I had not made a chair where I could rest my head and relax from time to time I would never have finished; even so this work so ruined my sight and injured my head that I still feel the effects, and I am astonished that Michelangelo bore all that discomfort so well. In fact, every day the work moved him to greater enthusiasm, and he was so spurred on by his own progress and improvements that he felt no fatigue and ignored all the discomfort.

The painting on the ceiling of the chapel is arranged with six pendentives on either side and one in the centre of the walls at the foot and the head; and on these Michelangelo painted prophets and sibyls, twelve feet high.[1] In the middle of the vault he depicted from the Creation up to the Flood and the Drunkenness of Noah; and in the lunettes he showed all the Ancestors of Jesus Christ. For the foreshortenings in these compartments he used no consistent rule of perspective, nor is there any fixed point of view. He accommodated the various compartments to the figures, rather than his figures to the compartments, for he was resolved to execute both the draped figures and the nudes so that they should demonstrate the perfect quality of his draughtsmanship. There is no other work to compare with this for excellence, nor could there be; and it is scarcely possible even to imitate what Michelangelo accomplished. The ceiling has proved a veritable beacon to our art, of inestimable benefit to all painters, restoring light to a world that for centuries had been plunged into darkness.

1. In fact, five pendentives on either side. Vasari's description, however, is substantially accurate, though in describing the histories he follows the logical sequence of the frescoes rather than the order in which they were painted. Michelangelo started work on the ceiling in 1508, the frescoes were unveiled in the summer of 1511, and the project was completed in 1512, setting the seal on his reputation as the greatest living artist.

Indeed, painters no longer need to seek new inventions, novel attitudes, clothed figures, fresh ways of expression, different arrangements, or sublime subjects, for this work contains every perfection possible under those headings. In the nudes, Michelangelo displayed complete mastery: they are truly astonishing in their perfect foreshortenings, their wonderfully rotund contours, their grace, slenderness, and proportion. And to show the vast scope of his art he made them of all ages, some slim and some full-bodied, with varied expressions and attitudes, sitting, turning, holding festoons of oak-leaves and acorns (to represent the emblem of Pope Julius and the fact that his reign marked the golden age of Italy, before the travail and misery of the present time). The nudes down the middle of the ceiling hold medallions painted like gold or bronze with subjects taken from the Book of Kings. Moreover, to show the perfection of art and the greatness of God, in the histories Michelangelo depicted God dividing Light from Darkness, showing him in all his majesty as he rests self-sustained with arms outstretched, in a revelation of love and creative power.

In the second history, with beautiful judgement and skill he showed the Creation of the Sun and the Moon, depicting God, supported by many *putti*, in an attitude of sublime power conveyed by the strong foreshortening of his arms and legs. In the same scene Michelangelo showed the Almighty after the Blessing of the Earth and the Creation of the Animals, when he is seen on the vaulting in the form of a foreshortened figure, flying through the air, which turns and changes direction as one walks about the chapel. The same happens in the next history, where God is dividing the Waters from the Earth. And both these figures are beautiful forms and refinements of genius that only the inspired hands of Michelangelo could create. Then he went on to the Creation of Adam, where he showed God being borne by a group of nude angels of tender age who appear to be bearing up not one figure alone but the weight of the world; and this effect is achieved by the venerable majesty of the Divine Form and the way in which he moves, embracing some of the *putti* with one arm, as if to support himself, while with the other he stretches out his

right hand towards Adam, a figure whose beauty, pose, and contours are such that it seems to have been fashioned that very moment by the first and supreme creator rather than by the drawing and brush of a mortal man. Beyond this in another scene he showed God taking our mother Eve from the side of Adam; and here we see the two nude figures, one so enslaved by sleep that it seems dead, and the other awakened to life by the divine benediction. The brush of this wonderfully ingenious craftsman arrestingly reveals the difference that there is between sleep and wakefulness and how the divine majesty can be portrayed in the firm and tangible terms that humans understand.

After this comes the scene when Adam, at the persuasion of a figure half woman and half serpent, brings death upon himself and upon us through the apple; and there again we see Adam and Eve, now being driven from Paradise by the angel who appears in sublime grandeur to execute the commands of a wrathful Lord. Adam displays his remorse at having sinned and his fear of death; and the woman also shows her shame, abasement, and desire for forgiveness, as she covers her breasts with her arms, pressing her hands palm to palm and sinking her neck on to her bosom, and turns her head towards the angel, showing more fear of the justice of God than hope of divine mercy. No less beautiful is the scene showing the sacrifice of Cain and Abel, where there are some figures bringing the wood, some bending down and blowing the fire, and others cutting the throat of the victim; and this Michelangelo executed as carefully and judiciously as the others. He displayed similar art and judgement in the history of the Flood, where there are depicted some dying men who are overwhelmed by terror and dismay at what has happened and in various ways are striving their utmost to find safety. For in the heads of these figures one sees life in prey to death, along with fear, dismay, and hopelessness. Michelangelo also showed the pious actions of many people who are helping one another to climb to safety to the top of a rock. Among them is a man who has clasped someone who is half dead and is striving his utmost to save him; and nothing better than this could be seen in living nature. Nor can I describe how well

expressed is the story of Noah, who is shown drunk with wine
and exposed, in the presence of one son who is laughing at
him and two others who are covering him up: a scene of
beautiful artistry that sets its own standards. Then, as if
Michelangelo's genius were emboldened by what he had al-
ready done, it soared even higher and achieved even more in
the five sibyls and seven prophets that are painted on the
ceiling. These figures, each ten feet or more in height, are
shown in varied attitudes, wearing a variety of vestments and
beautiful draperies; they are all executed with marvellous
judgement, and invention, and they appear truly inspired to
whoever studies their attitudes and expressions.

Thus, Jeremiah can be seen with his legs crossed, holding
one hand to his beard and resting an elbow on his knee; the
other hand rests on his lap, and the manner in which he in-
clines his head clearly expresses his melancholy and anxious
reflection, and the bitterness forced on him by his people.
Equally fine are the two *putti* and the first sibyl beyond him, in
the direction of the door. In this figure Michelangelo was
anxious to express the spirit of old age itself; she is enveloped
in draperies, to suggest that her blood had frozen with the
passing of time. And since her sight has failed, Michelangelo
has depicted her holding the book she reads very close to her
eyes. Beyond this figure follows the prophet Ezekiel, an old
man, full of movement and grace, and holding in one hand a
roll of prophecies while he raises the other and, as he turns his
head, prepares to utter words of lofty significance. Behind him
there are two *putti* holding his books.

Next to him there follows a sibyl who, in contrast to the
Erythraean sibyl described above, is holding a book at some
distance and is about to turn one of the pages, sitting deep in
contemplation, with one leg over the other, while she ponders
what she must write; and then a little boy behind her blows
on a burning brand to light her lamp.[1] Many aspects of this
figure are of exceptional loveliness: the expression of her face,
her head-dress, and the arrangement of her draperies; and her
arms, which are bared, are as beautiful as the rest. Beyond her

1. Vasari has transposed the two sibyls: the first is the Persian sibyl, and the
second the Erythraean.

Michelangelo painted the prophet Joel who, sunk within himself, has taken a scroll which he is reading with great attention and emotion; he looks like a living person who has applied his thoughts intently to the matter before him, and from his expression one can recognize that he is content with what he reads. Then over the door of the chapel Michelangelo placed the aged Zechariah who holds a book in which he is seeking something that he cannot find, crouching with one leg raised back and the other lower down, oblivious to the discomfort of this posture because of the intensity of his search. This is a figure marvellous in its old age, somewhat full in form and wearing beautiful draperies with a few folds. Then there is the (Delphic) sibyl, next towards the altar on the other side, who is displaying certain writings and who, with her little boys in attendance, is no less admirable than the others. And then beyond her we see the prophet Isaiah. He is lost in thought, and with his legs crossed he keeps one hand inside the pages of his book, to mark his place, while he rests the other elbow by the book and presses that hand to his cheek; he is called by one of the *putti* behind him, but stays motionless, turning only his head. Anyone who studies this figure, copied so faithfully from nature, the true mother of the art of painting, will find a beautifully composed work capable of teaching in full measure all the precepts to be followed by a good painter. Beyond him is the elderly (Cumaean) sybil, a seated figure of great beauty, in an attitude of extraordinary grace as she studies the pages of a book, with two beautiful *putti* at her side. Then comes the figure of a young man, representing Daniel, who is shown writing in a great book, copying things from certain other writings with eager intensity. As a support for the weight Michelangelo painted between Daniel's legs a *putto* who is supporting the book while he writes; and the brush of no other artist will ever paint a group as marvellous as this. The same holds true for the lovely figure of the Libyan sibyl who, having written a great volume drawn from many books, is about to rise to her feet in an attitude of womanly grace; and at one and the same time she makes as if to rise and to close the book, something most difficult, not to say impossible, for anyone but the master to have depicted.

What can I say of the four scenes in the corner-spandrels of the ceiling? In one of them, exerting all his boyish strength, there is David cutting off the head of Goliath, while some soldiers in the background look on in amazement. Just as astonishing are the beautiful attitudes of the figures in the scene at the corner opposite, where Michelangelo depicted the headless, writhing body of Holofernes and Judith placing the head on a shallow basket resting on the head of her serving-woman. This old woman is so tall that she has to stoop to allow her mistress to balance it properly; and using her hands to help support the burden and to cover it up, she turns her face towards the trunk of Holofernes which, though lifeless, draws up an arm and a leg and disturbs the silence inside the tent. This disturbance causes her terror and alarm, which are clearly seen in her expression. Altogether this is a picture composed with marvellous thought and care.

Even more beautiful and inspired than that and the other scenes is the story of the serpents of Moses, over the left-hand side of the altar. For here one sees the deadly havoc wrought by the rain of serpents as they bite and sting, and the brazen serpent itself that Moses placed upon a pole. Michelangelo vividly depicted the various deaths suffered by those who are doomed by the serpents' bites. The deadly poison is causing the death of countless men and women in terror and convulsion, not to mention the rigid legs and twisted arms of those who remain just as they were struck down, unable to move, and then again the beautifully executed heads shown shrieking and thrown back in despair. No less marvellously portrayed than the rest are those who keep their eyes fixed with heart-felt emotion on the serpent, the sight of which has already lessened their grief; among them is a woman who has been bitten and reduced to terror and who now in her great and obvious need is supported by another figure offering clear and welcome assistance.

There are more beautiful figures in the next scene, which shows Ahasuerus lying in bed and reading his chronicles. Thus, there are three men eating at a table, representing the council that was held to deliver the Jewish people and order the hanging of Haman. Haman himself was depicted in an

extraordinary example of foreshortening, for Michelangelo painted the trunk that supports his person and the arm thrust forward so that they seem in living relief, the same effect being seen in the leg that Haman stretches out and the other parts of the body that bend inwards. Of all the beautiful and difficult figures executed by Michelangelo this is certainly the most beautiful and the most difficult. It would take too long to describe the various wonderful gestures and poses that he employed to illustrate the story of the Ancestors of Christ, showing the genealogy of all the Fathers beginning with the sons of Noah. And it is impossible to describe adequately all the many features of the figures in this section of Michelangelo's work: the draperies, the expressions of the heads, and the innumerable original and extraordinary fancies, all most brilliantly conceived. Every detail reflects Michelangelo's genius; all the figures are skilfully and beautifully foreshortened; and every single feature is manifestly inspired and beyond praise.

Then who is not filled with admiration and amazement at the awesome sight of Jonah, the last figure in the chapel? The vaulting naturally springs forward, following the curve of the masonry; but through the force of art it is apparently straightened out by the figure of Jonah, which bends in the opposite direction; and thus vanquished by the art of design, with its lights and shades, the ceiling even appears to recede.

What a happy age we live in! And how fortunate are our craftsmen, who have been given light and vision by Michelangelo and whose difficulties have been smoothed away by this marvellous and incomparable artist! The glory of his achievements has won them honour and renown; he has stripped away the bandage that kept their minds in darkness and shown them how to distinguish the truth from the falsehoods that clouded their understanding. You artists should thank heaven for what has happened and strive to imitate Michelangelo in everything you do.

When the work was thrown open, the whole world came running to see what Michelangelo had done; and certainly it was such as to make everyone speechless with astonishment. Then the Pope, exalted by the results and encouraged to

undertake even more grandiose enterprises, generously rewarded Michelangelo with rich gifts and money. Michelangelo used to say of the extraordinary favours he was shown that they proved that his holiness fully recognized his abilities; and if sometimes, arising out of their intimacy, the Pope did him some hurt, he would heal it with extraordinary gifts and favours. There was an instance of this when Michelangelo once asked the Pope's permission to go to Florence for the feast day of St John and wanted some money from him for the purpose, and the Pope said:

'Well, what about this chapel? When will it be finished?'

'When I can, Holy Father,' said Michelangelo.

Then the Pope struck Michelangelo with a staff he was holding and repeated:

'When I can! When I can! What do you mean? I will soon make you finish it.'

However, after Michelangelo had gone back to his house to prepare for the journey to Florence, the Pope immediately sent his chamberlain, Cursio, with five hundred crowns to calm him down, as he was afraid that he would react in his usual unpredictable way; and the chamberlain made excuses for his holiness, explaining that such treatment was meant as a favour and a mark of affection. Then Michelangelo, because he understood the Pope's nature and, after all, loved him dearly, laughed it off, seeing that everything redounded to his profit and advantage and that the Pope would do anything to keep his friendship.

After the chapel had been finished, before the Pope was overtaken by death, his holiness commanded Cardinal Santiquattro and Cardinal Aginense, his nephew, that in the event of his death they should ensure that his tomb was finished, but on a smaller scale than first planned. So Michelangelo began work on the tomb once more, very eagerly, hoping to have done with it once for all without being hindered as much as before. (But for the rest of his life it was to bring him endless vexations and annoyances and drudgery, more than anything else he ever did; and for a long time it earned him the reputation of being ungrateful to the Pope who had loved and favoured him so much.) So Michelangelo

returned to the tomb and worked there continuously; and he also found time to prepare designs for the façades of the chapel. But envious fortune decreed that this memorial, which had got off to such a good start, should never be finished. For at that time Pope Julius died and the work was abandoned because of the election of Pope Leo X. Being no less grandiose than Julius in mind and spirit, Leo determined to leave in his native city (from which he was the first Pope), to commemorate both himself and his inspired fellow-citizen Michelangelo, such marvels as only a great ruler, as he was, could undertake.[1]

Thus he gave orders for the completion of the façade of San Lorenzo, the family church of the Medici; and this was why the tomb of Pope Julius remained unfinished, for Leo asked Michelangelo to give advice and plans and to be in charge of the project. Michelangelo resisted as firmly as he could, protesting that he was under an obligation to Santiquattro and Aginense to work on the tomb. But the Pope replied that he should forget about that as he had already taken care of it and arranged for them to release him, and he also promised that while he was in Florence Michelangelo would be able to work on the figures for the tomb, as he had already started to do. These suggestions greatly upset both the cardinals and Michelangelo, who went off in tears.

Then there followed endless discussions and arguments about the façade, on the grounds that a project of that kind should be made the responsibility of several artists; and in connexion with the architecture many craftsmen flocked to Rome to see the Pope, and designs were made by Baccio d'Agnolo, Antonio da Sangallo, Andrea and Jacopo Sansovino, and the gracious Raphael of Urbino, who was afterwards called to Florence for that purpose at the time of the Pope's visit. Thereupon, Michelangelo decided to make a model and not to accept anyone else as his guide or supervisor in the architecture of the façade. But because he refused any assistance in the event neither he nor anyone else carried out the

1. Here, as elsewhere, I have translated *divino* by 'inspired' rather than 'divine'. The adjective *divino* was widely used of Michelangelo during his lifetime, though Vasari does use it of other artists as well.

work; and in despair the craftsmen went back to attend to their own affairs. Michelangelo, who was going to Carrara, had an order authorizing Jacopo Salviati to pay him a thousand crowns. However, when he arrived, finding Jacopo transacting business in his room with some other citizens, he refused to wait for an interview, left without saying a word, and made his way to Carrara. Meanwhile, having heard of Michelangelo's arrival but not finding him in Florence, Jacopo sent him the thousand crowns to Carrara. The courier demanded a receipt for the money, only to be told by Michelangelo that it was for the expenses of the Pope and no business of his, that he was not in the habit of writing out receipts or acknowledgements on behalf of other people, and that he could take the money back; and so in a panic the courier went back to Jacopo without a receipt. While Michelangelo was at Carrara and, thinking that he would finish it, was having marbles quarried for the tomb as well as for the façade, word came to him that Pope Leo had heard that in the mountains of Pietrasanta near Seravezza, in Florentine territory, at the top of the highest mountain, Monte Altissimo, there were marbles of the same beauty and quality as those of Carrara. Michelangelo already knew this, but it seems that he was reluctant to do anything about it since he was friendly with the Marquis Alberigo, lord of Carrara, and for his sake preferred to use marble quarried at Carrara rather than Seravezza; or else it was because he thought it would be a long drawn-out business and he would waste a lot of time on it, as did in fact happen. Anyhow, he was compelled to go to Scravezza, although he argued in opposition to the idea that it would be less convenient and more costly (as, especially at the beginning, proved to be the case) and, moreover, that perhaps the reports about the marble were mistaken. All the same the Pope refused to listen to a word. And then it became necessary to build a road several miles long through the mountains, breaking up rocks with hammers and pick-axes to obtain a level, and sinking piles in the marshy areas. Michelangelo thus spent several years carrying out the Pope's orders, and finally he excavated five columns of the size required, one of which is on the Piazza di San Lorenzo at Florence, while the

others are on the seashore. And this was why the Marquis Alberigo, who saw his business ruined, subsequently became a bitter enemy of Michelangelo, although Michelangelo was in no way to blame for what happened.

As well as these columns Michelangelo excavated many other marbles – which are still in the quarries, where they have been abandoned for over thirty years. However, Duke Cosimo has now given orders for the completion of the road, of which there are two miles still to be built over difficult ground, for transporting these marbles. He has arranged as well for the construction of another road from a new quarry of excellent marble discovered by Michelangelo, so that many fine projects may be finished. In Seravezza, Michelangelo also discovered a hill of very hard and beautiful mixed stone near Stazzema, a village in the mountains; and Duke Cosimo has had built a paved road over four miles long to transport it to the sea.

To go back to Michelangelo's own life: from Carrara he returned to Florence where he wasted a great deal of time now on one thing and now on another. Then for the Medici Palace he made a model for the windows with supporting volutes that belong to the apartments at the corner. Giovanni da Udine decorated the room in stucco and painting, with results that are greatly admired; and Michelangelo gave the goldsmith Piloto instructions to make the shutters of perforated copper, which are certainly very impressive.

Michelangelo devoted many years of his life to quarrying marble, although it is true that while the blocks were being excavated he also made wax models and other things for the façade. But the project was delayed so long that the money the Pope assigned to it was spent on the war in Lombardy, and when Leo died the work was left unfinished, nothing having been accomplished save the laying of a foundation in front to support the façade and the transportation of a large column of marble from Carrara to the Piazza di San Lorenzo.

The death of Leo was a fearful blow to the arts and those who practised them, both in Florence and Rome; and while Adrian VI was Pope, Michelangelo stayed in Florence giving his attention to the tomb of Julius. Then Adrian died and was

succeeded by Clement VII, who was no less anxious than Leo and his other predecessors to leave a name glorified by the arts of architecture, sculpture, and painting. It was at that time, in 1525, that Giorgio Vasari was taken as a young boy to Florence by the cardinal of Cortona and placed with Michelangelo as an apprentice. However, Michelangelo was called to Rome by Pope Clement, who was ready to have a start made on the library of San Lorenzo and the new sacristy, in which he intended to place the marble tombs he was having built for his ancestors. Before leaving, Michelangelo decided that Vasari should go to work with Andrea del Sarto until he was free again himself, and in person he took Vasari along to Andrea's workshop to introduce him.

He then left for Rome in a hurry, harassed once again by Francesco Maria, duke of Urbino, the nephew of Pope Julius, who complained that Michelangelo had received sixteen thousand crowns for the tomb and yet stayed in Florence amusing himself, and who threatened him angrily that if he did not attend to the work he would make him regret it. After Michelangelo had arrived in Rome, Pope Clement, who wanted to make use of his services, advised him to settle his account with the duke's agents, for the Pope believed that in view of all he had done Michelangelo was a creditor rather than a debtor; and that was how matters were left. After the Pope and Michelangelo had discussed many things together, they resolved to finish completely the sacristy and the new library of San Lorenzo at Florence.

So Michelangelo again left Rome and raised the cupola of the sacristy as we see it today. He designed it in a composite style and asked the goldsmith Piloto to make for it a very beautiful ball with seventy-two facets. It happened that while the cupola was being raised Michelangelo was asked by some of his friends:

'Shouldn't you make your lantern very different from that of Filippo Brunelleschi?'

'Certainly I can make it different,' he replied, 'but not better.'[1]

1. The old sacristy of San Lorenzo was rebuilt by Brunelleschi after the basilica had been destroyed by fire in 1423. Michelangelo became involved in

Michelangelo made in the sacristy four tombs to hold the bodies of the fathers of the two Popes: namely, the elder Lorenzo and his brother Giuliano, and those of Giuliano, the brother of Leo, and of Duke Lorenzo, Leo's nephew. He wanted to execute the work in imitation of the old sacristy made by Filippo Brunelleschi but with different decorative features; and so he did the ornamentation in a composite order, in a style more varied and more original than any other master, ancient or modern, has ever been able to achieve. For the beautiful cornices, capitals, bases, doors, tabernacles, and tombs were extremely novel, and in them he departed a great deal from the kind of architecture regulated by proportion, order, and rule which other artists did according to common usage and following Vitruvius and the works of antiquity but from which Michelangelo wanted to break away.[1]

The licence he allowed himself has served as a great encouragement to others to follow his example; and subsequently we have seen the creation of new kinds of fantastic ornamentation containing more of the grotesque than of rule or reason. Thus all artists are under a great and permanent obligation to Michelangelo, seeing that he broke the bonds and chains that had previously confined them to the creation of traditional forms.

Later Michelangelo sought to make known and to demonstrate his new ideas to even better effect in the library of San Lorenzo: namely, in the beautiful distribution of the windows, the pattern of the ceiling, and the marvellous entrance of the vestibule. Nor was there ever seen such resolute grace, both in

plans to complete the Medici church of San Lorenzo after 1515. The first project – the creation of a façade – was abandoned; in 1520 he began planning the Medici Chapel attached to San Lorenzo; and subsequently he was commissioned to design the Laurenziana Library in the cloister. The marvellous sculptural decoration of the chapel is discussed (along with the rest of Michelangelo's work as a sculptor) by John Pope Hennessy in his *Italian High Renaissance and Baroque Sculpture* (Phaidon, 3 vols, 1963).

1 Cf. the Preface to Part Three of the *Lives* where Vasari discusses the meaning of these terms. Vitruvius was a Roman architect (Marcus Vitruvius Pollio) whose *De Architectura*, Libri x – rediscovered in the fifteenth century – exercised a profound influence on Renaissance architectural theory.

detail and overall effect, as in the consoles, tabernacles, and cornices, nor any stairway more commodious. And in this stairway, he made such strange breaks in the design of the steps, and he departed in so many details and so widely from normal practice, that everyone was astonished.

It was at that time that Michelangelo sent his assistant, Pietro Urbino of Pistoia, to Rome to carry to completion a very fine figure of the naked Christ bearing the cross, which was placed on behalf of Antonio Metelli beside the principal chapel of Santa Maria sopra Minerva. Soon afterwards there took place the sack of Rome and the expulsion of the Medici from Florence; and with the change of government it was decided to rebuild the city's fortifications and to appoint Michelangelo as Commissary General in charge of the work. Thereupon he drew up plans and had fortifications built for several parts of the city; and finally, he encircled the hill of San Miniato with bastions. These he made not with the usual sods of earth, wood, and bundles of brushwood but with a strong, interwoven base of chestnut, oak, and other strong materials and (in place of the sods) unbaked bricks of tow and dung which were squared very carefully. Subsequently the Signoria of Florence sent him to Ferrara to inspect the fortifications of Duke Alfonso I and his artillery and munitions. The duke treated him very courteously and begged him, at his leisure, to make something for him with his own hand, and Michelangelo readily agreed to do so. Then, returning to Florence, he worked continuously on the fortification. Yet despite this distraction he secretly spent time working for the duke on a picture of Leda, which he painted with his own hand in tempera (an inspired work, as I shall describe later) and on the statues for the tombs of San Lorenzo. At this time Michelangelo also spent six months or so at San Miniato in order to hurry on the fortification of the hill, because if the enemy captured this point, the city was lost. All these enterprises he pursued with the utmost diligence. Meanwhile, he continued the work in the sacristy of San Lorenzo, in which there were seven statues which were left partly finished and partly not. Taking these and the architectural inventions of the tombs into account, it must be confessed that he surpassed

all others in practice of the three arts. To be sure, the marble statues to be seen in San Lorenzo, which he blocked out or finished, provide convincing evidence for this claim. Among them is the figure of Our Lady, seated with her right leg crossed over the left and one knee placed on the other, while the child, with his thighs astride the leg that is uppermost, turns in a most enchanting attitude, looking for his mother's milk; and Our Lady, holding him with one hand and supporting herself with the other, leans forward to give it to him. Although this statue remained unfinished, having been roughed out and left showing the marks of the chisel, in the imperfect block one can recognize the perfection of the completed work. Michelangelo's ideas for the tombs of Duke Giuliano and Duke Lorenzo de' Medici caused even more astonished admiration. For here he decided that Earth alone did not suffice to give them an honourable burial worthy of their greatness but that they should be accompanied by all the parts of the world; and he resolved that their sepulchres should have around and above them four statues. So to one tomb he gave Night and Day, and to the other Dawn and Evening; and these statues are so beautifully formed, their attitudes so lovely, and their muscles treated so skilfully, that if the art of sculpture were lost they would serve to restore to it its original lustre.

Then among the other statues there are the two captains in armour: one, the pensive Duke Lorenzo, the embodiment of wisdom, with legs so finely wrought that nothing could be better, the other, Duke Giuliano, a proud figure, with the head, the throat, the setting of the eyes, the profile of the nose, the opening of the mouth, and the hair made with such inspired craftsmanship, as are the hands, the arms, the knees, the feet, and indeed every detail, that one's eyes can never be tired of gazing at it. One has only to study the beauty of the buskins and the cuirass to believe that the statue was made by other than human hands. But what shall I say of the Dawn, a nude woman who is such as to arouse melancholy in one's soul and throw sculpture into confusion? In her attitude may be seen the anxiety with which, drowsy with sleep, she rises up from her downy bed; for on awakening she has found the eyes

of the great duke closed in death, and her eternal beauty is contorted with bitter sorrow as she weeps in token of her desperate grief. And what can I say of the Night, a statue not only rare but unique? Who has ever seen a work of sculpture of any period, ancient or modern, to compare with this? For in her may be seen not only the stillness of one who is sleeping but also the grief and melancholy of one who has lost something great and noble. And she may well represent the Night that covers in darkness all those who for some time thought, I will not say to surpass, but even to equal Michelangelo in sculpture and design. In this statue Michelangelo expressed the very essence of sleep. And in its honour various erudite people wrote many Latin verses and rhymes in the vernacular, of which the following, by an unknown author, is an example:

The Night that you see sleeping in such loveliness was by an angel carved in this rock; and by her sleeping she has life; wake her, if you disbelieve, and she will speak to you.

To this, speaking in the person of Night, Michelangelo replied:

Dear to me is sleep, and dearer to be of stone while wrongdoing and shame prevail; not to see, not to hear, is a great blessing: so do not awaken me; speak softly.

To be sure, if the enmity that exists between fortune and genius, between the envy of the one and the skill of the other, had allowed this work to be completed, then art would have demonstrated that it surpassed nature in every way. However, in 1529, while Michelangelo was labouring with intense love and solicitude on these works, Florence was besieged, and this decisively frustrated their completion. Because of the siege Michelangelo did little or no more work on the statues, because he had been given by the Florentines the task of fortifying both the hill of San Miniato and, in addition, as I said, the city itself. After he had lent a thousand crowns to the Republic and found himself elected one of the Nine of the Militia (a council appointed for the war) Michelangelo turned all his thoughts and energies to the job of perfecting the fortifications. But in the end, when the enemy army had closed

round the city, with all hope of relief gradually fading and the difficulties of resistance increased, realizing that he was in grave personal danger Michelangelo resolved to save himself by leaving Florence for Venice. So, in secret, he left quietly by way of the hill of San Miniato, taking with him his pupil Antonio Mini and his loyal friend, the goldsmith Piloto. Each of them carried a number of crowns, sewn into his quilted doublet, and having reached Ferrara they decided to stay there. It happened that because of the tumult caused by the war and the alliance between the emperor and the Pope, who were besieging Florence, Duke Alfonso d'Este was keeping close watch in Ferrara, wanting to know from those who gave lodgings to travellers the names of all arrivals from day to day; and every day he had brought to him a description of all foreign visitors and where they came from. So when Michelangelo dismounted with his companions, intending to stay in Ferrara without making himself known, his arrival was notified to the duke, who was delighted to hear the news since he already enjoyed his friendship. Alfonso (a magnanimous ruler, who all his life took great pleasure in the arts) at once sent some of the notables of his court with instructions to conduct Michelangelo in the name of his excellency to the palace, to move there his horses and all his baggage, and give him comfortable quarters. Finding himself in the power of another, Michelangelo had no other course but to submit with a good grace; and so he went with them to see the duke, although he left his belongings at the inn. The duke chided him for his aloofness, but then welcomed him very warmly and gave him a number of costly gifts; then he tried to persuade him to stay in his service in Ferrara, promising to pay him a generous salary. Michelangelo, however, who had other plans, was unwilling to remain; so the duke begged him to stay at least while the war continued and renewed the offer to give him anything in his power. Not wanting to be outdone in courtesy, Michelangelo thanked him warmly and then, turning towards his two companions, said that he had brought twelve thousand crowns to Ferrara and that if the duke needed them they were at his disposal, along with himself. After this the duke led him on a tour of the palace, as he had done on a pre-

vious occasion, showing him all the fine works of art in his possession, including his own portrait by Titian which Michelangelo enthusiastically praised. However, the duke could not persuade him to stay in the palace and Michelangelo insisted on going back to the inn; whereupon the innkeeper received through the duke any number of things with which to do Michelangelo honour and was told not to accept any payment when he left.

From Ferrara Michelangelo went to Venice, where he stayed on the island of Giudecca; he left again, however, after he had been much sought after by various people in society, as he always had a low opinion of their understanding of his art. While he was there, it is said, he made for the city, at the request of Doge Gritti, a design for the bridge of the Rialto which was outstanding for its invention and ornamentation.

Meanwhile, he was strongly urged to return home and begged not to abandon his work in Florence, and he was sent a safe-conduct. Finally, overcome by longing for his native land, he made up his mind to go back, at some risk to himself. It was then that he finished the Leda he was painting for Duke Alfonso; and it was subsequently taken to France by his assistant, Antonio Mini. At this time Michelangelo saved the campanile of San Miniato, a tower whose two pieces of artillery had inflicted such terrible damage on the enemy's forces that the gunners in the enemy camp bombarded it with their heavy cannon. The tower was already half destroyed and would soon be a complete shambles. However, Michelangelo protected it so well with bales of wool and stout mattresses suspended by ropes that it is still standing.

They also say that during the siege of Florence Michelangelo was given the opportunity of satisfying an earlier ambition of his and obtaining a marble block from Carrara, eighteen feet high, that Pope Clement had given to Baccio Bandinelli who had also wanted it. As it was now public property Michelangelo asked the Gonfalonier for the marble, which he was given with instructions to put it to good use. Baccio had himself made a model and cut away a good part of the stone; and then when he was allocated the marble Michelangelo made a

model of his own. However, after the Medici were restored to power the block was given back to Baccio. And after the treaty had been signed, Baccio Valori, the Pope's emissary, received orders to arrest and imprison some of the citizens who had been politically active; and the tribunal also sen⁺ for Michelangelo. Suspecting that this would happen, he had secretly fled to the house of one of his friends where he stayed hidden for several days until the tumult had died down. Then Pope Clement, mindful of Michelangelo's talent and ability, ordered that everything possible should be done to find him and that far from being charged he should be given back his former appointments and told to attend to the work at San Lorenzo, in charge of which Pope Clement placed as commissary Giovanbattista Figiovanni, prior of San Lorenzo, who was an old servant of the Medici family. Reassured by this, to win Baccio Valori's goodwill Michelangelo then started work on a marble figure, six feet high, showing Apollo drawing an arrow from his quiver, and he carried it almost to completion. Today this statue is in the apartment of the prince of Florence, and it is a very precious work, even though it is not completely finished.[1]

At that time Michelangelo was visited by a gentleman from the court of Duke Alfonso of Ferrara, who having heard that he had made for him an outstanding work was anxious not to lose such a gem. When the man arrived in Florence he sought Michelangelo out and presented his letters of introduction. Michelangelo made him welcome and showed him the picture of Leda embracing the swan, with Castor and Pollux coming forth from the egg, which he had painted very rapidly in tempera. The duke's go-between, mindful of what he knew about Michelangelo's great reputation and being unable to perceive the excellence and artistry of the picture, said to him: 'Oh, but this is just a trifle.'

Michelangelo asked him what his own profession might be, knowing that no one can be a better judge than a man with experience of what he is criticizing. With a sneer, the courtier replied: 'I'm a dealer.' He said this believing that Michelangelo had failed to recognize him for what he was, and

1. In fact, a David.

laughing at the idea of such a question as well as showing his scorn for the trading instincts of the Florentines. Michelangelo, who had understood what he was getting at perfectly well, retorted:

'Well, you've just made a poor deal for your master. Now get out of my sight.'

About that time his assistant Antonio Mini, who had to find dowries for his two sisters, asked for the Leda, which Michelangelo readily gave him, along with most of the wonderful cartoons and drawings he had made for it, and also two chests full of models, as well as a great number of finished cartoons and some pictures that were already painted. When Antonio took it into his head to go to France he carried all these away with him. He sold the Leda to the king of France through some merchants, and it is now at Fontainebleau; but the cartoons and designs came to grief, since he died shortly afterwards and some of them were stolen. Thus Florence suffered the grievous loss of many of Michelangelo's great works. Subsequently, the cartoon of the Leda was returned to Florence, and it is now in the possession of Bernardo Vecchietti; similarly, four pieces of the cartoons for the chapel, with nudes and prophets, were brought back by the sculptor Benvenuto Cellini, and these are in the hands of the heirs of Girolamo degli Albizzi.

It became necessary for Michelangelo to go to Rome to serve Pope Clement who, although angry with him, as a friend of talented men forgave him everything. The Pope gave him instructions to return to Florence and finish the library and sacristy of San Lorenzo; and to save time, a considerable number of statues that were to be included were allocated to various other sculptors. Michelangelo allocated two of them to Tribolo, one to Raffaello da Montelupo, and one to Fra Giovanni Angelo of the Servites; and he assisted these sculptors in the work, making for them the rough clay models. They all set to with a will, and meanwhile Michelangelo had the library itself attended to. Thus the ceiling was finished with carved woodwork, executed from Michelangelo's models by the Florentines Carota and Tasso, who were excellent carpenters and masters of wood-carving; and similarly the

bookshelves were designed by Michelangelo and executed by Battista del Cinque and his friend Ciappino, who were skilled in that kind of work. To enhance the work still more, there was brought to Florence the inspired artist Giovanni da Udine, who with some of his own assistants and various Florentine craftsmen decorated the tribune with stucco. So with great solicitude everyone worked hard to bring the project to completion.

Michelangelo was preparing to have the statues carried into execution; but at that very time the Pope took it into his head to have him near him in person, as he wanted to have painted the walls of the Sistine Chapel, where Michelangelo had painted the ceiling for Julius II, who was the nephew of Sixtus. On the principal wall behind the altar, Clement wanted him to paint the Last Judgement, and he was determined that it should be a masterpiece. On the opposite wall, over the main door, he had commanded that Michelangelo should depict a scene showing Lucifer driven from heaven as a punishment for his pride and hurled with all the angels who had sinned with him into the depths of hell. (It was found that many years before Michelangelo had made various drawings and sketches for these subjects, of which subsequently one was executed in the church of Santissima Trinità in Rome by a Sicilian painter who had spent many months working for him and grinding his colours. This work is in the transept of the church, in the chapel of St Gregory. It was painted in fresco, with very poor results. However, one can glimpse a certain diversity and awesomeness in the groups of nudes as they rain down from heaven to turn into demons of weird and frightening appearance on reaching the centre of the earth: certainly a strange flight of the imagination.) [1]

While Michelangelo was making preparations to execute the cartoons and drawings for the Last Judgement on the first wall, never a day passed without his being troubled by the

1. Here and elsewhere I have usually translated *terribile* by 'awesome' or 'sublime'. The *terribilità* of Michelangelo's style and subjects was recognized by many of his contemporaries. The implications of the word are discussed by Robert J. Clements in *Michelangelo's Theory of Art* (Routledge and Kegan Paul, 1963).

agents of the duke of Urbino, who alleged that he had received sixteen thousand crowns from Pope Julius to execute his tomb. This accusation was more than he could bear, and, indeed, he was determined that one day he would finish the tomb, even though he was already an old man. He was more than willing to stay in Rome for this purpose (now that without seeking it he had been given a pretext for not going back to Florence) because he went in great fear of Duke Alessandro de' Medici. Michelangelo was convinced that Alessandro was no friend of his; for one day when the duke had given him to understand through Alessandro Vitelli that he should select the best site for the castle and citadel of Florence, he had replied that he would only go there if he were ordered to do so by Pope Clement.

Eventually agreement was reached that the tomb should be finished in the following manner: the plan for a free-standing rectangular tomb was scrapped, and instead only one of the original façades was to be executed, in whatever way best suited Michelangelo, and he was to include six statues from his own hand. In this contract with the duke of Urbino, his excellency consented that Michelangelo should be at the disposal of Pope Clement for four months in the year, either at Florence or wherever the Pope wanted to employ him. However, although Michelangelo thought that he would get some peace at last, he was not to finish with the tomb so easily; for Pope Clement, anxious to see the final proof of his genius, made him devote his time to the cartoon for the Last Judgement. However, although he convinced the Pope that he was working on that, he also kept working in secret, as hard as he could, on the statues for the tomb.

Then in 1534 came the death of Pope Clement, and thereupon work ceased on the sacristy and library at Florence which had remained unfinished despite the effort that had gone into them. Michelangelo was now fully convinced that he would be free to give all his time to finishing the tomb of Julius II. But after Paul III had been elected, before no time at all he had Michelangelo summoned before him and after paying him compliments and making him various offers tried to persuade him to enter his service and remain near him.

Michelangelo refused, saying that he was bound under contract to the duke of Urbino until the tomb of Julius was finished. Then the Pope grew angry and said:

'I have nursed this ambition for thirty years, and now that I'm Pope am I not to have it satisfied? I shall tear the contract up. I'm determined to have you in my service, no matter what.'

When he saw the Pope's determination, Michelangelo was tempted to leave Rome and somehow or other find a way to finish the tomb. All the same, being a prudent man and fearing the power of the Pope, he resolved to say things to please him and spin matters out (seeing the Pope was an old man) until circumstances changed. Meanwhile, the Pope was anxious to have some notable work from Michelangelo's hands, and one day, accompanied by ten cardinals, he sought him out at his home. When he arrived his holiness asked to see all the statues intended for the tomb of Julius, and he thought they were all marvellous, especially the Moses which, according to the cardinal of Mantua, was by itself enough to do honour to Pope Julius. Having seen the drawings and cartoons that Michelangelo was preparing for the chapel walls, which he thought stupendous, the Pope again begged him with great insistence to enter his service, promising that he would persuade the duke of Urbino to content himself with three statues and to have the others made from Michelangelo's models by other competent artists. This was then arranged by means of his holiness with the duke's agents, a fresh contract being drawn up and confirmed by the duke. Michelangelo freely committed himself to paying for the other three statues and having the tomb erected, and for this purpose he deposited 1,580 ducats with the Strozzi bank. He need not have taken this step; and certainly he now considered that he had done enough to free himself of that tedious and worrisome project. And then he had the tomb erected in San Pietro in Vincoli, as follows:

At the foot, he placed an ornamental base with four projections accommodating four terminal figures in place of the four Captives which were planned originally. Since this substitution impoverished the lower storey, he placed at the foot

of each of the figures a reversed console resting on a pedestal. Between the four terminals there were three niches, two of which (at the sides) were circular and were to have contained the Victories. Instead of the Victories, however, in one of the niches he placed a figure of Leah, the daughter of Laban, to represent the Active Life: in one hand she held a looking-glass, to signify the deliberation with which we should conduct our affairs, and in the other a garland of flowers, signifying the talents that adorn our life on earth and glorify it after death. In the other niche he placed a figure of Leah's sister, Rachel, representing the Contemplative Life: with her hands clasped and one knee slightly bent, she wears an expression of rapture on her face. Michelangelo executed these statues himself, in less than a year. In the centre, in the original plan, there was to have been one of the doors leading into the little oval temple containing the quadrangular sarcophagus; instead, there was a rectangular niche, containing a marble dado which supported the gigantic and wonderfully beautiful statue of Moses, of which enough has already been said. Over the heads of the terminal figures, which act as capitals, are the architrave, the frieze, and the cornice, projecting over the terminals and richly carved with foliage, ovolo mouldings, and dentils, and matched by other rich ornamentation. Then above the cornice is the upper storey of the façade, with four other kinds of terminal figures placed perpendicularly over those of the lower storey and taking the form of unadorned pilasters surmounted by differently moulded cornices. This part of the façade corresponds in its various details with the lower storey, and thus Michelangelo made an opening (to match the niche containing the statue of Moses) in which, resting on the projections of the lower cornice, was placed a marble sarcophagus bearing the recumbent statue of Pope Julius II, which was executed by the sculptor Tommaso Boscoli. In the niche beyond the figure of Julius is a statue of Our Lady holding the child in her arms, executed from Michelangelo's model by the sculptor Scherano da Settignano. Both these figures are tolerably good. In the other two rectangular niches (over the statues of the Contemplative Life and the Active Life) are respectively a sybil and a prophet, both seated, which were

made by Raffaello da Montelupo, as is described in the *Life* of his father, Baccio; but these were little to Michelangelo's liking. At the summit, the façade was given another kind of cornice, projecting like the cornice of the lower storey over the front of the work. Resting on this, over the terminal figures, were marble candelabra; and in the middle, above the prophet and the sybil, was the coat-of-arms of Pope Julius. Then in the spaces of the niches windows were built for the convenience of the friars who served the church so that, as the choir was placed behind the tomb, their voices could be heard and they could see divine service being celebrated. Altogether the tomb succeeded very well, although it was not as impressive as planned originally.

Since he could hardly do otherwise, Michelangelo resolved to enter the service of Pope Paul, who wanted him to continue with the work commissioned by Pope Clement without changing anything in the inventions and general conception of what had been decided, such was the Pope's respect for his great talents. Indeed, Pope Paul felt for Michelangelo such reverence and love that he always went out of his way to please him. For example, his holiness wanted to have his own coat-of-arms painted under the Jonah in the chapel, in place of the arms of Pope Julius; but when this suggestion was put to Michelangelo, not wanting to make changes that would do wrong to Pope Julius and Pope Clement, he would not agree, saying that his coat-of-arms would not look well there. And his holiness, to avoid offending him, accepted his decision. To be sure, the Pope fully appreciated Michelangelo's excellence and realized that he always did what was just and honourable, without any adulation or respect of persons: something which rulers rarely come across.

For the wall of the chapel, overhanging about a foot from the summit, Michelangelo then had carefully built a projection of bricks, which had been especially chosen and baked, to prevent any dust or dirt from settling on the painting. I shall not dwell on the details of the inventions and composition of the Last Judgement, since so many copies of all sizes have been printed that there is no call to waste time describing it. It is enough for us to understand that this extraordinary man

chose always to refuse to paint anything save the human body in its most beautifully proportioned and perfect forms and in the greatest variety of attitudes, and thereby to express the wide range of the soul's emotions and joys. He was content to prove himself in the field in which he was superior to all his fellow craftsmen, painting his nudes in the grand manner and displaying his great understanding of the problems of design. Thus he has demonstrated how painting can achieve facility in its chief province: namely, the reproduction of the human form. And concentrating on this subject he left to one side the charm of colouring and the caprices and novel fantasies of certain minute and delicate refinements that many other artists, and not without reason, have not entirely neglected. For some artists, lacking Michelangelo's profound knowledge of design, have tried by using a variety of tints and shades of colour, by including in their work various novel and bizarre inventions (in brief, by following the other method of painting) to win themselves a place among the most distinguished masters. But Michelangelo, standing always firmly rooted in his profound understanding of the art, has shown those who can understand how they should achieve perfection.

To return to the Last Judgement: Michelangelo had already finished more than three-fourths of the work when Pope Paul went to see it. On this occasion Biagio da Cesena, the master of ceremonies and a very high-minded person, happened to be with the Pope in the chapel and was asked what he thought of the painting. He answered that it was most disgraceful that in so sacred a place there should have been depicted all those nude figures, exposing themselves so shamefully, and that it was no work for a papal chapel but rather for the public baths and taverns. Angered by this comment, Michelangelo determined he would have his revenge; and as soon as Biagio had left he drew his portrait from memory in the figure of Minos, shown with a great serpent curled round his legs, among a heap of devils in hell; nor for all his pleading with the Pope and Michelangelo could Biagio have the figure removed, and it was left, to record the incident, as it is today.

It then happened that Michelangelo fell no small distance

from the scaffolding in the chapel and hurt his leg; and in his pain and anger he refused to be treated by anyone. Now at this time there lived a certain Florentine called Baccio Rontini, a friend and admirer of Michelangelo's and an ingenious physician. Feeling sorry for Michelangelo, one day he went along to see him at home; when he received no answer to his knocking, either from Michelangelo or the neighbours, he made his way up by a secret way from room to room until he found Buonarroti, who was in a desperate condition. And then Baccio refused to go away or leave his side until he was better. After he was cured, Michelangelo returned to the chapel and worked continuously until everything was finished. And the paintings he did were imbued with such force that he justified the words of Dante: 'Dead are the dead, the living truly live . . .'.[1] We are shown the misery of the damned and the joy of the blessed.

When the Last Judgement was revealed it was seen that Michelangelo had not only excelled the masters who had worked there previously but had also striven to excel even the vaulting that he had made so famous; for the Last Judgement was finer by far, and in it Michelangelo outstripped himself. He imagined to himself all the terror of those days and he represented, for the greater punishment of those who have not lived well, the entire Passion of Jesus Christ, depicting in the air various naked figures carrying the cross, the column, the lance, the sponge, the nails, and the crown of thorns. These were shown in diverse attitudes and were perfectly executed with consummate facility. We see the seated figure of Christ turning towards the damned his stern and terrible countenance in order to curse them; and in great fear Our Lady draws her mantle around her as she hears and sees such tremendous desolation. In a circle around the figure of Christ are innumerable prophets and apostles; and most remarkable are the figures of Adam and St Peter, included, it is believed, as being respectively the original parent of the human race that is now brought to Judgement and the first foundation of the Christian Church. At the feet of Christ is a most beautiful St Bartholomew, who is displaying his flayed skin. We see

1. *Morti li morti, e i vivi paren vivi*. Purgatory xii, 67.

also the nude figure of St Lawrence, and in addition an end-less number of male and female saints and other figures of men and women around Christ, near or distant, who embrace each other and rejoice, because they have won everlasting beatitude by the grace of God and as a reward for their good deeds. Beneath the feet of Christ are the Seven Angels with the Seven Trumpets as described by St John the Evangelist; as they sound the call to Judgement they cause the hair of those who are looking at them to stand on end at the terrible wrath of their countenances. Among the rest are two angels with the Book of Life in their hands; and near them on one side, depicted with perfect judgement, may be seen the seven mortal sins in the form of devils, assailing and striving to drag down to hell the souls that are flying towards heaven, all striking the most beautiful attitudes and wonderfully fore-shortened. Nor did Michelangelo hesitate to show to the world, in the resurrection of the dead, how they take to themselves once more bones and flesh from the same earth and how, with the help of others already alive, they go soaring towards heaven, where again they are assisted by the souls of those already blessed; and all this was painted with the appropriate judgement and consideration. Throughout the painting may be seen exercises and studies of various kinds, the perfection of which is clearly illustrated by a notable detail showing the bark of Charon. In an attitude of frenzy, Charon is striking with his oar the souls being dragged into his bark by the demons. Here, Michelangelo was following the description given by his favourite poet, Dante, when he wrote:

> Charon, his eyes red like a burning brand,
> Thumps with his oar the lingerers that delay,
> And rounds them up, and beckons with his hand.[1]

Michelangelo painted the heads of his demons with such marvellous force and variety that they are truly like monsters out of hell. And in the figures of the damned we can see the presence of sin and the fear of eternal punishment. Apart from the beauty of its every detail, it is extraordinary to see how this painting produces in its finished state an impression of

1. Canto III, *Inferno* (Sayers's translation).

such harmony that it seems to have been executed all in one day, and even so with a finish unrivalled by any miniature. To be sure, the awesomeness and grandeur of this painting, with its vast host of figures, are so overwhelming that it defies description; for in it may be seen marvellously portrayed all the emotions that mankind can experience. The discerning eye can easily distinguish the proud and the envious, the avaricious, the lustful, and other sinners of various kinds; for in this painting Michelangelo observed all the rules of decorum, and gave his figures the appropriate expressions, attitudes, and settings. This was a great and wonderful achievement; but it was all the same well within his powers, because he was always shrewd and observant and he had seen a lot of mankind, and thus he had acquired by contact with the day-to-day world the understanding that philosophers obtain from books and speculation. To any discerning critic the Last Judgement demonstrates the sublime force of art and Michelangelo's figures reveal thoughts and emotions that only he has known how to express. Moreover, anyone in a position to judge will also be struck by the amazing diversity of the figures which is reflected in the various and unusual gestures of the young and old, the men and the women. All these details bear witness to the sublime power of Michelangelo's art, in which skill was combined with a natural inborn grace. Michelangelo's figures stir the emotions even of people who know nothing about painting, let alone those who understand. The foreshortenings that appear to be in actual relief; the way he blended his colours to produce a mellow softness and grace; and the delicate finish he gave to every detail: these serve to show the kind of picture that a good and true artist should paint. In the contours of the forms turned in a manner no other artists could have rivalled Michelangelo showed the world the true Judgement and the true Damnation and Resurrection.

The Last Judgement must be recognized as the great exemplar of the grand manner of painting, directly inspired by God and enabling mankind to see the fateful results when an artist of sublime intellect infused with divine grace and knowledge appears on earth. Behind this work, bound in

chains, follow all those who believe they have mastered the art of painting; the strokes with which Michelangelo outlined his figures make every intelligent and sensitive artist wonder and tremble, no matter how strong a draughtsman he may be. When other artists study the fruits of Michelangelo's labours, they are thrown into confusion by the mere thought of what manner of things all other pictures, past or future, would look like if placed side by side with this masterpiece. How fortunate they are, and what happy memories they have stored up, who have seen this truly stupendous marvel of our times! And we can count Pope Paul III as doubly fortunate and happy, seeing that, by allowing this work to come into existence under his protection, God ensured future renown for his holiness and for Michelangelo. How greatly are the merits of the Pope enhanced by the genius of the artist! The birth of Michelangelo was indeed a stroke of fortune for all artists of the present age, for his work as a painter, a sculptor, and an architect has with its brilliance illuminated every problem and difficulty.

Michelangelo laboured for eight years on the Last Judgement, and he threw it open to view, I believe, on Christmas Day in the year 1541, to the wonder and astonishment of the whole of Rome, or rather the whole world. That year, I went to Rome myself, travelling from Venice, in order to see it; and I along with the rest was stupefied by what I saw.

As I described in the *Life* of Antonio da Sangallo, Pope Paul had caused a chapel called the Pauline to be built on the same floor, in imitation of that of Nicholas V; and for this he decided that Michelangelo should paint two large pictures containing two great scenes. In one of the pictures, therefore, Michelangelo painted the Conversion of St Paul, with Jesus Christ above and a multitude of nude angels making the most graceful movements, while below, dazed and terrified, Paul has fallen from his horse to the ground. His soldiers are about him, some trying to lift him to his feet, others dazed by the splendour and the voice of Christ shown with panic-stricken movements and striking the most beautiful and varied attitudes as they take to flight. The horse as it runs off is shown carrying along in its headlong course the man who is trying

to restrain it. And all this scene is composed with extraordinary skill and draughtsmanship. The other scene contains the Crucifixion of St Peter, who is depicted in a figure of rare beauty fastened naked upon the cross, while those who are crucifying him, having made a hole in the ground, are straining to raise the cross on high, so as to crucify him with his feet in the air. Here, too, there are many remarkable judicious and beautiful details. As has been said elsewhere, Michelangelo concentrated his energies on achieving absolute perfection in what he could do best, so there are no landscapes to be seen in these scenes, nor any trees, buildings, or other embellishments and variations; for he never spent time on such things, lest perhaps he should degrade his genius. These scenes, which he painted at the age of seventy-five, were the last pictures he did; and they cost him a great deal of effort, because painting, especially in fresco, is no work for men who have passed a certain age.

Michelangelo arranged that Perin del Vaga, an accomplished painter, should decorate the vaulting with stucco and various paintings, following his own designs, and this was also the wish of Pope Paul III; but the work was afterwards delayed and nothing more was done (so many projects are left unfinished, partly because of irresolution on the part of artists and partly because of the failure of their patrons to urge them on).

Pope Paul had made a start with fortifying the Borgo and he then summoned many gentlemen, along with Antonio da Sangallo, to a conference; he wanted Michelangelo to take part as well, since he knew that it was he who had planned the fortifications around the hill of San Miniato. After considerable discussion, therefore, Michelangelo was asked to say what his opinion was, and he spoke his mind freely, although he disagreed both with Sangallo and with many of the others. Whereupon, Sangallo told him that his profession was sculpture and painting, and not fortification. Michelangelo replied that of those he knew only little, but as for fortification, given the amount of thought he had devoted to it and the practical experience he had had, he considered he knew more than Sangallo or any of his family. Then he demonstrated to

him, in the presence of all the others, that he had made many errors; and as the arguments flew back and forth the Pope had to call for silence. Not long after this meeting, Michelangelo brought the Pope a plan for all the fortifications of the Borgo, which formed the basis of everything that was subsequently decided and put into effect. This was why the great gate of Santo Spirito, which was approaching completion under Sangallo's supervision, remained unfinished.

The spirit and genius of Michelangelo could not remain idle; and so, since he was unable to paint, he set to work on a piece of marble, intending to carve four figures in the round and larger than life-size (including a dead Christ) to amuse and occupy himself and also, as he used to say himself, because using the hammer kept his body healthy. This Christ, taken down from the cross, is supported by Our Lady, by Nicodemus (planted firmly on his feet as he bends down and assists her) and by one of the Marys who also gives her help on perceiving the failing strength of his mother, whose grief makes the burden intolerable. Nowhere else can one see a dead form to compare with this figure of Christ; he is shown sinking down with his limbs hanging limp and he lies in an attitude altogether different not only from that of any other of Michelangelo's figures but from that of any other figure ever made. This work, the fruit of intense labour, was a rare achievement in a single stone and truly inspired; but, as will be told later on, it remained unfinished and suffered many misfortunes, although Michelangelo had intended it to go at the foot of the altar where he hoped to place his own tomb.

It happened that in 1546 Antonio da Sangallo died; and since there was now no one supervising the building of St Peter's various suggestions were made by the superintendents to the Pope as to who should take over. At length (inspired I feel sure by God) his holiness resolved to send for Michelangelo; but when he was asked to take Sangallo's place Michelangelo refused, saying, to excuse himself, that architecture was not his vocation. In the end, entreaties being of no avail, the Pope commanded him to accept. So to his intense dismay and completely against his will Michelangelo was compelled to embark on this enterprise. Then one day or

other he made his way to St Peter's to have a look at the model in wood that Sangallo had made and to study the building itself. When he arrived he found there all the Sangallo faction who, crowding before him, said as agreeably as they could that they were delighted that he had been given responsibility for the building, and that Sangallo's model was certainly like a meadow where there would never be any lack of pasture.

'That's only too true,' observed Michelangelo; and by this (as he told a friend) he meant to imply that it provided pasture for dumb oxen and silly sheep who knew nothing about art. And afterwards he used to say openly that Sangallo's model was deficient in lights, that on the exterior Sangallo had made too many rows of columns one above another, and that with all its projections, spires, and subdivisions of members it derived more from the German manner than from either the sound method of the ancient world or the graceful and lovely style followed by modern artists. As well as this, he would add, fifty years of time and over three hundred thousand crowns of money could be saved on the building, which could also be executed with more majesty, grandeur, and facility, better ordered design, and greater beauty and convenience. Subsequently, Michelangelo convincingly demonstrated the truth of his words with a model he made himself, and which showed the building completed on the lines we can see today. This model cost him twenty-five crowns and it was made in a fortnight. In contrast, Sangallo's (as I said earlier) cost four thousand and took many years. And from these and various other circumstances it became evident that the building had been turned into a shop organized for making money on behalf of those who were trying to monopolize the work, which they were dragging out indefinitely. These methods were more than repugnant to a man of Michelangelo's rectitude; and, in order to get rid of the culprits, when the Pope was pressing him to accept the position of chief architect he said to them openly one day that they should enlist the help of their friends and do everything in their power to prevent his being put in charge. For if he were, he went on, he would refuse to allow any of them to enter the

building. These words, spoken in public, were taken very badly, as may well be imagined; and they explain why they conceived for Michelangelo a bitter hatred which grew daily more intense (as they saw him change all the plans, inside and out) till they could scarcely bear to let him live. Every day, as will be described, they thought up various new ways to torment him.

Finally, the Pope issued a *motu proprio* putting Michelangelo in charge of the building, with full authority, and giving him power to do or undo whatever he chose, and to add, remove, or vary anything just as he wished; the Pope also commanded that all the officials employed there should take their orders from him.[1] Then Michelangelo, seeing the great trust and confidence that the Pope reposed in him, wanted to demonstrate his own good will by having it declared in the papal decree that he was devoting his time to the fabric for the love of God, and without any other reward. (It is true that the Pope had previously granted him the toll for the river-crossing at Piacenza, which yielded about six hundred crowns; but he lost it when Pier Luigi died and was given instead a chancellery at Rimini, which was worth less and meant little to him. And though the Pope several times sent him money by way of a salary he would never take it; and the truth of this is witnessed by Alessendro Ruffini, who was then chamberlain to the Pope, and Pier Giovanni Aliotto, bishop of Forlì.)

The Pope eventually gave his approval to the model Michelangelo had made. This diminished the size of St Peter's but increased its grandeur in a manner which pleases all those able to judge, although there are some who claim to be experts (without justification) and who do not approve. Michelangelo found that four principal piers, made by Bramante and retained by Antonio da Sangallo, which were to help support the weight of the cupola, were weak; so he partly filled them in, making on each side two spiral stairways up which the beasts of burden can climb with the materials, as can men on horseback, to the uppermost level of the arches.

1. Michelangelo's appointment as Chief Architect to St Peter's was confirmed in January 1547. He remained responsible for this tremendous undertaking until his death.

He made the first cornice above the travertine arches; this curves round gracefully and is a marvellous and distinctive piece of work, better than anything else of its kind. He also began the two great hemicycles of the crossing, and whereas previously, under the direction of Bramante, Baldassare Peruzzi, and Raphael, as was said, eight tabernacles were being built on the side of the church facing the Campo Santo (and the same plan was followed by Sangallo) Michelangelo reduced the number to three, with three chapels behind them. Above these he placed a travertine vault and a range of windows alive with light, of varied form and sublime grandeur. However, as these things are in existence and can also be studied in engravings (Sangallo's as well as those of Michelangelo) there is no need to describe them. It is enough to record that Michelangelo as diligently as he could had the work pressed forward in those parts of the building where the design was to be changed, so that it would be impossible for anyone else to make further alterations. This was a shrewd and prudent precaution, for it is pointless doing good work without providing for what may happen later: the rash presumption of those who might be supposed to know something (if words were to be trusted more than deeds) can easily, with approval of the ignorant, have disastrous results.

The people of Rome, with the consent of Pope Paul, were anxious to give some useful, commodious, and beautiful form to the Capitol, and in order to embellish the district, to furnish it with colonnades, with ascents, with inclined approaches with and without steps, and also with the ancient and beautiful statues that were already there. For this purpose they sought advice from Michelangelo, who made for them a very rich and beautiful design in which on the side of the Senators' Palace (on the east) he arranged a façade of travertine and a flight of steps ascending from the two sides to meet on a level space giving access to the centre of the palace hall, with ornate curving wings adorned with balusters serving as supports and parapets. Then to improve the effect he mounted on pedestals in front of the steps the two ancient marble figures of recumbent river gods, one representing the Tiber and the other the

Nile. (Between these two rare statues, each eighteen feet long, it is intended to have a niche containing a statue of Jupiter.) On the southern side, to bring the Conservators' Palace into line he designed for it a richly adorned façade, with a portico at the foot filled with columns and niches for many ancient statues; and all around are various adornments of doors and windows, some of which are already in place. Then on the opposite side, towards the north, below the Araceli, there is to be another similar façade; and in front of this, on the west, is to be an almost level ascent of shallow steps with a balustrade. And here will be the principal entrance to the piazza with a colonnade and various bases on which will be placed the collection of ancient statues with which the Capitol is now so richly furnished. In the middle of the piazza, on an oval base, has been erected the famous bronze horse bearing the figure of Marcus Aurelius, which Pope Paul had removed from the Piazza di Laterano, where it had been put by Sixtus IV. Today work on this whole enterprise is yielding such beautiful results that it is worthy of being numbered among Michelangelo's finest achievements; and under the supervision of Tommaso de' Cavalieri (a Roman gentleman, one of the greatest friends Michelangelo ever had) it is now being brought to completion.

Pope Paul III had told Sangallo, while he was alive, to carry forward the palace of the Farnese family, but the great upper cornice, completing the outer edge of the roof, had still to be constructed, and his holiness wanted Michelangelo to undertake this and to use his own designs. Unable to refuse the Pope, who so greatly esteemed and favoured him, Michelangelo made a full-scale wood model, twelve feet long, and he caused this to be placed on one of the corners of the palace to show the effect of the finished work. His holiness and everyone else in Rome being pleased by the result, the part which can be seen now was carried to completion, producing the most beautiful and varied cornice that has ever been known in ancient or modern times. Consequently, after Sangallo died, the Pope wanted Michelangelo to take charge of the whole building as well; and so Michelangelo made the great marble window with the beautiful columns of variegated

stone which is above the principal door of the palace, surmounted by a large marble coat-of-arms, of great beauty and originality, belonging to Pope Paul III, the founder of the palace. Within the palace over the first storey of the courtyard Michelangelo continued the two other storeys, with their incomparably beautiful, graceful, and varied windows, ornamentation and crowning cornice. Hence, through the labours and genius of that man, the courtyard has been transformed into the most beautiful in all Europe. He widened and enlarged the great hall and reconstructed the front corridor, making the vaulting with a new and ingenious kind of arch in the form of a half oval. Then that same year at the Baths of Antoninus was discovered a block of marble, measuring fourteen feet in every direction, in which there had been carved by the ancients a figure of Hercules standing on a mound and holding the bull by its horns, with another figure helping him, and with a surrounding group of shepherds, nymphs, and animals: a work of truly exceptional beauty, which was believed to have been meant for a fountain. Michelangelo advised that it should be taken to the second courtyard of the Farnese Palace and there restored to spout water as it did originally. This was agreed, and the work is still being carried on today with great diligence, by order of the Farnese family. At the same time Michelangelo made designs for a bridge crossing the Tiber in a straight line with the palace, so that it would be possible to go direct to another palace and gardens that they owned in the Trastevere, and also from the principal door facing the Campo di Fiore to be able to see at a glance the courtyard, the fountain, the Strada Julia, the bridge, and the beauties of the other garden, all in a straight line as far as the other door opening on to the Strada di Trastevere. This was a marvellous undertaking which was worthy of that pontiff and of Michelangelo's talent, judgement, and powers of design.

Fra Sebastiano, Keeper of the Papal Seal, died in 1547; and at that time Pope Paul proposed that the ancient statues of his palace should be restored. Michelangelo was happy to favour the Milanese sculptor Guglielmo della Porta, whom Sebas-

tiano had recommended to him as a young man of promise; and liking his work he presented him to Pope Paul for the restoration of the statues. Things went so well that Michelangelo obtained for him the office of Keeper of the Seal, and then a start was made on the statues, some of which can be seen in the palace today. However, forgetting the benefits he had received from Michelangelo, Guglielmo later became one of his enemies.

In 1549 there took place the death of Paul III, whereupon after the election of Pope Julius III Cardinal Farnese commissioned a great tomb to be made for Pope Paul (his kinsman) by Fra Guglielmo, who arranged to erect it in St Peter's, under the first arch of the new church, beneath the tribune. This meant, however, that it would obstruct the floor of the church, and the position chosen was in fact quite wrong. So Michelangelo gave the sensible advice that it could not and should not stand there. Fra Guglielmo, thinking this was done out of envy, became filled with hatred against him. Later on, however, he came to realize that Michelangelo had spoken the truth and that he himself had been at fault because he had been given the opportunity to carry the work through and had not done so. I can testify to this myself, for in 1550 I had been ordered by Pope Julius III to go to Rome to serve him (and I went very willingly, because of my love for Michelangelo), and I took part in the discussion. Michelangelo wanted the tomb to be erected in one of the niches where the Column of the Possessed is today, which was the proper place; and I had so worked to arrange matters that Pope Julius was resolving to have his own tomb made in the other niche, with the same design as Pope Paul's, in order to balance it. But Fra Guglielmo, who opposed this scheme, brought it about that the Pope's own tomb was in the end never finished nor was that of the other pontiff; and all this was predicted by Michelangelo.

That same year Pope Julius made up his mind to have a marble chapel constructed in the church of San Pietro in Montorio with tombs for his uncle Cardinal Antonio de' Monte and for his grandfather, Fabriano, who was the founder of the greatness of his illustrious family. The designs and

models for these were made by Vasari; and then Pope Julius, who always admired Michelangelo's genius and who loved Vasari, wanted Michelangelo to settle what the price should be. For his part, Vasari begged the Pope to persuade Michelangelo to take the work under his general supervision. Now Vasari had proposed that Simone Mosca should do the carvings for this work and Raffaello da Montelupo the statues. However, Michelangelo advised against having any carved foliage, even on the architectural parts, saying that where there were marble figures nothing else was needed. Because of this Vasari feared that the finished work would be impoverished; but subsequently, when he did see it completed, he had to admit that Michelangelo had shown no little judgement. Then Michelangelo refused to let Montelupo make the statues, because he had seen how badly he had acquitted himself in those he himself had designed for the tomb of Pope Julius II. He was far happier that they should be allocated to Bartolommeo Ammanati (whom Vasari had recommended) even though he himself was at odds both with Ammanati and with Nanni di Baccio Bigio. This, as a matter of fact, had been caused by a trivial incident: for when they were boys, prompted by their love of sculpture rather than by any wish to offend him, they had gone into Michelangelo's house and stealthily filched from his servant Antonio Mini many of Michelangelo's drawings; subsequently, through the intervention of the magistrates, these were returned, and Michelangelo himself with the help of Giovanni Norchiati, canon of San Lorenzo, had saved them from any further punishment.

Discussing this escapade with Michelangelo, Vasari told him laughingly that he did not think they deserved any blame, and that if he had had the chance himself he would not merely have taken a few drawings but would have stolen everything of his that he could lay hands on in order to learn the art. One should encourage and reward those who try to improve themselves, Vasari added, and not treat them as if they had stolen someone's money or other important belongings. In this way the whole affair was turned into a joke.

So a start was made on the work for San Pietro in Montorio, and that same year Vasari and Ammanati went to bring the marbles from Carrara to Rome. Now at that time Vasari used to visit Michelangelo every day; and one morning (it being Holy Year) the Pope graciously gave them a dispensation to visit the seven churches on horseback and gain the indulgence together. While they were going from one church to another they discussed the arts very eagerly and fruitfully, and from their stimulating conversation Vasari composed a dialogue which will be published (with other material on art) at a favourable opportunity.[1]

That year also Pope Julius confirmed the decree issued by Pope Paul III regarding the building of St Peter's; and although members of the Sangallo clique spoke evil of Michelangelo they found the Pope unwilling to listen to a word of it. For Vasari had convinced his holiness that in fact Michelangelo had succeeded in breathing life into the building and he persuaded him to plan nothing without asking Michelangelo's advice. The Pope kept to this promise, for neither at the Villa Giulia did he do anything without finding out Michelangelo's opinion, nor in the Belvedere, when they made the existing stairway in place of the original built earlier by Bramante. (Bramante's stairway, for the principal niche in the centre of the Belvedere, consisted in two half circles with eight steps in each, a convex followed by a concave flight.) Michelangelo designed and had erected the very beautiful quadrangular staircase, with balusters of peperino-stone, which is there now.

Vasari had that year seen completed in Florence the printing of his biographies of the painters, sculptors, and architects. He had not written the biography of any living master (although there were several old artists who were still alive) with the exception of Michelangelo. And so he presented the work to Michelangelo, who received it with great pleasure. In it, in fact, were details of many things that Vasari had heard from Michelangelo's own lips, he being the oldest and wisest of all the craftsmen. Then not long after, having read the work, Michelangelo sent Vasari the following sonnet which

1. This 'dialogue' is lost.

he wrote himself and which I am happy to include here in
memory of his loving kindness:

> With pencil and with palette hitherto
> You made your art high Nature's paragon;
> Nay more, from nature her own prize you won,
> Making what she made fair more fair to view.
> Now that your learnéd hand with labour new
> Of pen and ink a worthier work hath done,
> What erst you lacked, what still remained her own,
> The power of giving life, is gained for you.
> If men in any age with Nature vied
> In beauteous workmanship, they had to yield
> When to the fated end years brought their name.
> You, re-illuming memories that died,
> In spite of Time and Nature have revealed
> For them and for yourself eternal fame.[1]

When Vasari left for Florence, he asked Michelangelo to
prepare the work for San Pietro in Montorio. However, he
also told his great friend Bindo Altoviti, who was then the
consul for the Florentine colony at Rome, that it would be
better to have the tombs erected in the church of San Gio-
vanni de' Fiorentini, that he had already suggested this to
Michelangelo, who was in favour, and that this would be a
good opportunity for completing the church. Bindo liked
the suggestion, and being very intimate with the Pope he
urged him strongly to have the chapel and tombs that his
holiness was having made for Montorio put up in San Gio-
vanni de' Fiorentini instead, adding that this would give the
Florentines in Rome the opportunity and incentive to meet
the expense of having their church completed. If his holiness
would build the principal chapel, he said, the merchants would
then build six more and gradually have all the work carried
out. Because of this the Pope changed his mind, although the
model had been made and the price agreed; and he went to
Montorio and sent for Michelangelo. Vasari, meanwhile, was
writing every day to Michelangelo, who sent him news of
what was happening. So on 1 August 1550 Michelangelo

1. This translation of the sonnet *'Se con lo stile e co' colori avete'* is by John
Addington Symonds.

wrote telling Vasari of the Pope's change of plan, and this is what he said:

My dear Giorgio,

Concerning the new foundations for San Pietro in Montorio, as the Pope did not want to hear about them I did not write to you, knowing that you were already informed by your man here. Now I must tell you the following, namely that yesterday morning after he had gone to Montorio the Pope sent for me. I met him on the bridge when he was on his way back and had a long conversation with him about the tombs you were commissioned to do; and finally, he told me he had determined that he would have them built not on the hill but in the church of the Florentines instead. Then he asked me for my opinion and for a design, and I strongly encouraged him, thinking that in this way the church would be brought to completion. As for the three letters I have received from you, I myself cannot aspire to such heights; but if I were anxious to be in some degree what you say I am, it would be only so that you might have a worthy servant. However, seeing you are a man who brings the dead back to life, I am not at all astonished that you should prolong the life of the living, or rather that you should snatch from the hands of death and immortalize those who are scarcely alive. Such as I am, then, I am all yours. Michelangelo Buonarroti. Rome.

While these matters were being arranged and the Florentines living in Rome were trying to find the money that was needed several difficulties arose, nothing was settled, and enthusiasm began to cool. Meanwhile, Vasari and Ammanati excavated all the marbles at Carrara and they were sent to Rome; and Ammanati went with them, taking a letter to Buonarroti in which Vasari wrote that he should get the Pope to say where he wanted the tomb to go and that, when the order was given, he should prepare the foundation. As soon as Michelangelo received the letter he spoke to his holiness, and then he wrote to Vasari as follows:

My dear Giorgio,

As soon as Bartolommeo arrived here I went to have a word with the Pope; and when I saw that he wanted preparations made at Montorio for the tombs I looked for a mason from St Peter's. Busybody found this out and wanted to send someone to suit himself; and to avoid striving against a man who sets the winds in motion I stood

aside, seeing that I'm a lightweight and have no wish to be blown off my feet. Anyhow, I think we have to forget all about the church of the Florentines. Come back soon, and keep well. I have nothing more to say. 13 October 1550.

'Busybody' was Michelangelo's name for the bishop of Forlì, because he meddled in everything. As the Pope's head chamberlain he was in charge of the medals, jewels, cameos, small bronze figures, pictures, and drawings, and he wanted everything to depend on him. Michelangelo tried to keep out of his way, because he found the bishop's meddling always dangerous and feared lest his ambitions should land him in a spot of serious trouble. Anyhow, the Florentines lost an excellent opportunity of building their church and God knows if there will ever be another. This caused me great sorrow; but I thought I should briefly record what happened to show the way Michelangelo always tried to help his own people and friends, and the profession of architecture.

Vasari had scarcely returned to Rome, just before the beginning of 1551, when the Sangallo clique in a plot against Michelangelo persuaded the Pope to summon to a meeting in St Peter's all the builders and overseers, hoping to convince his holiness by slanderous accusations that Michelangelo had ruined the building. Now Michelangelo had built ready for vaulting the hemicycle of the king of France (where the three chapels are) with the three upper windows; but not knowing what was to be done with the vault, and relying on their own poor judgement, they had convinced the elder Cardinal Salviati and Marcello Cervini (who later became Pope) that St Peter's would be left poorly lit. So after they had all assembled the Pope told Michelangelo that the deputies alleged that the hemicycle would have little light.

Michelangelo said: 'I would like them to speak for themselves.'

Cardinal Marcello declared: 'Here we are.'

Then Michelangelo said to him: 'My lord, above these windows in the vault, which will be made of travertine, are to go three more.'

'But you never told us that,' the cardinal remarked.

And then Michelangelo announced: 'I'm not and I don't

intend to be obliged to discuss with your Eminence or any-one else what I ought or intend to do. Your duty is to collect the money and guard it against thieves, and you must leave the task of designing the building to me.'

Then he turned to the Pope and added: 'Holy Father, you know what my earnings are from this enterprise, and you know that unless my labours bring me spiritual satisfaction I am wasting all my time and work.'

The Pope, who loved him, put his hand on Michelangelo's shoulder and said:

'Both your soul and your body will profit, never fear.'

After he was rid of the others the Pope's love for Michel-angelo grew almost boundless; and the following day he ordered him and Vasari to go to the Villa Giulia, where they had many discussions together, which brought that work al-most to its present beauty; nor was any aspect of the design planned or carried out without Michelangelo's advice and judgement. The Pope once insisted (this was on one of the many occasions when Michelangelo went to see him with Vasari, and this time they found him in the company of twelve cardinals, by the fountain of the Acqua Vergine) the Pope insisted, I repeat, that Michelangelo should sit by his side, despite his humble resistance, for he always paid the greatest honour to his genius.

His holiness commissioned Michelangelo to make a model for the façade of a palace he wanted to build alongside San Rocco, with the idea of using the mausoleum of Augustus for the remainder of the walls. So Michelangelo produced a design of incomparable richness, variety, and originality, for in everything he did he was in no need of architectural rules, either ancient or modern, being an artist with the power to invent varied and original things as beautiful as those of the· past. This model now belongs to Duke Cosimo de' Medici, to whom, when he went to Rome, it was given by Pope Pius IV, and who keeps it among his most precious belongings.

The Pope held Michelangelo in such high regard that he constantly defended him against those cardinals and others who tried to slander him; and he always insisted that other artists, no matter how skilled or distinguished, should wait on

Michelangelo at his own house. His holiness held him in such respect and reverence that to avoid wearying him he refrained from asking for many things that Michelangelo, old as he was, would certainly have done.

When Paul III was living Michelangelo had on his orders made a start on rebuilding the bridge of Santa Maria, which had been weakened and ruined by time and the continuous flow of the water. He constructed caissons and started to repair and refound the piers, and he succeeded in completing a substantial part of the work, at no little cost in wood and travertine. Then during the reign of Julius III it was proposed at a meeting of papal administrators to finish the work, and it was suggested that the architect Nanni di Baccio Bigio would, by doing it under contract, save a great deal of time and money. They also claimed that it would be to Michelangelo's benefit to relieve him of the task, since he was old and uninterested in it, and that if nothing were done it would never be finished. The Pope was anxious to avoid any strife, and so not realizing what the outcome would be he authorized the clerks to do what they wanted, telling them to treat it as within their competence. Then, without telling Michelangelo, they handed the work over to Nanni, with an unrestricted contract and all the materials. But instead of doing what was necessary to make the foundations secure, Nanni even despoiled the bridge of a good number of the blocks of travertine with which many years before it had been strengthened and paved. He sold the travertine, which had increased the weight and solidity of the bridge, and substituted gravel and similar materials, so that the internal structure appeared sound. On the exterior he constructed parapets and various supports so that it seemed to be totally rebuilt. But, as the bridge had now been thoroughly weakened and debilitated, five years later in 1557 the impetus of the flood that happened that year caused such destruction that there was revealed for all to see the bad judgement of those clerks and the loss that Rome suffered through neglecting the advice of Michelangelo. For he predicted the destruction of the bridge many times to his friends and to me; and I remember his saying, when we were crossing it together on horseback:

'Giorgio, this bridge is shaking. Let's ride faster in case it crashes down while we're on it.'

To return to what we were discussing earlier: after the work at Montorio had been finished, to my great satisfaction, I returned to serve Duke Cosimo in Florence; this was in 1554. Both Michelangelo (whose adversaries tormented him continually in one way or another) and Vasari were grieved at their separation and they wrote to each other every day. In April of the same year Vasari sent Michelangelo the news that his nephew Lionardo had had a son and that in company with many noble ladies they had taken him to be baptized and had revived the name Buonarroto. Michelangelo replied with a letter to Vasari in these words:

My dear Giorgio,
Your letter gave me tremendous pleasure, seeing that you still remember this poor old man and even more because you were present at the triumph you describe, namely the birth of another Buonarroto. I send my heartfelt thanks for this news; however, I disapprove of such pomp, because men should not rejoice when the whole world is weeping. And I consider that Lionardo has no cause to celebrate a birth with the kind of rejoicing that should be reserved for the death of someone who has lived a good life. Now don't be surprised at my not replying immediately; it's just that I don't want to seem like a businessman. As for all the flattering remarks in your letter, I wish I deserved only one of them; and then I believe I could discharge a tiny part of my debt by giving myself to you body and soul. I am constantly aware that I owe you far more than I can repay. Seeing how old I am, I can never expect to square the account in this life but must wait for the next. So I beg you to be patient, and I remain yours. Things here go on as usual.[1]

During the reign of Paul III, Duke Cosimo had already sent Tribolo to Rome to see if he could persuade Michelangelo to return to Florence and finish the sacristy of San Lorenzo. But Michelangelo pleaded that having grown old he could no longer support the burden of the work, and he gave various excuses for not being able to leave Rome. Finally, Tribolo

1. The first complete edition in English of Michelangelo's letters (1506–1563) was published in 1963 (*The Letters of Michelangelo* translated by E. H. Ramsden, Peter Owen, London).

asked him about the stairway for the library of San Lorenzo, for which Michelangelo had caused many stones to be prepared although there was no model nor any certainty as to its exact form; there were some marks on a pavement and some rough designs in clay, but the true and final plans could not be found. However, despite all the entreaties made by Tribolo, who invoked the name of the duke, all Michelangelo would say was that he did not remember them.

Vasari was then instructed by Duke Cosimo to write to Michelangelo asking him to reply saying what final form the stairway should have, in the hope that because of his love and friendship for Vasari he would say something that might lead to a solution and to the completion of the work.

So Vasari wrote telling Michelangelo what the duke wanted and adding that he himelf would be given the task of executing what was still to be done, and that he would do this with the fidelity and care that, as Michelangelo knew, he was always accustomed to give to work for Michelangelo. So Michelangelo then sent the directions for making the stairway in a letter dated 28 September 1555.

Giorgio, my dear friend,

Concerning the stairway for the library that I've been asked about so much, believe me if I could remember how I planned it I would not need to be asked. A certain staircase comes to my mind just like a dream, but I don't think it can be the same as the one I had in mind originally since it seems so awkward. However, I'll describe it for you: first, it is as if you took a number of oval boxes, each about a span deep but not of the same length or width, and placed the largest down on the paving further from or nearer to the wall with the door, depending on the gradient wanted for the stairs. Then it is as if you placed another box on top of the first, smaller than the first and leaving all round enough space for the foot to ascend; and so on, diminishing and drawing back the steps towards the door, always with enough space to climb; and the last step should be the same size as the opening of the door. And this oval stairway should have two wings, one on either side, following the centre steps but straight instead of oval. The central flight from the beginning of the stairs to half-way up should be reserved for the master. The ends of the two wings should face the walls and, with the entire staircase, come about

three spans from the wall, leaving the lower part of each wall of the anteroom completely unobstructed. I am writing nonsense, but I know you will find something here to your purpose.

At that time Michelangelo also wrote to Vasari that Julius III being dead, and Marcellus elected Pope, the clique that was hostile to him had seized the chance to harass him again. And when the duke heard of this he was so displeased that he made Giorgio write and tell Michelangelo to leave Rome and come to live in Florence, where he wanted nothing from him except occasional advice and plans for his buildings, and where he would receive all he wanted without needing to do any work himself. The duke's private secretary, Leonardo Marinozzi, brought Michelangelo further letters from his Excellency and also from Vasari. But then Marcellus died, and when Michelangelo went to kiss the feet of the newly elected Paul IV he received countless offers; and being anxious to see the finish of St Peter's, to which he believed himself committed, he stayed where he was. Making his excuses, he wrote telling the duke that for the time being he was unable to serve him; he also sent the following letter to Vasari:

My dear Giorgio,
 As God is my witness, it was against my will that I was forced to start work on the construction of St Peter's by Pope Paul III ten years ago; and if work on the fabric had continued up to the present time in the way it started, then enough progress would have been made for me to agree to return home. But for lack of money the work has been continually delayed and it is now being held back just as the construction has reached the most exhausting and difficult part. So to abandon it at this stage would mean the shameful waste of all the labours I have undertaken for the love of God during these ten years. I am writing this speech in reply to your letter, and also because I have had a letter from the duke that has made me astonished that his lordship should condescend to address me so graciously. For this I am deeply grateful to him and to God. I am wandering from the subject because I have lost my memory and my wits, and as writing is not my profession I find it very irksome. In conclusion, to make you understand what would happen if I abandoned the building and left Rome: first, I would make many thieves happy, and I would be responsible for its ruin, and perhaps for closing it down for ever.

And then Michelangelo added in this letter to Giorgio, by way of excuse to the duke, that he had a house and other belongings in Rome, which were worth thousands of crowns, and as well as this like all old men he was in danger of his life because of a disease of the kidneys, colic, and the stone, as could be testified by Master Realdo, his doctor, to whom after God he was grateful for his life. So for all these reasons, he went on, he could not leave Rome; and, indeed, he had no heart for anything except death. In several other letters, now in Vasari's possession, Michelangelo asked him to beg the duke to forgive him, and he also, as I said, wrote to the duke directly. Certainly, had he been up to making the journey he would have set out for Florence without hesitating, and I am sure that he would never have wanted to go back to Rome, he was so moved by the kindness and affection shown him by the duke. Meanwhile, he continued working on various parts of St Peter's, with the object of making it impossible to change what was done.

During this time certain people had informed him that Pope Paul IV was minded to make him alter the façade of the chapel where the Last Judgement is painted since, as the Pope said, the figures there revealed their nakedness too shamelessly. When he heard this, Michelangelo commented: 'Tell the Pope that this is a trivial matter and can easily be arranged; let him set about putting the world to rights, for pictures are soon put right.'

The office of the chancery at Rimini was now taken away from Michelangelo, but he would not discuss this with the Pope, who in fact knew nothing about it. The decision was taken by the Pope's cupbearer, who wanted to have him paid for his work on St Peter's a monthly stipend of a hundred crowns instead; but when the first month's payment was brought to his house, Michelangelo refused to take it. The same year saw the death of Urbino, Michelangelo's servant, or rather, since this was what he had become, his companion. Urbino first came to live with Michelangelo in Florence in 1530, the year of the siege, after his pupil Antonio Mini had gone to France. He proved a devoted servant, and during the twenty-six years that he lived with him he was made a rich

man by Michelangelo. who had come to love him so much that, old as he was, when Urbino fell ill he looked after him, sleeping in his clothes at night in order to see to his wants. Vasari wrote to Michelangelo to comfort him after Urbino's death, and he had the following reply:

My dear Giorgio,

I cannot write easily, but I shall say something in answer to your letter. You know that Urbino is dead. I owe the greatest thanks to God, but my loss is heavy and my sorrow is boundless. I owe God many thanks, for while when he was alive Urbino showed me how to live and in his death he taught me how to die, not with grief but with desire. I kept him with me for twenty-six years, and I found him a rare and faithful friend; and now that I had made him rich and expected him to be the support and comfort of my old age, he has been taken from me; nor have I any hope left, save to see him in Paradise. God has given me a token of this through the happy death that Urbino made. Even more than dying it grieved him to leave me in this treacherous world with so many troubles, although the better part of me has gone with him. All I have left, indeed, is my infinite distress. I commend myself to you.

In the time of Paul IV Michelangelo was employed on many parts of the fortifications of Rome; in this connexion he also served Salvestro Peruzzi, whom, as said elsewhere, the Pope had commissioned to make the great gate of Castel Sant'Angelo, which is today half-ruined. Michelangelo busied himself with distributing the statues for that work, and examining and correcting the models of the sculptors. At that time the French army approached Rome, leading Michelangelo to fear that he would come to a violent end along with the city. Antonio Franzese of Casteldurante, whom Urbino had left to serve him after he died, determined to flee from Rome, and Michelangelo himself went secretly to the mountains of Spoleto, where he stayed in various hermitages. About then Vasari wrote to him, sending a little work which the Florentine citizen, Carlo Lenzoni, had left at his death to Cosimo Bartoli who was to have it printed and dedicated to Michelangelo. When he received the book from Vasari, Michelangelo wrote as follows:

My dear friend Giorgio,

I have received from you the little book by Cosimo and I am send-
ing with this an acknowledgement which I beg you to give to him
with my regards.

During the past few days, although it cost me a great deal of
effort and money, I have been happily visiting the hermits in the
mountains of Spoleto, and as a result I returned only half-heartedly to
Rome, for indeed peace is to be found only in those woods. I have no
more to tell you; I am glad you are well and happy, and I commend
myself to you. 18 September 1556.[1]

Michelangelo used to work every day, for recreation, on
the block of stone with four figures that we have already
mentioned; and at this time he broke it into pieces. He did this
either because it was hard and full of emery and the chisel
often struck sparks from it, or perhaps because his judgement
was so severe that he was never content with anything he did.
That this was the case can be proved by the fact that there are
few finished statues to be seen of all that he made in the prime
of his manhood, and that those he did finish completely were
executed when he was young, such as the Bacchus, the Pietà
in St Peter's, the giant David at Florence, and the Christ in
the Minerva. It would be impossible to add to these or take
away a single grain without ruining them. The others, with
the exception of Duke Giuliano and Duke Lorenzo, the
Night, the Dawn, the Moses, with the other two, which al-
together do not amount to eleven, the others, I say, and there
were many of them, were all left unfinished. For Michelangelo
used to say that if he had had to be satisfied with what he did,
then he would have sent out very few statues, or rather none
at all. This was because he had so developed his art and judge-
ment that when on revealing one of his figures he saw the
slightest error he would abandon it and run to start working
on another block, trusting that it would not happen again.
He would often say that this was why he had finished so few
statues or pictures. Anyhow, he gave the broken Pietà to
Francesco Bandini. At that time on the introduction of Fran-
cesco Bandini and Donato Giannotti, the Florentine sculptor,

1. In fact, the letter was dated 28 December.

Tiberio Calcagni, struck up a close friendship with Michelangelo. And then one day when he was at his house, after they had discussed things together for a long time, Tiberio asked Michelangelo why he had broken the Pietà (which was in the house) and had wasted all his marvellous efforts. Michelangelo answered that the reason for this was the importunity of his servant Urbino who had nagged him every day to finish it; and as well as this a piece had broken off from the arm of the Madonna. And these things, he said, as well as other mishaps including his finding a crack in the marble, had made him so hate the work that he had lost patience and broken it; and he would have smashed it completely had not his servant Antonio persuaded him to give it to someone just as it was. After he heard this, Tiberio spoke to Bandini, who was anxious to have something by Michelangelo, and Bandini then persuaded him to promise two hundred gold crowns to Antonio, if he would beg Michelangelo to allow Tiberio, using Michelangelo's models, to finish the statue for Bandini. This would mean that Michelangelo's labours would not have been thrown away, he said. Michelangelo was happy with this arrangement, and he gave the block to them as a gift. It was immediately carried off and subsequently put together by Tiberio who added God knows how many new pieces. All the same, it still stayed unfinished because of the death of Bandini, of Michelangelo, and of Tiberio. Today it is in the possession of Francesco's son, Pierantonio Bandini, in his villa at Montecavallo.

To return to Michelangelo: it was now necessary for him to find another block of marble, so that he could continue using his chisel every day; so he found a far smaller block containing a Pietà already roughed out and of a very different arrangement.

Meanwhile, there had entered into the service of Paul IV the architect Pirro Ligorio, who was also concerned with the building of St Peter's. Michelangelo was being harassed once aga' and they were going about every day saying that he was in his second childhood. Angered by all this, he would willingly have returned to Florence, and when he delayed he was again pressed to do so by Giorgio Vasari in his letters to him. But Michelangelo knew that he was too old, for he had

now reached the age of eighty-one. So when at that time he
wrote to Vasari by his courier, sending him various religious
sonnets, he said to him that he was at the end of his life, that
he must take care where he directed his thoughts, that by
reading what he wrote Vasari would see he was at his last hour
and that the image of death was engraved on his every
thought. In one of his letters he said:

God wishes it, Vasari, that I should continue to live in misery for
some years. I know that you will tell me that I am a foolish old man
to want to write sonnets, but since there are many who say that I am
in my second childhood I have wanted to act accordingly. I see from
your letter how much you love me, and be sure of this, that I would
be glad to lay these tired bones beside those of my father, as you beg
me to do. But if I left here I would cause the utter ruin of the building
of St Peter's, and this would be a great disgrace and sin. But when the
building has been so far advanced that it can never be changed, then
I hope to do all you ask, if I am not sinning by keeping frustrated
certain gluttons who can't wait for me to leave.

Accompanying this letter was the following sonnet, written
in his own hand:

> Now hath my life across a stormy sea,
> Like a frail bark, reached that wide port where all
> Are bidden, ere the final reckoning fall
> Of good and evil for eternity.
> Now know I well how that fond phantasy
> Which made my soul the worshipper and thrall
> Of earthly art is vain; how criminal
> Is that which all men seek unwillingly.
> Those amorous thoughts which were so lightly dressed,
> What are they when the double death is nigh?
> The one I know for sure, the other dread.
> Painting nor sculpture now can lull to rest
> My soul, that turns to His great love on high,
> Whose arms to clasp us on the cross were spread.[1]

From this it was seen that Michelangelo was gradually
drawing away from the world towards God and casting from
himself the cares of art, persecuted as he was by those malig-
nant artists and influenced by some of those who were in

1. Symonds's translation of the sonnet, 'Giunto è gia'l corso della vita mia'.

charge of the building of St Peter's and who would have liked, as he used to say, to come to blows. On Duke Cosimo's orders, Vasari replied briefly to Michelangelo's letter, encouraging him to return to his home, and sending him a sonnet with rhymes corresponding to those Michelangelo himself had used.

Michelangelo would gladly have left Rome, but he had grown so old and feeble that despite his resolve (which I shall mention later) his flesh betrayed his spirit. Now it happened that in June 1557, in the construction of the vault over the chapel of the king (which was in travertine and for which Michelangelo had made a model) an error occurred because Michelangelo was unable to go along and supervise as often as he used to.[1] What happened was that the master builder shaped the whole vault on one curve, struck from a single centre instead of from several. Writing as a friend and confidant of Vasari's, Michelangelo sent him the plans, with these words at the foot of two of them:

The curve marked on the drawing in red was taken by the master builder as the shape of the whole vault, so that when it became a semi-circle at the apex of the vault he realized he had made an error in the shape of the curve as a whole, as shown here on the drawing in black. With this error, the vault has progressed to the point where it is necessary to remove a large number of stones since it is built of bricks instead of masonry. The diameter of the arch, excluding the surrounding cornice, is twenty-two spans. The mistake arose (even though I made an exact model, as I always do) because in my old age I have not been able to go there all that often. So whereas I expected that the vault would be finished by now, it will take all winter. If people could die of shame and grief I would be dead by now. Please explain to the duke why I am not in Florence.

Then on another of the drawings, showing the plan of the building, Michelangelo wrote:

Giorgio,.
So that you can understand the problem of the vaulting better, note the way it rises from ground level and was of necessity divided into three over the lower windows, separated by pilasters, as you see;

1. The chapel of the king – *la cappella del re* – refers to the southern hemicycle of the transept of St Peter's.

and they go up pyramidally in the centre, towards the apex of the vault, as do the ends and sides of it. It has to be struck from an infinite number of centres, which keep changing and alter from point to point so that it is impossible to lay down a fixed rule, and the circles and rectangles created by the movements of the planes towards the centre have to be increased and diminished in so many directions at once that it is difficult to find the right way of doing it. All the same they had the model (which I always make) and they ought not to have committed so gross an error as to try and make one single curve of vaulting do for all three vault shells. This was why, to our great shame and loss, it has to be reconstructed, and a great number of stones have been removed. The vault with its ornaments and sections is entirely of travertine, like the lower part of the chapel, and this is something rarely seen in Rome.

When he saw all the obstacles, Duke Cosimo excused Michelangelo from returning to Florence, telling him that his peace of mind and the continuation of St Peter's were of greater importance to him than anything else in the world, and that he was not to worry. In the same letter that I quoted above, Michelangelo asked Vasari to thank the duke for him from the bottom of his heart for all his kindness, and he added: 'God grant that I may be able to serve him with this body of mine.'

For, he went on, his memory and understanding had gone to wait for him elsewhere. (The date of this letter was August 1557.) So Michelangelo was shown that the duke had more regard for his life and honour than for his presence, much as he wanted him at his side. All these things, and many others there is no call to repeat, I learned from letters Michelangelo wrote himself.

In St Peter's Michelangelo had carried forward a great part of the frieze, with its interior windows and paired columns on the outside following the huge round cornice on which the cupola has to be placed. But now little was being done. So bearing in mind his state of health, Michelangelo's closest friends urged him in view of the delay in raising the cupola at least to make a model for it. These were men such as the cardinal of Carpi, Donato Giannotti, Francesco Bandini, Tommaso Cavalieri, and Lottino. Michelangelo let several

months go by without making up his mind, but at length he started work and little by little constructed a small model in clay, from which, along with his plans and sections, it would later be possible to make a larger model in wood. He then began to work on the wooden model, which he had constructed in little more than a year by Giovanni Franzese, who put into it great effort and enthusiasm; and he made it so that its small proportions, measured by the old Roman span, corresponded perfectly and exactly to those of the cupola itself. The model was diligently built with columns, bases, capitals, doors, windows, cornices, projections, and every minor detail, as was called for in work of this kind: and certainly in Christian countries, or rather throughout the whole world, there is no grander or more richly ornamented edifice to be found.[1]

Michelangelo completed the model to the immense satisfaction of all his friends and all Rome besides; and he thus settled and established the form of the building. Subsequently, Paul IV died and was succeeded by Pius IV, who while causing the building of the little palace in the wood of the Belvedere to be continued by Pietro Ligorio (who remained architect to the palace) made many generous offers to Michelangelo. He also confirmed in Michelangelo's favour the *motu proprio* concerning the building of St Peter's which he had originally received from Paul III and had renewed by Julius III and Paul IV. He restored to him part of the revenues and allowances taken away by Paul IV, and employed him in many of his building projects. And during his pontificate he had the work on St Peter's pushed forward very vigorously. Michelangelo notably served the Pope in making a design for the tomb of his brother, the marquis of Marignano, which Cavaliere Leone Leoni of Arezzo, a first-class sculptor and a great friend of Michelangelo's, was commissioned to erect in the cathedral of Milan. (And it will be described in the appropriate place.) At

1. Vasari now goes on to describe in considerable and somewhat confused detail Michelangelo's model for the dome of St Peter's. A brief account of Michelangelo's work on St Peter's may be found in *An Outline of European Architecture* by Nikolaus Pevsner (Penguin Books). For a detailed and scholarly appreciation of Michelangelo as architect the student should see *The Architecture of Michelangelo* by James S. Ackerman (Zwemmer, London, 1961).

that time Leone made a very lifelike portrait of Michelangelo on a medal, on the reverse of which, out of compliments to him, he showed a blind man led by a dog, with the following legend: DOCEBO INIQUOS VIAS TUAS, ET IMPII AD TE CONVERTENTUR.[1] This so pleased Michelangelo that he presented Leone with several of his drawings and with a model in wax of Hercules crushing Antaeus.

We have no other portraits of Michelangelo save two paintings, one by Bugiardini and the other by Jacopo del Conte, and a bronze relief by Daniele Ricciarello; but many copies have been made of Leone's portrait, and indeed I myself have seen a vast number both in Italy and abroad.

That same year Cardinal Giovanni de' Medici, Duke Cosimo's son, went to Rome to receive the cardinal's hat from Pius IV and, as his friend and servant, Vasari thought that he should accompany him. He went with him very happily and stayed in Rome for about a month to enjoy the company of his dear friend Michelangelo, whom he visited constantly. On the orders of his Excellency, Vasari brought with him the model in wood for the ducal palace in Florence, along with the designs for the new apartments which he himself had built and decorated. Michelangelo wanted to see these models and designs since, being an old man, he could not see the works themselves. The paintings were extensive, varied, and full of diverse inventions and fantasies, showing the castration of Uranus and stories of Saturn, Ops, Ceres, Jove, Juno, and Hercules; each apartment was devoted to histories, in numerous compartments, concerning one of these gods. Similarly, the lower rooms and halls were adorned with stories of all the heroes of the Medici family, starting with Cosimo the Elder and continuing with Lorenzo, Leo X, Clement VII, the Lord Giovanni, Duke Alessandro, and Duke Cosimo. Along with episodes from their lives were shown their portraits with those of their children and of many of the famous people of ancient times, distinguished in affairs of state or warfare or literature, all taken from life. Vasari wrote a dialogue concerning these pictures in which he

1. I shall teach the wicked your ways, and the impious will be converted to you.

explained the histories and the meaning of the inventions and the relationship between the fables in the upper rooms and the histories in the lower apartments; and this was read by Annibale Caro to Michelangelo, who derived great pleasure from it. When Vasari has more time, he intends to publish this dialogue.[1]

In this connexion, when Vasari wanted to start work on the Great Hall he decided that the ceiling should be raised, since it was so low that it stunted the room and robbed it of light. But the duke refused permission, not because he was worried about the cost (as later became clear) but because of the danger of raising the posts by as much as twenty-six feet. However, his Excellency then judiciously decided that Michelangelo should be asked for his opinion. Michelangelo therefore was shown the model for the hall in its original condition and then as it would appear with the beams renovated and with a new design for the ceiling and walls, and with the drawings for all the various scenes that were to be painted there. After he had studied all this, and also examined the method to be used for raising the posts and the roof and the steps to be taken to execute all the work swiftly, Michelangelo became a partisan rather than a judge; and when Vasari returned to Florence he carried a letter to the duke in which Michelangelo urged him to carry on with the enterprise which, he added, was truly worthy of him. The same year Duke Cosimo visited Rome with his consort, Duchess Leonora, and immediately he arrived Michelangelo went to see him. After he had welcomed him very affectionately, out of respect for his great talents the duke made Michelangelo sit by his side, and then with much familiarity his Excellency discussed with him all the paintings and sculptures he had commissioned at Florence and what he intended to do for the future, and notably the Great Hall. Michelangelo once again encouraged and reassured him about that project, and said that his love for Cosimo made him regret that he was not young enough to serve him himself. During their conversation his Excellency remarked that he had discovered the way to work porphyry; and seeing Michelangelo's disbelief, he later (as I mention in the first chapter of

1. The *Ragionamenti*, published by Vasari's nephew in 1588.

my technical section) sent him a head of Christ executed by the sculptor Francesco del Tadda, which astonished him.[1] Michelangelo, to the duke's great satisfaction, visited him several times while he was in Rome, and he also went to see his son, the most illustrious Don Francesco de' Medici, when he visited Rome a little later. He was delighted with Don Francesco, who treated him with great affection and reverence and always held his cap in his hand when talking to him, out of respect for so distinguished a man; and he wrote to Vasari saying that it grieved him that he was weak and indisposed since he would like to have done something for him; instead, he was going about trying to buy some beautiful antique to send to him in Florence.

It was at that time that the Pope asked Michelangelo for a design for the Porta Pia. He made three very beautiful and lavish designs and of these the Pope chose the least costly, which may now be seen completed and is greatly praised. When he saw that the Pope had it in mind to restore the other gates of Rome as well Michelangelo made still more drawings for him; and he also made one, at the pontiff's request, for the new church of Santa Maria degli Angeli in the Baths of Diocletian, which were to be converted into a place of Christian worship. Michelangelo's design was preferred to many others furnished by various excellent architects, including as it did so many fine and appropriate features for the convenience of the Carthusian friars (who have now brought the work almost to completion) that his holiness and all the prelates and nobles of the papal court marvelled at his judgement. His ideas made use of all the skeleton of those baths, out of which was formed a truly beautiful church with an entrance surpassing the expectations of all the architects, who gave him unstinted praise and honour. Michelangelo also designed for his holiness, who wanted it for the new church, a bronze ciborium which has now been executed for the most part by Jacopo Ciciliano, a rare craftsman who was greatly admired by Michelangelo and whose castings are so delicate and smooth that they hardly need polishing.

1. The technical section (*teoriche*) is the three-part Introduction to the *Lives*, dealing with Architecture, Sculpture, and Painting.

Several times the Florentines living in Rome discussed how best to make a start on the church of San Giovanni in the Strada Giulia, and at one of their meetings the heads of the wealthiest families among them each promised to contribute to the building according to his means, and a good sum of money was collected. Then, after they had argued whether they should follow the original plans or try to do something better, it was decided to raise a new edifice on the old foundations; and eventually they put three people in charge of the project, namely, Francesco Bandini, Uberto Ubaldini, and Tommaso de' Bardi. They in turn asked Michelangelo for a design, pleading that it was a shame that the Florentines had spent so much money in vain, and adding that if his genius did not avail to finish the work then there was nothing they themselves could do. Michelangelo promised that he would do what they wanted as devotedly as he had ever done anything, both because in his old age he was glad to be occupied with sacred things, redounding to the honour of God, and then because of his love for his country, which had never left him.

At the discussion Michelangelo had with him a young Florentine artist called Tiberio Calcagni who was very anxious to study sculpture and who also, after he had gone to Rome, started to give his time to architecture. Being fond of him, Michelangelo, as was mentioned earlier, had given him to finish the marble Pietà he himself had broken, as well as a bust of Brutus in marble, much larger than life-size, of which he had executed, using light chisels, only the head. This is a work of rare beauty which Michelangelo had copied for Cardinal Ridolfi (at the request of his close friend Donato Giannotti) from a portrait of Brutus cut on a cornelian of great antiquity belonging to Giuliano Cesarino.

So for his architectural work, since his old age meant that he could no longer draw clear lines, Michelangelo made use of Tiberio, who was a modest and well-mannered young man. He wanted to use his services for the church of San Giovanni and he asked him to take the ground-plan of the original foundations. This was brought to him as soon as it was ready; and then, through Tiberio, Michelangelo informed the commissioners (who had not expected him to have anything ready)

that he had been working for them; and finally, he showed them the drawings for five beautiful churches which left them amazed. They were reluctant to choose one themselves, as Michelangelo suggested, and they preferred to rely on his judgement; but he insisted that they should make up their own minds and then, unanimously, they picked out the richest. After the choice had been made, Michelangelo told them that if they put the design into execution they would produce a work superior to anything done by either the Greeks or the Romans: words unlike any ever used by him, before or after, for he was a very modest man. At length it was resolved that Michelangelo should supervise the work and that it should be executed by Tiberio; Michelangelo promised to serve them well, and with this arrangement the commissioners were fully content. Tiberio was then given the plan to produce a fair copy, with interior and exterior elevations, as well as a clay model which Michelangelo advised him how to set up. In ten days Tiberio finished a model of eight spans, which pleased the Florentine colony so much that they then had him make a wooden model which is now in the consulate: here is a building as rare in its ornate variety as any church ever seen. But after work had been started and five thousand crowns had been spent, the funds failed, much to Michelangelo's annoyance, and the project has remained suspended ever since.

Michelangelo also procured for Tiberio the commission to finish under his direction a chapel for Cardinal Santa Fiore in Santa Maria Maggiore; but this remained unfinished because of the unhappy death of Tiberio himself as well as of the cardinal and Michelangelo.

Michelangelo had been seventeen years in the construction of St Peter's, and several times the superintendents had tried to have his authority taken away from him. When they failed in this they sought to oppose him in every other matter, now on one far-fetched pretext and now on another, in the hope that as he was so old that he could do no more they would force him to retire from sheer weariness. Then it happened that the overseer, Cesare da Casteldurante, died, and for the sake of the building Michelangelo sent there, while he was

looking for a suitable successor, Luigi Gaeta, who was too young but very competent. Some of the deputies had often tried to get Nanni di Baccio Bigio put in charge (for he was always urging them and promising the earth) and in order to get their own way the same men sent Luigi Gaeta away. After he had heard of this, in his anger Michelangelo refused to go to St Peter's any more; and they then started to spread it abroad that he was no longer competent and that a replacement must be found; and they also alleged that he had told them he no longer wanted to be troubled with the building. All this came back to Michelangelo who sent Daniele Ricciarelli of Volterra to Bishop Ferratino, one of the commissioners, who had informed Cardinal Carpi that Michelangelo had told one of his servants that he no longer wanted to be troubled with the building. Daniele told him that this was not Michelangelo's wish, and in reply the bishop said that he was sorry Michelangelo had not discussed what was in his mind, but that a replacement was needed and he would have gladly accepted Daniele himself. With this arrangement, Michelangelo showed himself satisfied. However, after he had given the commissioners to understand that they would be offered a replacement of Michelangelo's choice, Ferratino then put forward not Daniele but Nanni Bigio. Then after Bigio had been accepted and installed, not long after he arranged for a scaffolding of beams to be raised from the Pope's stables, on the side of the hill, to the great tribune on that side of the church, because he argued, too many ropes were being consumed in drawing up the materials and it was better to transport them this way. However, when Michelangelo heard of this, he straight away went to see the Pope, whom he found on the piazza of the Capitol; and when he started to make his protest his holiness took him along to a private room where he said:

Holy Father, the commissioners have found to replace me someone I know nothing about. However, if they and your holiness have decided that I am no longer capable I shall withdraw to Florence where I can stay near the Grand Duke, who has so often desired my presence, and end my life in my own house. So I beg for your kind dismissal.

The Pope was incensed by what he heard and after he had consoled Michelangelo he told him to come back and talk to him the following day at Araceli. Then he called together all the commissioners and demanded to know the reasons for what had happened. They argued that the building was going to ruin and that mistakes were being made in the construction; but knowing that this was untrue, the Pope ordered Agabrio Scierbellone to examine the structure and require Nanni, who was making the accusations, to point out the errors. This was done; Agabrio discovered that the complaints were inspired by envy and were completely unfounded; and Nanni was contemptuously dismissed in the presence of many noblemen. Nanni was also reproached for having ruined the bridge of Santa Maria and, after promising to clean the harbour at Ancona at little cost, having choked it more in one day than the sea did in ten years. This was the end of Nanni's connexion with St Peter's, where, for seventeen years, Michelangelo had devoted himself entirely to settling the essential features of the building so as to frustrate those whose envious hostility made him think they would make changes after his death. Today, in consequence, the building is secure enough to be safely vaulted. Thus we see that God, who looks after good men, favoured Michelangelo during his lifetime and never ceased to protect both him and St Peter's. Then Pius IV, who survived Michelangelo, told the superintendents to alter nothing that Michelangelo had laid down. His successor, Pius V, followed the same policy even more emphatically; and to avoid confusion he told the architects Pirro Ligorio and Jacopo Vignola to follow Michelangelo's designs with unswerving fidelity. Indeed, when Pirro was presumptuous enough to propose several changes he was discharged in disgrace. Pius V was as zealous for the glory of St Peter's as for the Christian religion; so much so that in 1565, when Vasari went to kiss his feet, and again when he was summoned in 1566, he talked only of how to make sure that Michelangelo's designs were followed. Then to avoid any confusion his holiness commanded Vasari to go with his private treasurer, Guglielmo Sangalletti, and on his authority tell Bishop Ferratino, who was supervising the builders, to pay strict attention to all the important

memoranda and records that Vasari would give him, so that the words of malignant and presumptuous men would have no power to upset the arrangements or details left to posterity by Michelangelo's genius. Giovanbattista Altoviti, a friend of Vasari and of the arts, was present on this occasion; and after Ferratino had heard what Vasari had to say, he eagerly accepted every available record and promised that everyone, including himself, would without fail observe all Michelangelo's arrangements and designs in the building; he would, he said, protect, safeguard, and maintain the work of the great Michelangelo.

To return to Michelangelo himself: about a year before his death Vasari secretly prevailed on Duke Cosimo de' Medici to persuade the Pope through his ambassador Averardo Serristori that, since Michelangelo was now very feeble, a careful watch should be kept on those who were looking after him, or helping him in his home. Vasari suggested that the Pope should make arrangements so that, in the event of his having an accident, as old men often do, all his clothes, his drawings, cartoons, models, money, and other possessions should be set down in an inventory and placed in safe-keeping for the sake of the work on St Peter's. In this way, if there were anything there concerning St Peter's or the sacristy, library, and façade of San Lorenzo, no one would make off with it, as frequently happens in such cases. In the event, these precautions proved well worth while.

Michelangelo's nephew Lionardo wanted to go to Rome the following Lent, for he guessed that his uncle had now come to the end of his life; and Michelangelo welcomed this suggestion. When, therefore, he fell ill with a slow fever he at once made Daniele write telling Lionardo that he should come. But, despite the attentions of his physician Federigo Donati and of others, his illness grew worse; and so with perfect consciousness he made his will in three sentences, leaving his soul to God, his body to the earth, and his material possessions to his nearest relations. Then he told his friends that as he died they should recall to him the sufferings of Jesus Christ. And so on 17 February, in the year 1563 according to Florentine reckoning (1564 by the Roman) at

the twenty-third hour he breathed his last and went to a better life.[1]

Michelangelo had a strong vocation for the arts on which he laboured, and he succeeded in everything he did, no matter how difficult. For nature gave him a mind that devoted itself eagerly to the great arts of design. And in order to achieve perfection he made endless anatomical studies, dissecting corpses in order to discover the principles of their construction and the concatenation of the bones, muscles, nerves, and veins, and all the various movements and postures of the human body. He studied not only men but animals as well, and especially horses, which he loved to own. Of all these he was anxious to learn the anatomical principles and laws in so far as they concerned his art; and in his works he demonstrated this knowledge so well that those who study nothing else except anatomy achieve no more. As a result everything he made, whether with the brush or the chisel, defies imitation, and (as has been said) is imbued with such art, grace, and distinctive vitality that, if this can be said without offence, he has surpassed and vanquished the ancients, for the facility with which he achieved difficult effects was so great that they seem to have been created without effort, although anyone who tries to copy his work finds a great deal of effort is needed.

Michelangelo's genius was recognized during his lifetime, not, as happens to so many, only after his death. As we have seen, Julius II, Leo X, Clement VII, Paul III, Julius III, Paul IV, and Pius IV, all these supreme pontiffs, wanted to have him near them at all times; as also, as we know, did Suleiman, emperor of the Turks, Francis of Valois, king of France, the Emperor Charles V, the Signoria of Venice, and lastly, as I related, Duke Cosimo de' Medici, all of whom made him very honourable offers, simply to avail themselves of his great talents. This happens only to men of tremendous worth, like Michelangelo, who, as was clearly recognized, achieved in the three arts a perfect mastery that God has granted no other person, in the ancient or modern world, in all the years that the sun has been spinning round the world. His imagination was so powerful and perfect that he often discarded work in

1. Michelangelo died on 18 February 1564.

which his hands found it impossible to express his tremendous and awesome ideas; indeed, he has often destroyed his work, and I know for a fact that shortly before he died he burned a large number of his own drawings, sketches, and cartoons so that no one should see the labours he endured and the ways he tested his genius, and lest he should appear less than perfect. I have some examples of his work, found in Florence and placed in my book of drawings; and these not only reveal the greatness of his mind but also show that when he wished to bring forth Minerva from the head of Jove, he had to use Vulcan's hammer: for he used to make his figures the sum of nine, ten, and even twelve 'heads'; in putting them together he strove only to achieve a certain overall harmony of grace, which nature does not present; and he said that one should have compasses in one's eyes, not in one's hands, because the hands execute but it is the eye which judges. He also used this method in architecture.

No one should think it strange that Michelangelo loved solitude, for he was deeply in love with his art, which claims a man with all his thoughts for itself alone. Anyone who wants to devote himself to the study of art must shun the society of others. In fact, a man who gives his time to the problems of art is never alone and never lacks food for thought, and those who attribute an artist's love of solitude to outlandishness and eccentricity are mistaken, seeing that anyone who wants to do good work must rid himself of all cares and burdens: the artist must have time and opportunity for reflection and solitude and concentration. Although all this is true, Michelangelo valued and kept the friendship of many great men and of many talented and learned people, when it was appropriate. Thus, the great Cardinal Ippolito de' Medici loved him dearly, and on one occasion, having heard that a beautiful Arab horse of his had taken Michelangelo's fancy, he sent it to him as a gift, along with ten mules laden with fodder and a groom to look after it; and Michelangelo accepted it with pleasure. Another great friend of his was the illustrious Cardinal Pole, whose goodness and talents Michelangelo especially revered. He could also claim the friendship of Cardinal Farnese and of Santa Croce (who afterwards became

Pope Marcellus), of Cardinal Ridolfi, Cardinal Maffeo, Monsignor Bembo, Carpi, and many other cardinals, bishops, and prelates whom there is no need to name. Other friends were Monsignor Claudio Tolomei, the Magnificent Ottaviano de' Medici (a crony of his whose son he held at baptism), Bindo Altoviti (to whom Michelangelo gave the cartoon for the chapel, showing the drunken Noah being mocked by one of his sons while the other two cover up his nakedness), Lorenzo Ridolfi, Annibale Caro, and Giovan Francesco Lottini of Volterra. But infinitely more than any of them Michelangelo loved the young Tommaso de' Cavalieri, a well-born Roman who was intensely interested in the arts. To show Tommaso how to draw Michelangelo made many breathtaking drawings of superb heads, in black and red chalk; and later he drew for him a Ganymede rapt to Heaven by Jove's eagle, a Tityus with the vulture devouring his heart, the chariot of the Sun falling with Phaëton into the Po, and a Bacchanal of children, all of which are outstanding drawings the like of which has never been seen. Michelangelo did a portrait of Tommaso in a life-size cartoon, but neither before nor afterwards did he do any other portrait from life, because he hated drawing any living subject unless it were of exceptional beauty. Because of the great delight that he took in these drawings, Tommaso was subsequently given many others that Michelangelo once did for Fra Sebastiano Viniziano to carry into execution. These were truly miraculous, and Tommaso treasures them as relics, generously making them available to craftsmen. Michelangelo, indeed, always lavished his affection on people of merit, nobility, and worth; for in everything he was a man of judgement and taste. Tommaso also persuaded Michelangelo to execute many drawings for his friends, among others a panel picture of the Annunciation for the Cardinal di Cesis, in a new style, which was later painted by Marcello of Mantua[1] and placed in the marble chapel built by the cardinal in the church of the Pace at Rome. Another Annunciation, also painted by Marcello, is to be found on a panel in the church of San Giovanni in Laterano; and the drawing for this is in the possession of Duke

1. Marcello Venusti (1512-79).

Cosimo de' Medici, who was given it after Michelangelo's death by his nephew Lionardo Buonarroti and who treasures it as a jewel. His Excellency also has a Christ praying in the Garden and many other drawings, sketches, and cartoons by Michelangelo, along with the statue of Victory with a captive beneath, ten feet in height, and four other captives in the rough which serve to teach us how to carve figures out of marble by a method which leaves no chance of spoiling the stone. This method is as follows: one must take a figure of wax or some other firm material and lay it horizontally in a vessel of water; then, as the water is, of course, flat and level, when the figure is raised little by little above the surface the more salient parts are revealed first, while the lower parts (on the underside of the figure) remain submerged, until eventually it all comes into view. In the same way figures must be carved out of marble by the chisel; the parts in highest relief must be revealed first and then little by little the lower parts. And this method can be seen to have been followed by Michelangelo in the statues of the prisoners mentioned above, which his Excellency wants to be used as models by his academicians.

Michelangelo loved and enjoyed the company of his fellow craftsmen, such as Jacopo Sansovino, Rosso, Pontormo, Daniele da Volterra, and Giorgio Vasari of Arezzo, for whom he did countless acts of kindness. Intending to make use of him some day, Michelangelo caused Vasari to pay attention to architecture, and he was always ready to confer with him and discuss matters of art. Those who assert that Michelangelo would never teach anyone are wrong, because he was always willing to help his close friends and anyone else who asked for advice. (I myself was present on many occasions when this happened, but out of consideration for the deficiencies of others I shall say no more.) To be sure, he was unlucky with the people who went to live with him in his house, but this was because he chanced upon pupils who were hardly capable of following him. For example, his assistant Pietro Urbino of Pistoia was a talented person, but he would never exert himself; Antonio Mini was willing enough, but he was a slow thinker, and when the wax is hard it does not take a good

impression; Ascanio dalla Ripa Transone[1] worked very hard indeed, but never produced results, either in the form of designs or finished works. Ascanio spent years on a picture for which Michelangelo provided the cartoon, and all in all the high expectations he aroused have gone up in smoke. I remember that Michelangelo, taking pity on Ascanio for his lack of facility, used to help him personally, but it was of little use. If he had found someone suitable, old as he was he would (as he told me more than once) have then made anatomical studies and commentaries for the benefit of his disciples, for they were often misled. However, he hesitated because of his inability to convey his thoughts, for he was not practised in literary expression, although in his letters he said what he wanted very aptly and concisely and he loved reading the works of our Italian poets. He was especially fond of Dante, whom he greatly admired, and whom he followed in his ideas and inventions, and also of Petrarch, who inspired him to write madrigals and sonnets of great profundity, on which commentaries have been written. Benedetto Varchi, for example, has read before the Florentine Academy an admirable lecture on the sonnet that begins:

> The best of artists hath no thought to show
> Which the rough stone in its superfluous shell
> Doth not include . . .[2]

Michelangelo sent any number of his verses to the Marchioness of Pescara, who replied to him in both verse and prose.[3] She won his devotion because of her accomplishments, and she returned his love; and very often she went from Viterbo to Rome to visit him. For her, Michelangelo designed a Pietà showing Christ in the lap of Our Lady, with two little angels. As well as this admirable work he did an inspired Christ nailed to the cross, with his head uplifted and com-

1. Ascanio Condivi.
2. Symonds's translation of:

> Non ha l'ottimo artista alcun concetto,
> Ch'un marmo solo in se non circonscriva . . .

3. Vittoria Colonna (1490–1547), intimate friend of Michelangelo and Castiglione, one of the most famous women of Renaissance Italy.

mending his spirit to the Father, as well as a Christ at the well with the woman of Samaria.

Being a devout Christian, Michelangelo loved reading the Holy Scriptures, and he held in great veneration the works written by Fra Girolamo Savonarola, whom he had heard preaching from the pulpit. He greatly loved human beauty for its use in art; only by copying the human form, and by selecting from what was beautiful the most beautiful, could he achieve perfection. This conviction he held without any lascivious or disgraceful thoughts, as is proved by his very austere way of life. For example, as a young man he would be so intent on his work that he used to make do with a little bread and wine, and he was still doing the same when he grew old, until the time he painted the Last Judgement in the chapel, when he used to take his refreshment in the evening after the day's work was finished, but always very frugally. Although he became very rich he lived like a poor man, and he rarely if ever invited his friends to eat at his table; nor would he ever accept gifts from anyone, because he feared that this would place him under some kind of permanent obligation. This sober way of life kept him very alert and in want of very little sleep, and very often, being unable to rest, he would get up at night and set to work with his chisel, wearing a hat made of thick paper with a candle burning over the middle of his head so that he could see what he was doing and have his hands free. Vasari saw this hat several times, and seeing that Michelangelo used candles made not of wax but of pure goat's tallow, which were first-rate, he once sent him four bundles of these, weighing forty pounds. With all courtesy, Vasari's servant brought these candles to Michelangelo and presented them to him. (This was at the second hour of the night.) And when Michelangelo refused to accept them, the man said:

'Sir, these candles have been breaking my arms between the bridge and here and I've no intention of taking them back. There's a big mound of dirt in front of your door where they'll stand beautifully, and I'll set them all alight for you.'

At this Michelangelo said: 'Just put them down here then. I'm not having you play tricks at my door.'

Michelangelo told me that often when he was young he

used to sleep in his clothes, on occasions when he was tired out with work and did not want to take them off just to put them on again. There are some who have taxed him with being miserly, but they are mistaken, for both with works of art and his other property he proved the contrary. As was said, he gave various works to Tommaso de' Cavalieri and Bindo, and drawings of considerable value to Fra Bastiano; and to Antonio Mini, his disciple, he gave drawings, cartoons, the picture of the Leda, and all the models in wax and clay that he ever made, which, as explained, have been left in France. To Gherardo Perini, a Florentine gentleman who was his great friend, Michelangelo gave three sheets containing drawings of various heads in black chalk, which were truly inspired; after Perini's death these fell into the hands of the most illustrious Don Francesco, prince of Florence, who treasures them as the gems they certainly are. To Bartolommeo Bettini Michelangelo gave a cartoon showing Cupid kissing his mother, Venus, another inspired work which is now in the possession of his heirs at Florence. And for the Marquis del Vasto he made the cartoon of a *Noli me tangere*, another outstanding work. Both these cartoons were beautifully painted by Pontormo, as I have said. Then again Michelangelo gave the two captives to Ruberto Strozzi, and the broken marble Pietà to his servant Antonio and Francesco Bandini. I cannot imagine how anyone can accuse of miserliness a man who gave away so many things for which he could have obtained thousands of crowns. There is no more to be said, save that I know from personal experience that he made many designs and went to see many pictures and buildings without ever demanding payment for his services.

But let us come to the money he possessed. This came not from rents or trade but was earned by the sweat of his brow as a reward for his studies and labours. And can a man be called miserly who helped many poor people, as he did, and who secretly provided dowries for many young girls, and made the fortunes of those who helped and served him in his work? He enriched his assistant Urbino who had served him for so many years, for example, saying to him once: 'If I die, what are you going to do?'

'I'll have to look after someone else,' said Urbino.

'Oh, you poor creature,' Michelangelo replied. 'I'll save you from such misery.'

And then he gave him two thousand crowns in a lump sum, a gesture to be expected only from Caesars and Popes. As well as this, Michelangelo used to give his nephew three and four thousand crowns at a time; and at the end he left him ten thousand crowns, along with the property at Rome.

Michelangelo enjoyed so profound and retentive a memory that he could accurately recall the works of others after he had seen them and use them for his own purposes so skilfully that scarcely anyone ever remarked it. Nor has he ever repeated himself in his own work, because he remembered everything he did. Once when he was a young man he was with some friends of his, who were painters, and, for the price of a supper, they competed to see who could best draw one of those crude and clumsy figures like the match-stick men that ignorant people scratch on walls. Michelangelo made good use of his memory to recall one of those crude outlines he had seen on a wall, and he drew it as accurately as if he had it before his eyes, and did better than any of the painters. This was especially difficult for a draughtsman of his distinction, accustomed as he was to producing sophisticated work.

Michelangelo rightly scorned those who injured him; but he was never known to harbour a grudge. On the contrary, he was a very patient man, modest in behaviour and prudent and judicious in all he said. His remarks were usually profound, but he was also capable of shrewd and witty pleasantries. Many of the things he said I made a note of, but to save time I shall quote just a few of them.

Once a friend of his started talking to him about death and remarked that it must sadden him to think of it, seeing that he had devoted all his time to art, without any respite. Michelangelo replied that this was not so, because if life was found to be agreeable then so should death, for it came from the hands of the same master. He was once standing by Orsanmichele, where he had stopped to gaze at Donatello's statue of St Mark, and a passer-by asked him what he thought of it. Michelangelo replied that he had never seen a figure which had more the air

of a good man than this one, and that if St Mark were such a man, one could believe what he had written. Again, he was once shown a drawing done by a novice whom it was hoped he would take an interest in, and seeking to make excuses for the boy his sponsors said that he had only just started to study the art. Michelangelo merely said: 'That's evident.' He said the same kind of thing to a painter who had produced a mediocre Pietà, remarking that it was indeed a pity to see it.

When he was told that Sebastiano Veniziano was to paint a friar in the chapel of San Pietro in Montorio he commented that this would spoil the place; and when he was asked why, he added that seeing that the friars had ruined the world, which was so big, it was not surprising that they should spoil the chapel, which was so small. A painter once earned a great deal for a work which had cost him a considerable amount of time and effort. When he was asked what he thought of him as an artist, Michelangelo replied: 'So long as he wants to be rich he'll stay poor.'

Once a friend of Michelangelo, who was in holy orders and already saying Mass, came to Rome all decked out like a pilgrim and greeted Michelangelo, who pretended not to recognize him. He was forced to explain who he was; Michelangelo pretended to be astonished at seeing him robed the way he was, and as if congratulating him he exclaimed:

'Oh, you do look fine! It would be good for your soul if you were as good within as you seem on the outside.'

This priest had recommended a friend of his to Michelangelo, who had given him a statue to execute; he then asked Michelangelo to give his friend more work and Michelangelo very good-naturedly did so. However, the friar had asked these favours only because he thought they would be refused, and when the contrary happened he showed his envy. Michelangelo was told about this, and he remarked that he never cared for these gutter-people, meaning that one should have nothing to do with people who have two mouths.

A friend asked Michelangelo his opinion of someone who had imitated in marble several of the most famous antique statues and boasted that his copies were far better than the originals. Michelangelo answered:

'No one who follows others can ever get in front of them, and those who can't do good work on their own account can hardly make good use of what others have done.'

Again, some painter or other had produced a picture in which the best thing was an ox. Michelangelo was asked why the artist had painted the ox more convincingly than the rest, and he replied: 'Every painter does a good self-portrait.'

As he was passing by San Giovanni in Florence, Michelangelo was asked what he thought of Ghiberti's doors; he replied: 'They are so beautiful that they could stand at the entrance to Paradise.'

When he was working for a prince who changed his plans every day and could never make up his mind, Michelangelo said to a friend of his: 'This lord has a mind like a weathercock; it turns with every wind that touches it.'

He went to see a piece of sculpture that was ready to be put on show, and the sculptor was taking great pains to see that it was in the right light so that it would look its best. Michelangelo said to him: 'Don't take so much trouble; the important thing will be the light on the public square.'

He meant that when an artist's work is put on public view, the people decide whether it is good or bad.

Another time, a great nobleman in Rome took it into his head that he would like to be an architect. He had several niches constructed in which he intended to place various statues, and each niche had a ring at the top and was far too deep for its height. When the statues were put in place the effect was disappointing, and he asked Michelangelo what he should put in their place. Michelangelo replied: 'Hang some bunches of eels on the rings.'

Once, when a gentleman who claimed to understand Vitruvius and to be a fine critic joined the commissioners of St Peter's, Michelangelo was told: 'You now have someone in charge of the building who has great genius.'

And he answered: 'That is true, but he has no judgement.'

Another time, a painter had executed a scene in which many of the details were copied from other pictures and drawings, and indeed there was nothing original in it. The painting was

shown to Michelangelo, and after he had looked at it a close friend of his asked for his opinion.

'He has done well,' Michelangelo commented, 'but at the Day of Judgement when every body takes back its own members, I don't know what that picture will do, because it will have nothing left.'

And this was a warning to artists to practise doing original work.

On his way through Modena, Michelangelo saw many beautiful terracotta figures, coloured to look like marble, which had been executed by the local sculptor, Antonio Begarelli. He thought they were excellent, and seeing that Begarelli did not know how to work in marble he said:

'If that clay were to be changed into marble, so much the worse for the antiques.'

Told that he ought to resent the way Nanni di Baccio Bigio was always trying to compete with him, Michelangelo said: 'Anyone who fights with a good-for-nothing gains nothing.'

A priest, a friend of his, once told him: 'It's a shame you haven't taken a wife and had many sons to whom you could leave all your fine works.'

Michelangelo retorted: 'I've always had only too harassing a wife in this demanding art of mine, and the works I leave behind will be my sons. Even if they are nothing, they will live for a while. It would have been a disaster for Lorenzo Ghiberti if he hadn't made the doors of San Giovanni, seeing that they are still standing whereas his children and grandchildren sold and squandered all he left.'

Once Vasari was sent by Julius III at the first hour of the night to Michelangelo's house to fetch a design, and he found Michelangelo working on the marble Pietà that he subsequently broke. Recognizing who it was by the knock, Michelangelo left his work and met him with a lamp in his hand. After Vasari had explained what he was after, he sent Urbino upstairs for the drawing and they started to discuss other things. Then Vasari's eyes fell on the leg of the Christ on which Michelangelo was working and making some alterations, and he started to look closer. But to stop Vasari seeing it, Michelangelo let the lamp fall from his hand, and they

were left in darkness. Then he called Urbino to fetch a light, and meanwhile coming out from the enclosure where he had been working he said:

'I am so old that death often tugs my cloak for me to go with him. One day my body will fall just like that lamp, and my light will be put out.'

Nevertheless, Michelangelo enjoyed the company of people like Menighelli, a crude and commonplace painter from Valdarno but a very agreeable sort of man. Menighelli used to visit Michelangelo, who once made for him a drawing of St Roche and St Anthony to paint for the country people. Indeed, Michelangelo, whom kings found difficult to handle, would often put other work aside to do simple things just as Menighelli wanted them; and among other things Menighelli got him to make the model of a crucifix, which was extremely beautiful. Menighelli then formed a mould from this and made copies in papier maché and other materials which he went about the countryside selling. He used to make Michelangelo roar with laughter, especially when he told him some of his anecdotes, such as the story of a peasant who had asked him for a picture of St Francis and was disappointed when he found the robes painted grey since he would have liked something brighter; and when Menighelli put a pluvial of brocade on the saint's back, the peasant was as happy as a lark.

Michelangelo was also fond of the stone-cutter Topolino who imagined he was an expert sculptor but who was in fact very mediocre. Topolino spent many years at the quarries of Carrara, from where he sent marble to Michelangelo; and he never sent a shipment without including three or four figures which he had roughed out himself and which made Michelangelo nearly die of laughter. Eventually, after he had returned from Carrara, Topolino roughed out a marble figure of Mercury and determined to finish it. He had almost done so when he asked Michelangelo to look at it and give his honest opinion.

'You're a fool, Topolino,' Michelangelo said, 'to want to make statues. Don't you see that from his knee to his foot this Mercury is lacking about eight inches, and that you've made him both a dwarf and a cripple?'

'Oh, that's nothing,' said Topolino. 'If that's all, I shall see to it. Leave it to me.'

Michelangelo laughed at the man's naïvety; but after he had left, Topolino took a piece of marble, and having sawn the Mercury in two below the knees and added the length required, he gave the figure a pair of buskins to hide the joins. Then he asked Michelangelo to come and see what he had done; and having had another good laugh, Michelangelo was left marvelling at the way such blunderers, when driven to it, resort to measures beyond even the most competent artists.

While he was finishing the tomb of Julius II in San Pietro in Vincoli, Michelangelo caused a stone-cutter to execute for it an ornamental terminal figure. He guided him by saying: 'Cut away here, make it level there, polish here . . .' until, without realizing what was happening, the man had carved a figure. After it was finished, as the stone-cutter was staring at it in astonishment Michelangelo inquired: 'Well, what do you think?'

'I think it's fine,' he said, 'and I'm grateful to you.'

'Why's that?'

'Because through you I've discovered a talent I never knew I had.'

Now, to be brief, I must record that Michelangelo's constitution was very sound, for he was lean and sinewy and although as a child he had been delicate and as a man he had suffered two serious illnesses he could always endure any fatigue and had no infirmity, save that in his old age he suffered from dysuria and gravel which eventually developed into the stone. For many years he was syringed by the hand of his dear friend, the physician Realdo Colombo, who treated him very devotedly. Michelangelo was of medium height, broad in the shoulders but well proportioned in all the rest of his body. As he grew old he took to wearing buskins of dogskin on his legs, next to the skin; he went for months at a time without taking them off, then when he removed the buskins often his skin came off as well. Over his stockings he wore boots of cordswain, fastened on the inside, as a protection against damp. His face was round, the brow square and lofty, furrowed by seven straight lines, and the temples projected

considerably beyond the ears, which were rather large and prominent. His body was in proportion to the face, or perhaps on the large size; his nose was somewhat squashed, having been broken, as I told, by a blow from Torrigiano; his eyes can best be described as being small, the colour of horn, flecked with bluish and yellowish sparks. His eyebrows were sparse, his lips thin (the lower lip being thicker and projecting a little), the chin well formed and well proportioned with the rest, his hair black, but streaked with many white hairs and worn fairly short, as was his beard which was forked and not very thick.

There can be no doubt, as I said at the beginning of his *Life*, that Michelangelo was sent into the world by God as an exemplar for those who practise the arts so that they might learn from his behaviour how to live and from his works how to perform as true and excellent craftsmen. I myself, who must thank God for countless blessings rarely experienced by men of our profession, count among the greatest of them to have been born at a time when Michelangelo was living, and to have been thought worthy to have him for my teacher, and to have enjoyed his intimate friendship, as everyone knows and as the letters he wrote to me can prove. For the sake of the truth and because of the debt I owe to his love and kindness, I have set myself to write many things about him, and all true, which many others have failed to do. The other blessing I have received was something Michelangelo reminded me of when he wrote:

Giorgio, thank God for it, that He had you serve Duke Cosimo, who spares no expense to enable you to build and paint, and so put his ideas and projects into execution; whereas if you consider other artists, whose biographies you have written, they have enjoyed no such encouragement.

Michelangelo was followed to the tomb by a great concourse of artists, friends, and Florentines; and he was honourably buried in the church of Santi Apostoli, in the presence of all Rome. His holiness expressed the intention of having a personal memorial and sepulchre erected for him in St Peter's itself.

Although he travelled with the post, his nephew Lionardo arrived after all was finished. Duke Cosimo had meanwhile resolved to have the man whom he had been unable to honour while he was living brought to Florence after his death and given a noble and costly burial; and after the duke had been told of the happenings in Rome, Michelangelo's body was smuggled out of Rome by some merchants, concealed in a bale so that there should be no tumult to frustrate the duke's plan. Before the corpse arrived, however, Florence received the news of Michelangelo's death and at the request of the acting head of their academy, who at that time was the Reverend Don Vincenzo Borghini, the leading painters, sculptors, and architects assembled together and were reminded that under their rules they were obliged to solemnize the obsequies of all their brother artists. Borghini added that as they had done so with such love and devotion, and to everyone's satisfaction, in the case of Fra Giovann'Agnolo Montorsoli (the first to die after the foundation of the Academy) they could well imagine what they ought to do to honour Buonarroti who had by the artists of Florence unanimously been elected the first academician and the head of them all. To this proposal, the artists responded that, as men who loved and were indebted to the genius of Michelangelo, they must strive in every possible way to pay him the utmost honour. After this resolution had been taken, so that the artists need not be inconvenienced by having to assemble every day, four men of high reputation and proven ability were elected to arrange for the ceremonies and obsequies: namely, Angelo Bronzino and Giorgio Vasari, painters, and Benvenuto Cellini and Bartolommeo Ammanati, sculptors. These artists were chosen to decide among themselves, and in consultation with Borghini, every single detail of the arrangements; and they were empowered to make use of all the resources of the Academy. They accepted this charge all the more readily as they found all the artists, young and old, coming forward eagerly to offer to execute the pictures and statues needed for the ceremonies. They then decided that, in the name of the Academy and confraternity of artists, the consuls and Borghini (by virtue of his official position) should

tell the duke what their plans were and ask him for all the help and favours that were needed, and especially for permission to hold the obsequies in San Lorenzo, the church of the most illustrious Medici family, where most of the works that Michelangelo did in Florence are to be found. His Excellency was also to be asked to agree that Benedetto Varchi should compose and read the funeral oration so that Michelangelo's great genius might fittingly be eulogized by Varchi's great eloquence. Varchi needed the duke's agreement to accept this role, as he was in the personal service of his Excellency, but they were certain that he himself would never have refused, being a generous man and greatly devoted to Michelangelo's memory.[1]

After all this had been agreed and the academicians had dispersed, Borghini wrote to the duke as follows:

The Academy and confraternity of painters and sculptors have resolved, if it please your most illustrious Excellency, to do some honour to the memory of Michelangelo Buonarroti, because of the debt owed to the genius of perhaps the greatest artist that ever lived (one of their own countrymen and so especially dear to them as Florentines) and also because of the benefits the arts have received from his incomparable works and inventions. Thinking themselves obliged to show the greatest possible appreciation of his achievements, they have therefore wanted their wishes expressed to your Excellency by one of their members, and they have rightly asked your Excellency for support. At their request and since it is my duty (for your Excellency was again pleased to have me this year as your representative among them) I have undertaken the task. Certainly, the enterprise seems to me worthy of these upright and accomplished men; and, moreover, I am aware of the way in which your Excellency fosters the arts and (as a unique resource and protection for men of talent at the present time) surpasses even your ancestors, who conferred such extraordinary favours on talented artists. We know that Lorenzo the Magnificent caused a memorial to be put up in the cathedral to Giotto, dead so long before, and had a fine marble sepulchre raised for Fra Filippo Lippi, all at his own expense, and on many different occasions conferred great benefits and honours on other artists. For all these reasons, I have been emboldened to recommend to your

1. Benedetto Varchi (1503–65), Florentine historian, who was asked by Cellini (and refused) to correct the style of his *Autobiography*.

Excellency the petition of the Academy, which seeks to honour the genius of Michelangelo, the favoured pupil of the school of Lorenzo the Magnificent. This will be to their great satisfaction and will win the enthusiastic approval of the populace; it will bring no small encouragement to those who practise the arts and will demonstrate to all Italy the magnanimity and goodness of your most illustrious Excellency, whom may God long preserve in happiness, to the advantage of your people and for the benefit of art.

To this letter, the duke replied as follows:

Reverend and well-beloved,
 The eagerness which the Academy has shown and is showing in its preparations to honour the memory of Michelangelo Buonarroti, who has gone to a better life, has greatly consoled us following the loss of that most singular artist. And not only will we give our consent to what has been asked in the memorandum but we shall also arrange for his bones to be brought to Florence, as from what we are told, he himself desired. All this we write to the Academy to encourage its members to honour the achievements of this great man in every possible way. May God keep you in contentment.

The letter, or rather memorandum, mentioned above, which the Academy addressed to the duke, ran as follows:

Most illustrious Excellency,
 The Academy and members of the confraternity of design, which was established by the grace and favour of your Excellency, have heard with what concern and zeal you have taken steps through your envoy in Rome to have the body of Michelangelo Buonarroti brought to Florence; having assembled together, they have unanimously resolved to solemnize his obsequies in the best manner possible. Knowing, therefore, that your Excellency was revered by Michelangelo and loved him as much in return, they beg you, of your infinite goodness and liberality, to consent to the following. First, that they may solemnize his obsequies in San Lorenzo, the church built by your ancestors which shelters so many splendid examples of Michelangelo's sculpture and architecture and near which you contemplate the construction of a studio serving the Academy of Design as a permanent centre of studies for architecture, sculpture, and painting. Second, we beg you to commission Benedetto Varchi not only to compose the funeral oration but also to deliver it himself, as he has readily agreed to do given your consent. In the third place, we beg and beseech you out of the same goodness and liberality to assist

the Academy in all that their own limited resources cannot supply for the ceremonies. These things have all been discussed in the presence and with the agreement of the Very Reverend Vincenzo Borghini, prior of the Innocenti, your Excellency's representative at the Academy of Design.

The duke replied to the Academy as follows:

Dear friends,
 We are happy to grant all your petitions, such has been the affection we have always felt for Michelangelo's rare genius and that we bear also towards all of your profession. So do not fail to pursue all that you have planned for his obsequies, and we shall not fail to help you in your requirements. Meanwhile we have written to Benedetto Varchi concerning the oration and to the Rector of the hospital concerning other matters that may be needed in this matter. We bid you farewell. From Pisa.[1]

The letter to Varchi read:

Beloved Benedetto Varchi,
 Our devotion to the rare genius of Michelangelo Buonarroti makes us desire to have his memory honoured and celebrated in every way; we shall, therefore, be pleased if you would accept the task of preparing the oration to be given at his obsequies, according to the resolution taken by the deputies of the Academy, and we shall be especially pleased if you would deliver it yourself. We bid you farewell.

Bernardino Grazzini also wrote to the deputies to tell them that the duke was displaying all the enthusiasm that could possibly be hoped for and that they could expect to receive from his Excellency every kind of help and favour. While all these things were being arranged at Florence, Michelangelo's nephew, Lionardo Buonarroti, was in Rome, where he had gone on hearing that his uncle was ill, only to arrive too late, although he travelled with the post. He was told by Daniele da Volterra, who had been a very dear friend of Michelangelo, and by others who had been close to that devout and venerable artist, that Michelangelo had asked and prayed for his body to be taken to his homeland, the noble city of Florence,

 1. The 'Rector of the hospital' was Vincenzo Borghini, prior of the Innocenti, the Foundling Hospital established early in the fifteenth century.

which he had always loved deeply. So with great determination and promptitude Lionardo secretly smuggled the corpse out of Rome and sent it to Florence in a bale, disguised as a piece of merchandise.

I must emphasize that Michelangelo's last wish confirmed what was certainly true (although many think the contrary), namely, that the reason for his having stayed away from Florence for so long was because of the climate; experience had taught him that the air of Florence, being harsh and raw, was extremely bad for his health, whereas the milder and more temperate climate of Rome kept him in good health, with all his faculties as lively and intact as ever, to nearly his ninetieth year, and enabled him to continue working to the very last.

As Michelangelo's body arrived quickly and unexpectedly at Florence, some of the arrangements for its reception were still to be completed; and at the request of the deputies on the day of its arrival, which was 11 March, a Saturday, the corpse was placed in the vault of the Confraternity of the Assumption, which is beneath the steps at the back of the high altar of San Pietro Maggiore. Nothing more was done that day, and then the next day, which was the second Sunday in Lent, all the painters, sculptors, and architects secretly assembled by the church, where they had taken nothing more than a pall of velvet, richly decorated and embroidered with gold, which they draped over the bier and the coffin, on which there lay a crucifix. Then at nightfall they gathered round the corpse, and the oldest and most distinguished masters each took one of a large number of torches brought for the purpose and the young men raised the bier at the same moment. They did this so eagerly that those who could approach near and get a shoulder under the bier could indeed count themselves fortunate, for they realized that in the future they would be able to boast of having carried the remains of the greatest man their arts had ever known. Inevitably, all the activity around the church had caused a crowd to gather, and it grew larger still after it was revealed that Michelangelo's body was there and was to be carried to Santa Croce. As I said, every precaution had been taken to keep the proceedings secret and prevent the spread of rumours, since it was feared that if a

crowd gathered there would be confusion and disorder and also because they were anxious that at that stage everything should be carried out quietly and without pomp, all public display being reserved for a more convenient and appropriate time. However, what with one thing and another, the contrary took place. For as to the crowd, the news passed from mouth to mouth and in the twinkling of an eye the church became so full of people that only with the greatest difficulty was the corpse carried to the sacristy, there to be freed from its wrappings and laid to rest. As for the magnificence of the occasion, although certainly it is very impressive and splendid to see a funeral procession with a sea of wax-lights, a great crowd of priests and acolytes, and mourners all clothed in black, none the less, on this occasion just as imposing was the sight of so many distinguished artists, already highly honoured and promising even more for the future, gathered together round the body of Michelangelo to assist in the ceremonies with such love and devotion. To be sure, the number of such artists (and they were all present) has always been very great in Florence, where the arts have always flourished. (And without offence to other cities I think I may say that their first and principal centre is Florence, just as that of the sciences was Athens.)

As well as the craftsmen there were so many citizens following them and so many others who had joined the procession as it went through the streets that the place could hold no more; and, more impressive still, nothing was heard except praise of Michelangelo, everyone agreeing that true genius has so much power that, after hope of further honour or achievement from a great artist has gone, yet for its own sake and merit it continues to be loved and honoured. For these reasons, the demonstration was more sincere and wonderful than any lavish display with gold and banners could possibly have been. So with its distinguished escort, Michelangelo's body was carried into Santa Croce, where the monks performed the customary services for the dead; and it was then taken (not, as was said, without the greatest difficulty because of the crowds) into the sacristy. Then Vincenzo Borghini, who was there by virtue of his office as the duke's representative,

thinking to do something that would please many people and also (as he later confessed) anxious to see in death the man he had never seen while he was living, resolved to have the coffin opened. And then, when that was done, whereas he and all of us who were present were expecting to find that the body was already decomposed and spoilt (since Michelangelo had been dead twenty-five days, and twenty-two in the coffin) on the contrary we found it still perfect in every part and so free from any evil odour that we were tempted to believe that he was merely sunk in a sweet and quiet sleep. Not only were his features exactly the same as when he was alive (although touched with the pallor of death) but his limbs were clean and intact and his face and cheeks felt as if he had died only a few hours before.

After the great crush of people had left, arrangements were made to put the body in a tomb of the church near the altar of the Cavalcanti family, beside the door leading to the cloister of the chapter-house. Meanwhile, word of what was happening spread through the city, and so many young men ran to see the corpse that it was scarcely possible to close the tomb; and if it had been day instead of night-time it would have had to be left open for many hours to satisfy the people. The following morning, when the painters and sculptors were preparing for the ceremony, many of those talented people who have always abounded in Florence attached various verses in Latin and Florentine over the tomb, and this continued for some time; and the compositions which were later published formed only a small proportion of the many that were written.

But to come to the obsequies: these were not solemnized the day after St John's Day, as had been planned, but were postponed until 14 July. The three deputies (the fourth, Benvenuto Cellini, being somewhat indisposed had played no part at all in the matter) chose as their commissary the sculptor Zanobi Lastricati, and decided that they would arrange an imaginative display, worthy of their art, rather than anything that was ostentatious and costly. They all emphasized that it was a question of how a man like Michelangelo should be honoured by men of his own profession whose wealth con-

sisted not in vast possessions but in artistic skill; the answer was to avoid any regal pomp or superfluous vanities, to display ingenious inventions and works full of vigour and charm created by the knowledge and dexterity of our craftsmen, and thus to honour art by art.

So although we had already received from his Excellency all the money we had asked for, and were assured of being given any more that might be needed, none the less we were convinced that we were expected to provide something whose originality and beauty sprang from skill and imagination rather than a lavish display demanding considerable outlays and elaborate equipment. All the same, in the event, the magnificence of the occasion equalled the works that were created by the academicians, and the splendour of the ceremony matched the admirably ingenious and fanciful inventions.

The final arrangements were as follows. In the central nave of San Lorenzo and between the two lateral doors (one leading to the street, the other to the cloister) was erected a rectangular catafalque, fifty-six feet high, twenty-two feet long, and eighteen broad, with a figure of Fame at the top. On the base of the catafalque, four feet from the floor, on the side facing the principal door of the church, were two beautiful recumbent figures of river-gods, namely, the Arno and the Tiber. The Arno was holding a cornucopia of flowers and fruit, to signify the artistic achievements of Florence which have been so great and so many that they have filled the world, and notably the city of Rome, with extraordinary beauty. This thought in turn was aptly represented by the attitude of the figure of Tiber, shown with one arm extended and the hand full of flowers and fruit from the cornucopia opposite; the enjoyment by this figure of the fruits of the Arno also signified that Michelangelo had spent a great many years of his life in Rome, where he created those marvellous works that have astonished the world. The Arno had a lion as its sign, and the Tiber a wolf, with the infants Romulus and Remus; both the river-gods were colossal figures of exceptional grandeur and beauty, and both looked like marble. The Tiber was executed by Giovanni di Benedetto of Castello, a pupil of

Bandinelli's, and the Arno by Battista di Benedetto, a pupil of Ammanati's, both excellent young artists of considerable promise.[1]

Having been furnished in this way and adorned with lights, the church became crowded by people beyond number, for everyone, putting every other care aside, had run to see this noble spectacle. When the procession entered the church, first came the duke's representative, accompanied by the captain and halbardiers of the duke's guard, and followed by the consuls and the academicians, and, in brief, by all the painters, sculptors, and architects of Florence. After all these had taken their places between the catafalque and the high altar, where for a good space of time they had been awaited by a vast gathering of nobles and gentlemen, seated according to their personal rank, a solemn Mass for the Dead was begun, with music and every kind of ceremony. After Mass finished, Varchi mounted the pulpit to perform an office which he had not undertaken since the death of Duke Cosimo's daughter, the most illustrious duchess of Ferrara. Then with the elegance of manner, the expressions, and the tone of voice which were peculiarly characteristic of his style of oratory, Varchi praised the divine Michelangelo, describing his merits, his life, and his works. One can truthfully say that Michelangelo was most fortunate not to have died before our Academy was established, considering the magnificent pomp and ceremony with which it honoured his death. And it must be counted fortunate that he passed on to everlasting life and happiness before Varchi, for he could not have been eulogized by a more eloquent or

1. Vasari continues with his description of the catafalque, with its paintings (showing episodes from the life of Michelangelo), its inscription to 'the greatest painter, sculptor, and architect that ever lived', and various colossal figures and statues. The church itself, he records, was lavishly decorated with hangings, pictures, and statues, representing the great artists of antiquity and of modern times, and other scenes showing the honours conferred on Michelangelo during his lifetime: altogether an extraordinary demonstration of the veneration in which he was held by Vasari's contemporaries, as if he were a saint as well as the 'divine' artist. A fascinating account of the obsequies of Michelangelo and of the role of Vasari can be read in *The Divine Michelangelo* by Rudolf and Margot Wittkower (Phaidon, 1964). This contains a facsimile edition of a booklet on the memorial service which is closely related to Vasari's own account: Jacopo Giunti's *Esequie del divino Michelagnolo* (1564).

learned man. Benedetto Varchi's funeral oration was published fairly soon afterwards, as was another very fine oration, praising Michelangelo and the art of painting, which was composed by the most noble and learned Leonardo Salviati, who was then a young man of about twenty-two, a brilliantly accomplished and versatile writer, in both Latin and Tuscan, as is recognized today and as the whole world will discover in the future.

But what shall I say, or what can I say that will be adequate, of the ability, goodness, and foresight shown by the Very Reverend Vincenzo Borghini? Let it be enough to record that it was with Borghini as their leader, guide, and counsellor that the accomplished artists of the Academy of Design solemnized Michelangelo's obsequies. For although each artist was capable of achieving far more in his own branch of art than was required for the obsequies, on this occasion, as always when an enterprise is to be carried through worthily, it was necessary to put a single man with complete authority in charge of all the arrangements. As it was not possible in a single day for the whole city to see the decorations in Santa Croce (as the duke wished) everything was left standing for several weeks, to the satisfaction of the people of Florence and of visiting strangers from places around.

Now I shall not include here the very many epitaphs and verses in Latin and Tuscan composed by various able men in honour of Michelangelo, for they would need a volume to themselves and in any case have been quoted and published elsewhere. But I shall not omit to mention, as I end this *Life*, that after Michelangelo had been honoured in all the ways described above, the duke then ordered that he should be entombed in Santa Croce, where he had himself expressed the wish to be buried along with his ancestors. To Michelangelo's nephew Lionardo, his Excellency gave all the marbles and variegated stones that were needed for the sepulchre, which was designed by Giorgio Vasari and carried out by Battista Lorenzi, an able sculptor, who also did the bust of Michelangelo. Three statues, representing Painting, Sculpture, and Architecture, are to adorn the tomb; and these have been allocated to Battista, to Giovanni dell'Opera, and to Valerio

Cioli, Florentine sculptors. Work on the statues and the tomb is proceeding now and they will soon be finished and put in place. The cost of the tomb (not counting the marbles received from the duke) is being met by Lionardo Buonarroti; but in order not to fail in any way in honouring the memory of the great Michelangelo, his Excellency proposes to place his bust with a memorial tablet in the cathedral, where are to be found the busts and names of other distinguished Florentines.

DESCRIPTION OF THE WORKS OF
TITIAN OF CADORE
Painter, c. 1487/90–1576

TITIAN was born in Cadore, a small town on the River
Piave, about five miles distant from the pass of the Alps, in
the year 1480; his family, the Vecelli, was one of the noblest in
the district. He grew into a boy of fine spirit and lively intelli-
gence, and at the age of ten he was sent to stay with his uncle,
a respected Venetian citizen, who saw that he was anxious to
become a painter and so placed him with Giovanni Bellini, an
accomplished and very famous painter. Under his discipline
Titian studied hard, and he soon showed that nature had
endowed him with all the qualities of intelligence and judge-
ment that are necessary for the art of painting. Now at that
time Giovanni Bellini and the other painters of that part of
Italy, not being in the position to study ancient works of art,
often, or rather always, used to copy what they were doing
from life, in an arid, crude, and laboured manner; so for the
time being Titian himself followed their style of work.

Subsequently, however (this was about the year 1507),
Giorgione of Castelfranco, being dissatisfied with the methods
then in use, began to give his pictures more softness and
greater relief. Despite his development of a fine style, how-
ever, Giorgione still used to work by setting himself in front
of living and natural objects and reproducing them with colours
applied in patches of harsh or soft tints according to life; he
did not use any initial drawings, since he firmly believed that
to paint directly with colours, without reference to drawing,
was the truest and best method of working and the true art of
design. Giorgione failed to see that, if he wants to balance his
compositions and to arrange his various inventions well, the
painter must first do various sketches on paper to see how
everything goes together. The idea which the artist has in his
mind must be translated into what the eyes can see, and only

then, with the assistance of his eyes, can the artist form a sound judgement concerning the inventions he has conceived. In addition, if the artist wants to comprehend the nude he must study it extremely carefully, and he can only do this by making use of drawings; the painter becomes a slave if he has to keep a nude or draped model in front of him all the time he is working. On the other hand, by constantly drawing on paper he gradually learns how to design and paint with ease when he comes to execute the final work; and when he acquires experience in this way he develops perfect judgement and style, and he is not weighed down by the labour and effort characteristic of the work of the artists we mentioned earlier. Moreover, the use of drawings furnishes the artist's mind with beautiful conceptions and helps him to depict everything in the natural world from memory; he has no need to keep his subject in front of him all the time or to conceal under the charm of his colouring his lack of knowledge of how to draw, as for many years (having never seen Rome or any completely perfect works of art) did the Venetian painters, Giorgione, Palma, Pordenone, and the rest.

After Titian had seen Giorgione's style and method of working he abandoned the manner of Giovanni Bellini, though he had practised it for a long time, and adopted that of Giorgione. Before very long he was imitating his works so well that (as I shall describe later) his pictures were sometimes mistakenly believed to be by Giorgione. Then, having grown older in experience and judgement as well as years, Titian executed many works in fresco, which cannot be enumerated in order as they are dispersed in various places. It is enough to record that they were so good that many knowledgeable people gave it as their opinion that he would become a truly great painter, as indeed he did. At the time he first began to paint like Giorgione, when he was no more than eighteen, Titian did the portrait of a friend of his, a gentleman of the Barberigo family, which was held to be extremely fine, for the representation of the flesh-colouring was true and realistic and the hairs were so well distinguished one from the other that they might have been counted, as might the stitches in a doublet of silvered satin which also appeared in that work. In

short the picture was thought to show great diligence and to be very successful. Titian signed it on a dark ground, but if he had not done so, it would have been taken for Giorgione's work.

Meanwhile, after Giorgione himself had executed the principal façade of the Fondaco de' Tedeschi, through Barberigo Titian was commissioned to paint some scenes for the same building, above the Merceria. After this, he painted a large picture with life-size figures which is now in the hall of Andrea Loredano, who lives near San Marcuola. This picture shows Our Lady on the journey to Egypt in the middle of a great forest, and it contains several landscapes. These were beautifully executed because Titian had studied this kind of painting for many months, when he gave hospitality for that purpose to some German painters who specialized in depicting verdant scenes and landscapes. In the woods he painted a number of animals, drawn from life, which are truly convincing and realistic. Next, in the house of a crony of his called Giovanni van Haanen, a Flemish merchant, Titian painted Giovanni's own portrait and also an *Ecce Homo*, with a number of figures, which Titian himself and many others regard as an extremely beautiful work. He also did a painting of Our Lady with other life-size figures of men and children, all portrayed from various members of the household.

Then, in the year 1507 (while the Emperor Maximilian was waging war against the Venetians), according to his own account Titian painted for the church of San Marziale a picture showing the Angel Raphael with Tobias and a dog; and in the background is a landscape with a little wood in which St John the Baptist is depicted kneeling in prayer to heaven, from which there comes a radiance which bathes him in light. It is thought that he executed this work before he started work on the façade of the Fondaco de' Tedeschi. (In connexion with this façade, Titian uncovered part of what he did, and then many gentlemen, not realizing that he was working there instead of Giorgione, cheerfully congratulated Giorgione when they happened to meet him and said that he was doing better work on the façade towards the Merceria than he had done for the part which is over the Grand Canal. This so

incensed Giorgione that until Titian had completely finished and his share in the work had become general knowledge he would hardly show himself out of doors. And from then on he would never allow Titian to associate with him or be his friend.)

The following year, 1508, Titian published in a woodcut his Triumph of the Faith with its countless figures: our first parents, the patriarchs, prophets, sibyls, the Holy Innocents, the martyrs and apostles, and Jesus Christ himself, borne in triumph by the four evangelists and the four Doctors of the Church, with the Holy Confessors behind. This is a picture of great force and fine style, in which Titian showed expert knowledge. I well remember Fra Sebastiano del Piombo talking about this and saying that if Titian had been in Rome at that time and had seen work by Michelangelo and Raphael along with the ancient statues, and had studied drawing, he would have done really stupendous things, in view of his wonderful facility in colouring. He deserved, Fra Sebastiano added, to be celebrated as the finest and greatest imitator of nature as far as colour was concerned, and with a foundation of the supreme method of design he would have rivalled both the painter from Urbino and Buonarroti.[1]

Subsequently, Titian went to Vicenza where he painted in fresco, on the gallery where the courts of justice are held, a picture of the Judgement of Solomon, a very fine work. On his return to Venice he painted the façade of the Palazzo Grimani; then in Padua, for the church of Sant'Antonio, he did some more frescoes illustrating events from the life of St Anthony, and for the church of Santo Spirito he painted a little altarpiece showing St Mark seated in the middle of various saints, for whose faces he did some portraits from life executed in oils with marvellous diligence. Many people have thought that this panel was by Giorgione. At that time because of the death of Giovanni Bellini there was left unfinished a scene being painted for the hall of the Great Council, and showing Frederick Barbarossa kneeling before Pope Alexander III, who is placing his foot on his neck, at the door of the church of San Marco. Titian completed this picture, changing

1. Raphael, of course, and Michelangelo.

many details and putting in portraits of his friends and of others; and the Senate rewarded him by giving him an office in the Fondaco de' Tedeschi called the Agency, which yields three hundred crowns a year and which the senators customarily give to the best painter in the city on condition that he accept the obligation to portray the city's ruler, or doge, at his election, for the fee of only eight crowns to be paid by the doge concerned. As they are done, these portraits are put on public view in the palace of San Marco.

During the year 1514 Duke Alfonso of Ferrara caused to be decorated a small chamber for which he commissioned the local painter Dosso to paint various compartments showing stories of Aeneas, Mars, and Venus, and in a grotto Vulcan with two smiths at the forge. The duke also wanted to have there some pictures by Giovanni Bellini, who painted on another wall a vat of red wine with some Bacchanals around it, together with musicians and satyrs and other drunken figures, both male and female, and near them a nude and very beautiful Silenus riding on his ass in the middle of various figures with their hands full of grapes and other fruits. This work was coloured and finished so diligently that it is one of the finest pictures Giovanni Bellini ever painted, though there is a certain sharpness in the style of the draperies which suggests the German manner. (This is not surprising, for he imitated a picture by the Fleming Albrecht Dürer which about that time had been brought to Venice and lodged in the church of San Bartolomeo; it is a rare work of art, alive with beautiful figures painted in oils.) On the vat he painted, Giovanni Bellini wrote the words: *Ioannes Bellinus Venetus p. 1514*; and as, being an old man, he was not able to finish the work completely Titian was sent for to do so, as the most capable of all the other painters. Anxious to better himself and make his name, Titian applied himself very diligently and executed the two scenes needed to complete the room. In the first of these he depicted a river flowing with bright red wine with drunken singers and musicians, male and female, and a nude woman asleep, so beautiful that she seems alive, together with various other figures. On this painting, Titian signed his name. In the other scene, which is next to this and

is the first to be seen on entering, he painted a host of pretty Cupids and *putti* in a variety of attitudes. This, as much as the first scene, delighted the duke. Among the loveliest of its details is the sight of one of the *putti* making water into a river and watching his reflection in the water, while the others are moving in front of a pedestal in the shape of an altar on which is a statue of Venus with a sea-conch in her right hand and near her the figures of Grace and Beauty, two lovely forms executed with wonderful diligence. On the door of a wardrobe Titian painted an image of Christ, from the waist upwards, to whom one of the common Jews is showing the coin of Caesar; and this marvellous and wonderful painting of Christ, along with the other pictures in that room, are said by our leading craftsmen to be the finest and best executed of all Titian's works. Without doubt they are outstanding pictures, and Titian well deserved to be most generously recompensed and rewarded by the duke, of whom he did an excellent portrait showing him with one arm resting on a great piece of artillery. Titian also did the portrait of Signora Laura, who later became the duke's wife; and he produced a breath-taking painting. To be sure, gifts can work wonders with those who labour for the love of art, and are spurred on by the generosity of princes.

At that time Titian made friends with the inspired Lodovico Ariosto, who acknowledged him as a most outstanding painter and celebrated him in his *Orlando Furioso*:

> . . . and Titian who honours
> Cador, as they do Venice and Urbino.[1]

After he had returned to Venice, for the father-in-law of Giovanni da Castel Bolognese Titian did a painting in oils on canvas of a naked shepherd and a country girl who is offering some pipes for him to play, with an extremely beautiful landscape. This picture, today, is to be found in Faenza, in Giovanni's house. Next, for the church of the Frari, called the Ca'grande, Titian painted an altarpiece for the high altar

1. . . . e Tizian che onora
 Non men Cador, che quei Venezia e Urbino.

showing Our Lady ascending into heaven and below her the twelve apostles who are watching as she ascends; but there is little to be seen of this work, because it was painted on cloth and has not, perhaps, been looked after very well. In the same church, for the chapel of the Pesari family, he painted a picture of the Madonna, with her Son in her arms, and St Peter and St George; and round about are the patrons of the work, kneeling down, all portrayed from life: they include the bishop of Paphos and his brother, just returned from the victory which the bishop had won against the Turks. For the little church of San Niccolò in the same convent Titian painted an altarpiece on which he depicted St Nicholas, St Francis, St Catherine, and also a nude St Sebastian portrayed from life whose fine limbs and trunk are conveyed without artifice, all being presented just as Titian saw it in nature, so that the body of St Sebastian seems as if printed from a living figure, it is so fleshlike and natural. It is held therefore to be extremely beautiful, as is the very lovely figure of Our Lady with the infant Christ in her arms, at whom all the saints are looking. The subject of this picture was drawn on wood by Titian himself and then engraved and printed by others.

For the church of Rocco, after he had done the works described above, Titian painted a picture of Christ carrying the cross on his shoulder and being dragged along at the end of a rope by one of the Jews; this image (which many people have attributed to Giorgione) is today held in the greatest veneration in Venice, where it has received in alms more crowns than Titian and Giorgione ever earned in all their lives.

Titian was then asked to Rome by Bembo (who at that time was secretary to Pope Leo X and whom he had already portrayed) so that he might see Rome itself, and visit Raphael of Urbino and other artists. But he kept putting things off from one day to the other until Raphael died in 1520, and then Leo, and in the end Titian did not go.

For the church of Santa Maria Maggiore he did a painting of St John the Baptist in the desert among some rocks, an angel that seems alive, and a little piece of distant landscape with some trees on the bank of a river, all extremely graceful.

He painted portraits from life of Prince Grimani and Loredan, which were held to be admirable; and not long afterwards he portrayed King Francis when he was leaving Italy to return to France. Titian also painted the portrait of Andrea Gritti, the year he was elected doge, producing a work of rare quality in which he depicted Our Lady, St Mark, and St Andrew with the countenance of the doge. This marvellous picture is in the Sala del Collegio. And since, as I said, he was under an obligation to do so, he has also portrayed, in addition to those I mentioned, the following who have been doges in their time: Pietro Lando, Francesco Donato, Marcantonio Trevisan, and Veniero. However, he has recently been excused this duty by the two doges and brothers, Priuli, on account of his great age.

Before the sack of Rome, Pietro Aretino, one of our most famous contemporary poets, had gone to live in Venice where he became very friendly with Sansovino and Titian. This brought Titian great honour and advantages, for the reason that Aretino made him known wherever his pen reached, and especially to important rulers (as will be described in the proper place).[1] Meanwhile, to return to Titian's works, he made the altarpiece for the altar of St Peter Martyr in the church of SS. Giovanni e Paolo, depicting the holy martyr, in a figure larger than life, prostrate on the ground in a forest of very great trees, and furiously assailed by a soldier who has wounded him so grievously in the head that, as he lies there half alive, one sees the horror of death in his face; and the expression of another friar, who has taken to his heels, similarly reflects terror and fear of death. In the air above are two nude angels, descending from heaven with a flash of lightning which lights up both the beautiful landscape and all the rest of the work, and of all the pictures painted so far by Titian this is the most finished, the most celebrated, the greatest and the best conceived and executed. When it was seen by Gritti (who was always very friendly towards Titian and Sansovino as well) he had Titian allocated a great scene in the hall of the Great Council, showing the rout of Ghiaradadda. Here Titian depicted soldiers fighting in furious combat while a terrible

1. Pietro Aretino (1492–1556), a scurrilous, talented, and versatile writer.

rain falls from heaven. This work, wholly taken from life, is held to be the best of all the scenes in the hall, and the most beautiful. In the same palace, at the foot of a stairway, he did a painting in fresco of the Madonna.

Not long afterwards he painted a very fine Christ seated at table with Cleophas and Luke for a gentleman of the Contarini family, who rightly decided that the picture was worthy to be on public view. So, as a lover of his country and of the commonwealth, he presented it to the Signoria. It was kept for a long time in the apartments of the doge but today it is on view to the public, over the door where everyone may see it, in the Salotto d'Oro in front of the hall of the Council of Ten.

Titian also made, about the same time, for the School of Charity a picture of the Virgin ascending the steps of the Temple, in which he depicted all kinds of heads portrayed from life. And for the School of St Faustinus he did a small picture of St Jerome in Penitence, which won great praise from other artists, but which, along with the church itself, was destroyed by fire two years ago.

It is said that in the year 1530, when the Emperor Charles V was in Bologna, through the agency of Pietro Aretino Titian was asked by Cardinal Ippolito de' Medici to go to that city. And there he executed a very fine portrait of his Majesty in full armour, which so pleased the emperor that he had him paid a thousand crowns; however, subsequently, Titian had to give half of this to the sculptor Alfonso Lombardi, who had made a model to be reproduced in marble.

After his return to Venice, Titian found that a number of gentlemen who had taken Pordenone into their favour (giving high praise to the works executed by him on the ceiling of the Sala de' Pregai and elsewhere) had won for him the commission to paint a little altarpiece in the church of San Giovanni Elemosinario; this was so that he should do something in competition with Titian, who shortly before had painted for the same place a picture showing St John the Almoner in the robes of a bishop.[1] However, for all the

1. Giovanni Antonio Pordenone (1483/4–1539) was a north Italian painter who settled in Venice where for a short while he seemed to rival Titian's supremacy.

diligence with which he worked, Pordenone's altarpiece fell far short of Titian's work. Meanwhile, for the church of Santa Maria degli Angeli at Murano, Titian painted a very fine panel picture of the Annunciation. But the man who had commissioned it was reluctant to pay the five hundred crowns demanded and so Titian sent the picture, on the advice of Pietro Aretino, to the Emperor Charles V who was so tremendously pleased with it that he made him a gift of two thousand crowns. Where this painting was to have gone a work by Pordenone was placed instead.

No long time passed before Charles V, returning with his army from Hungary to confer with Pope Clement at Bologna, wanted Titian to paint his portrait once again. And before he left Bologna Titian also painted a portrait of Cardinal Ippolito de' Medici, in Hungarian dress, and in another smaller picture the same cardinal in full armour. Both of these are now in Duke Cosimo's wardrobe. At this time Titian also did portraits of Alfonso d'Avalos, marquis del Vasto, and of Pietro Aretino, who then persuaded him to become the friend and servant of Federigo Gonzaga. Titian went back with Gonzaga to his own state, where he painted his portrait, which is a living likeness, and then the portrait of the cardinal, his brother. After these were finished, for the adornment of one of Giulio Romano's rooms he painted twelve figures, from the waist upwards, of the twelve Caesars, beneath each of which Giulio subsequently painted a story from their lives.

In his birthplace, Cadore, Titian has painted a panel picture showing Our Lady with St Tiziano the bishop and a portrait of himself, kneeling. In the year when Pope Paul III went to Bologna and then on to Ferrara, Titian went to court, where he painted the Pope's portrait (a very fine work) and from it another for Cardinal Santa Fiore. These two portraits, for which the Pope paid him very generously, are now in Rome, one in the wardrobe of Cardinal Farnese and the other in the hands of the heirs of Cardinal Santa Fiore; many copies were taken from them and are now dispersed throughout Italy. About the same time Titian also did a portrait of Francesco Maria, duke of Urbino; this was a marvellous work which

prompted Pietro Aretino to honour him in a sonnet beginning:

> When the great Apelles used his art
> To paint the face and form of Alexander . . .

In the wardrobe of the same duke there are two very lovely female heads painted by Titian as well as a young recumbent Venus with flowers and light draperies about her (a very beautiful and well-finished picture), and, in addition, a half-length figure of St Mary Magdalen with her hair all loose, a really outstanding painting. There also are the portraits of Charles V, King Francis as a young man, Duke Guidobaldo II, Pope Sixtus IV, Pope Julius II, Paul III, the old Cardinal of Lorraine, and Suleiman, emperor of the Turks: all these are portraits from the hand of Titian, as I said, and they are all very beautiful. (There are many other works in the same wardrobe, including a head of Hannibal of Carthage engraved on an antique cornelian, and a lovely marble head by Donatello.)

In 1541, for the friars of Santo Spirito at Venice, Titian painted the altarpiece of the high altar. He showed the descent of the Holy Spirit upon the apostles, and he depicted God-the-Father in the image of fire and the Holy Spirit in the form of a dove. This panel deteriorated very quickly and after a great deal of litigation Titian had to paint it again, and it is the second version which is over the altar today. For the church of San Nazzaro in Brescia he painted an altarpiece for the high altar in five scenes: in the centre is Jesus Christ returning to life, with some figures of soldiers around him; and at the sides are shown St Nazarius himself, St Sebastian, the Angel Gabriel, and the Virgin receiving the Annunciation. For a wall at the entrance of the cathedral of Verona he painted a panel picture showing the Assumption of Our Lady into heaven, with the apostles on the ground below, which is regarded as the best of the modern works in that city.

In 1541 Titian executed the portrait of Don Diego di Mendoza, at that time ambassador of Charles V to Venice, producing a splendid full length standing figure; and with this Titian started what has since come into fashion, namely

the creation of full-length portraits. In the same fashion he executed the portrait of the Cardinal of Trent, when a young man; and for Francesco Marcolin he did a portrait of Pietro Aretino, though this was not as fine as another he did of the same subject which Aretino himself sent as a gift to Duke Cosimo de' Medici, to whom he also sent a head of Signor Giovanni de' Medici, the Lord Duke's father. This head was copied from a cast belonging to Aretino which was taken from Giovanni's face when he died at Mantua. Both these portraits are in Duke Cosimo's wardrobe, along with many other noble pictures.

Now that same year, after Vasari had been thirteen months in Venice in order to execute a ceiling for Giovanni Cornaro and some works for the Confraternity of Hosiers, Sansovino, who was directing the construction of Santo Spirito, had had him make designs for three large oil-paintings which he was also to execute on the ceiling. But Vasari left Venice, and these pictures were then allotted to Titian who executed them very beautifully and with wonderful artistry foreshortened his figures from below upwards. In one he depicted Abraham sacrificing Isaac, in the other David severing the head of Goliath, and in the third Abel slain by his brother Cain. At this time Titian also painted a self-portrait, to leave as a reminder of himself for his children. Then in 1546, at the summons of Cardinal Farnese, he went to Rome where he found Giorgio Vasari who had returned from Naples and was working for the cardinal on the hall of the Palazzo della Cancellaria. The cardinal recommended Titian to Vasari, who then lovingly kept him company and took him to see the sights of Rome. After Titian had rested for some days he was given rooms in the Belvedere so that he could set his hand to painting once more the portrait of Pope Paul, at full length, with those of Farnese and of Duke Ottaviano. He executed these extremely well, and those lords were delighted with his work. And they persuaded him to paint, for presenting to the Pope, a half-length figure of Christ in the form of an *Ecce Homo*. This picture, either because the works of Michelangelo, Raphael, Polidoro, and others had made him lose courage, or for some other reason, did not seem to the painters for all its

qualities to be as good as many other of Titian's paintings, especially the portraits. Then one day Michelangelo and Vasari went along to visit Titian in the Belvedere, where they saw a picture he had finished of a nude woman, representing Danaë, who had in her lap Jove transformed into a rain of gold; and naturally, as one would do with the artist present, they praised it warmly. After they had left they started to discuss Titian's method and Buonarroti commended it highly, saying that his colouring and his style pleased him very much but that it was a shame that in Venice they did not learn to draw well from the beginning and that those painters did not pursue their studies with more method. For the truth was, he went on, that if Titian had been assisted by art and design as much as he was by nature, and especially in reproducing living subjects, then no one could achieve more or work better, for he had a fine spirit and a lively and entrancing style. To be sure, what Michelangelo said was nothing but the truth; for if an artist has not drawn a great deal and studied carefully selected ancient and modern works he cannot by himself work well from memory or enhance what he copies from life, and so give his work the grace and perfection of art which are beyond the reach of nature, some of whose aspects tend to be less than beautiful.

Eventually, after he had received many gifts from those noblemen (including a fairly lucrative benefit for his son Pomponio) Titian left Rome to return to Venice. But first his second son, Orazio, did a very fine portrait of the accomplished violinist Battista Ceciliano, and he himself painted several portraits for Duke Guidobaldo of Urbino. Then when he reached Florence and saw the city's rare works of art he was as impressed and amazed as he had been when he arrived in Rome. He visited Duke Cosimo (who was then at Poggio a Caiano) and offered to paint his portrait, but his Excellency showed no great interest, perhaps because he was anxious to avoid slighting the distinguished artists to be found in his city and dominion.

After his return to Venice, Titian finished for the Marquis del Vasto a picture of an Allocution (as they called it) made by that nobleman to his troops. And after that he executed

portraits of Charles V, of the Catholic king, and of many others. After these had been finished, for the church of Santa Maria Nuova in Venice he painted a small panel picture of the Annunciation; and then, with the assistance of his young men, for the refectory of SS. Giovanni e Paolo he painted a Last Supper. For the high altar of the church of San Salvadore he painted an altarpiece of the Transfiguration of Christ on Mount Tabor, and for another altar in the same church he did a painting of the Annunciation. But these works, though they have some good aspects, are not greatly esteemed by Titian himself, and in fact fall short of the perfection of his other pictures. In any case, since the works of Titian, especially the portraits, are without number it is hardly possible for me to mention them all; so I shall draw attention only to the most memorable, without putting them in the order in which they were painted, as it is not important to know which was first or which later.

As was said, Titian many times painted the portrait of Charles V, and in the end he was summoned for that purpose to court where he portrayed Charles as he was during his later years. The invincible emperor was so pleased by Titian's work that, once they had met, he would never be painted by anyone else; and every time Titian did his portrait he made him a gift of a thousand crowns in gold. His Majesty also ennobled Titian, giving him a pension of two hundred crowns, secured on the Treasury of Naples. Similarly, when he portrayed Charles's son, King Philip of Spain, Titian received from him an additional fixed allowance of two hundred crowns. So with the four hundred just mentioned and the three hundred that he has on the Fondaco de' Tedeschi from the Signori of Venice, without exerting himself Titian has a regular yearly income of seven hundred crowns. Portraits of Charles V and King Philip were sent by Titian to the Lord Duke Cosimo, who has them in his wardrobe. Titian also executed portraits of Ferdinand, king of the Romans, who was later elected emperor, and of his sons, Maximilian (now emperor) and Maximilian's brother. He did portraits of Queen Maria and, for the Emperor Charles V, of the duke of Saxony when he was a prisoner.

But what a waste of time this is! For there has been hardly a single lord of great name, or prince or great lady who has not been portrayed by Titian, a painter of extraordinary talent in this branch of art. He painted portraits of King Francis I of France (as was said), of Francesco Sforza, duke of Milan, the marquis of Pescara, Antonio da Leva, Massimiano Stampa, Giovanbattista Castaldo, and countless other lords besides. And as well as all the works I mentioned earlier he did many others at various times.

For example, in Venice, by command of Charles V, he painted a great altarpiece showing the Trinity enthroned: Our Lady and the infant Christ; the Dove over him, against a background of fire, to signify love; and the God-the-Father surrounded by fiery cherubim. To one side is Charles V himself and on the other the empress, both swaddled in linen with their hands joined in prayer, and surrounded by many saints. He painted the scene as commanded by his imperial Majesty, who at that time, when he was at the height of his victories, was beginning to show an inclination to withdraw from worldly things (as he subsequently did) and to die as a true Christian in fear of God and intent on salvation. The emperor told Titian that he wanted to place this picture in the monastery in which he subsequently ended his life. (As it is an outstanding work it is expected that it may shortly be published in engravings.) Titian also painted for Queen Maria a picture showing Prometheus bound to Mount Caucasus and torn by the eagle of Jove, a Sisyphus in hell burdened by his stone, and a Tityus devoured by the vulture. All these, except for the Prometheus, were sent to her Majesty, as well as a Tantalus (life-size like the others) painted in oils on canvas. Titian also did a Venus and Adonis that are really marvellous, showing Venus in a swoon on the ground while the youth is about to leave her, and some very lifelike dogs. On a panel of the same size he depicted Andromeda, bound to the rock, being liberated from the sea-monster by Perseus; and nothing could be more enchanting than this picture. Equally lovely is the painting of Diana, bathing in a stream with her nymphs, who transforms Actaeon into a stag. He also painted a picture showing Europa carried out to sea on the back of the bull. All

these paintings are in the possession of the Catholic king, and are held very precious for the vivacity that Titian's colouring has lent to the figures, which seem truly real and alive. It is certainly true that the method used by Titian for painting these last pictures is very different from the way he worked in his youth. For the early works are executed with incredible delicacy and diligence, and they may be viewed either at a distance or close at hand; on the other hand, these last works are executed with bold, sweeping strokes, and in patches of colour, with the result that they cannot be viewed from near by, but appear perfect at a distance. This method of painting is the reason for the clumsy pictures painted by the many artists who have tried to imitate Titian and show themselves practised masters; for although Titian's works seem to many to have been created without much effort, this is far from the truth and those who think so are deceiving themselves. In fact, it is clear that Titian has retouched his pictures, going over them with his colours several times, so that he must obviously have taken great pains. The method he used is judicious, beautiful, and astonishing, for it makes pictures appear alive and painted with great art, but it conceals the labour that has gone into them.

Recently, in a picture six feet high and eight feet broad, Titian painted Jesus Christ as a Child in the lap of Our Lady, being adored by the Magi, with a good number of other figures, each about two feet. This is a very lovely work, as is another picture copied from it which Titian gave to the old cardinal of Ferrara. Another extremely beautiful panel picture, in which he depicted Christ being mocked by the Jews, was placed in a chapel of the church of Santa Maria delle Grazie at Milan. For the queen of Portugal he painted another fine picture, slightly under life-size, showing Christ being scourged by the Jews at the column. For the high altar of San Domenico in Ancona he painted an altarpiece with Christ on the cross, and at the foot the beautifully executed figures of Our Lady, St John, and St Dominic; this work was in his later style, painted as I described with patches of colour.

In the church of the Crocicchieri at Venice, there is a panel

picture on the altar of St Lawrence in which Titian depicted the martyrdom of the saint and a building which is full of figures. St Lawrence is shown, in foreshortening, lying half on the gridiron over a great fire which is being kindled by some men standing about. Since Titian was representing the effect of night, there are two servants holding torches which light up the areas where the reflection of the fire burning thickly and fiercely below the gridiron does not reach. He also depicted a flash of lightning, springing down from heaven and cleaving the clouds to subdue the light of the fire and the torches, shining over the saint and the other principal figures. And as well as these three sources of light, the figures he painted in the distance at the windows of the building are bathed in the glow of the nearby lamps and candles. All this work, in short, is executed with beautiful art, genius, and judgement.

In the church of San Sebastiano at the altar of St Nicholas there is a little panel picture by Titian showing St Nicholas, who seems truly alive, seated in a chair painted to look like stone, with an angel holding his mitre. This work was commissioned by the advocate, Niccolò Crasso. Afterwards, for sending to the Catholic king, Titian painted a St Mary Magdalen, whom he showed down to the middle of the thighs, and all dishevelled, that is to say, with her hair falling over her shoulders and throat and breast; raising her head, with her eyes fixed on heaven, she reveals remorse in the redness of her eyes and sorrow for her sins in the tears she is shedding. This picture profoundly stirs the emotions of all who look at it; and, moreover, although the figure of Mary Magdalen is extremely lovely it moves one to thoughts of pity rather than desire. After it had been finished this picture appealed so greatly to a Venetian nobleman called Silvio that he gave Titian a hundred crowns to have it, as he was an enthusiastic lover of painting. As a result Titian had to paint another, which was no less beautiful, to send to the Catholic king.

Among the portraits by Titian is one of a Venetian citizen called Sinistri, a great friend of the artist's, and another of Paolo da Ponte, whose beautiful young daughter Giulia (who was a confidante of his) Titian also portrayed, as he did the

lovely Signora Irene, a young woman well versed in literature and music who was studying design. (When she died about seven years ago she was honoured by nearly every Italian writer.) Titian also painted the portrait of Francesco Filetto, the orator of happy memory, with one of his sons, who seems truly alive, standing in front of him in the same picture. (This painting is in the possession of Matteo Giustiniano, a lover of the arts, who has had his own portrait painted by Jacopo da Bassano. This is a fine work, as are the many others executed by Bassano, notably the small pictures and the paintings of animals of all kinds which are dispersed throughout Venice, where they are very highly regarded.)

Titian also did a second portrait of Bembo (after he had been made a cardinal), one of Fracastoro, and one of Cardinal Accolti of Ravenna, which Duke Cosimo has in his wardrobe. And our own Danese, the sculptor, has in his house in Venice a portrait by Titian of a gentleman of the Delfini family.[1] In addition, Niccolò Zono has seen a portrait by Titian of Rossa, the wife of the Grand Turk, a lady of sixteen, with that of her daughter Cameria, both of whom are depicted wearing lovely clothes and ornaments. In the house of the lawyer Francesco Sonica, a crony of Titian's, there is a portrait by Titian of Francesco himself, along with a large picture of Our Lady on the journey into Egypt. The Blessed Virgin has dismounted from the ass and is seated on a rock by the wayside; near at hand is St Joseph and the little St John, who is offering the Infant Christ some flowers gathered by an angel from the branches of a tree, which is in a wood full of animals; and in the distance the ass is grazing. All this forms a most graceful picture, which has been placed by the gentleman I mentioned in the palace he has built near Santa Justina in Padua.

In the house of a gentleman of the Pisani family, near San Marco, there is a marvellous portrait of a lady from the hand of Titian. For the Florentine, Monsignore Giovanni della Casa, a great contemporary figure distinguished both by blood and by learning, Titian painted a very beautiful portrait of a lady whom that nobleman loved when he was in

1. Danese Cattaneo (1509–73).

Venice. In return, he honoured Titian with the superb sonnet beginning:

> Titian, now I clearly see in a new guise
> My belovèd idol, opening her eyes . . .

Recently this eminent painter sent to the Catholic king a picture of the Last Supper with Christ and the apostles, which was fourteen feet long and a work of exceptional beauty.

In addition to the work mentioned above and many other pictures of less worth, which are ignored for the sake of brevity, Titian has in his house, sketched in and begun, the following works: the martyrdom of St Lawrence, a picture similar to the one described above, which he intends to send to the Catholic king; a large canvas showing Christ on the cross between the two thieves, and the executioners below, which he is painting for Giovanni d'Anna; a picture which was started for the Doge Grimani, father of the patriarch of Aquileia. Then for the hall of the Great Palace at Brescia Titian has begun three big pictures which are to form part of the decorations of the ceiling, as we mentioned when discussing the Brescian painter, Cristofano, and his brother.

Titian also, many years ago, began work for Duke Alfonso I of Ferrara on a picture showing the nude figure of a young woman bowing before the goddess Minerva; there is another figure close by, and in the distance a stretch of sea with Neptune in his chariot in the centre. However, because of the death of this ruler, whose ideas Titian was following, it was never finished and it is still in Titian's hands. Titian has also nearly but not quite finished a picture of Christ appearing to Mary Magdalen in the garden under the appearance of a gardener. The figures in this work are life-size, as are those in another picture of the same size of the entombment of Christ in the presence of Our Lady and the other Marys. Among the good things to be seen in Titian's house there is also a picture of the Madonna, with, as was said, a self-portrait finished four years ago, a very lifelike and beautiful painting. Finally, there is a painting of St Paul reading, a half-length figure so well portrayed that it seems to be the very St Paul inspired by the Holy Spirit. All these works, as I say, Titian has executed,

with many others which I leave out to avoid becoming wearisome, up to his present age of seventy-six years. Titian has always been in sound health and as fortunate as any man of his kind has ever been; from heaven he has received only favours and blessings. His house at Venice has been visited by all the princes, men of letters and distinguished people staying or living in Venice in his time; for, apart from his eminence as a painter, Titian is a gentleman of distinguished family and most courteous ways and manners. He has had some rivals in Venice, though none of any great worth. So he has easily surpassed them through the excellence of his work and his ability to mix with and win the friendship of men of quality. He has earned a great deal of money because his paintings have always commanded high prices; but during these last few years he would have done well not to have worked save to amuse himself, for then he would have avoided damaging with inferior work the reputation won during his best years before his natural powers started to decline. When Vasari, the author of this history, was at Venice in 1566 he went to visit his dear friend Titian, and he found him, despite his great age, busy about his painting, with his brushes in his hand. On that occasion Vasari took great pleasure in conversing with Titian and looking at his works. And Titian introduced to him his talented young Venetian friend, Giovan Maria Verdezzotti, a competent draughtsman and painter, as he has demonstrated in some very fine landscapes from his own hand. This young gentleman has had from Titian, whom he loves and honours as a father, two figures within two niches painted in oils, namely, an Apollo and a Diana.[1]

Titian, therefore, who has adorned with great pictures the city of Venice, or rather all Italy and other parts of the world, deserves the love and respect of all craftsmen, who ought to admire and imitate him in many things. For he is a painter who has produced and is still producing works which command unstinted praise and which will live as long as the memory of illustrious men endures.

1. In 1566 when Vasari saw him in Venice Titian was about ninety, not seventy-six as Vasari says earlier.

NOTES ON THE ARTISTS

CIMABUE

The only surviving work by Cimabue which is known to be his from documents is the figure of *St John* in the mosaic in the apse of Pisa Cathedral, of 1301. This is almost certainly Cimabue's last work and is not very suitable as a means of judging his style in painting. Nevertheless, several pictures are recorded by Vasari which correspond fairly closely in style, and these form the basis for all modern attributions to Cimabue.

Two of them are the *Crucifix* in Santa Croce, Florence, and the very large *Madonna and Child*, formerly in Santa Trinita in Florence and now in the Uffizi. Vasari mentions these quite specifically and he also mentions some frescoes in the basilica of St Francis at Assisi, perhaps including the famous *Madonna with St Francis* in the Lower Church. The frescoes in the Upper Church still exist, though in a very damaged condition. They were restored in the 1950s, but there is still room for argument about their style.

The most important surviving picture which can reasonably be attributed to Cimabue is, therefore, the *Santa Trinita Madonna* in the Uffizi, and, on the basis of the style of this work, several other pictures have been attributed to him, including a *Crucifix* in Arezzo and *Madonna* panels in Bologna and Paris, as well as several pictures now in the National Gallery of Art in Washington. The Washington pictures, however, are not generally accepted as Cimabue's work.

The *Rucellai Madonna*, described by Vasari as carried to the church to the sound of trumpets, is now generally thought to be the work of Duccio.

GIOTTO

There exist a fairly large number of paintings, both in fresco and on panel, which are certainly by Giotto and which therefore serve as the core of his work. As several of these are described explicitly by Vasari, it should not be difficult to arrive at a reasonably consistent picture of Giotto's art. However, the question is greatly complicated by the frescoes in the basilica of St Francis at Assisi. The chief of these are twenty-eight scenes, in the nave of the Upper Church, of the Life of St Francis together with several frescoes in the Lower Church, of

which those in the Magdalen Chapel and the *Franciscan Virtues* are perhaps the most important. Modern critical opinion is sharply divided on the question of Giotto's authorship of the St Francis cycle, although the traditional attribution of these scenes to Giotto (which can be traced back for at least one hundred years before Vasari wrote) is still maintained by many scholars.

Vasari mentions several other pictures which can be attributed with some certainty to Giotto. The most important are the large fresco cycle in the Arena Chapel at Padua and the series of frescoes in the church of Santa Croce in Florence. The Arena Chapel frescoes are certainly by Giotto; and those scholars who reject the attribution of the St Francis frescoes do so on the grounds that they are not painted in the same style as the Paduan cycle. Vasari records that Giotto painted four chapels and several altarpieces in Santa Croce in Florence, and he also mentions two works in the church of Ognissanti in Florence, a large *Madonna* and a small panel of the *Dormition of the Virgin*. The *Madonna* is accepted as being the one now in the Uffizi in Florence and it is generally received as a touchstone of Giotto's style. The small panel must be identified with the picture now in Berlin, but for inscrutable reasons some scholars who accept the Ognissanti *Madonna* reject the Berlin panel.

During the late 1950s and early 1960s the two surviving fresco cycles – of the four mentioned by Vasari – in Santa Croce, Florence, have been cleaned with surprising results. The scenes from the *Life of St Francis*, though badly damaged, now show Giotto's late style. The scenes from the *Lives of the two SS. John* have proved to be painted in a different technique, and are much less well preserved; nevertheless, the style of the parts that have been preserved is clearly Giotto's and it is necessary to reassess the development of his style in comparison with the *St Francis* cycle in the same church. Vasari records several other pictures by Giotto, such as the two crucifixes in Santa Maria Novella, in Florence, and in Rimini, both of which are usually accepted as Giotto's work by those who believe him to be the author of the St Francis cycle at Assisi. The great mosaic in St Peter's described by Vasari was very largely remodelled in the seventeenth century, so that it no longer gives a true idea of Giotto's design. There are, however, two fragments from the original mosaic, one of which is preserved in the Museum of St Peter's.

There are also several altarpieces which are tentatively identified with those recorded by Vasari, the most important of them being the two in Washington (some panels of which are in the Horne Museum in Florence and in Chaâlis in France), and the altarpiece now in the museum of Santa Croce in Florence which has recently been identi-

fied as the one recorded by Vasari in the Badia (the Abbey). Finally, there is the altarpiece in the Louvre of St Francis, which is signed by Giotto and recorded by Vasari. This, however, in spite of its credentials, is very generally regarded as a product of Giotto's workshop rather than a work of his own hand; and the same is usually said of the altarpiece now in the Vatican Museum, although research following a recent cleaning now shows that the picture, commissioned by Cardinal Stefaneschi for St Peter's, is of much greater importance than was formerly believed.

Several other pictures recorded by Vasari are either rejected by a majority of scholars or can be shown with certainty to be by some other painter. Thus, the frescoes in Naples are generally regarded as works of a follower of Giotto, but the panels on the doors of the sacristy of Santa Croce, which are now in the Accademia, Florence, Berlin, and Munich, are known to have been painted by Giotto's follower and assistant, Taddeo Gaddi.

The account of Giotto given by Vasari in his second edition, which is the one translated here, differs in several respects from that given in the edition of 1550; and it is clear that for the later account Vasari added a good many works in order to magnify Giotto's importance. Most of them have been taken away again by modern critics. The present position of Giotto studies is that many scholars accept the premises which Vasari himself accepted and therefore, by and large, share Vasari's views; whereas those who begin by rejecting the Assisi frescoes find themselves compelled to reject all but a very small number of works as Giotto's own, thus correspondingly increasing the importance of his school.

UCCELLO

Several of the works mentioned by Vasari at the beginning of this *Life* can no longer be traced, and two of Uccello's most famous late works, the *Hunt by Moonlight*, now in Oxford, and the *Predella* for the Urbino altarpiece, now in the Gallery in Urbino, are not mentioned by Vasari at all. The frescoes in the cloister of Santa Maria Novella, and especially the most famous of Uccello's works, the *Deluge*, have survived, but in very fragmentary condition. The *Deluge*, which is described at length by Vasari, was restored in the 1950s and is now in better condition than it has been for centuries. Nevertheless, all these frescoes are little more than ghosts of what they once were.

On the other hand, the frescoes painted inside Florence Cathedral have survived in fairly good condition, the most famous being the one described by Vasari as representing the Englishman 'Acuto', who

in fact was Sir John Hawkwood. As Vasari records, the fresco is signed by Uccello and it is also datable to 1436, so that it is a key work in establishing the development of Uccello's style. The *Four Heads of Prophets* painted at the corners of the clock-face have also survived, but they are very high up and difficult to see.

The panel painting of *Five Famous Florentines* is identifiable with the picture now in the Louvre; but the *Battle Scenes*, which according to Vasari were restored by Bugiardini to their detriment, are probably not to be identified with the three large panel paintings of *Battles*, which are now divided between Florence, Paris, and London. These were painted for the Medici family, between 1454 and 1457.

The works in Padua, which Vasari mentions briefly, disappeared long ago, but it is thought that some traces of Uccello can be found in Paduan painting of the mid and late fifteenth century.

GHIBERTI

Vasari's principal source of information on the life and works of Lorenzo Ghiberti was the autobiography written by Ghiberti in the last years of his life. There is, therefore, not much room for disagreement over attribution, and almost all the works mentioned by Vasari are both certainly by Ghiberti and still in existence.

The three most important are the trial-piece of the *Sacrifice of Abraham*, now in the Bargello in Florence, with which Ghiberti won the competition for the first Baptistry Doors, and the two pairs of Doors themselves. These Doors represent by far the greater part of Ghiberti's life-work.

Most of the other works mentioned by Vasari are also still in Florence, but Ghiberti's autobiography makes it clear that he was in addition responsible for a considerable amount of work as a goldsmith, all of which has long ago been broken up or melted down.

MASACCIO

Vasari's *Life* is of fundamental importance in the reconstruction of Masaccio's life and works. This is because his two major works, both described by Vasari, are the altarpiece painted for Pisa and the frescoes in the Brancacci Chapel in Florence. The altarpiece was dismembered centuries ago. The frescoes in the Brancacci Chapel are known, from Vasari and other writers, to have been painted by Masaccio, Masolino, and Filippino Lippi. It was, therefore, impossible to be certain which of the frescoes in the chapel were to be attributed to Masaccio; but fortunately the description given by Vasari of the Pisa altarpiece made

it possible to identify the surviving fragments in various galleries. The most important panel from it is the *Madonna*, now in the National Gallery, London, but other parts have been identified in Pisa, Naples, Berlin, and a private collection in Vienna. The style of the altarpiece and the style of the frescoes could then be matched, and other works such as the *Trinity* in Santa Maria Novella in Florence, or the *St Anne* altarpiece, now in the Uffizi, can be brought into relationship with Masaccio's authenticated works.

There is still room for the dispute over the exact demarcation between Masaccio and Masolino, and the most difficult problems, at present, are those connected with the San Giovenale altarpiece, dated 1422, discovered by L. Berti in 1961 and now in the Uffizi. This is the earliest datable work that can be associated with Masaccio and it makes even more complex the relationship with Masolino which is the problem presented by the Sta Maria Maggorie altarpiece, two panels of which are now in the National Gallery, London, one apparently by Masaccio and the other (like the rest of the altarpiece) by Masolino.

BRUNELLESCHI

Vasari was particularly well informed on the life and works of Brunelleschi, since he had a considerable amount of information available in the *Anonymous Life of Brunelleschi*, written late in the fifteenth century. All Brunelleschi's surviving works are in Florence, where the oral tradition was also particularly strong. There is therefore no doubt about the attribution of Brunelleschi's main works, the dome and lantern of Florence Cathedral, the churches of San Lorenzo and Santo Spirito, and the Loggia of the Foundling Hospital.

Only two of Brunelleschi's major works present any difficulties; these are the church of Santa Maria degli Angeli, and the Pazzi Chapel which stands in the cloister of Santa Croce. The Angeli still exists, but was abandoned unfinished in the 1430s and the original design has to be reconstructed. More serious is the fact that the Pazzi Chapel – which is certainly Brunelleschi's – was omitted from the list of works in the *Anonymous Life* (which is incomplete). This meant that Vasari, who knew that the chapel was by Brunelleschi, did not know where to put it in chronological order. He therefore got it out of the way by putting it at the beginning of the *Life*, and this misled many generations into thinking that it was an early work, whereas in fact it seems to have been designed in the 1430s but left still unfinished at Brunelleschi's death in 1446. Nothing is known with certainty of any of Brunelleschi's activities outside Florence.

DONATELLO

Vasari describes almost all the surviving works by Donatello, as well as a number of others which are either unidentifiable or else not generally accepted as his work. Practically all Donatello's major works were executed for Florence and are still there, either in the Cathedral, Cathedral Museum, Baptistry, churches, or the Bargello Museum. A few works, such as the statue of *Abundance* and the brick and stucco works made for the Cathedral, are known to have been destroyed; while a few other works recorded by Vasari in Florence, such as the figures belonging to the Martelli family, have been dispersed (some are in Berlin and Washington), but there is considerable disagreement about their authenticity.

Outside Florence Vasari mentions the important tomb in Naples and the pulpit at Prato, both of which Donatello is known to have made in collaboration with the architect and sculptor Michelozzo. The works in Padua, which are among Donatello's most important, are still in the city, as are those in Venice and Faenza.

PIERO DELLA FRANCESCA

Vasari's account of Piero is doubtles coloured by the fact that they both came from Arezzo, but there can be no doubt that the amount of space devoted to Piero by Vasari has been helpful in retaining Piero's name in all subsequent histories of painting.

Vasari begins by recording his activity as a writer, and Piero's treatises have, in fact, come down to us. The frescoes in Ferrara and Rome have been lost for centuries, but most of the main surviving works are recorded by Vasari. The great cycle of frescoes in San Francesco at Arezzo is properly given the place of honour, although Vasari and many others regard the fresco of *The Resurrection*, in the town hall at San Sepolcro (the modern form of Borgo San Sepolcro, Piero's birthplace), as Piero's masterpiece. Among panel paintings, Vasari records the altarpiece in Perugia, now in the Gallery there, and the altarpiece painted for the convent of St Augustine at Borgo San Sepolcro, known from documents but long ago dismembered. It was convincingly reconstructed in recent times by Professor Meiss, who pointed out that three panels of *Saints* in the National Gallery, London, the Frick Collection in New York, and the Poldi-Pezzoli Gallery in Milan, all came from the same altarpiece, which must have been an Augustinian one. The *Madonna* (which must have formed the centre) is still lost, but another panel representing St Augustine himself has now come to light and is in the Gallery in Lisbon.

The most important pictures by Piero not mentioned by Vasari are the two small portraits of the Duke and Duchess of Urbino, in the Uffizi, Florence, and the large altarpiece, which also contains a portrait of the Duke, now in the Brera, Milan. This is often mis-identified with the altarpiece attributed to the otherwise unknown Fra Carnevale by Vasari in his *Life* of Bramante.

FRA ANGELICO

By far the largest number of surviving works by Fra Angelico are to be found in Florence in his own convent of San Marco, now a museum. This contains the fresco cycle mentioned by Vasari as well as a number of panel pictures which have been transferred there. The most important of these is the one mentioned by Vasari as having been painted for the Linen-drapers or Cloth Guild since it is Fra Angelico's earliest datable work, of 1433. It is now thought that Fra Angelico was born about 1400, rather than 1387, which helps to explain the otherwise very late date for this altarpiece. Among the other works described by Vasari are the frescoes in the Vatican in the chapel of Nicholas V, as well as those in another chapel, since destroyed. He also records the beginning of a fresco cycle in the cathedral at Orvieto, and the panels painted for the doors of the Silver Cupboard in the Annunziata at Florence which are now in the Museum of San Marco. The panel of the *Coronation of the Virgin* may perhaps be identical with the large panel now in the Louvre, and small panels from the Reliquaries have been identified with those now in Florence and in the Gardner Musuem, Boston.

There are other important works in Cortona, Munich, Berlin, Dublin, Washington, and elsewhere, which are either identifiable with parts of altarpieces recorded by Vasari or have been attributed to Angelico on stylistic grounds.

ALBERTI

Vasari makes considerable play with the fact that Alberti was a theorist rather than a practical architect, and he mentions his writings as being particularly important. The *Ten Books on Architecture* he records as printed in 1481, although no edition earlier than the mid 1480s seems to be known. The first Italian translation appeared in 1546, followed by an illustrated one in 1550.

Vasari goes on to mention almost all of Alberti's surviving build-ings – the church at Rimini; the façade of Santa Maria Novella in Florence (which is actually dated 1470, though designed earlier); the works for the Rucellai family in Florence, although Vasari seems

to be cautious in his attribution of the palace to Alberti; as well as the work at the Annunziata in Florence and the design of the church of Sant'Andrea in Mantua. The other church in Mantua, San Sebastiano, is not explicitly cited by Vasari. On the other hand, he mentions Alberti's works in the other arts, particularly his paintings, none of which has come down to us. One possible exception is a bronze plaque with a profile portrait of Alberti, now in the National Gallery of Washington, which has been held to be a self-portrait.

FRA FILIPPO LIPPI

At the beginning of the *Life* of Fra Filippo Vasari mentions a fresco of 'the Carmelite Rule', and this very unusual subject is certainly that of a fresco known only in a fragmentary state. It was covered by layers of whitewash and for many years Vasari's reference to it seemed meaningless but the recovery of a few figures and some fragments of landscape has allowed us to confirm that it is the fresco mentioned by Vasari and that, as he said, it was painted at the beginning of Fra Filippo's career. It is stylistically very close to Masaccio and because of this it has been necessary to revise earlier opinions concerning Fra Filippo's artistic development. Vasari records several other works by Fra Filippo, including some of the most important, such as the fresco cycle in Prato Cathedral, which is known to have been begun in 1452 and was completed about 1464. The unfinished frescoes in Spoleto Cathedral were begun in 1467 and left incomplete in 1469 when Fra Filippo died.

Other works recorded by Vasari are the *Nativity* painted for the Medici family, now in Berlin; the *Annunciation* still in the church of San Lorenzo in Florence, and the works now in the Museum at Prato. Three other works by Fra Filippo which are particularly famous do not seem to be recorded unequivocally by Vasari: they are the circular *Madonna*, known as the 'Pitti Tondo' in the Gallery of that name in Florence, the large *Coronation* of 1441 in the Uffizi, and the *Barbadori* altarpiece of 1437–8 in the Louvre.

The earliest work by Fra Filippo to bear a date is the *Madonna*, of 1437, at present in the National Gallery, Rome, but known as the 'Tarquinia Madonna' because it came from the little town of Corneto Tarquinia not far from Rome, which probably means that Vasari never saw it.

BOTTICELLI

Nearly all of Botticelli's most famous pictures are recorded by Vasari, although some are not mentioned by him. It is, in fact, very difficult

to construct a series of documented and datable works by Botticelli. The latest known is the *Mystic Nativity* in the National Gallery, London. This is not mentioned by Vasari, but fortunately it is signed and dated. On the other hand, Vasari mentions several of the pictures still in Florence, such as the figure of *Fortitude*, in the Uffizi, which is known to be datable in 1470. He also records the *St Augustine* fresco in Ognissanti as well as the most famous works now in the Uffizi, such as the *Birth of Venus*, the *Allegory of Spring*, the *Calumny of Apelles*, and the large altarpiece of the *Adoration of the Magi* which has portraits of the Medici family. Vasari also records an altarpiece from San Barnabà, now in the Uffizi, and another, painted for the Convertite, which is very probably the altarpiece now in the Courtauld Institute Galleries in London.

The frescoes in the Vatican are also mentioned by Vasari and are datable about 1482, so that there is a fairly large body of work which can be ascribed with some confidence to Botticelli, particularly as the style of these pictures is highly individual. On the other hand, Vasari devotes considerable space to the altarpiece painted for Matteo Palmieri which, he says, was suspected of heresy. This seems certainly to be the picture in the National Gallery, London, which is now ascribed to Botticini, and no doubt Vasari confused the names. The style is not unlike that of Botticelli so it is easy to see how the mistake arose. (The heresy Matteo Palmieri is known to have held was that human souls are those of the angels who remained neutral when Lucifer rebelled.) The picture seems to have remained in the Palmieri family chapel for a great number of years in spite of its suspect orthodoxy.

VERROCCHIO

Verrocchio's activity as a painter and sculptor is fairly well documented. He seems to have run a large workshop in which Leonardo da Vinci and Lorenzo di Credi, to name only two, worked for considerable periods. The famous *Baptism*, now in the Uffizi, is described by Vasari, both in the *Life* of Verrocchio and in that of Leonardo. This is the picture which, according to Vasari, was left unfinished because Verrocchio was so overcome by the superiority of the angel painted by Leonardo that he abandoned painting in favour of sculpture. It is true that Verrocchio was more active as a sculptor than as a painter, and there are relatively few paintings which can be attributed to him. They include the *Madonna* and the *Tobias and the Archangel*, in the National Gallery in London, as well as *Madonnas* in Berlin and Washington, and, perhaps most interesting of all, the *Madonna* formerly in Sheffield (now in the National Gallery of Scotland,

Edinburgh), which once belonged to John Ruskin. It was exhibited at the Royal Academy in 1960 and at that time the suggestion was made that it was partly, or even wholly, by Leonardo. The suggestion, however, has not met with general acceptance and when it was sold to Edinburgh it was as a Verrocchio.

Most of Verrocchio's major works in sculpture are recorded by Vasari, including the bronze *David*, the *Boy with a Dolphin*, the tomb of Cosimo de' Medici in the Old Sacristy of San Lorenzo, the silver relief for the cathedral, and the statue of the *Incredulity of St Thomas*, all of which are still in Florence. Verrocchio's most famous work outside Florence, and perhaps his masterpiece, is the equestrian statue of the mercenary soldier Colleone (called Bartolommeo da Bergamo by Vasari) which stands outside SS. Giovanni e Paolo in Venice. This, as Vasari says, was unfinished when Verrocchio died in 1488.

MANTEGNA

Most of the major works by Mantegna are recorded by Vasari, including the engravings which are nowadays regarded as works produced under Mantegna's supervision rather than actually by him. Vasari mentions the three main fresco cycles which Mantegna is known to have painted, but one of them, the chapel in the Vatican, is now entirely destroyed and no trace of it has been preserved. Another, the fresco cycle in the Eremitani Church in Padua, is described at considerable length by Vasari and came down to us in comparatively good preservation, although one or two of the frescoes were rather badly damaged. The entire church was destroyed in 1944, and only a few fragments, pieced together with infinite patience, have survived. Fortunately a photographic record exists and a full series of new photographs was made only a few days before the air raid.

The only important surviving fresco cycle is, therefore, the series of scenes from the life of the Gonzaga Court at Mantua which occupy part of the walls and the whole of the ceiling of a small room[1] in the castle at Mantua. These were presumably not seen by Vasari since he mentions them only very briefly, although he notes that they were particularly famous for their perspective foreshortenings. In fact, the ceiling, which seems to have a central circular opening with figures peering downwards over a balustrade, is one of the most sophisticated pieces of illusionism produced in the fifteenth century and looks forward to the similar feats by Correggio in the sixteenth century and by the great Baroque decorators of the seventeenth century.

1. The *Camera degli Sposi*.

On the other hand, Vasari gives a comparatively full description of the *Triumphs of Caesar* which, in a somewhat battered condition, have been for centuries in the British Royal Collection. They have now been cleaned and freed from eighteenth-century repaints, so that they may now be seen in better state of preservation than was feared when the cleaning was begun. They are exhibited in a special gallery built for them at Hampton Court.

Of the other pictures mentioned by Vasari the most famous is the High Altarpiece painted for San Zeno in Verona, where it still is. The *Madonna with the heads of angels* is now in the Brera in Milan, and the *Madonna of the Quarries* is in the Uffizi in Florence. The *Madonna of Victory*, which Vasari records as having been painted in commemoration of a victory over the French, is now, ironically enough, in the Louvre in Paris, where it was placed when Napoleon looted it in the last years of the eighteenth century.

LEONARDO

Leonardo painted relatively few pictures, probably because of the diversity of interests recorded by Vasari. On the other hand, he left many hundreds of drawings, including many scientific ones, for example the studies of the anatomy of the horse and human anatomy, as well as studies for pictures including some drawings on linen, such as those mentioned by Vasari at the beginning of the *Life*. About half of the surviving pictures attributed to Leonardo are described in some detail by Vasari. They include the unfinished *Baptism*, now in the Uffizi in Florence, which Vasari records as having been begun by Verrocchio and to which Leonardo added one angel. This must have been one of Leonardo's earliest works; but two, and probably three, of his most famous paintings are clearly recorded by Vasari. They are the *Last Supper*, in Milan, now very damaged, the *Mona Lisa*, in the Louvre, and the large picture, also in the Louvre, of the *Madonna and Child with St Anne*, which must be the *Madonna* described by Vasari as having gone to France.

Other pictures certainly by Leonardo which can probably be identified with works mentioned by Vasari are the unfinished *Adoration of the Magi*, now in the Uffizi in Florence, on which Leonardo was working in 1481; the *Madonna* which contained a vase of flowers with dewdrops on it must be the picture in Munich; while the *Baptist* in the Louvre is probably the picture described by Vasari as 'an angel with his arm upraised'. The portrait of a woman called Ginevra de' Benci has been convincingly identified with the portrait of a woman against a background of juniper (*ginepra*), formerly in the

collection of the Princes of Liechtenstein and now in the National Gallery, Washington.

CORREGGIO

Vasari was not particularly well informed about the circumstances of Correggio's life, but he nevertheless records two of the three main fresco cycles, those in the dome of San Giovanni Evangelista and the cathedral in Parma. The earliest fresco cycle is in a convent in Parma, and Vasari probably never had the opportunity to see it. At least two of Correggio's major altarpieces are recorded unequivocally – the *Madonna with St Jerome*, now in the Gallery at Parma, and the *Nativity* with the light shining from the figure of the Child, which is almost certainly the picture now in Dresden.

Other works recorded by Vasari probably include the *Agony in the Garden*, now in the Victoria and Albert Museum, London (Wellington Museum), and the *Deposition from the Cross*, in the Parma Gallery, which is probably identifiable with the *Dead Christ* recorded by Vasari. His mythological pictures include some in Rome, Vienna, and London, but none of these seems to be certainly identifiable with those mentioned by Vasari.

GIORGIONE

The works of Giorgione have always been highly controversial, largely owing to the absence of any considerable body of authenticated work. The frescoes mentioned by Vasari as those which he was unable to interpret on the exterior of the Fondaco dei Tedeschi in Venice have now all but entirely disappeared and are known to us only from eighteenth-century engravings and some faded fragments of the originals. On the other hand, a picture of a woman called Laura, in the Gallery at Vienna, has a contemporary inscription on the back, but the portrait is not mentioned by Vasari and is in rather unsatisfactory condition. The principal work, on which almost all attributions are based, is the large altarpiece in Giorgione's birthplace, Castelfranco. Vasari says that Giorgione painted there, but he does not specify this work which, because of its close similarity to the late works of Giovanni Bellini, is generally thought to date from very early in Giorgione's short career.

Many of the other portraits mentioned rather vaguely by Vasari have been identified with existing pictures, but there can be no certainty in these identifications and the problem is made worse by the similarity of style between Giorgione, Titian, and Sebastiano del Piombo.

RAPHAEL

Raphael died when Vasari was a boy of about nine, but his fame was such and his pupils were so numerous and so nearly contemporary with Vasari that it cannot have been very difficult to gather information about his pictures. The task would have been made somewhat easier because most of Raphael's mature works, which were the foundation of his enormous reputation, are frescoes in Rome, and the very extent of his reputation made it comparatively easy to find out about works painted in Perugia or Florence while he was still comparatively unknown.

Almost all of the works mentioned by Vasari can be identified without much difficulty; for example, the *Sposalizio* (which is signed and dated 1504) now in the Brera in Milan, the *Madonna of the Goldfinch*, in Florence, or the *Ansidei Madonna*, now in the National Gallery, London. Most of the works painted during the last twelve years of Raphael's career are easily identifiable, and far the most important are the frescoes in the Vatican, the fresco of *Galatea*, together with the other frescoes on the ceiling of the Loggia, in the Farnesina in Rome, and such works as the tapestries and the great altarpiece of the *Transfiguration*, in the Vatican Museum. Seven of the cartoons for the tapestries have survived and are on loan from the Royal Collection to the Victoria and Albert Museum in London.

Only two problems are presented by the list of pictures recorded by Vasari. One is the portrait of *Pope Julius II*, which existed in two versions, in the Pitti and Uffizi Galleries in Florence. The argument over the superiority of the Uffizi version over the one in the Pitti, generally thought to be the copy by Titian which Vasari mentions, was dramatically settled in 1970 when a third version, in the National Gallery, London, was cleaned and revealed itself as undoubtedly the original by Raphael. The second problem is the *Madonna* which Vasari records as having been painted at the same time as the portrait of Julius and as showing the birth of Christ, with the Virgin covering the child with a veil, and St Joseph near by. There are a good many versions, or rather copies, of this picture, but no one of them is of sufficiently high quality to justify an attribution to Raphael himself. The copies do, however, agree sufficiently closely for us to have a very good idea of the appearance of the original.

MICHELANGELO

We are very well informed on the works of Michelangelo since Vasari wrote his first *Life* before 1550, while Michelangelo was still alive. In 1553 Michelangelo's pupil, Ascanio Condivi, wrote an

authorized biography intended to correct those parts of Vasari's *Life* which Michelangelo himself did not like. These two, together with the final version of Vasari's *Life*, written after Michelangelo's death in 1564, give a very complete account of all his major works. In particular, they record the three great fresco cycles in the Vatican and the cartoon for a fresco in Florence, which was destroyed early in the sixteenth century but is known to us in part from Michelangelo's preparatory drawings and from an early partial copy now in the collection of the Earl of Leicester.

Michelangelo's principal works in sculpture, the *David* and the unfinished figures for the Medici Chapel in San Lorenzo, are still in Florence, while the final version of the Tomb of Julius II is in San Pietro in Vincoli in Rome, and various figures originally made for it but subsequently abandoned are in Florence and Paris. The *Pietà* in St Peter's and the *Risen Christ* made for Santa Maria sopra Minerva in Rome are both still there, and the *Madonna* in Bruges is still in the church for which it was made. Of the late versions of the *Pietà* two are in Florence, including one in the cathedral which Michelangelo originally intended for his own tomb, while the latest of all, the so-called *Rondanini Pietà*, is now in the Civic Museum in Milan. An early crucifix recorded as having been made for the church of Santo Spirito in Florence was thought to have been lost for centuries, but late in 1963 it was suggested that a crucifix still in the monastery attached to Santo Spirito is in fact the missing work; it now seems to have won general acceptance.

TITIAN

Vasari himself tells us, in the course of his description of the works of Titian, that he was in Venice in 1566 and paid a call on Titian, who, although he was then a very old man, was still painting and spoke to him at length. From this it is evident that Titian, who did not die until 1576, gave Vasari a considerable amount of information about his works, and it is a fact that Vasari describes more than thirty pictures which can be identified and almost all of which are still in existence. Two important exceptions are the frescoes which Titian painted at the very beginning of his career, along with Giorgione, on the Fondaco dei Tedeschi, and the large canvas of the *Murder of St Peter Martyr*. The frescoes, like Giorgione's, have disappeared. The other major loss, the altarpiece of *St Peter Martyr*, is less serious in that copies give us a good idea of the original appearance of the picture. The painting itself was originally in the church of SS. Giovanni e Paolo and was destroyed by fire in 1867, but quite good copies are known, and they confirm the importance of the picture in

the history of Venetian painting, since it has a violence of gesture which is echoed in the landscpe and is in harmony with the dramatic nature of the subject.

Several other pictures mentioned by Vasari cannot be identified with absolute certainty: for example, the portrait of *Duke Alfonso with a Cannon*, which may be identical with a picture in New York, and there are a few other portraits, including those of *Charles V* and *Ippolito de' Medici in Armour*, which do not seem to be identifiable.

Several other pictures are mentioned by Vasari in a rather generalized way, but there is still a long list of positively identifiable works, which would be enough to give us a clear idea of Titian's development even if we had no other source of information. They include such masterpieces as the frescoes in Padua, the *Assumption* in the church of the Frari, the *Pesaro Madonna*, the enormous picture of the *Presentation of the Virgin*, which is on a wall of what is now the Accademia in Venice, the portraits of Pope Paul III, the three ceilings now in Santa Maria della Salute, the *Allegory* painted for Charles V, taken by him on his abdication to the monastery at Juste, as well as such famous late works as the pictures of *Diana* in Vienna and in the collection of Lord Ellesmere, or the *Martyrdom of St Lawrence*, now in the Escorial near Madrid, which was actually in Titian's studio when Vasari visited him and was not sent to Spain until December 1567.

FURTHER READING

—— · ——

Vasari on Technique, by Louisa S. Maclehose and G. Baldwin Brown (Dent, 1907; Dover Publications, paperback, 1960): an accurate translation, with useful notes and illustrations, of Vasari's Introduction to the *Lives*, his technical treatise on architecture, sculpture, and painting.

Artistic Theory in Italy 1450—1600, by Anthony Blunt (Oxford University Press, first edition, 1940; also in paperback): an illuminating commentary on Renaissance art theory from Alberti to the later Mannerists.

Classic Art, by H. Wölfflinn (Phaidon Press, 1952): first published in 1899, this classic of art history has had a major influence on subsequent art historians and in this illustrated translation makes a very stimulating introduction to the period.

The Art of the Renaissance, by Peter and Linda Murray (Thames and Hudson, 1963; also in paperback).

An Index of Attributions made in Tuscan Sources before Vasari, by Peter Murray (Leo S. Olschki, Florence, 1959) lists the sources that Vasari drew upon.

The High Renaissance (1967), and *The Late Renaissance and Mannerism* (1967), by Linda Murray, both reprinted and revised as one volume (Thames and Hudson, 1977).

The Architecture of the Italian Renaissance, by Peter Murray (Thames and Hudson, 1986).

Introduction to Italian Sculpture, by Sir John Pope-Hennessy, three volumes (Phaidon paperback, 1986).

Giorgio Vasari: The Man and the Book, by T. S. R. Boase (Princeton University Press, 1979), based on a series of (A. W. Mellon) lectures, is readable and scholarly, fairly well illustrated, critical, but sympathetic to Vasari, and the best general introduction to him in English.

Vasari Pittore, by Paolo Barocchi (Milan, 1964): a reasonably well-illustrated essential first book for the study of Vasari as an artist.